THE
STRANGER AND THE
STATESMAN

James Smithson, John Quincy Adams,

and the Making of America's

Greatest Museum: The Smithsonian

William Morrow

An Imprint of HarperCollins*Publishers*

THE
STRANGER
AND THE
STATESMAN

Nina Burleigh

HarperCollins books may be purchased for educational, business, or sales promotional use. For information please write: Special Markets Department, HarperCollins Publishers Inc., 10 East 53rd Street, New York, NY 10022.

FIRST EDITION

Designed by Cassandra J. Pappas

Printed on acid-free paper

Library of Congress Cataloging-in-Publication Data

Burleigh, Nina.
 The stranger and the statesman: James Smithson, John Quincy Adams, and the making of America's greatest museum: The Smithsonian / Nina Burleigh.—1st ed.
 p. cm.
 Includes bibliographical references (p.).
 ISBN 0-06-000241-7 (hc)
 1. Smithsonian Institution—History. 2. Smithson, James, 1765–1829.
 3. Adams, John Quincy, 1767–1848. I. Title.

Q11.B97 2003
069'.09753—dc21

2003044239

03 04 05 06 07 WBC/RRD 10 9 8 7 6 5 4 3 2 1

FOR FELIX

Felix est qui potest causas rerum intellegere.

Happy the one who can learn the causes of things.

—VIRGIL'S TRIBUTE TO LUCRETIUS

Contents

Acknowledgments

I am deeply grateful to editor Rachel Kahan for first suggesting this story. My agent Deborah Clarke Grosvenor encouraged me to write it and, without her vision, the project would never have gotten off the ground. I have been very fortunate to have a fine editor in Claire Wachtel, whose enthusiasm has never flagged.

I would also like to thank Bill Cox at the Smithsonian Archives; Smithsonian paleontologist Ellis Yochelson for his ideas and materials; David Smith at the New York Public Library for always going beyond the call of duty; Rodolf De Salis for research help in London; Nausicaa Pouscoulous in Paris, Marc Rothenberg at the Smithsonian, Dr. Frank James at the Royal Institute, Neil Chambers at the Museum of Natural History in London; American historian Michael Conlin; Brian Dolan; Edwin Grosvenor; Pascale Heurteul at the Musee d'Histoire Naturelle; Fabienne Queyroux at the Institut de France; Peter Schimkat; Jennifer Pooley at William Morrow; Allan Metcalf at MacMurray College for early support and Latin translation.

For lodging and laughs in Washington, D.C., thanks to DeeDee Slewka; for the same in New York, Ed Rollins.

THE
STRANGER AND THE
STATESMAN

THE BODY SNATCHERS

ALEXANDER GRAHAM BELL did not spend the Christmas season of 1903 in the festive tradition. Instead the inventor of the telephone and his wife, Mabel, passed the holiday engaged in a ghoulish Italian adventure involving a graveyard, old bones, and the opening of a moldy casket. They had traveled by steamship from America at their own expense and made their way down to the Italian Mediterranean by train. The entire route was gloomy, as befit their mission. The feeble European winter sun dwindled at four o'clock every afternoon and rain fell incessantly, but the Bells were undeterred. There was little time. They were in Europe to disinter the body of a minor English scientist who had died three-quarters of a century before and bring it back to America.

The couple arrived at Genoa a few days before Christmas and checked into the Eden Palace Hotel perched on the edge of the medieval port. The hotel was a pink, luxurious resort in summer, but in winter, drafty and exposed. The city itself spilled down the steep hillsides to the edge of the sea, a shadowy warren of fifteenth-century cathedrals and narrow, twisting alleys that had seen generations of

plague, power, and intrigue. Once an international center of commerce and art, with palazzi and their fragrant gardens stretching to the water's edge, Genoa in winter at the turn of the twentieth century was a grim place with a harbor full of black, coal-heaped barges.

A steady rain had been falling on France and Italy for days, in Genoa whipped almost vertical by the tramontane, icy winds that blow down from the Alps into the Mediterranean in the winter. Mabel Bell had been hoping to alleviate the dolefulness of the duty by touring the city, but because of the weather she was unable to walk the alleys and visit the pre-Renaissance palazzi once inhabited by Genoa's doges. She was forced to sit in the grand lobby of the Eden Palace Hotel, watching the palms beyond the rattling panes get thrashed in the wind, and wait as her husband sorted through the tangled bureaucracy involved in disinterring a body in Italy.

The Bells had come to Italy in haste because the remains of James Smithson—minor eighteenth-century mineralogist, bastard son of the first Duke of Northumberland, and mysterious benefactor of the Smithsonian Institution—were in peril. Seventy-seven years before, Smithson had, for unknown reasons, bequeathed his fortune—the equivalent of fifty million dollars in current money—to the United States to fund at Washington, D.C., an institution, in his words, "for the increase & diffusion of Knowledge among men." Now the bones of this strange and still little-understood man were about to be blasted into the oblivion of the Mediterranean Sea. Smithsonian officials had tried in early years to learn more about the obscure Englishman, but their attempts were largely fruitless and they abandoned the effort by 1903. To make matters worse, almost all of Smithson's personal effects and papers had been destroyed in a fire at the Smithsonian in 1865. To lose his bones to the sea would put an ignominious coda on the stranger's murky life story.

The old British cemetery where he was buried occupied a picturesque plot of ground on a cliff overlooking the Mediterranean, but it was adjacent to a vast marble quarry. Blasting work to expand the port had been under way for years. The surface of the graveyard belonged to the British, but the hundreds of vertical feet of earth below extending to sea level belonged to the Italians. In 1900 the owners of the marble quarry had informed the British consulate that by the end of 1905 their blasting for marble would finally demolish the cemetery. When the Bells arrived, some coffins had already been dislodged from their graves, tipped over, and crashed into the gaping void below. The Italians were soon to evict all of the English dead in similar fashion.

BY 1903 Alexander Graham Bell was fifty-six years old and one of America's foremost scientists, a genuine celebrity whose name caused audiences to cheer and applaud. The telephone he'd invented in his youth had changed the world radically in ways that he and his contemporaries understood and the American people appreciated. He had become a wealthy man because of the phone, but he never stopped inventing. He was responsible for a variety of "firsts," including the first hydrofoil, the first respirator, the first practical phonograph, and the first metal detector (the last designed in frantic haste to locate the assassin's bullet in President James Garfield), and he was involved with early experiments in flight. Bell was devoted to science as a kind of spiritual calling, and in his later years, his white beard and dignified bearing, coupled with his sonorous voice, gave him a Mosaic air. When he realized his aerodrome, a watercraft on pontoons, was not airworthy, he wrote: "There are no unsuccessful experiments. Every experiment contains a lesson. If we stop right here, it is the man that is unsuccessful, not the experiment."

Bell's interest in the fate of Smithson's remains was purely altruistic. He was already wealthy and regarded as an American hero, and he had nothing to gain in terms of stature by making the journey himself. The old bones obviously held some scientific interest for him, but forensic anatomy was not one of his known interests. Rather, Bell, as a man of science, felt a certain spiritual kinship with the little-known scientist who had squirreled away a fortune to give to the United States. The idea of the benefactor's bones being upended into the Mediterranean Sea had piqued him. He was the only member of the Smithsonian Board of Regents sufficiently moved to do anything about it.

Most of what we know about this trip comes from the journal kept by Mabel Bell, who had been deaf since childhood. Throughout their marriage, it had been her habit to record, in vivid detail, her and her husband's travels and adventures. Her journals and photographs offer a day-by-day account of the couple's Christmas excursion to Genoa. Because of the weather, Mabel wasn't enjoying herself, but she was devoted to Alec, as she called her husband. On December 30, she sat in the entrance hall of the Eden Palace Hotel, with the cold wind blowing in through loosely hung glass doors and "hugging the steam register" for warmth. As the hotel staff moved about lighting lamps against the winter gloom, she pulled a great blue wool coat around her shoulders and wrote a letter to her daughter Daisy in Paris.

"I am afraid you will think I am no good at all when I confess I haven't been out except to the grave and the bank. But the weather has been unspeakable and the hotel is some distance from the heart of town, and one can't see anything out of the old ramshackle landaus [four-wheeled, horse-drawn carriages] and they can be very cold. There is nothing I want to do except drive in an open carriage, out of the question in pouring rain, or walk about, equally impossible with pleasure."

The inclement weather had aggravated Alexander Bell's already fragile health. As he described it in his notes, "I caught cold in the train from Paris, and this has been aggravated by chilly rain on Christmas day without wraps. Am therefore keeping indoors as much as possible." Ironically, Bell had partly undertaken the trip to improve his health. "I have not been at all well for more than a year past," he wrote to the secretary of the Smithsonian a few days before departing. "Although I feel I have perfectly recovered, Dr. Sowers is anxious that I should have complete rest for a short period of time and the benefit of an ocean voyage. I propose therefore to start for Europe immediately."

Mabel didn't record her views on how "rest" and an "ocean voyage" both met the doctor's orders, but she fervently wished that Alec would quickly open the grave and be done with the gruesome duty. As soon as they arrived in Italy they realized their business was going to be more complicated. A Byzantine bureaucracy had to be satisfied before any digging could begin. The Bells had had reason to expect that getting the bones to the United States would be an easier matter. There was certainly not going to be any trouble on the American end. A week before leaving, the Bells had been informed officially by the U.S. Treasury that "no regulations have been issued by this Department regarding the passage through customs of caskets containing the remains of persons dying abroad." But the Bells soon realized that the Italians had other attitudes that were bound to complicate and prolong the trip.

The Bells soon regretted not having done more research before leaving for Italy. Mabel noted that her husband "spoke of wishing to consult a lawyer and wondering that Mr. Langley [Smithsonian secretary Samuel Langley] and Alec had not obtained a legal opinion concerning the possible strength of this claim before he left America."

While ill in the hotel at Genoa, Bell went to work drafting the

letters to the various Italian bureaucrats and politicians whose favors he needed. Mabel was worried about him, and she shared her fear with her daughter. "Papa had a feverish cold and as he would not allow me to send for a doctor and would go out with the fever on him, I could not help feeling anxious. And one evening he got so white and faint that I was really frightened for a little while, he is so big and his heart so far from strong, that I am sure he could not go through what might be an ordinary attack of pneumonia for another."

To expedite matters and protect her husband's health, Mabel stepped in to handle some of the details herself. She visited the cemetery first to make the preliminary observations. "It might have been as much as his life was worth to venture out on that damp chilly day," Mabel explained. Leaving her husband in the hotel room, Mabel walked up to the cemetery in the rain with the American consul, William Bishop, to meet the Italian grave digger and "discuss ways and means of removing whatever we found." The cemetery was situated on the flat summit of the heights of San Benigno, a promontory that jutted out into the bay, framing one part of a bowl of land and water, in the hollow of which lay the city of Genoa. The cliff had once formed an important defensive fortification for the city that was now no longer needed. Quarry blasting had created a precipice at the very front of the cemetery with a two-hundred-foot sheer drop to the sea. "Very little more blasting will do away with the promontory altogether," she wrote. Indeed, San Benigno in Genoa today is a sea-level industrial park and no trace of any "heights" remains.

While Mabel was at the cemetery, Bell grappled with the bureaucracy from his room. "There seemed to be no end to the red tape necessary to remove the body," Mabel wrote. "A permit to export the body beyond Italian limits, a permit to open the grave, a permit to purchase a coffin, permits from the National government,

city government, the police, the officers, etc., etc. Alec felt very anxious that the whole matter should be kept very quiet and that we should leave with the body as soon as possible. He said that once we were on the ship, we were safe with the remains and it was necessary to be very sure that Washington would sustain him in any trouble that might arise."

Just when they had satisfied the Italians, a new hurdle appeared. "Mr Bishop [the American consul] came in hastily at seven [in] the morning with a grave face and took Alec off to one room. Evidently something of importance had happened. The police or Mayor's clerk had found on file a permanent injunction restraining any one from disturbing the grave of James Smithson and refused to give the permit." Distant relatives of Smithson's—a French family that had tried for generations to extract some of his bequest money from the United States—were protesting the removal of the body. For several days, the Bells were stymied.

"Just now it looks as if they hold the winning cards," Mabel wrote her daughter. "We have all the permits to remove the coffin now and this morning they opened the grave to see what shape the remains were. But the family has put up an injunction." Before going out that morning, Bell's last words to his wife had been "I fear we may go home again without the body." "Won't that be a sell," Mabel wrote to her daughter.

The American inventor eventually prevailed. Armed with hand-copied family trees of Smithson showing the distance between the benefactor and the French family, and a wallet full of lira, Bell went into cloak-and-dagger mode, playing spy, diplomat, and grave robber at once. Since the dead man had bequeathed his entire estate to the Americans, Bell argued that the United States—not the relatives—was the legal owner of his bones. He told the Italians he was in Italy as a representative of President Theodore Roosevelt (not technically true—the president didn't interest himself in the mission

until Bell was already on his way back to America). Throwing around bribe money (he gave a thousand lira to the American consul to grease palms) and the president's name, Bell finally obtained all necessary permissions and negated the French claims.

The minute the legalities were dispensed with, the Bells went straightaway to the grave site. On the way to the cemetery in a carriage, they passed a tall marble column dedicated to Christopher Columbus, who was born in Genoa. Beyond that was a view of the gray sea and the whole wharf "where black hulled ships lay so thick that the water was like rivers meandering between them," Mabel wrote. Farther on, the Bells passed near "La Lanterna," the grimy black lighthouse on a rock jetty that had symbolized Genoa since the Middle Ages. Then they turned and started up a steep narrow street between stucco walls only partially obscuring medieval palazzi with grand views of the harbor.

At the top of this twisting road they found a tiny rectangular cemetery, no more than fifty feet wide and enclosed by high white walls crowned with sparkly bits of broken glass. It was overgrown and weedy, but Mabel found it graceful and wrote that its design promoted reflection rather than depression. Even in winter there were bright red lilies and carnations in bloom. Towering cypresses lined the long gravel walkway that separated the tombs from a tiny white classical chapel with a small portico and pillars. The cemetery was so small, "there was scarcely anything in the enclosure but the chapel," Mabel wrote. She compared the little graveyard to "a beautiful park of cypress trees whose dark foliage was relieved against the white marble paving and the pink and white chapel. The cypresses were tall sentinels of the graves beneath."

Smithson was interred in the most conspicuous tomb in the cemetery. The body rested inside a sarcophagus surrounded by an iron fence half buried in weeds and debris. Within the railing was a cenotaph of white marble on a pedestal, inscribed with the following words:

JAMES SMITHSON, ESQ.
Fellow, Royal Society, London
Who Died at Genoa June 26, 1829.
Age 75 Years.

On the other side of the monument, a few lines were carved into the marble. "This monument is erected and the ground on which it stands is purchased in perpetuity by Henry Hungerford, Esq., the deceased's nephew, in token of gratitude to a generous benefactor and as a tribute to departed worth." Hungerford was a frivolous dandy who went by the name Baron Eunice La Batut. The baron was a cosmopolitan wanderer who lodged in various Continental hotels before his untimely death in his late twenties. The erection of the tomb was one of the most serious tasks he'd ever undertaken. But his intention to mark his uncle's resting place "in perpetuity" was not to be realized.

Snow and a bitter wet wind stung the small disinterment party as they assembled on the promontory above the sea. The graveside witnesses included the Bells, the American consul, and a few representatives from the British and Italian governments. They were joined by three Italian laborers—the cemetery gardener, a Genovese architect charged with opening the tomb, and a metalworker named Paolo Parodi, who was tasked with transferring the remains to a metal casket and soldering the package shut for its journey overseas.

Huddled within the cemetery, the Bells could hardly wait to get the bones out to sea and safe from perhaps another round of bureaucratic skirmishing. "In a snow storm and with strong wet winds adding to the general discomfort of everything, James Smithson's grave was this morning opened, his bones carefully collected and placed in a zinc coffin," Mabel wrote. "It has been hard work bringing about the events of this morning and we shall not feel that we have really obtained secure possession of these remains

until the *Princess Irene* is safely on the high seas and out of reach of interdict by Italian or French warrant."

The tomb was opened with as much dignity as possible given the weather and the desolation of the cemetery. Bell himself recorded, with scientific detachment, the sight that greeted the assembled party as the stone lid was lifted from the sarcophagus. "I was surprised at the remarkable state in which the remains were found," he wrote. "The skeleton was complete. The bones have separated but they did not crumble when exposed to air as I had feared they would. As the stone slab covering the grave was removed, it looked as though the body was covered with a heavy blanket, under which the form was outlined. I could not explain this until the discovery was made that in the passage of time the casket had crumbled to dust. It was this dust which lay like a rug over the remains." Bell lifted the skull out of the casket and held it aloft in the bitter wind, examining it. For a moment, he was eye to eye socket with the remains of a fellow man of science whose belief in an Enlightenment-era ideal of bringing knowledge to the masses had resulted in the creation of America's first and foremost scientific institution.

On January 7, 1904, Bell and Mabel finally saw the bones—now packed in zinc (coincidentally, a mineral Smithson had studied at length)—loaded onto the passenger steamer *Princess Irene.* They then boarded the ship themselves and left from Genoa Harbor for New York. "It is hoped that these few bones, almost all that really remains of what was once a wealthy gentleman and scientific student, will escape the fate that has befallen all his other possessions which preceded him to America," Mabel wrote (referring to the fire that destroyed Smithson's effects in 1865) as she and her husband headed back to the United States.

AS AN EX OFFICIO MEMBER of the Smithsonian Institution Board of Regents, Bell had advocated moving Smithson's bones to

the United States for several years before his trip, but there was little interest in the project at the Smithsonian, or for that matter in the American government. In March 1901 he wrote to Mabel in Paris, from Washington, D.C.: "Glad you approved of the idea of bringing poor Smithson to the United States and giving him an honored resting place beside the Institution he founded. Trouble was I couldn't get the Regents to see it. The proposition to bring Smithson's body here received ONE VOTE—my own—and that was all."

Bell was indignant that the U.S. government would not attempt to rescue the bones of the man responsible for the Smithsonian Institution. In all likelihood, the official disengagement had to do with the fact that there was relatively little public support for the Smithsonian itself. The Smithsonian by 1903 was spending large sums—$450,000 annually. It was at the center of an elaborate system of exchanging scientific literature with other nations, but its museum collections and public reach were nowhere near what they are today, with twenty million American visitors annually to seventeen massive collections in Washington alone.

Bell had some powerful supporters, however. Chief among them was his son-in-law Gilbert Grosvenor, the first editor of *National Geographic* magazine. Grosvenor wrote articles about the imminent demise of the bones, burnishing up the remarkable story of the lonely benefactor in the process. Published in the *New York Herald,* the main story prompted a public response that in turn provoked the regents to agree that Bell should go to save the Smithson remains. The public relations campaign continued while Bell and his wife were in Italy. Grosvenor penned outraged articles noting that the American authorities still had not organized a proper reception for the bones. With just days left before the remains were to arrive, Grosvenor took his case directly to President Roosevelt, who authorized a hero's welcome for the bones.

The government went into full ceremonial mode as the *Princess Irene* was steaming across the Atlantic. A U.S. Navy dispatch vessel,

USS *Dolphin*, was sent to meet the steamer in New York Harbor. As Bell and the remains approached, the *Dolphin* fired salutes and then the coffin was winched aboard the *Dolphin* and draped with the American flag. Bell boarded the vessel and accompanied the remains for the final leg of the journey to Washington, D.C.

On the *Dolphin*, Bell wrote the speech he would give when they docked in Washington. "I am deeply moved by the honor and dignity bestowed me to perform the mission of bringing to this country the remains of the late James Smithson. As you are aware, James Smithson, [in his] love for our American vivacity and spirit bequeathed his entire fortune to the United States . . . in order that his name might be perpetuated among the earth's greatest benefactors. . . . It is needless for me to say that as his sole heir and the proud possessor of Smithson's great and generous benefactions, it behooves us at this time to provide an appropriate resting place for his remains, such that will honor him who has so highly honored us."

His duties completed, Bell returned to his home in Washington and resumed his ruminations and experiments. Meanwhile, the U.S. Navy ordered "as large a force of Marines as may be available" to form a parade along with the Marine Band as Smithson's casket was lifted from the *Dolphin*'s deck and carried to the gate of the Navy Yard in Washington. There a troop of the Fifteenth Cavalry awaited to escort the bones across town. The British ambassador himself and most of the regents accompanied the funeral procession back through Washington to the Smithsonian.

Bell nearly didn't attend this final leg of the journey of the bones. His mind—preoccupied again with inventions and experiments— had already moved on to other matters, perhaps the flying machine he was trying to design. Notorious for his love of solitude, Bell was essentially nocturnal. He loved working alone until three or four A.M. and sleeping in the morning. He had resumed that schedule as

soon as he got back into his Washington home. His desk was piled high with several months' worth of correspondence, not to mention his and other men's ongoing scientific projects. These projects immediately consumed his attention, leaving him little appetite for the burst of pomp that concluded his involvement in the Smithson disinterment. With the real job accomplished, Bell had settled back into the scientific sanctuary where he was happiest, and had to be coaxed into his black suit and stovepipe hat to play his part in the final official act. A servant of Bell's, Charles Thompson, recorded the events of the early morning of January 25, 1904.

"Hoi. Hoi," he called into Bell's bedroom. "Breakfast and newspapers here, Mr. Bell. It's now nine o'clock and I can't give you another minute."

"Why am I to get up if I don't want to?" the inventor mumbled blearily from his bed.

"Because you are to be at the Navy Yard at 10 a.m. sharp to escort the remains of James Smithson to their last resting place."

"Nonsense. What are you talking about? He's been dead for fifty years."

"Can't help it, sir. He's in Washington now and you brought him here."

Bell was silent for a while. Then, "Why did he come to bother me?"

Only through the intervention of Mabel, did Bell get to the Navy Yard in his formal suit and top hat in time for the official ceremony.

BY FEBRUARY 1904 the remains of James Smithson were finally inside the institution that owes its existence to his bequest of more than $500,000 in 1836 dollars. Congress had to grant its approval for the American reburial of the British citizen and, as with everything congressional, that took some negotiating. The

bones lay inside the Castle for several more months. During this period, sentiment turned a little against the whole enterprise. In a Washington gossip column published in a New York newspaper, the writer noted that the remains of the benefactor were still lying dishonorably in a room at the Smithsonian months after their arrival. "Could he have had his 'say' about it, it seems to me that Mr. Smithson would not have chosen to have had his coffin opened at this late date and its contents talked about on two continents. At any rate, the pitiful evidences of decay are entitled to the respect of silence."

The job of creating a respectful resting place for the benefactor was taken up by Smithsonian officials. The board of regents formally recommended that a Smithson memorial be funded by Congress and began taking proposals from architects and artists for a tomb. The suggestions ranged from a massive shrine that would have dwarfed the Lincoln Memorial to recycling a Syrian sarcophagus that had been donated to the Smithsonian years before. In the end, Congress balked at funding anything elaborate, so the regents sent for the original sarcophagus in Genoa. When that arrived, it was reassembled in a special Mortuary Room, constructed to the left of the entrance to the Castle. There, on March 6, 1905, in a small ceremony following the regents' meeting, the bones were reinterred.

Eternal silence wouldn't settle around the bones just yet. In the mid-1970s the Smithsonian, motivated by continuing curiosity about Smithson's mysterious life, reopened the tomb, nearly obliterating the benefactor forever in the process. This time, Smithsonian workers with a blowtorch set the velvet material around the bones on fire. Unable to use a fire extinguisher that would scatter the fragile bones across the room, the workers took mouthfuls of water from a nearby fountain and spit on the small conflagration. The bones were then removed and laid before a forensic expert.

Dr. Jo Lawrence Angel, curator of the Physical Anthropology Department of the Smithsonian, was charged with examining the bones using twentieth-century forensics. He examined the skeleton and produced a ten-page report, noting first that the transfer of the bones from the grave to the American resting place "had not been especially orderly." The skull and jaw rested at one end of the sarcophagus but the rest of the bones were jumbled together with old brass coffin nails and masses of dirt and plaster, all "commingled irregularly like fruit in a cake," the examiner wrote.

Once the bones were separated from the debris and the skeleton reassembled, the examiner wove a life story. The most interesting conclusion was that Smithson had suffered malnourishment in early childhood. His adult stature was not what it should have been and "certainly below" that of the English upper class at the time. He was somewhere in the vicinity of 165 and 172 centimeters, far shorter than the five-foot-ten guess made by Bell and his original coffin-openers on first looking at the bones in Genoa.

He was a short, slight man, so slight as to seem "feminine," the examiner wrote. He had been right-handed. He was quite possibly a heavy drinker of alcohol. His dental state was appalling—not unusual for his time. He was missing seventeen teeth at death, lost to painful periodontal disease. The wear on one tooth indicated he might have smoked a pipe. Certain peculiarities of the right little finger suggest that he may have played the harpsichord, the piano, or a stringed instrument such as a violin.

The bones, though delicate, also reflected a hardy outdoor life, with wear on the knees indicating someone who spent time working on the ground. His hands were the hands of a man used to rough work, with fingers gnarled from repetitive use of tools. These intimate details confirmed some things already publicly known about the life of James Smithson, and added new questions. Malnourishment? Feminine bones? Intriguing new facts, but no

inspection of his crumbled remains, no matter how exacting, could really unravel the story of his life and motives.

Into that void, a great deal of legend had already been poured. American newspaper articles covering the Bells' mission give a hint as to the myth that had developed around the mysterious Englishman. On December 30, 1903, the same day that Mabel Bell was writing to her daughter lamenting Alec's dire state of health in Genoa, the *Philadelphia Inquirer* was editorializing under the headline "Smithson's Bones Belong Here": "It is an event of more than ordinary interest that the bones of James Smithson are to be transferred from Genoa . . . through the largesse of Professor Alexander Graham Bell. . . . It is entirely fitting that the man who never saw this country, but who nearly a century ago appreciated the potentialities of the American people, should find his last resting place among those he served so well."

This article—like so much else written about James Smithson in the years after his money arrived in America—was a mélange of fact, myth, and propaganda. Even now, no one really knows whether Smithson "appreciated the potentialities of the American people." We don't know if he thought about the American people at all. We have no concrete evidence that Smithson either liked or disliked Americans as a people. We only know that in his will, using a phrase common among British educational reformers of his day, he asked that his money be used to build an institution bearing his name at Washington for the increase and diffusion of knowledge among men. Smithson was a total stranger to the Americans when his money arrived at the U.S. Mint in 1838. His intentions and mind-set when he wrote the famous will became a matter of scholarly, psychological, and political conjecture for nearly two centuries. Was he mad, radical, drunk, progressive, or just amusing himself? Did he have a megalomaniacal old-age fantasy about his name carved into a castlelike building? Did he genuinely care about

diffusing knowledge among the human inhabitants of a savage, distant land and new nation? The facts are few and they lie like stones at the bottom of a pool of legend. We know that Smithson never set foot in America. He spent most of his life in the company of British and Continental scientists. He probably had no personal knowledge of the character of the American people, and if he had any opinion at all, it matched that of the British men of his class and time: that is, the Americans were a race of provincials with backwater customs and tastes, menaced by wild animals and aborigines.

To complicate matters, politically Smithson was definitely no Leveller, and at the end of his life, he was probably more monarchist than republican. His political views had changed over the years of his life. These complexities have posed problems for Americans from the very beginning of the Smithsonian saga because Smithson does not fit neatly into the popular characterization of him as a man who, spurned by the British nobility, turned his posthumous aspirations toward a distant classless country. As a young man, he lived in France during the years of the Revolution, and at the time he wrote exuberant letters cheering the demise of kings and priests alike. Later, though, he—like many English—became disgusted with the Terror and Napoleon's wars. Later still, he experienced a profound personal transformation, beginning with his mother's death, in which he became increasingly obsessed with his own noble blood lines. All his life he considered himself an aristocrat, not a man of the people. In later years he described himself as a *"seigneur anglais"*—an English lord—which he most certainly was not.

Americans have repeatedly and somewhat correctly portrayed Smithson as a social outcast. His social standing was due not only to his illegitimate birth but to personality quirks as well, chiefly his reticence. The fact is that upper-class British bastards in the eighteenth

century were often no worse off than the third or fourth sons of the gentry.

During his life the odds against James Smithson's achieving immortality were tremendous. Probably even he, in his years as a high-stakes gambler, would have bet against it. The story of his strange bequest is a chronicle of one random victory of the forces of enlightenment, rational thought, and progress over the forces of ignorance, superstition, self-indulgence, and greed. This small but epic battle was waged in Smithson's life, within the man himself, in his work, among his colleagues and his peers, and eventually on the public stage in Washington, D.C. His curious and unlikely story links libertine, dissipated eighteenth-century Europeans with puritanical, nation-building Americans a generation or two later, feudal England with republican America, and Enlightenment gentleman scientists with their more utilitarian counterparts in the age of machines and beyond, into the dawn of the era of telecommunications.

THE DUKE AND THE WIDOW

O N J U LY 2, 1761, the *Bath Chronicle* was filled with news scandalous, useful, and strange. A militiaman was committed to Newgate for raping a six-year-old girl. John Tucker was going to the gallows for committing bestiality with mares. "Abel Tyler, collier of Clutton, dropt down dead as he was tying up his garters." A local farmer's cow had "calved one with two heads, two tails, and five legs that lived three days with no sustenance." Bath being a health resort, this news shared space with longer columns of advertisements for cures for venereal disease, stomach disorders, and fevers, and for Dr. John Harper's Female Pills. The schedules for "flying stage post-chaises"—the most modern conveyance yet between Bath, Bristol, and London—took another column.

As the paper of record in England's most popular resort town, the *Bath Chronicle* also kept its readers abreast of the comings and goings of the great during the social season. And so it reported, without further comment, that on July first, "Earl and Countess of Northumberland arrived here." The thirty thousand residents of Bath in 1761 needed no further explanation. The Northumberlands

were among the very, very richest people in the country. Their arrival at Bath, a steamy, seamy spa frequented by royals and aristocrats during the season, would have attracted attention without the newspaper item. The Bath Abbey bells pealed when the Northumberland coaches pulled into the city to mark their arrival. Earl Hugh Percy, né Smithson, and his Lady Betty—to be elevated to Duke and Duchess of Northumberland in five years—were in the habit of traveling ostentatiously to put it mildly, attended by no fewer than eight footmen, a piper, and Swiss Guards. The writer Horace Walpole, a social equal, was always agog at their eye-popping retinue. "She [the duchess] had revived the drummers and pipers and obsolete minstrels of her family; and her own buxom countenance at the tail of such a procession gave it all the air of an antiquated pageant or mumming."

The commotion of the Northumberlands bustling into Bath in 1761 should have attracted a crowd, but the residents and thousands of visitors who swelled the streets during the social season were rather blasé. For fifty years, Bath had been growing in popularity, and by the 1760s, England's foremost resort had reached social critical mass. Royals came and went, along with hordes of nobles from dukes on down. The city was beautiful and sophisticated. The architects John Wood and his son had designed and built the graceful sandstone buildings that are to this day the finest example of Georgian architecture in a single place. The curving streets, with their honey-colored town houses nestled in semicircles and squares on terraced land rising from the river Avon, attracted visitors high and low. Husband-hunting women, fortune-hunting men, upper-middle-class families (Jane Austen's characters), and the richest of the rich all mingled together at the various balls and musical spectacles in the Pump Room, an elegant hall constructed around the fabled baths. About them, the sick or hypochondriacal took the waters, either by full immersion in the green, sulfurous pools or by sipping the liquid from dainty teacups.

The Northumberlands made frequent trips to Bath because they—like most of their friends and contemporaries—believed the waters would cure various aches and pains. In his later years, Hugh Smithson was gouty to the point of disability and had to be carried about London in a chair. Gout is a very painful disease directly related to eating and drinking habits that has come to symbolize eighteenth-century excess. Given his diet, the twice-daily consumption of several well-larded meat courses followed by countless dishes of creamed vegetables and puddings, it is no surprise that in 1761, while he was still in his forties, the soon-to-be duke was already seeking treatment.

Bath waters had been considered curative since Roman times, and were still believed to ameliorate a variety of ills, from hideous skin diseases to female problems to gout. The baths themselves, mossy sulfurous pools housed in the courtyards of elegant sandstone buildings with violins keening along the edges, had been in use for centuries. In the eighteenth century, science still had not yet recognized the importance of sanitation. Most people, therefore, just didn't notice what would have alarmed modern bathers: The truly ill, especially people with virulent skin diseases, floated and defoliated alongside the well. Those who chose to immerse themselves in the waters at Bath, whether dukes or cobblers, were equally liable to share pool space with dead animals and even human feces. The ladies who sipped the supposedly curative water from delicate Sèvres teacups were essentially drinking the same fluid in which the bathers relieved themselves.

Men and women usually spent the early morning hours together in the waters, the men in linen drawers and jackets, the women dressed in billowing brown linen bathing costumes. Ladies kept little floating bowls beside them, for holding handkerchief, scented nosegay, and beauty patches. After immersion, bathers were carried off in sedan chairs and wrapped in warm blankets for a sweat. Later, they were ferried across the Avon again, where they breakfasted

on buttery rolls in the Spring Gardens before parading through the streets in their finery.

Bath didn't just attract the sick. It was also a social scene. "They went there well and came away cured," Walpole wrote. Balls and musical entertainment were nightly diversions. Men and women of different classes could socialize more freely than they might in London or at the big country houses. The writer Tobias Smollett captured the democratic social flavor of the Bath scene in his epistolary novel, *The Expedition of Humphry Clinker,* written in the 1760s: "Every upstart of fortune, harnessed in the trappings of the mode, presents himself at Bath. . . . All of them hurry to Bath because here, without any further qualification, they can mingle with the princes and nobles of the land. Even the wives and daughters of low tradesmen, who like shovel-nosed sharks, prey upon the blubber of those uncouth whales of fortune."

A MODERN MAN or woman transplanted into the Pump Room to watch the grand Northumberlands taking the waters—once he or she got over the alarming public health situation—would be startled at the many differences between us and them. First of all, eighteenth-century Europeans were much shorter than we are, probably by six or more inches. They were also, thanks to their creamy, meaty diet and different exercise habits, rounder and paler. They had fewer teeth, and even a full set probably didn't gleam pearly white. They died at a younger age, and of ailments that are curable today in a single dose, but, in some ways, they were hardier. They could consume mind-boggling amounts of fat-laden food and booze. If they were lucky and healthy, they survived deadly childhood diseases without inoculation, infection without antibiotics, and dentistry and surgery without anesthetics.

The Northumberlands and their friends also moved differently than we do, more slowly and deliberately, according to rules and as

if in a ballet. At Bath, as in their country houses and London mansions, fashionable people adhered to strict standards of deportment and deviated from them only in the most extreme circumstances, and at the peril of their reputations. Ladies and gentlemen were judged not only by their accents but by how they stood and sat. Books like *The Dancing Master* listed the rules required for walking, saluting, and making bows in all kinds of company. A whole chapter explained "how to take off your hat and replace it." Men could take monthlong classes in how to introduce themselves to a circle.

"It was by no means an inferior science to know how to enter a drawing room in which some thirty ladies and gentlemen were seated with both assurance and grace," T. H. White has written. "To penetrate this circle and to make a slight inclination as you walked round it; to make your way to your hostess and to retire with dignity, and without ruffling your fine clothes, for you were dressed in lace, and your hair was in 36 curls, all powdered. You were carrying your hat under your arm, your sword reached to your heels, and you were armed with a huge muff, the smallest being two and a half feet wide."

Extreme politeness vied everywhere with vulgarity. Perhaps the most piquant difference between our time and theirs would be the eighteenth-century olfactory experience. Besides rudimentary sewage systems in cities, which left rivers of filth running in the streets, people simply did not bathe as often as we do. The fixed bath, except at spas like Bath, was almost unknown and the typical washbasin was the size of a mixing bowl. Dr. Johnson himself wrote, "I hate immersion." Bathing was so infrequent that the following anecdote can be considered typical: In 1768 a hairdresser asked a well-coiffed lady how long it had been since her "head had been opened and repaired." She answered not above nine weeks ago. The hairdresser replied that "that was as long as a head could well go in the summer . . . [before] it began to be a little *hazarde*."

The earl and his lady lodged grandly at apartments in the city of

Bath and, when not taking the waters, they socialized. In the 1760s they often visited at the Batheaston villa owned by Sir John and Lady Miller. Lady Betty was especially enamored of this couple because she was fond of a pastime they too enjoyed, imported from France, called *bouts-rimes*. In this fashionable game, players acted out their literary pretensions by writing lines of doggerel and then having judges—other friends—decide whose "poetry" was the best.

Lady Betty was so fond of *bouts-rimes* she even published a book of her own efforts. At the Miller villa, she enthusiastically scribbled lines in the drawing room and submitted them for judgment. The exercises were truly insipid and one can easily imagine the drawing room company politely tittering as Lady Betty was fitted with the myrtle crown for the following inane opus, attributed to her:

> The pen which I now take and brandish
> Has long lain useless in my standish
> Know every maid from here in pattern
> To her who shines in glossy satin
> That could thy now prepare an olio
> From best receipt of book in folio
> Ever so fine for all their puffing
> I should prefer a buttered muffing
> A muffin jove himself might feast on
> If eat with Miller at Batheaston.

Hugh, earl and future Duke of Northumberland, did not share his wife's passion for this parlor game, although he went along to the parties. If there was going to be a game in the room, Hugh preferred high-stakes whist. He also preferred talking politics, or architecture, or sharing the latest information about industrial and agricultural advancements that might increase his yields. He liked collecting and talking about great art and collecting, if not reading,

books. He had commissioned a vast library at the medieval castle at Alnwick, the Northumberland family seat, measuring sixty-four by twenty-two feet. It was the largest room in the castle. Hugh was also a collector of women, and so, while his wife, growing stout and bearded already, was giggling over her *bouts-rimes*, the earl was engaged in another pursuit, involving a beguiling young widow who sometimes graced the Millers' parties.

ON APRIL 9, 1761, three months before the arrival of the Northumberlands, the *Bath Chronicle* shared news of highway robberies and local farm mishaps. "Great numbers of sheep have been killed by dogs in the night in fields adjoining the city," went the lead item. Women who swore out bastards to men not their husbands were listed in a column, possibly a spring rite.

Prominently displayed among all this news, on the front page, was the following notice: "Yesterday evening the remains of John Macie, Esq., were interred in a vault adjoining the church at Weston, near this City. All the militia quartered in the Neighborhood attended the Funeral in Procession, with their Arms reversed, and fired three volleys over his grave, &c."

Lieutenant John Macie was a citizen from a prosperous local family with long roots in the Bath area and he was still a relatively young man when he died. A graduate of Oxford and later awarded their honorary doctorate in civil law, he was the heir to a line of sugar refiners and divines that had lived in the region for centuries. Macie had been a lieutenant in the Somersetshire militia, justice of the peace, and High Sheriff. He owned the biggest house in the village of Weston, a colonnaded affair he'd refurbished and expanded, along with hundreds of acres of pasture and limestone quarry land around Bath.

An inscription in All Saints Church in Weston still reads: "John

Macie, Esq. The last representative of a most respectable Family resident for centuries in this Parish, died March 27, 1761 aged 42 years." He left his estate—more than six hundred acres and the grand house in Weston—to his widow, Elizabeth Hungerford Keate Macie, to use and to profit by during her lifetime. The couple had no children. Mrs. Macie was obliged to return all the property to the Macie family heirs on her death, a matter which she resented and fought in court.

John Macie's untimely death left his twenty-nine-year-old widow very wealthy with £800 per year. She went into full mourning immediately after her husband's death, wearing black bombazine for three months and covering her head with a black veil. At the end of three months she could have gone into second mourning and allowed herself to wear gray. It was equally acceptable to return to social life, and she soon did just that.

Once out of mourning, the young widow Macie drowned her sorrows in the Bath social whirl, which included the frivolous parlor games at the Millers' of Batheaston. As a member of the landed gentry, of aristocratic blood herself, and now a wealthy woman in her own right as heiress to her husband's estate, she socialized with other members of the landed gentry and the Millers provided the ideal venue, near to her own house. The numbers of such people were relatively small in England at the time. The widow Macie, in possession of her own income, once she took off her weeds, occupied an enviable position for a woman her age. Old enough to know things that virginal brides do not, young enough to be attractive, and rich enough to confidently move among the elites, the widow Macie was beginning a new life. She embarked upon it with a sense of adventure, courage, and, apparently, very elevated sights.

SIR HUGH SMITHSON, who became the first Duke of Northumberland of the third creation in 1766 (there had been Dukes of Northumberland before but the line and therefore title had died out twice already), was born in 1715 in Yorkshire. He was baptized Roman Catholic in one of the smaller landholding families and four of his father's sisters became Catholic nuns in Flanders, a sign of the family's unpopular piety. He died seventy-one years later, an Anglican and one of the richest men in England, with an income of £50,000 a year, when the average upper-middle-class Englishman was considered quite rich at £1,000 a year. He died bearing one of the country's most distinguished names, Percy, thanks to his marriage to an heiress from that family. He left behind two legitimate sons, one of whom became a Revolutionary War hero (on the English side) and who succeeded him as duke, and at least four bastards, a respectable and not unusual breeding record for an eighteenth-century nobleman.

Hugh Smithson was known as one of the handsomest men of his day. In his youth he had a strong nose and chin, full lips, and a fine head of natural brown hair. He had inherited the looks of his mother, a ravishing beauty named Philadelphia Revely. In an early portrait of him painted by Gainsborough (who had such disdain for his wealthy clients that he liked to say "they have but one part worth looking at, and that is their purse"), it is easy to see how he attracted the attention of the richest young heiress in the land. He had the flowing brown locks of a boy, and the strong nose and jaw of a man.

The Smithson head for business had been honed through generations of tenant and yeoman farming before Hugh's great-grandfather took the family from farmers to landowners via a London haberdashery. Long after he took one of England's noblest names by marriage and became a duke, the latter-day Hugh was taunted over his relatively humble origins by fellow aristocrats, who

had no use for men whose rise was due to merit or luck—certainly the case with Hugh Smithson. Everyone knew his wealth had depended on his looks and intelligence, some timely, unexpected deaths, and the love of an heiress.

Smithson's wife, Elizabeth Seymour, eventually Duchess of Northumberland, was vastly richer than her chosen man, as heiress to an ancient family that had been collecting castles and huge tracts of land since the Middle Ages. Among her Percy ancestors was Shakespeare's Hotspur. She was the granddaughter of the Duke of Somerset, Charles the Proud, variously described as "tyrannical" and "mad," and the redheaded Lady Elizabeth "Carrots" Percy. Carrots was the last *real* Percy, and her fortune was so vast that suitors murdered one another over her when she was still in her teens.

Eighteenth-century aristocratic marriages were all about combining estates, but the notion of love was also revered. The union of Betty and Hugh involved both money and a real love affair—at least on the lady's side. Most of the initial credit for the marriage goes to Lady Betty as an heiress in demand. Hugh Smithson had at first wooed another more beautiful woman unsuccessfully. Young Lady Betty heard about it and shared her interest in the handsome, ambitious member of Parliament by publicly wondering how any lady could have rejected a man so fine. Smithson heard of this and was inspired with courage. He proposed and they were married on July 16, 1740.

It wasn't at all clear when she married Hugh Smithson that Lady Betty would inherit the family estates. She stood in line after her younger brother to inherit all the Percy holdings, but there was no reason to expect the brother to die young. The estate included more than a hundred thousand acres of land in Northumberland along the Scottish border, two medieval castles, and London's largest private palace, Northumberland House.

For the first ten years of their marriage, she was merely Lady Betty and her husband was Sir Hugh. There was no reason to believe the future would change their very comfortable but not towering status. Then, in 1744 Lady Betty's brother, Lord Beauchamp, the Percy heir, died prematurely in Italy of smallpox at the age of eighteen. When Lady Betty's father came into the inheritance five years later, he had no male heirs, so an unusual stipulation was made that all the Percy estates and titles would pass to Hugh Smithson, and then to his heirs—but *only* by the body of Lady Betty. A year later, Lady Betty's father died and Smithson—by an act of Parliament—took the more socially important name of Percy. Soon after he became earl. Thus continued the rise of Hugh Smithson from Yorkshire baronet to Hugh Percy, eventually Duke of Northumberland.

Once they came into their riches, Betty and Hugh, now Percys and Northumberlands, lived so extravagantly that Horace Walpole (who made no secret of his disdain for the social upstart Smithson) predicted that Smithson would lose all his wife's money. Instead, the former baronet expanded and improved the family's vast landholdings in the north of England, as well as completing lavish refurbishments of the Percy estates in London, Isleworth, and Alnwick.

The holdings of the modern-day Northumberland family estate offer an idea of the towering wealth of the first duke and duchess. The twelfth duke—a direct descendant of Hugh Smithson—today owns more than 130,000 acres of English real estate (not including industrial property like coal mines, also part of the estate). In rural Northumberland he holds about 120,000 acres, in Berwickshire 9,000 acres, in suburban Surrey 3,750 acres, and in Middlesex—that is, in fantastically expensive modern-day London itself—550 acres. Some of this massive fortune existed within the Percy family before Hugh married Lady Betty, but it was consolidated and expanded under the Northumberland name by Hugh Smithson.

Smithson's improvements affected all of the Percy holdings. Lady Betty had inherited two moldering castles in the north of England, Warkworth and Alnwick, and Smithson decided to make Alnwick, a vast medieval pile on the border with Scotland (most recently the backdrop for the *Harry Potter* movies), into the family seat. The castle had been falling into ruin since the sixteenth century. From 1691, a common school was kept inside its crumbling yellow fastness. Smithson repaired it all in kingly style, but in the process inserted a pseudo-Gothic architectural element so that the medieval character of the building was compromised. This alteration met with various snide remarks from purists and the envious. One contemporary commentator criticized it more for its new-money ambience than the design. "Instead of the disinterested usher of the old times, he [Northumberland] is attended by a valet eager to receive the fees of attendance," wrote one. The "incompatible elegance of the apartments" offended as did the "equally inconsistent gardens, more adapted to a villa near London than the ancient seat of a great baron. In a word, nothing, excepting the numbers of unindustrous [*sic*] poor that swarm at the gate, excites any idea of its former circumstances."

Hugh Smithson also improved the appearance and the yield of his wife's vast lands. The region primarily exported three things— coal, corn, and salt. At the time, corn was grown on every improbable piece of land, even heathered moors and steep hillsides. The region's famous coal mines were just becoming a major source of income. "Naked and bleak was the countryside around Alnwick," wrote one observer in the early eighteenth century, before Hugh Smithson set to work. One of Smithson's supporters, the Bishop of Dromore, wrote that Smithson "found the country almost a desert and he clothed it with woods and improved it with agriculture." Native forests that had once covered the rolling hills had long been destroyed in the days of border warfare with Scotland and then

further picked over by peasants looking for fuel. Smithson planted twelve thousand trees annually on the lands during the years of his control. He hired the greatest landscape gardener of the day, Capability Brown, to make the borderlands' vista more pleasing to the eye. Brown covered the hilltops with foliage in design and scattered long belts of plantings over the slopes. In the valleys, larger forests were created. This process of improving the view had a downside for the local inhabitants. As with the Highland Clearances in Scotland, Smithson's beautification project diminished the independence and importance of Alnwick and "stymied the development of the natural resources of the town," according to one local historian.

Hugh Smithson's mercantile and farming roots paid off handsomely. Between 1749 and 1775, the rents from Northumberland estates drastically increased—from £8,600 annually to £50,000. The duke, while getting richer, also improved his laborers' dwellings, unusual at the time. His semifeudal court, complete from chamberlain down to peer, provoked sneers, ridicule, and envy, but he also gave the borderlands region a new center for patronage. At Alnwick, the old town around the castle, the distinctive Percy lion, with its stiff perpendicular tail, was erected on the bridge over the river Aln during this period of family resurgence in 1773. Even today, a Percy lion confronts visitors entering the town.

The crenellated golden medieval castle of Alnwick and the vast attached borderlands gave the first Duke of Northumberland his raw wealth and political power, but Smithson's social standing was secured in London, where he and the duchess entertained on a royal scale at two of the most lavish, conspicuous private houses of the day. Northumberland House was the Percy family residence inside London and had been for some years. This grand "house" was situated on four and a half acres of what is now Charing Cross and the Strand, with gardens stretching to the edge of the river

Thames. A Tudor redbrick pile with the Percy lion on its roof, it had 140 rooms and 300 windows. The interior could comfortably accommodate 1,500 people. However, the courtyard and the gateway were not enough to handle all the chairs and carriages that brought the crowds, a problem often alluded to in accounts of the duke and duchess's sumptuous parties.

The refurbishment of this building, begun in 1749, was one of Hugh Smithson's first projects after marrying his wife. When he was finished, the interior was lavish enough to rival many palaces in Europe. His most notorious contribution to the building was the commission of a portrait gallery, 160 feet long, 26 feet wide, and two stories high, filled with copies of the great masterpieces. It doubled as a ballroom. An awestruck guest at a November 1761 party for the coronation of George III left this description of the room: "The ceiling is decorated with gilt stucco and divided into five parts, in which are painted Fame on the wing, a Diana, a triumphal chariot, a Flora, and Victory with a laurel wreath. One wall has a marble chimney piece supported by figures of Phrygian prisoners copied from the Capitol at Rome. Above them were life-size portraits of the host and hostess in Peer's robes. Four large crystal chandeliers with 25 candles each lit the gallery more brilliantly than was necessary."

Smithson also commissioned one of the most famous rooms in London, called the glass drawing room, at his house. Designed by Robert Adam using the latest Italian and French glass-making techniques, the walls in this jewel-like room were mirrored plate-glass panels backed with red pigments and metallic fragments that gave the impression, when candles were lit, of sheets of melted rubies. Woven through the sparkly crimson was gold leaf in arabesque patterns. A model of the room is still on display at the Victoria and Albert Museum in London.

The Northumberland fetes were most famous for fantastic

displays of illumination. In the preelectric era, the ability to turn night into day was a primal display of power. For the king's birthday on June 5, 1764, the duke had his gardens illuminated with ten thousand lamps. The party was "a fairy scene," wrote one guest. "Arches and pyramids of lights alternately surrounded the enclosure; a diamond necklace of lamps edged the rails and descent with a spiral obelisk of candles on each hand and dispersed over the lawn were little bands of kettledrums, clarinets, fifes etc., and the lovely moon who came without a card." The meals served at these fetes were amazing. One "menu for a majesty's dinner" described in a letter of the duchess listed seventeen different meat dishes, complete with a full boar's head—and that was only the second course.

Huge numbers of servants were always needed to keep this house running. Hugh Smithson was an involved and attentive master. He wrote out meticulous rules for the help, including exactly what hour they were to rise, what they were to eat, and what kind of silverware they were to use when eating in the kitchen. The provisions required to feed the staff and family at Northumberland House—even without parties—were staggering. In the week ending March 26, 1757, the household consumed, among other things: 52 stone and 6 pounds of beef, 26 stone and 5 pounds of mutton, 9 stone and 6 pounds of veal, 2 stone of pork, 2 lambs, 6 calves' feet, 1 ox tongue, 24 pounds of bacon, 11 pounds of lard, 58 pounds of butter, 160 dozen eggs, 12 rabbits, 34 pounds of cheese, 3 chickens, a 23-pound ham, 130 loaves of bread, and so on.

Much of this food was produced on the family farm at Syon (pronounced Zion), the Northumberland country residence just outside London at Isleworth. This sprawling house was a former monastery until King Henry VIII evicted the Catholics (later his body, bloated and awaiting burial, was famously attacked there by the household dogs). From the garden edge, the family had access to the London

house via the Thames, which flowed between the grounds of both houses. When the weather permitted, the Northumberlands and their entourage floated between their two residences on a gilded barge equipped with musicians, avoiding the crowds, heat, mud, or dust of the carriage trip.

The duke hired Robert Adam to improve Syon House too, and the architect transformed the old monastery into a villa modeled on the emperors' homes in ancient Rome. The cold spacious lobby was paved with black and white parquet and presided over by white marble statuary, but it led into rooms of progressively increasing splendor and profusion. Every nook of the house was crammed with Italian sculpture, and the floors were inlaid with Italian marble. Gold leaf gilded the ceilings. Art objects were imported from all over Europe to decorate the walls and mantels. Adam himself designed the gilt and carved chairs and side tables with inlaid marble and mirror tops. These objects are still studied by connoisseurs of English furniture and decoration. Smithson preferred the peaceful environs of Syon House to his other dwellings. In old age he retired there.

THE MORE RECENT ANALOGUES for Hugh Smithson, Duke of Northumberland, would be most ostentatiously rich men in London or New York, like Malcolm Forbes or Andrew Carnegie, perhaps—men not exactly to the manner born, but whose wealth was vast and whose conspicuous consumption of it stunned observers and bordered on vulgarity. Knowing this, we can understand why so much of what's recorded about Smithson's character is not complimentary. It is hard to tell how much of his bad press was due to his own faults and how much to envy of his staggering wealth and good fortune in marrying the Percy heiress. The writer George Selwyn described him as being "nothing but fur and diamonds." But

Samuel Johnson was suitably impressed to observe that "he is only fit to succeed himself." *The Complete English Peerage of 1775*, written while the duke was alive and which might be expected to fawn, described him as "one of the most polite and accomplished noblemen of the present age; an excellent judge of the fine arts."

The duke employed the writer Louis Dutens as his son's tutor and Dutens saw fit to record for posterity a relatively low opinion of his employer, damning him with faint praise. "He had great talents and more knowledge than is generally found amongst the nobility," the pedagogue observed with a dash of eighteenth-century class resentment. "Although his expenditure was unexampled in his time, he was not generous, but passed for being so owing to his judicious manner of bestowing favors."

Walpole liked to pass around the apocryphal story that Smithson was the son of a coachman and also that he was a card cheat. (The latter charge was also made by others.) "The nobility beheld his pride with envy and anger," Walpole wrote of him. "And thence were the less disposed to overlook the littleness of his temper, or the slender portion he possessed of abilities; for his expense was a mere sacrifice to vanity, as appeared by his sordid and illiberal behaviour at play. Nor were his talents more solid than his generosity. With mechanic application to every branch of knowledge he possessed none beyond the surface; and having an unbounded propensity to discussion, he disgusted his hearers without informing them." Having said that, Walpole could also see Smithson's better qualities. "Yet his equals were but ill-grounded in their contempt of him. Very few of them knew so much; and there were still fewer that had not more noxious vices, and as ungenerous hearts. Lord Northumberland's foibles ought to have passed almost for virtues in an age so destitute of intrinsic merit."

As might be expected from a man of staggering wealth and ambition, Smithson was vigorously involved in court and election politics,

but he was never historically significant. At various points he served as lord lieutenant of Northumberland and lord chamberlain to Queen Charlotte, was sworn into the Privy Council, and was named lord lieutenant of Ireland. After much crass lobbying, he was made a Knight of the Garter, one of only twenty-three men to share that royal honor. He was seen as a friend of both King George II and George III, and to cement the latter relationship, he had his eldest son married to the daughter of John Stuart, third Earl of Bute, the king's closest adviser. This marriage of political convenience proved a catastrophe for young Earl Percy, who had to endure an embarrassing public divorce hearing before the House of Lords, in which his young wife was accused of nymphomania and his own activities were revealed even as his sexual prowess was questioned.

As duke, Hugh Smithson, like many of the peers, was associated with unethical politics. He engaged in the usual aristocratic practice of buying political power in his borough. When his candidate opposed the wild populist John Wilkes in an election in 1768, a riot took place at the election meeting with two men killed. Smithson himself was accused of fomenting it and almost prosecuted for murder. His fondness for pomp was so well known that the London mob could never resist trying to deflate him when he moved about the street. During the anti-Catholic Gordon Riots in 1780, he was forced from his carriage and robbed of watch and purse after a cry was raised that he was riding with a Jesuit confessor. The mob also once forced him and the duchess to drink Wilkes's health in public. Smithson knew how to handle a mob, though. During the Wilkes election riots in 1768, when Northumberland House was being attacked, he had all the three hundred windows lit up and then ordered the alehouses on the nearby wharf opened, which drew the whole crowd off his house.

Hugh Smithson and his family didn't have to do much strolling among the common people anyway. In 1756 Northumberland

House accounts show that the stable consisted of eighteen horses, a landau, two chariots, a four-wheel post chaise, a two-wheel post chaise, and a two-wheel chair. These conveyances were all painted with the family coat of arms and affixed with small replicas of the Percy lion.

LADY BETTY, the Duchess of Northumberland, was the woman who had made all this possible. Equal parts insufferable snob and jovial adventuress, she was never a great beauty, but she made up for her average looks with high personal energy and the unabashed flaunting of her pedigree. She had a long nose—which in old age would become rather hooked and cronish—but as a young woman she was pleasing enough. In one portrait, painted by George Romney shortly after her marriage to Hugh, she is actually quite pretty and understated in her dress, with tiny pearls woven into her hair, thin bow-shaped lips, and a direct, clear gaze, not yet supercilious, but certainly confident. Lace rims the satin sleeves and low neck of her dress, and more pearls are draped across her breast. In later years, the duke gained a certain gravitas and retained his shapely legs, but the duchess grew a double chin and her lively, direct gaze took on a cruel edge. In middle age, as Lady Harriet Spencer described her, she was "very fat and has a great beard almost like a man."

She was a lady of the bedchamber—meaning she spent countless hours in the physical presence of royalty—but she gave up that role when it became too confining. An independent woman, she traveled extensively in Europe without her husband, and kept a diary of her travels that contains lively, acute observations on Continental royalty and nobles. Some of her journeys were actually dangerous. She nearly perished in her mid-fifties during one unusually rough Channel crossing that made the newspapers. In her diaries, she

described being knocked across her cabin and trapped by the weight of a locker during a late-winter storm. "I call'd to them to beg for God's sake would they sit down on the locker at the entrance and by that means they might get safe at me. I can't help but mention here that poor Tizzy [a beloved lapdog the duchess occasionally had blooded to keep in good health] got to me first and kept licking at my face." She gamely reboarded the boat the next day and completed that Channel crossing in time for the marriage of Marie-Antoinette and Louis the dauphin.

The duchess was lavish in her habits and attire and unashamed of it. The jewels she wore at a royal court in 1765 cost £150,000. The newspapers said she wore "such a pyramid of baubles on her head that she was exactly like the princess of Babylon." Walpole called her "the great vulgar countess" and criticized her ostentation. "Show and crowds and junketing were her endless pursuits," he complained, but Walpole enjoyed the show when it suited him. The prickly writer often condescended to socialize at Northumberland House and even participated in her wilder adventures. He seemed to have some affection for the duchess and called her "a jovial lump of contradictions, familiar with the mob, whilst stifled with diamonds, and attentive to the most minute privileges of her rank, whilst shaking hands with a cobbler."

She was game for whatever amusement was on tap, from ghost-hunting to inspecting aborigines. In her diary, she describes being present when a group of American Cherokees—adorned with feathers, shells, and face paint, visited the queen. "The Chief had the Tail of a Comet revers'd painted in Blue on his forehead, his left cheek black & his left eyelid Scarlet and his Rt Eyelid Black & his right cheek Scarlet," she wrote. "The second had nothing particular except his Eylids which were painted Scarlet, the 3rd had painted in Blue on his cheeks a large pair of wings which had a very odd effect as they look'd directly as if his Nose & Eyes were flying away."

The duchess also patronized the arts, inviting Italian opera singers like Niccolini to perform in her house in London as was the fashion among her set. She attended theaters with a longer retinue than the queen's but wasn't afraid to rub shoulders with the mob. Her diaries describe the rumpus involved in escaping from at least one London theater fire. Oliver Goldsmith wrote a ballad, "Edwin and Angelina," for her amusement in 1764. James Boswell corresponded with her.

She was not as keen on collecting the masterpieces her husband craved, contenting herself with what we might call more kitschy items. Dutens described the difference between the couple's tastes: "The Duke was fond of the arts and sciences. . . . The Duchess, on the contrary, was pleased with little witticisms in a circle of friends and amused herself by collecting prints and medals and by making other collections of different sorts." At Alnwick Castle, the dozens of insipid Höchst and Frankenthal porcelain figurines of peasants and artisans she collected during her solo travels in Germany are still on display in small cabinets.

Their tastes differed but the Northumberlands shared a fondness for ducal glory. In later life, the couple sat for separate portraits in full finery, padded to triple their actual size within layers of velvet and ermine and silk. The duke's elegantly stockinged leg is turned out just so, like a supermodel's, a sword at his side, and the duchess rests her plump hand on the ducal crown. Lace cascades for a foot below his chin and down the length of her arms and bosom. Both wear their hair powdered and dressed.

Elizabeth Seymour Percy loved her husband, quite madly it seems from her diary. She bore him two sons and a daughter. Nearly a century after her death, during a restoration of Alnwick Castle, a relic in the marble sarcophagus was opened. It included a large packet of love letters from the duchess to her husband, Hugh, which crumbled to dust when they were touched.

The duchess was not one to confine her man or, for that matter, herself, with her sentiment, but she was not to be crossed on the matter of her family's glory. "She was mischievous under the appearance of frankness; generous and friendly without delicacy or sentiment; and a fond wife without curbing her Lord's amours, or her own," Walpole wrote. She put up with Smithson's dalliances, but she was not as indifferent as some other noblewomen of the time, especially on the subject of illegitimate offspring. Rather, her love for Hugh Smithson was the foundation on which she and he were restoring the Percy name to its medieval glory. His affairs were acceptable only insofar as they did not interfere with that goal.

ONE OF SMITHSON'S AMOURS in the 1760s involved the newly widowed Elizabeth Hungerford Keate Macie. Mrs. Macie could match the duchess for blue blood if not estates and jewels. She was a member of a branch of the Hungerford family, a revered name in the medieval English aristocracy. The Hungerford line began with two brothers, Walter and Robert, of the Wiltshire gentry, in the 1300s. They were knighted and vastly expanded their landholdings, as did their sons, through marriages and charters. Descendants of these men served in the courts of Henry V and Henry VI, but the power of the line dwindled during the late fifteenth century, when the family patriarch was executed for supporting the house of Lancaster. One surviving member of the family served both Henry VII and Henry VIII and saw a new peerage created for the family. His great-grandson, Walter, Lord Hungerford, was executed with Thomas Cromwell (among his alleged crimes was "procuring certain personages to ascertain by conjuration how long the King should live"), and the barony expired with him. Surviving family members then famously gambled off the remains of the estates in the court of Charles II.

Elizabeth's relationship to this great line came through her paternal grandmother, Frances Hungerford, the daughter of Lady Frances Seymour, a member of the Seymour family (as was the Duchess of Northumberland, making the two Elizabeths cousins) and Sir George Hungerford, head of one branch of the Hungerford family, seated near Bath. She married John Keate, a lawyer. The Keates were a respectable landed family, descended from wealthy London merchants and philanthropists. Elizabeth Macie's father, John Hungerford Keate, married Penelope Fleming, whose family were wealthy antiquaries. The Keates had three children, Lumley, Elizabeth, and Henrietta Maria. The Hungerford name still reverberated with enough lingering greatness at the end of the eighteenth century that Henrietta's husband, George Walker, added Hungerford to his own after his marriage.

In 1761, when John Macie died, Elizabeth's brother, Lumley, had not yet inherited any of the Hungerford estates which were due him. Like Hugh Smithson's wife, Lady Betty, with a healthy younger brother as family heir, Elizabeth Macie had no reason to expect she was going to be enriched by the Hungerford money. Her mother Penelope Fleming Keate's 1764 will left the "widow Elizabeth Macie" of Bath nothing but trinkets including "100 guineas for a ring or what she chuses and my silver spoon tray, and a ring of an amethyst heart with a little crown over it of diamonds and my whole piece of white padusory."

No paintings of Elizabeth Macie and only five letters in her hand have been found, but fortunately for us she was an extremely litigious woman. The historical record of her life is limited to wills, deeds, tax rolls, and an astonishing number of lawsuits. The only aspect of her personality that has survived the years and the embarrassed reticence of her own family is the indestructible record of her fight for her legal rights. Besides her two marriages, the record shows that Mrs. Macie involved herself in no fewer than nine court

cases, including one messy attempt to annul a marriage. We know from the same records that she was a sophisticated and independent woman who frequented fashionable watering holes all over Europe, including Spa, the Continental equivalent of Bath in what is now Belgium, and that she resided sometimes in Paris, and that she knew how to protect and profit from her own property. We know from her own will that she bore two sons, and from her son James Smithson we know that she told him that his father was the Duke of Northumberland.

Mrs. Macie's lifestyle—widowed but not in weeds, having affairs, bearing illegitimate children, and fighting for her rights in the courts whenever she felt her property was threatened—was controversial for her time. Women in her position, who were widowed young, generally remarried and settled down in quiet comfort under the protection of a man. Her boldness probably explains why she is absent from some—though not all—of the Hungerford family trees, a problem that confused early Americans trying to divine something about her son. The fact that she was enough of a Hungerford to inherit a half-interest in the Studley estate is provable in court and property records.

Some of the mystery about Mrs. Macie's life has to be blamed on Victorian reluctance to look the Georgian aristocracy in its wanton face. The Americans were always forthright about Smithson's bastard origins, admirable given the nation's Puritan leanings. It behooved American politicians and Smithsonian officials to portray the benefactor as a victim of the British class system. There was less interest, though, in discovering more about the woman who birthed him, and who essentially—from all evidence available to us today—amassed and protected the fortune that founded the Smithsonian.

Unfortunately, the romance between the duke and Mrs. Macie can't be proved with letters, those ubiquitous leavings of the

eighteenth-century nobility. No billets-doux, no lockets, no exchanged portraits or other tokens of their romance survive. No one with any certain knowledge of the facts has ever confirmed or denied Smithson's claim that the Duke of Northumberland was his father. Rumors about the affair have been passed down within the Northumberland family, but without documentation.

History is rife, however, with evidence that passionate sexual affairs between unmarried members of the gentry and aristocracy during the same years were quite common. From private letters and from official divorce proceedings, we know that contemporaries of Mrs. Macie's were women who regarded sexual desire in a frank and sometimes bold way, even if English society officially restricted women in that regard. Women of Mrs. Macie's class and situation—widowed, young, rich, and literally or figuratively without husbands but sexually experienced—took lovers all the time, from the ranks of the married, unmarried, and upper and lower classes. Lasciviousness in women was not frowned upon either. Draped in yards of expensive silk to their shoes, women of the time favored plunging necklines that exposed swelling flesh in a style few women would display in public today. The anonymous author of a 1739 pamphlet wrote that female adultery among the elite was now "rather esteemed a fashionable vice than a crime."

Often these romances happened under the nose of the spouse, perhaps carried on even in the same house. Sometimes, they involved secret trysts and travel abroad. Throughout the latter part of the eighteenth century, English aristocrats sailed back and forth across the Channel, hiding themselves in Italy and France with their lovers, waiting for divorce to free them or passion to fade.

Early American investigators into Smithson's life reported, without sourcing, that the duke and the widow Macie commenced their affair at Bath. It seems a logical assumption. The two were in Bath at the same time, during a period when Mrs. Macie was suddenly

without a husband. Many illicit love affairs were initiated at Bath. The Methodists called the town "Satan's own headquarters." Guidebooks at the time claimed the mixed bathing of men and women was reminiscent of scenes from the Resurrection. Another observer commented on the "tempting amorous postures" of the bathing women.

Adultery was hardly confined to Bath, however. Loose attitudes toward sex prevailed among the British elite in London as well. In the late eighteenth century, the upper classes believed in recognizing the animal needs of the body. The poet William Blake spoke for this point of view when he wrote that "Art and Science cannot exist, except by naked beauty displayed." His advice was "to let men do their duty and women will be such wonders."

By taking mistresses, the duke was merely being a man of his time. The aristocracy rejected the whole concept of "matrimonial chastity," finding it insipid. There was no social pressure for the duke to confine himself to a fat, bearded middle-aged woman, even if she was the source of his wealth. It was common, even expected, for men in the duke's position to keep one or more mistresses, and according to published gossip, he did. Freedom of sexual expression, the historian Lawrence Stone has written, "was one of the many by-products of the eighteenth-century pursuit of happiness."

The fact that Hugh Smithson had numerous lovers is indisputable. He acknowledged and supported two illegitimate daughters whose mother or mothers are unknown, and one of his affairs was chronicled in a popular magazine. Longtime Northumberland estate archivist Colin Shrimpton never found in the family papers any letters between Hugh and his lovers, who, besides Mrs. Macie, often came from "the acting sorority," he said. The archivist attributes the absence of such documents to a deliberate erasure of the record two centuries ago. "If anybody would have done it, the first duchess had every reason to feel rather aggrieved," Shrimpton said.

"It would be true to say that his philanderings did put the marriage under some sort of tension. She was not as laid-back as many other aristocratic women of her day seemed to be."

The duchess was not in the dark either. The peccadilloes of the rich were a constant source of amusement for the British press even then, and the duke himself was the subject of one of the London magazine *Town and Country*'s "Tête-à-Tête" columns in 1769. Thinly disguised only as "Honorius, the Duke of N——," he was paired with an Irish beauty named "Mrs. White."

By the time Elizabeth Macie encountered him in the 1760s, Hugh Smithson was certainly one of Smollett's "uncouth whales of fortune," lolling in the waters of Bath, but Mrs. Macie, with a small fortune in her own right, was no "shovel-nosed shark" preying on him. They probably came together as near equals in social status, he an offspring of the merchant class whose fortunes had risen thanks to a beneficial marriage and she the heiress to a smaller fortune but with genuinely aristocratic blood.

The duke and the widow conceived James Lewis Macie in 1764. By this point in his life, Hugh Smithson was a committed voluptuary, very much a man of his time and class. He slept on a bed made up with 150 yards of crimson damask, he decked himself out in diamond buckles, pink brocade jackets, and brilliant silk stockings. He sat down to tables groaning with hundreds of dishes of creamy food and occupied himself collecting art treasures to fill his three private palaces. In a portrait painted in 1764, Hugh is gazing off into the near distance with a benevolent, beatific gleam in his eyes, a small mysterious smile on his lips. The overall effect is just shy of a sated leer. In the ripeness of his middle years, the duke's life was sweet indeed.

3

NOBODY'S CHILD

PREGNANT WITH the Duke of Northumberland's child in late 1764, Elizabeth Macie didn't linger in Bath to look for a man to act as the official father, as was customary among the women of her class. Nor did she publicly "swear out a bastard" to the duke before a magistrate, as the peasant girls were wont to do. A lady of independent means and energy, discreet and courageous, she packed up her household—linens, silk, silver, and servants—and moved to Paris to await the birth of the baby, far away from the stares and gossip of friends and neighbors.

Leaving England *enceinte,* as the French would say, Elizabeth Macie was in good company. Doctors often recommended leisurely travel to aristocratic pregnant women who could afford it. Lady Holland had herself carried around Italy in a sedan chair in her sixth month, even across mountain streams. Bastards bounced around in many elite English nurseries, birthed abroad and brought home under cover of being orphaned cousins or godchildren. Illegitimacy was still a scandal for the women involved, especially during the pregnancy itself. English ladies with inconvenient bulges

often went abroad, using "health" as a cover for their real motive, and France was the most convenient destination. Georgiana, Duchess of Devonshire, famously fled to Nice to give birth to her illegitimate child in secrecy. Lady Bess Foster, the lover (and subsequently second wife) of Georgiana's husband, fled through France and then hid herself in a dank room on the Mediterranean island of Ischia to await the birth of her illegitimate daughter. Given the propensity for illicit sex among the British elites in the late eighteenth century, and the double standard applied to mistresses once they found themselves in the family way, the route from London to the Continent was familiar to many an aristocratic woman doubled over with morning sickness. Generally, the fathers knew what was happening, and there is no reason to believe Mrs. Macie did not share her news with the duke. Some men, if their ardor ran high, even followed their pregnant lovers abroad. Others waited out the inconvenience at home with their wives.

The mid-eighteenth-century journey from England to France was not an easy one for a pregnant woman, but for Englishwomen in general it was a passage to relative freedom. Frenchwomen held a different place in society. As historian Brian Dolan has written, British women who traveled to France in the 1700s were pleasantly surprised to find the opinions of women given as much importance in social gatherings as those of men. Parisian women were significant players in the intellectual life of the Enlightenment. As *salonnières,* their opinions and ideas were part of the national cultural discourse. In England, the custom of separating the men from the women after dinner was still alive and well and would remain so for decades to come.

A pregnant Englishwoman without a husband in France was not exactly the scandal it would have been in Bath or London. Catholic France hadn't just experienced the Puritan Revolution with its asceticism—a tendency decidedly absent in practice among the

English aristocracy by the mid–eighteenth century but still very present in spirit. Not that the French didn't raise their eyebrows at single and pregnant Anglo-Saxons in their midst, but even if the French smelled *scandale*, the cost to an Englishwoman's reputation in Gallic anonymity was insignificant.

To reach the relatively feminist paradise of Paris, Elizabeth Macie had to endure an arduous journey that could last a week, sometimes more. In Bath, she would have taken a stagecoach jouncing over rutted dirt roads toward Dover and the English Channel. The coaches were stuffy, heavy machines, dark inside, often without windows and lighted only by the opening in the upper part of the door. She probably had the means to hire her own coach, but if she took one of the public conveyances, she shared seat space with six people, facing one another, and additional male passengers clung on outside. Uncomfortable as they were, coaches were the swiftest conveyances available—sometimes unnervingly so. "The machine rolled along with prodigious rapidity over the stones and every moment we seemed to fly into the air, so that it was almost a miracle that we still stuck to the coach and did not fall," wrote one rattled traveler describing a late-eighteenth-century trip through England.

Stepping out of the coach finally at Dover, Mrs. Macie would have taken the fresh sea air but confronted a seedy scene. Dover was a busy port city crawling with smugglers, sharps, and drunken sailors. Tobias Smollett made the same trip in the mid-1760s. With his wife and servants in tow, he decided that the town was filled with pirates and cheats and "without all doubt a man cannot be much worse lodged and worse treated in any part of Europe" than Dover.

After a short rest at Dover, Mrs. Macie boarded one of the packet boats that plied the Channel between England and either Calais or Boulogne. She probably opted for the longer water crossing to Calais—to shorten the amount of time she'd have to spend in a bumpy coach on the French side—and passed an unpleasant

twenty-four hours on the water, squeezed into tiny accommodations with seasick fellow passengers everywhere.

The water passage could be merely uncomfortable or positively harrowing, depending on the weather, but it was never pleasant. Even in relatively good weather, passengers suffered, and while there were separate quarters for the very rich, they were still crammed into uncomfortably tiny and not terribly clean spaces. "The cabin was so small that a dog could hardly turn in it and the beds put me in mind of the holes described in some catacombs in which the bodies of the dead were deposited being thrust in feet forwardmost," Smollett wrote of his boat. "We sat up all night in a most uncomfortable situation, tossed about by the sea, cold, cramped and weary and languishing for want of sleep." Arrival times depended entirely on the weather. Passengers could easily find themselves being unloaded in a downpour and at the hour of the wolf. If the wind was blowing away from land, they were obliged to crawl overboard into a French rowboat, half filled with water, to get ashore.

Landing on the French side, thoroughly chilled and nauseated, English travelers were always obliged to tip the sailors drink money and then bribe French customs before they could get to a bed. The propensity for graft at Boulogne and Calais was as notorious as at Dover. From the customs house, there was a long walk to the nearest inn. Room reservations were, of course, impossible to make. Travelers spilling out of boats by moonlight and stumbling in the dark to the nearest inn were lucky if the beds were not already filled. Late-arriving lodgers usually sat up in cold kitchens for a night, waiting bleary-eyed until the other guests woke up and vacated a bunk.

After another rest, Mrs. Macie hired a chaise to carry her and whatever servants or companions she'd brought along, on to Paris. In the morning, the first sight of French land—especially in summer—was always cheering. The sandy soil near the gates of Calais was ablaze with common yellow horned poppies. Driving deeper into France, Mrs. Macie passed the first of many magnificent

châteaus, whose aristocratic owners kept game on the grounds for hunting. The forests were elegantly maintained, and vast tracts of trees larger than those in England lined the way.

Approaching Paris, Mrs. Macie and her small retinue were pleasantly surprised by their treatment at the auberges, or inns. Besides the picturesque peasants toiling in the fields, they occasionally encountered a gaggle of aristocrats engaged in a *chasse* along the woods near the roads. These parties of fashion always struck the British as absurd, equipped with their jackboots, bag wigs, swords, and pistols, suddenly jumping down from a coach and hiding behind trees with drawn muskets, shooting at any hares that happened to pass. For the French peasants, of course, the lords' unlimited right to hunt was one of the many perceived offenses that sparked the Revolution.

Arriving at the entrance to Paris, Elizabeth Macie noticed certain physical differences between Paris and London immediately. The air was much clearer than in London, perhaps because less coal was burned. The streets were more lively and narrow and cramped with buildings and people. More families lived within each building than in London, giving the city a more crowded feel. Butchers displayed carcasses out on the street, shocking some British, but the food itself was generally complimented by British travelers.

London was darker from the coal, but Paris was smellier. Public latrines lined the walkways, and their emanations competed with the steaming horse droppings on the cobbled streets. There was only one sewer, running from the Bastille to Chaillot, and in the rest of the city sewage was discharged directly into the streets, where by way of cesspools, it eventually made its way to the Seine. Running water was not yet piped into the houses as it was in London and the river was appallingly dirty. In 1765 one English visitor to Paris described the Seine as "thick and muddy . . . and very purgative, especially to strangers, so that they carry clear water about in Pails and sell it at a very extravagant Price."

Pungent smells and meat strung up in the narrow streets were only the beginning of the colorful Parisian circus that greeted and often beguiled English visitors. Socially, there was a vitality that was different in quality from that of London. Café society was thriving. Half a million people lived in Paris at the time, with three thousand cafés to choose from. As ever, Parisians loved their little dogs and went nowhere without them. A breed called the lion dog, a lapdog with a mane like a lion's, was popular. "Everybody appears to me to keep a dog," wrote Samuel Johnson's friend Mrs. Thrale, "and the smallest are in the highest Estimation." The Duchess of Northumberland—traveling with her own lapdog—recorded her own giddy first impressions, on the night after she arrived in Paris in the spring of 1770:

In the evening I went to the old Boulevard where I am always pleased with the chearfulness & whimsical variety of the spectacle, the confusion of Riches & poverty, Hotels & hovels, pure Air & stinks, people of all sorts and conditions, from the P of the Blood to the Crocheteur. . . . Beaux parading on horseback, People of fashion sitting on chairs in little parties of 5 & 6 with their long tankards of Brass or Silver or cover'd with Linen, usually ornamented at Top with either the figure of a Cock, a Bacchus or a Cupid . . . filled with a tisane of wild endive. These people are always whimsically dressed, some with silver'd helmets, others with running footmen's caps with large bouquets & feathers & silver plated fronts, and often very clean aprons and waistcoats. The sides of the walks are almost cover'd with Prints & border'd with Women selling Eggs, Loaves, Apples, Nosegays, Cakes &c, others of both sexes running about among the voitures & mounting on the steps of them, offer for sale Fans, Oranges, Swetemeats, Frogs &c. Here a group of little boys fighting, there a sett of footmen round a table drinking beer, old soldiers Smoaking. Puppet shews, raree shews, monsters, dancing dogs, & c &c &c & Crowds incredible.

The duchess did find one chief and pleasant difference between the mob in Paris and the mob in London: "I did not hear a single Oath swore" in the crowds, she wrote.

Mrs. Macie and any other British who happened to be in Paris in the 1760s were treated with great admiration and respect. The French were in the grip of *anglomanie*—a mania for all things English. In Paris at the time, even the English language was in vogue, as were certain English fashions, including riding gear and country houses. The English did not exactly return the adulation. On the contrary, they professed to be scandalized by the French. The author Frances Brooke shared the prevailing English view of Continental manners at the time: "I have said married women are, on my principles, forbidden fruit. I should have explained myself. I mean in England, for my ideas on this head change as soon as I land at Calais." Frenchwomen supposedly had different moral standards than proper British ladies. "Coquettry is dangerous to English women," Brooke continued, "because they have sensibility; it is more suited to the French, who are naturally something of the salamander kind."

The French had their own strict rules of fashion, food, and discourse, but in general they had a more relaxed attitude toward daily life. The French indulged themselves with an unusually large number of holidays (every day was another saint's day on the Catholic calendar), which the British felt sapped them of their productivity. Smollett called them "lazy in their vivacity." He was mesmerized by the indolence of the girls who lived across from his rented lodgings. "There are three young lusty hussies, that lives just opposite my windows, who do nothing from morning till night. They eat grapes and bread from seven till nine, from nine till twelve they dress their hair, and are all afternoon gaping at the window to view passengers. I don't perceive that they give themselves trouble to make their beds or clean their apartment. The same spirit of idleness and

dissipation I have observed in every part of France and among every class of people."

Paris had a darker side too, one that would explode soon enough. "Man is born free but everywhere is in chains," wrote the French philosopher-novelist-composer Jean-Jacques Rousseau, a member of the French Enlightenment whose passionate rhetoric inspired the revolutionary generation. Paris in 1765 was a city still completely ancien régime. While the king and his court paraded from palace to palace in tapestried splendor, haggard beggars lined the streets, petty criminals were publicly punished in horrific medieval chains and cages before being put to death, and every night starveling babies were left on church and abbey doorsteps.

JACQUES LOUIS MACIE (his French name) was born into this Paris sometime in the first three or four months of 1765. There is no record of Macie's birth in Paris, but we know from his university records that he was born during this time and from his English naturalization papers that he was born in Paris. He might have been born inside a convent. In 1765 there were fifty convents in the six arrondissements that constituted Paris. Their extensive gardens gave parts of the city a pastoral feel. The kitchen gardens alone belonging to the Carthusian order of nuns covered thirteen metropolitan acres. Many women gave birth at these convents, and if the baby Macie was helped into the world by women of religious orders, nuns would have baptized him a Catholic within hours. No record of his birth and baptism survives. French revolutions during the next hundred years destroyed most such documents along with the convents.

Unless Mrs. Macie hid herself inside a room for months, her French neighbors and their servants noticed her condition. Other Englishwomen in similar straits had been subjected to a certain

amount of Gallic nosiness—for example, Lady Coke, who ran off to France to salve a broken heart, and wrote to her mother on New Year's Day, 1770: "I don't know whether I have observed to you that the French have a great deal of curiosity & very soon after my arrival, as would not believe I came here for my health, they were curious to the last degree to find out what had brought me here."

When her time came, Mrs. Macie was attended, in her own house or at a convent, by an *accoucheur*, or an obstetrician. By the mid–eighteenth century, the odds were still good that she would have been attended by a midwife, but male doctors had begun to take on the job of delivering babies. Certain advances had already taken place, including the invention by a male French doctor of curved forceps to help get the baby out. Childbirth was still dangerous and primitive, without antibiotics or anesthetics. The best a midwife could do for pain was ply the mother with drink. Women in hospitals died in huge numbers, mostly from childbed fever, also known as puerperal fever or the black assizes, a massive infection that only disappeared when doctors recognized the relationship between cleanliness and disease later in the nineteenth century.

At thirty-three, Mrs. Macie was hardy and lucky enough to have survived the birth of her first child without any lasting problems. Her illegitimate son, however, did not enter the world with the benefits that his mother's class and breeding should have guaranteed him. For one thing, his mother was soon distracted by other matters. Within three years and probably much earlier, she was back on the Continental social circuit without the baby in tow. In this, she was not entirely unusual. Like that of most upper-class women at the time, her parenting style would be considered negligent by our standards.

Eighteenth-century attitudes toward children couldn't have been more different from those of our era. One reason for parental indifference was simply the rate of infant mortality. Babies died at rates

higher than those found in most third-world countries today, and they died whether the parents were rich or poor—although the poor were much worse off. Women whose babies died—if they themselves survived the birth—swallowed their grief and rose and went about their business. This comparatively blasé attitude was rooted in the sheer prevalence of death, a prevalence that spared no family. The English historian Edward Gibbon was the eldest and only survivor of six children, all of whom died in infancy. Gibbon later wrote that his father repeatedly named each of the following sons Edward in order to ensure that the name would be perpetuated in the family in the event of the eldest's death.

Parental indifference was also a fashion with Mrs. Macie's class and generation. To be too attached to one's children was considered bad taste. "One blushes to think of loving one's children," wrote one mid-century French essayist. Upper-class parental indifference toward children was related to a disbelief in the ideal of happy marriage itself. Domesticity was regarded as insipid. Having children simply made a woman less fit for amorous adventures. "The height of bad taste was reached by those who loved their spouses and children, and made a display of it," one historian has written. Only in the latter part of the century did a drive toward domesticity begin and some elite parents start to think about spending more time with their offspring. "Nothing can justify this monstrous indifference" toward babies among the aristocracy, the *Lady's Magazine* told mothers in 1774, setting the new tone.

Elizabeth Macie shared some of the child-rearing habits of her class and time. Like most of her contemporaries, she put her son into the care of a nurse during his first years, while she traveled abroad, took property in England, remarried, and then tried to extricate herself from a bad husband. She was probably oblivious to nursery perils. "There is little doubt that a puzzling lack of sense existed in a society which entrusted its children to strangers," wrote

one historian of eighteenth-century childhood. This is not to imply that Mrs. Macie did not love her infant son. He later lived with her during his childhood and sometimes adulthood as well, she named him as her executor, and he changed his name in middle age to fulfill a dying wish of hers, all attesting to what was probably a close relationship between mother and son.

James Smithson's childhood malnourishment was severe enough to be written into his bones and indicate to later generations that he was much smaller than he should have been as an English adult of his time and class. His malnourishment most likely had to do with the quality of the nurse who served as his proxy mother, because his own mother was certainly well-off enough to feed him. In the care of a French wet nurse, Jacques was not only temporarily motherless but subject to the numerous risks of Continental, mid-eighteenth-century nursery life. These hazards started in the labor room. As soon as he was born, the baby would have been presumed to be hungry and forcibly fed "pap," a combination of bread or flour soaked in milk, water, or beer and occasionally prechewed by the nurse. During the first hours of his life, he might also have been treated to a "posset," flour and sugar or oil of sweet almonds, or syrup of violets. He might also have been fed a "comforter"—butter, sugar, and some cordial, possibly whatever the midwife, her assistants, and the mother had been sipping at during the labor. When he was a little older, he might have been fed with primitive bottles, made of pewter with a cloth-covered sponge as a nipple.

Once he survived infancy, Jacques faced a variety of nursery scourges. Worms were an unrelenting problem in babies and toddlers, but they were minor annoyances compared with the endemic deadly or deforming childhood diseases. Fevers were the usual mode of death for children. Typhus, diphtheria, scarlet fever, measles, and mumps were all untreatable at the time. Some attempted cures were deadly themselves. Whooping cough was treated with "the shock of

a sudden fright"—for example, making the child ride on a bear or eat an unknown piece of an animal and then telling the child it was a mouse. Rickets—a vitamin deficiency that was not understood at the time—caused the bones to grow deformed, and was common in children from nine to twenty-four months old. Cures for it included well-boiled beer, motion—the baby being swung and carried about—and four ounces of French red wine daily. Another cure included earthworms. Boiled snails were a common remedy for coughs. Smallpox still killed half the children aged five to nine, although inoculation was becoming more common in the latter part of the century.

When little Jacques Macie got sick, there was no pediatrician to come and treat him. Eighteenth-century physicians actually tried to avoid treating children. "I know there are some of the physical tribe who are not fond of practicing among infants," one writer on childhood diseases observed at the time. "I have heard an eminent physician say that he never wished to be called to a young child because he was really at a loss to know what to offer it!"

THERE IS another reason the childhood of Jacques Macie was less than idyllic. When he was just three years old, his mother let herself be duped by a violent fortune hunter, and for several years the boy—when he was with his mother—surely witnessed some ugly scenes of domestic discord and violence. Besides the birth of her child in 1765, another event around the same time dramatically changed the fate and fortune of the widow Macie. Her younger brother, Lumley Hungerford Keate, died unmarried and childless at thirty-two in England in 1766. Lumley had been the sole heir to the massive Hungerford estate passed on to him by a cousin of their father, John Keate. The estate consisted of two sets of more than one thousand acres of farm, wood, and meadow land in the rolling

chalk hills of Wiltshire, as well as a manor house and tenant housing. Elizabeth and her sister, Henrietta Maria, were Lumley's sole heirs.

Studley Hungerford and Durnford Hungerford, as the two estates were known, were located between Salisbury and Amesbury in southwestern Wiltshire, a region of softly rolling green hills dotted with sheep and cattle. The area is familiar to tourists today for the prehistoric relics scattered in the region, including Stonehenge and other stone monuments from Druid times and ancient chalk drawings of horses carved into the green hills. When Elizabeth inherited it, the chalk downs surrounding Great Durnford were even more covered with evidence of prehistoric activity than exists today, with remains including Bronze Age barrows, prehistoric fields systems, a Neolithic mortuary enclosure, and an extensive Bronze Age cemetery.

At Durnford the manor house and vast property began as a sixteen-acre estate in 1086. Elizabeth's branch of the Hungerford family had held and expanded it from the fifteenth to the eighteenth centuries. Daisy-dotted meadows abutted rough pasture and woodland, and none of it was enclosed. Tenants living in thatched-roof cottages raised sheep and corn on the open land. Medieval stone farmhouses were also part of the landscape.

Southern Wiltshire was known not only for bucolic tranquillity but also for some of the finest houses of the landed gentry. It still is famous for some of the greatest English country houses ever built. A less restless woman than the widow Macie might have been quite satisfied to marry a member of the local gentry, settle into the rhythm of country life, and live out her days tending orchards and overseeing tenants, making her house a social center. The region was hardly an agrarian backwater filled with country boors. Studley House was sixteen miles from Bath and not far from the massive Georgian facade of a house owned by Lord Lansdowne. Lansdowne

employed the radical scientist Joseph Priestley to tutor his sons. In a laboratory in the wing of this great house, Priestley identified oxygen in 1774, one of the great chemical breakthroughs in late-eighteenth-century science.

Mrs. Macie was back in England after her brother's death, and sometime between 1765 and 1768 she acquired a grand, new, honey-colored house on Queen Square in Bath, next door to the one the architect John Wood had built for himself. It is unthinkable that she would have brought the fatherless babe-in-arms back to Bath with her when she took possession of this dwelling or her inheritance in Durnford. In any event, she did not remain there for long. Paris and London were her preferred haunts, places where she might land an invitation to a glittering dinner hosted by the international aristocracy, or run into other members of the leisured, sophisticated class always on the move between England and the Continent.

She had little or no sentimental attachment to the ancestral estate, regarding it chiefly as a source of income. After some years of dispute in Chancery Court with distant family members, the estate was partitioned, and Elizabeth was granted the manor and nine hundred acres of lands in 1771. She earned income from it for two decades, then in 1791, she sold her share. The estate, which had been in the Hungerford family for eleven generations and 365 years, left the family forever. Proceeds from this sale made Mrs. Macie a very wealthy woman, in addition to what she had earned from the lands John Macie had left for her to profit by during her lifetime. Like Hugh Smithson, Mrs. Macie proved herself a very capable and astute businesswoman. She was always keenly aware of her properties and rents and exactly how much money she was worth. She wasn't afraid to demand her due, in court if necessary. She engaged in nine lawsuits between 1765 and 1795. She fought disputes with family members, defended herself against charges that

she was taking timber and quarry profits she wasn't entitled to, and brought accusations against her stewards over moneys she claimed they were stealing.

She also battled the claims of one very bad husband.

The rich widow Macie was a ripe and experienced thirty-six years old when she met John Marshe Dickinson at Amsterdam in April 1768. Dickinson was a Cambridge scholar and the layabout son of a politically active London City attorney named Marshe Dickinson, who had been Lord Mayor of London in 1756. John Marshe Dickinson had served in the military and for a time held the ceremonial post of Superintendent of His Majesty's Gardens. But in 1764 the younger Dickinson was asked to exchange his post for a pension in order to accommodate the wishes of his father's political protector, the Duke of Bedford, who apparently wanted to give the post to someone else. This request incensed Marshe Dickinson, who looked upon it as a "slur" to the family, but the king refused to intervene, and young John Dickinson was forced to give up his position.

By August 1768 Macie and Dickinson were frolicking in the luxurious casino rooms at Spa. They left Spa together on September 9 heading for Paris, he proposed in Brussels, and they were married in a room at the Dutch ambassador's residence on the banks of the Seine on September 23. The British ambassador and his chaplain were both away, leaving the Dutch venue as perhaps the only Protestant alternative in Catholic France and therefore possibly legal by British standards (a precaution Elizabeth would live to regret). The wedding witnesses were a motley crew of cosmopolites and dissipated aristocrats, including the Earl of Massarene, a peer of Ireland; French banker Isaac Penchaud; and Major-General John Irvine, of whom the political writer Nathaniel Wratall wrote, "No income, however large, could survive for his expenses." Massarene was twenty-seven at the time, and about to be detained for debts.

He wrote his witness statement from a French prison, reporting that the ceremony was "well-lighted up" and held at eight in the evening.

The couple moved into a rented house in Paris, living with the now four-year-old boy Jacques and settled down to what the courts were to describe as seven months of "carnal copulations." The happy honeymoon was short. Dickinson wasted no time getting down to business—the widow's money. Shortly after their marriage in Paris, Dickinson tried to get his new wife to sign over all her holdings to him. As Elizabeth Macie later told a Chancery Court magistrate, Dickinson "made various applications to [me] to vest the whole of my estate real and personal by proper deed and instruments for that purpose in his absolute power and Disposal."

According to Elizabeth, Dickinson then "compelled her" to journey from Paris to England in the spring of 1769, a trip she claimed she was not healthy enough to make because she was again pregnant. She blamed Dickinson for a miscarriage she suffered somewhere on the road between Paris and Calais. "Very weak and ill, occasioned by the former cruelty and ill treatment of her by John Dickinson," her lawyers informed the court, "she suffered from so much fatigue she miscarried in the course of said journey and was in the utmost hazard and danger of her Life."

The warring Dickinsons arrived in England about the last day of May 1769. It is possible they had little Jacques in tow, but equally possible that he was left in Paris with his nurse. Once in London, Dickinson promptly proposed that his wife sell her lands and turn over the proceeds to him. She resisted, even though she was ill. "At the time she was in such a low languishing state that she was advised by her physician to confine herself to the same floor," her lawyers wrote. When Dickinson's own entreaties failed to change her mind, his lawyer visited Elizabeth and told her that turning over her property was the way "to make a good husband" of Dickinson.

When Elizabeth still refused to comply, Dickinson physically attacked her. His behavior became "so outrageous and violent that your oratrix considered her life to be in danger," her lawyers told the court. At one point, Dickinson's manservants "held him down by force and violence so she could escape." He tracked her down again "and broke down the door to get in." He again brought his lawyer to try to persuade her to give him money and sign over her property. She refused. Dickinson and the lawyer stayed and argued with her "until past three in the morning."

In court papers, Elizabeth painted her husband as a fortune-hunting criminal. Dickinson was in debt and had mortgaged his house in Gloucester "for more than it is worth." He had illegally collected the rents from her properties himself, made off with her jewels, forbidden tenants to pay her directly, and even stolen her clothes. Letters from Elizabeth to Dickinson show, however, that she was quite in love with him. In March 1769, while pregnant with the baby she was to miscarry, she wrote: "I shall always carry towards you as it becomes your wife to do. If you are wise Dickinson return to me this evening without going to the Temple [a "privileged spot for debtors" in Paris, according to *The Dictionary of National Biography*] for perhaps on your conduct this Evening depends the future peace of both our lives and the life itself of an infant you acknowledge to be your own!" She signed it, "E. D." Later, she wrote, "Sick or well Dickinson, Rich or poor I shall love & wish open arms to receive you."

Eventually, Elizabeth's passion ran thin and she argued that she was not obliged to give her new husband a penny of her money because the marriage—so carefully entered into at Paris with a Dutch Protestant chaplain—was a sham. It was "not agreeable to the laws of England" because the parties had not lived in France for a month before getting hitched and banns were never published in accordance with French law.

Dickinson's defense, written by his lawyers, naturally cast him in a more favorable light. According to him, Elizabeth was simply out of control, a temperamental social butterfly who ignored his pleas for commonsense behavior. The evening before she started the journey on which she miscarried, he claimed, "she attended a public dinner at the Prince of Conti's and did not return home until long after the defendant was returned to rest." He denied the miscarriage was caused by "such fatigue as mentioned in the bill or from this defendant's ill treatment. On the contrary it happened through the extreem [sic] fury of her temper which this defendant saith did frequently upon any contradiction or disappointment threw her into very violent agitations." ("Violent moods" were in fact one of the recognized causes of miscarriage among eighteenth-century doctors.) As for his own violence, he admitted to having broken a door to get into her house during an argument.

The outcome of her Chancery case is typical of how the rights of men trumped those of women in eighteenth-century courts. Dickinson swore that Elizabeth had *promised* before their marriage "to put him in possession of goods and effects to the value of 20,000 pounds." She denied it. Despite acknowledgment of domestic violence and the fact that Dickinson had taken rent money owed to her, Elizabeth Macie—"Disobedient and Refractory," as his lawyers had labeled her—was ordered to reimburse Dickinson to the tune of £4,968 and change, and return "any jewells or trinkets" her husband had given her. Elizabeth objected to paying up, and then Dickinson died suddenly in 1771. He left behind a coronation medal, £24 in cash, six dozen and five bottles of "different wine," six dozen bottles of Rhenish wine, and considerable debts.

After his death, Elizabeth paid Dickinson's lawyers the money he owed them, and no more. For four hundred pounds and thanks to a timely death, she had extricated herself from a "pretended" marriage to an abusive man. But by the legal standards of the day,

Elizabeth Hungerford Keate Macie Dickinson must have considered herself lucky. Divorces were extremely rare in those days, requiring an act of Parliament, and were almost never brought by women. Married women had very limited property rights under English law. What rights they did possess were known only to those with the means and wherewithal to hire attorneys. Husbands were not only free to seize their wives' property, they had the right to seize and forcibly confine their wives. Confining a wife was not declared illegal in England until 1891.

Mrs. Macie almost lost everything. In 1769 her house on Queen Square was already listed under John Marshe Dickinson's name in the Bath tax rolls. She was saved by her connections, her determination, and her knowledge of her rights. Chancery Court—to which Elizabeth had resorted—could confirm a married woman's right to any bequest received from a relative. But any woman of her generation who took advantage of the courts would have needed close familiarity with the law, and that was rare.

This ugly domestic saga, in which his mother nearly lost her fortune, unfolded at least partially before her son's eyes. Its effects were deep and lasting. On an emotional level, the boy grew into a man who would never marry, and not even—as far as the record can show—have a relationship with a woman other than his mother. Financially the effects were even more profound, but in a positive way. Mrs. Macie's litigiousness—her willingness to fight for what she believed was hers—is the chief reason why her son, James Smithson, died with a fortune to bequeath to the Americans.

WHILE MRS. MACIE was prosecuting her lawsuit against Dickinson, she was not romantically idle. She might have been spending time with the Duke of Northumberland again or taken up with someone whose name is not part of the record. She had

shed the cumbrous person of John Marshe Dickinson after what she now called the "pretended marriage," but she didn't dispose of him altogether. Thanks to that marriage, she had a name to give to her next fatherless son, Henry Louis Dickinson, born in Hexham, Northumberland, not far from Alnwick Castle, in August 1771.

Henry Dickinson was another son of the duke's, according to the school records of Charterhouse, where the boy was educated. It is unclear why, if he was another Smithson son, Mrs. Macie did not insist that he too take the name Smithson, as she eventually asked her firstborn to do. Charterhouse was a London school and the province of the professional classes—the sons of doctors, lawyers, clergy—rather than the landed gentry. School records list him as Henry Louis Dickinson, "natural son of the Duke of Northumberland." He was at the school from March 1780 to April 1784. The location of his birth indicates a connection to the duke, as does the fact that he later joined the army in Northumberland.

By 1774 Elizabeth's legal troubles were, for the most part, settled. She was single again (technically twice-widowed) and she had grown much richer during the nine years of her eldest son's life. She was still just in her early forties. Her income from Great Durnford was considerable and she was firmly in control of the Macie lands, where she was improving the tenant houses and selling timber and quarry rock as well as collecting rents from tenants.

At this point, Elizabeth Macie decided it was time to bring her firstborn son to London and make him a proper English boy. She had a house in Mortlake by the Thames, a mere one bend down the river from Syon House. She also owned a house in London, in a respectable neighborhood on Upper Charlotte Street, and to these dwellings the family—mother, servants, and two sons—moved. The London to which little Jacques Macie—now James—moved in 1774 was a hurly-burly, crashing city that had just enjoyed a massive building boom. Three stupendous bridges now joined the two

sides of the city across the Thames, "so vast, so stately, so elegant they seem to be the work of giants," Smollett wrote. Still, the streets were mostly dirt and so rutted that small sticks had to be spread on the ground before the king's coach could deliver him to Parliament.

Where Parisians had their café culture, Londoners had fast-paced commerce and private clubs. Smollett's country squire Matthew Bramble was overwhelmed by the sheer busyness of London. "The hod-carrier, the low mechanic, the tapster, the publican, the shopkeeper, the pettifogger, the citizen, all trod upon one another. All is tumult and hurry, one would imagine they were impelled by some disorder of the brain."

A small boy walking in London, dodging the splattering mud and horses' hooves, darted between the white-silk-stockinged legs of men in breeches and short waistcoats. Hats were always worn outdoors, with small wigs beneath. Women like Mrs. Macie wore loose sack-back dresses at home but put hoops under their skirts when they went to formal affairs. The sack dresses were open down the front, to reveal pretty petticoats, with sleeves decorated with flounces. Upper-class women were always splendid, but their preening men were even more eye-catching. Inside private palaces like Northumberland House, males were outfitted in cascades of lace, splendid colors—hot pinks, emerald greens, violets, and scarlets—and sumptuous fabrics that would not be rivaled in men's fashion again in Western history, not even during the dandy Edwardian years or the "mod" 1960s. The duke himself, James's father, habitually wore scarlet and pink silk coats with ermine trim.

Genteel people like the duke and Mrs. Macie were a decided minority on the London streets. The common people were a rough, disorderly, often riotous multitude. They were referred to as the mob—from the Latin phrase *mobile vulgus*, meaning the "movable" or "changeable" or "fickle" crowd. In a society where all the power

and wealth was concentrated within the tiniest circle of men, the mob's power was limited to street action, which occurred with growing frequency throughout the late eighteenth century. Typically, people formed "parades" as itinerant bands marching (or running) through the streets, gathering fresh forces and becoming a mob on their way. Political slogans were sometimes shouted, for example, "Wilkes and Liberty!" in 1768, in support of the wild politician who had just been jailed by the king for libel. Often rioters damaged property, from shattering a few windowpanes, all the way to breaking in and smashing shutters, banisters, doors, and any movable furniture, even pulling down the structure.

Besides the dangers of the roving mob, the antics of young aristocratic men contributed to the street chaos. These "young bloods" drank hard and then played cruel, violent jokes such as tossing beggars around in blankets, throwing waiters out of windows, stealing dogs from blind men, and taking blind horses into china shops. Street urchins imitated them and threw handfuls of dust in the wind as coaches passed in order to disturb the horses. Cruelty abounded. Ducking ponds where dogs chased ducks were popular amusements at parks, and sometimes, to increase the fun, an owl would be tied to the duck's back, which caused it to dive in terror until one or both of the birds died.

LONDON DIFFERED from Paris in a very significant way, one that Mrs. Macie felt more keenly than her small boy. Paris was the intellectual capital of France where women participated as full partners in the discussion. There were a few salons on the French model in London at the time, but London was a city of private clubs habituated by men. Venues such as Brooks' and Almack's were dark, leathery places where men like the Duke of Northumberland and his peers gathered to drink, smoke, gamble, and argue

politics. The intellectual elite did not permanently reside in London, and the great thinkers and writers—Hume, Adam Smith, Gibbon, and Goldsmith—were not of any one circle. Women remained with one another in the parlor. Even a British writer of the time, Nathaniel Wraxall, complained that the English were too addicted to "clubs composed exclusively of men, to be capable of relishing a mixed society, when researches of taste and literature constitute the basis and central point of that union."

When James Macie was old enough, he too would enter that exclusive universe of men in clubs, a world for which his training from now on had to prepare him. Of English blood, the boy had spent his first years as a French *garçon,* known to his playmates, tutors, and nurses as Jacques, speaking and being spoken to in French. A thoroughly French boy at nine years old, perhaps not even literate in English, he had a Gallic tint that would never leave him. Even after decades of British citizenship, a scientific colleague would remark that Mr. Smithson was more like a foreigner than an Englishman.

Once in England and attached to a tutor, the boy now called James was subject to all the brutality of the primary education style predominant in eighteenth-century England. Educators shared the belief that children needed to be "molded" and hardened. Signs of "willfulness" in a child had to be exterminated in order to prepare the child for adulthood. Methods included limiting food to toast, water, and a piece of meat, without sugar or butter; corporal punishment; and that most English of all tortures, the cold bath. James Nelson, in "An Essay on the Government of Children" of 1763, advised: "The more Water and the colder the Bath the better. At first use only two or three times a Week, afterwards every Day. And continue it till every appearance of weakness be vanished." The poet Robert Southey believed his little sister's death in 1779 was caused by his parents' practice of dipping her into the coldest well

water every morning in efforts to "strengthen" her. Another common practice was forcing children to do their lessons harnessed in iron collars, with backboards strapped over their shoulders.

One adult male influence in Macie's young London life was the poet and collector George Keate. Keate lived just a five-minute walk away from Elizabeth Macie's Charlotte Street house. He was her first cousin, the son of her father's brother, and one of England's minor wits at the time. Keate wrote mediocre poetry in the popular classical style (a representative line: "Nor think, soft virgins of the lyre, / Ignobel views my schemes inspire"). He is better known for his curiosity cabinet and intellectual and artistic friends than for his poetry. The French writer Voltaire called Keate his *"Très cher confrère"* (twenty letters between them still exist). His friends included the actress Angelica Kauffmann, the writer Mary Delany, and the playwright David Garrick, who once wrote of him: "I must say a word to you by our friend Keate. He is a very agreeable man, and has comforted me much in this strange mixture of mortals at Bath. No man starts a laugh better, or makes a better chase."

Keate was also a fellow of the premier English scientific organization, the Royal Society, which would eventually welcome James Macie as a member in his young adulthood. Keate's well-known collection of coins, shells, minerals, gems, and insects made his household a sort of museum at no. 8 Charlotte Street. He died in 1797. The sale of his coins alone in 1801 lasted two days at Sotheby's, the library sale took three days, and in 1802 the other contents took eleven days to auction. In 1802 the *Times* lamented that Keate's collection would "enrich the cabinets of the first collectors of Europe, it certainly ought to have become a national purchase."

SOON AFTER their arrival in London, Mrs. Macie arranged for her son's official naturalization as a British citizen. She hired a lawyer named Joseph Gape, who was one of the trustees of the Hungerford estates, to draw up a parliamentary bill to naturalize Jacques—now James—as a British citizen in 1774, giving his age as "9 years and four months or thereabouts." The naturalization petition was granted by the Crown with all the restrictions commonly applied to all individuals born abroad seeking to become British citizens.

The document read: James Louis "shall be and is hereby from henceforth . . . a free born subject of this Kingdom of Britain." Under his act of naturalization, the boy had the right to inherit property and own manors, estates, lands, and chattel if it was directed to him by name, but not through any hereditary patrimony. He was especially prohibited from opportunities that might have come to him as a legitimate son of the aristocracy. Specifically, the document stated that James Louis "shall not be hereby enabled to be of the Privy Council or a member of either House of Parliament or to take any office or place of trust either civil or military or to have any grant of lands, tenements or hereditaments."

The document effectively barred James Macie from a career in the military or church—avenues normally chosen by younger sons of the nobility. Various Americans over the years have cited these prohibitions as evidence of a conspiracy against the illegitimate son of the Duke of Northumberland, and perhaps even a motive for Smithson's eventual gift to the Americans. One writer proposed that the prohibitions were evidence that the Duke of Northumberland himself (a member of the Privy Council) or his duchess, formerly lady of the bedchamber to the queen but now two years from her death, were behind it.

In fact, *all* naturalized foreign-born citizens of illegitimate birth were restricted similarly in England. The British law on naturalization

in effect when James Macie arrived was called the Act of Settlement. It had been written in 1700 to secure the Protestant succession on the British throne and was meant to prevent the new foreign and alien Hanoverian kings from clotting British government with their German cronies. It had the inadvertent effect later of disqualifying bastard children like James who were born abroad.

The relevant words in the act are: "That after the said limitation shall take effect as aforesaid, no person born out of the kingdom of England, Scotland or Ireland, or the dominions thereunto belonging (although he be naturalized or made a denizen except such as are born of English parents) shall be capable to be of the Privy Council, or a member of either House of Parliament, or to enjoy any office or place of trust, either civil or military, or to have any grant of lands, tenements or hereditaments from the crown, to himself or to any other or others in trust for him."

The key part of the law, and the words by which Smithson was disadvantaged, were in parentheses and had to do with his illegitimate birth: *"although he be naturalized or made a denizen* except *such as are born of English parents."* As a bastard Macie was legally *filius nullius,* "nobody's child," ergo no English parents and therefore no office of trust for him. Boys like Macie were "nobody's child" in the sense that parental consent to marry was impossible to acquire.

The law did not prevent the boy Macie from posing a potential threat to the Duke of Northumberland's legitimate children if he ever chose to claim himself as an heir, but the ducal grant itself limited his father. Hugh Percy, né Smithson, had assumed the title when Macie was a year old, and the dukedom—like his Percy estate—came with many restrictions. Chief among them was that Hugh Percy's heirs be limited to those begotten by his lawful wife, in whose veins at least some Percy blood actually flowed. Another nobleman, the Earl of Cardigan, who was offered a similarly hindered dukedom during the same year, simply turned it down, saying

he thought it was a punishment, not a reward. Hugh Smithson ambitiously acquiesced.

Elizabeth Macie was able to get her son citizenship, but nothing she could do would gain him entrée into British society at a level that reflected his true parentage. Her own twice-widowed status was no mark of shame, but anyone who bothered to do the math would know that the small boy living with her was no son of the late John Macie, Esq., of Weston. Women with illicit breeding records like Mrs. Macie's were punished with exclusion at the top levels of society, which essentially meant that she would not be received by other women of her rank and above. Still, as a widow, she enjoyed certain benefits that were withheld from divorced women. She controlled her own money. Most important, she had no fear that her illegitimate child would be taken away from her by an estranged husband—a common practice among warring spouses in the nobility.

In 1774, when James Macie arrived in London, the Duke of Northumberland was in his declining years physically (gout had crippled him) but still at the height of his wealth and stature. He spent more and more of his time at Syon House, and more often than not he stayed at home while his wife went junketing abroad. Elizabeth Macie's London house, while large and well appointed, was no glittering palace. If the Northumberland family lore is to be believed, the gouty old duke still saw Mrs. Macie by sneaking into her house through an underground tunnel he had built to connect her house with a property he'd acquired nearby.

Living in London with his mother, James Macie grew up knowing that he was an illegitimate son of one of the richest men in England. In England in the late eighteenth century, bastards in the upper classes were not unusual, but their identities and rights were

limited. Even James Macie's name was open to debate. The law stated: "A bastard has *no surname* except such as he acquires by reputation or except such as he chooses to adopt. He has such Christian name as he may be baptised or registered by."

England had retained aspects of its feudal past well into the eighteenth century (and in some respects, still does to this day), and chief among these aspects was the set of rules governing the passage of lands and moneys from father to firstborn son. Patrimony was jealously guarded in law and in fact, and British law was explicit on illegitimacy. Bastards were allowed to inherit personal property left to them specifically by name, but that was all. They were incapable of inheriting real property (anything that would normally descend automatically from father to son); nor could they claim any share of personal estate as next of kin to a party dying intestate. Even the sons of bastards were similarly limited. "There can be no collateral succession through bastards; for as they cannot be heirs themselves, so neither can they have any heirs but those of their own bodies," the law stated.

In other respects, English bastards were very much in the same position as second, third, or fourth legitimate sons. They could hold land in fee simple (outright ownership) and dispose of it as they found proper, bequeathing whole estates to whomever they wished. James Macie eventually took full advantage of both those rights.

In some families the bastard children were tacitly acknowledged as faux cousins or orphaned children of friends. The nurseries of the great castles and private palaces were filled with odd assortments of children, half brother or sister to each other, living as siblings or cousins. In others, bastards were kept at a distance, or not supported at all.

Siring four bastards—two girls and two boys, and not all by the same mother—the Duke of Northumberland was in fine company. The Prince of Wales, the future regent, had countless putative

illegitimate children, though their paternity was never determined because the mothers usually had other lovers at the same time. The Duke of Norfolk, a contemporary of Northumberland's, was a notorious libertine who supposedly liked to watch through a glass partition as the mothers of his numerous bastards were paid at the same bank on the same day. "Blue eyes, Jewish noses, gipsy skins and woolly black hair were seen to be grafted on to the unmistakeable Howard features of the infants borne along in the mothers' arms or of stalwart children now obliged to wheel their mother in on a chair," wrote Osbert Sitwell more than a century later of this heartwarming family scene. The fourth and last Duke of Queensbury, a lecherous drunk known as "Old Q," fathered a number of illegitimate children, including Maria Fagniani, the future wife of the third Marquess of Hertford, to whom he left the huge sum of £300,000. The children of the Countess of Oxford were known as "the Harleian Miscellany." In the 1790s Devonshire House held three legitimate children of the duke and duchess, and two of the duke's bastards with his mistress Lady Bess Foster. Two bastards from each parent were being brought up elsewhere.

Making bastards was no mark of shame in the upper classes; *being* a bastard of the upper classes wasn't necessarily shameful either. Most of the boys were well educated and faced little social discrimination in their careers or marriages, other than the financial limitation common to any upper-class children born after the first son. Illegitimate girls, dependent on making matches with men of fortune, suffered worse fates. Lord Mulgrave remarked in the House of Lords in 1800 (the same year James Macie took his real father's name) that "bastardy is of little comparative consequence to the male children," but that illegitimate girls had to struggle "with every disadvantage from their rank in life."

Little is known of the two bastard daughters born to the duke except that he acknowledged them and paid for their schooling. No

records exist to identify their mother, nor is there any clue as to why the duke paid for their educations but not his son's. The *Gentleman's Magazine* obituary of one of the girls, Dorothy Percy, in 1794 identified the two sisters, Philadelphia and Dorothy, as natural daughters of the late duke. They were educated in Paris at their father's expense. They "received an education under the fullest private sanction of their fond and most noble father suitable to their high birth and fortune in the convent of Panthemont in Paris." The convent educated the daughters of Parisian nobility, and Thomas Jefferson sent his own daughter to the school when he was minister to France from 1785 to 1789 (long after the sisters had attended). The sisters spent their lives under the influence of the religious orders. The obit says that after their schooling they went into "retirement in the exercise of elegant accomplishments, but still more in the practice of the most rational piety." The Duke had also settled money on them—although they are not mentioned in his will—because the obit refers to their "bounty." They apparently shared this bounty with the poor "by pursuing modest poverty to its most wretched recesses." The sisters died unmarried and within a few years of each other. At the time of her death, the younger sister, Dorothy Percy, was aware enough of her relationship to James Macie that she left three thousand pounds to him in her will, identifying him as "my half-brother, James Macie . . . of Upper Charlotte Street." This fact alone suggests that there was some relationship between the duke and James Macie.

The eighteenth-century aristocracy is rife with examples of nobility who were on good terms with their illegitimate offspring, but generally the status of these children depended on the goodwill of the spouse. So, for example, the tenth Earl of Pembroke had children by two mistresses. One of the sons had a successful naval career and was on good terms with his half brother, the legitimate heir, and with the countess, whose only request was that the bastard

children not take the family name. In 1721 the Duke of Buckingham made provisions in his will for at least three illegitimate children, two of whom were girls that he even put in the "most generously indulgent care" of his wife after his death. The Duke of Devonshire gave one of his illegitimate daughters by his wife's best friend a dowry of £30,000, which enabled her to marry the man of her choice. But the Duke of Northumberland, encumbered by the restrictions on his title and essentially a mere pretender to the Percy name, could offer nothing overtly to his own bastards without the indulgence of his duchess. She was apparently not inclined to give it in the case of James Macie, while curiously allowing his illegitimate half sisters to bear her own Percy name.

The social acceptance of bastards in England was by no means limited to the upper classes. Erasmus Darwin, physician, polymath, and grandfather of Charles Darwin, fathered two illegitimate children, whom he raised openly and saw educated. It was not uncommon either for illegitimate sons of the eighteenth century to make a lasting name for themselves. One English bastard who attained distinction in life was Richard Wallace, born in 1818 to either the Marquess of Hertford or the marquess's mother. Wallace was raised in Paris and eventually held a seat in Parliament and founded the Wallace Collection of art, now the property of the British nation.

Across the ocean, in puritanical America, bastards were being bred, but not at the rate with which the British aristocracy was producing them. A few American bastard sons, whose lifetimes roughly coincide with Smithson's, rose to prominence in the new nation. Ben Franklin's oldest son, William, for example, was always acknowledged and lived in his father's house. William's son, William Temple, became Franklin's literary executor, but William Franklin himself turned against his father by supporting the English during the Revolution and moving to England after the war. Alexander Hamilton, the first American treasury secretary, who

was born illegitimately in the Virgin Islands in 1755, spent his life pursued by the taunt "West Indian Bastard" but rose to become a great American statesman (before being killed in a duel with Aaron Burr).

Unlike his half sisters, Macie was not openly acknowledged and supported by his father, and this is one of the central mysteries of his life story. The duke might have given covert financial support to his son and to Mrs. Macie—there are intriguing and unexplained regular deposits made to her bank account and later to Macie's that don't seem to be rent incomes—but no wills, bank records, or other documents conclusively prove the money came from Hugh Smithson. It seems likely that at some time before he died, the duke handed to young Macie or his mother various untraceable but redeemable bank bonds and annuities. The boy was most certainly not treated as a member of the Northumberland family. By the time little James Macie arrived in London, the nurseries at Northumberland and Syon House had been quiet for decades. The duke's other children were all much older. James's half brother Lord Hugh Percy, the future second duke, was well into his thirties. He was about to become an officer in the war with the Americans. James's other half brother, Algernon Percy, was a university student making a grand tour of Europe with his tutor. The illegitimate sisters were living mostly in France.

James Macie could have learned about the scandal of his half brother's divorce in 1779. All the titillating details were published in a "Tête-à-Tête" column as well as in the public record. But the American War of Independence was what chiefly occupied British attention during James Macie's early years in London, and Lord Percy was one of their heroes.

Macie arrived in London as the Revolutionary War was beginning. From the boy's first days in England, adults around him were talking about the colonists and their rebellion. As a boy and an

adolescent, Macie would have seen accounts of how the war was going in British journals like *Town and Country Magazine,* which ran lengthy "News from the Colonies" dispatches during the hostilities and afterward. The British attitude toward the Americans during this period was generally one of injury and betrayal. Dr. Johnson published "Taxation No Tyranny," expressing the prevailing view. Some radicals, followers of the journalist and banned parliamentarian John Wilkes, tried to form a Society of Supporters of the Bill of Rights, but it never got off the ground.

It is unclear exactly when Macie knew he was the duke's son, but it was common knowledge by the time he entered university. If his mother told him as a teenager, even with limited or no relations with the great Northumberland family, Macie knew that his half brother was a war hero and, it soon became obvious, fighting on the losing side. As a young teenage boy, having a relative—even a much older and unacknowledged one—regarded as a war hero would certainly have heightened his interest in the events across the Atlantic.

In 1781, when James Macie was sixteen, the British surrendered at Yorktown. Two years later, the Treaty of Paris was signed, with Britain recognizing the independence of the United States. The teenage boy could not have missed news of all this distant turbulence, nor could he have been unaware of the sense of loss suffered by the British, who mostly had regarded the distant land as a quasi paradise containing both treasure and surpassing savagery. If anything, the wild American colonies represented not warfare to a London boy of Macie's age, but wilderness and Indians, freedom from tutors and discipline, maybe even opportunity.

IN JUNE OF 1786, the duke died at age seventy-one. His wife, the duchess, had died ten years before. Hugh Percy, né Smithson, had been deteriorating for years, suffering from such severe gout

that he had to be carried around in a chair at all times. *Town and Country Magazine,* which published a lavish obituary, also published the "London General Bill of Christenings and Burials" for the year of his death, listing all causes of death in London in 1786. Death by gout was relatively rare. The leading causes, carrying off thousands, were convulsions and consumption, followed by fever, ague, and "dropsy." Only sixty-three people died of gout.

In the years before his death, the duke mostly retired from public life, after deciding he was not getting the respect he deserved from the Crown. For the last ten years of his life, he spent most of his time at Syon House, in the great Adam-designed gallery surrounded by the Italian art he'd collected and looking out on the heron-dotted marshlands that bordered the Thames. At the very end of his life, he was a lonely man reduced to offering money to his son's former tutor to stay with him and be his companion. Dutens refused.

The duke's funeral was an event of great ceremony, befitting a man whose annual income at death was a staggering £50,000. *Gentleman's Magazine* ran a two-page obituary for "the Most Noble Hugh, Duke and Earl of Northumberland, Earl Percy, Baron Warkworth and Louvaine, Lord Lieutenant and Custos Rotelorum of the counties of Middlesex and Northumberland and of the town of Newcastle upon Tyne, Knight of the Most Noble Order of the Garter and Baronet."

The duke's body lay in state at Northumberland House for two days before the burial. People who wanted to pay their respects had to acquire a ticket, which permitted four people each. The spectacle drew crowds. The *London Gazette* advised readers on June 18, 1786, that space for chairs and carriages would be tight. "Ladies and Gentlemen who have applied for tickets to view the Body of the late Duke of Northumberland, lying in state tomorrow, are earnestly requested to order their servants to set down and take up

in the wide carriage way below Charing Cross, with their horses heads towards Whitehall."

Among the thousands who thronged the great house during the duke's lying in state was Abigail Adams, wife of John Adams and mother of John Quincy Adams, who would play a crucial role in the handling of James Smithson's money decades later. Mrs. Adams left a piquant American-eye view of the duke's lying in state, which she termed "farce." She wrote to her niece that she accepted a ticket because she'd heard the funeral pageantry would be unmatched by any except for royalty. Northumberland House was, she wrote, a "great immense pile of building" and the illumination—always the duke's great specialty at parties—was splendid. The funereal scene she described is straight out of an Edgar Allan Poe story.

"I never before understood that line of Pope's 'When Hopkins dies a thousand lights attend,'" Mrs. Adams wrote. "I believe there were two thousand lights here, for daylight was totally excluded, and upon the walls were as many escutcheon as candles, [with] a light in each, and these plates are all washed with silver. Being put up upon the black cloth and lighted in this manner gave the rooms a tomblike appearance. Through these rooms we moved with a slow pace and a solemn silence into that which contained the corpse, surrounded by 24 wax lights upon enormous silver candlesticks."

Abigail's curiosity about the dead man himself was not satisfied. "He was so buried amidst stars and garters and the various insignias of the different offices he sustained that he might as well have been at Syon House, for all that we could see of him." She heard that the body was dressed in white satin and blond lace but she couldn't see it. "This farce was kept up for days," she concluded.

The duke's love of pomp followed him literally into the burial vault. The funeral procession to Westminster Abbey involved dozens of guards, banners, and peace officers, and even separate

horses to carry the duke's coronet on a cushion, as well as his sword. At the abbey, funeral music was performed by a choir in proper habits, and the burial service read by the dean in "the most solemn and pathetick manner," according to *Town and Country Magazine*.

When the duke died, James Macie had just turned twenty-one. He had already lived a fatherless childhood. As a boy, did James Macie consider himself a bastard son in the strictest psychological sense, *filius nullius,* nobody's child? It seems unlikely. His true parentage was common knowledge by the time he was a university student. If he grieved over his father, it was a private matter. He is nowhere mentioned in the duke's will—nor are his illegitimate half sisters. The vast money, lands, and titles all went to the two legitimate sons.

James Macie never lived with the duke, and there was never any question of his officially inheriting money or properties from his father because of the specific restrictions on the duke's title. The duchess had died in 1776, when James Macie was just eleven years old, theoretically freeing the duke to at least invite his illegitimate son to tea. We don't know whether the duke met his illegitimate son, or if he was aware, for example, that as an adolescent the boy bore a striking resemblance to Lord Hugh Percy, the duke's eldest son and heir (paintings of the half brothers as students made around the same age show this). There are a few bits of evidence that indicate more than a passing connection between father and son. The most certain and most poignant is that when James Smithson died many, many years later in Italy, a portrait of Hugh Smithson and some silver plate with the Northumberland family crest were among his final possessions.

4

<center>—</center>

CHOOSING SCIENCE

O N THE WARM SPRING EVENING of April 26, 1787, a Thursday, the members of the Royal Society convened at the Crown and Anchor Tavern on the Strand and sat down to dinner at five o'clock. Sir Joseph Banks, gouty, bewigged, and massive, his eyebrows visible from the farthest corners of the room, amply filled the place of honor. No napkins were laid down, in the English style of the time. The men—for the fifty or so scientists and dilettante aristocrats in attendance were all men—heard a cursory mumbled prayer, then picked up their three-pronged forks and tucked into the steaming roast beef, boiled beef and mutton, and heaped potatoes and vegetables. Different sauces were arranged around the table in glass decanters and bowls, so each diner could season his meat as he pleased. The men downed their beef and mutton with copious pewter pots of strong beer called porter. The pewter pots were preferable to glasses because it was possible to swallow a whole pint at one gulp.

Such prodigious meat consumption had not always been the club's style. Fifty years before, Royal Society members had vowed

to eat only fish and pudding at their meetings, out of consideration for one of their earliest presidents, Dr. Edmond Halley—discoverer of the comet—who had no teeth. Over the years, the carnivores had prevailed. And as circumnavigation of the globe became more common, and Joseph Banks involved himself with more expeditions and more sea captains, the club was the occasional recipient of a very special dinner present—a giant turtle. On rare Thursdays, diners passed up the domestic meat and devoured one of these exotic four-hundred-pound beasts, harnessed and dragged by rope across thousands of miles of ocean from the West Indies or the South Seas.

After the meat was eaten, servants removed the plates and reset the table with fine crystal decanters filled with the best port, Madeira, and claret from Bordeaux. Each diner was given several different glasses for the different libations, and various cheeses were rolled around the table in mahogany boxes to provoke thirst. Toasts were made, round after round, until various royals, present in flesh or spirit, and each and every guest had been honored with a brimming glassful. The wine course was followed by coffee, five or six cups per person, and then brandy, rum, and other strong liqueurs. When nature called, the men would relieve themselves in a pot at the sideboard without interrupting their conversation, an English custom instituted not so much for convenience as to preempt any excuse for the weak of stomach or head to sneak out before the drinking was finished.

When this gluttonous marathon ended, scientists and their guests tramped the short distance up the Strand to attend to the Royal Society's official business in Somerset House on the Thames. The meeting room was elegantly if simply furnished, with pewlike benches, arranged in parallel lines in rows from the front to the back of the room. At the head of the room, facing the benches, was the president's chair, a colossal piece of furniture made of

mahogany and mounted with an escutcheon painted with the insignia of the society. A table was set before the president's chair, covered with an enormous cushion of crimson velvet on which speakers rested their arms. Next to that was a table for the recording secretaries, whose large notebooks and inkwells shared space with a gilt silver mace, the symbol of all royal institutions in England.

The meeting convened precisely at eight o'clock, as usual. The newest members of the society, James Lewis Macie, Esq., and Sir Thomas Gery Cullum, Bart., paid their fees, and, having signed an obligation in the charter book, were admitted as full members. Macie, at twenty-two, was the youngest man in the room, and the youngest ever admitted to the society, which was formed in 1662 for the purpose of promoting literary and scientific conversation. He had grown into a small, soft-spoken, and studious young man, with a tendency toward weak health. His seriousness had attracted some powerful patrons and on this night he was relishing a major gesture of their support. Macie sat in one of the hard-backed benches and probably said very little. Like his chief mentor, the eccentric and deeply shy chemist Henry Cavendish, he was not very expressive.

One never knew what entertainment might be scheduled at the Royal Society in the 1780s. The so-called Age of Discovery was under way and miracles were being unearthed afar and hauled back to England, or brought to light in laboratories, or sometimes simply conjured up. A new electrical generating device could be on display, or some live electric eels from Suriname, which every member might poke to feel a stroke of current, or a live sucking alligator brought back from America. Human specimens were brought in too and exhibited much like the beasts. American and Polynesian Indians, Eskimos, and Chinamen had been examined.

The shows attracted all manner of nonscientific dignitaries as well. Continental and British royalty dropped by, and intrepid sea

captains like William Bligh, his ship in dry dock between expeditions, could be circulating on any given night. Among the men Macie recognized in the room on that April night were some of those who had recommended him for membership. There was the aristocratic collector and dilettante Charles Fulke Greville, the original lover of the notorious Lady Emma Hamilton. In another chair was the Irish chemist Richard Kirwan, who called mineralogy—young Macie's specialty—"the letters of Nature, which written up into words, became geology."

Their attention, like young Macie's, was riveted just now on the reading of a paper sent to the fellows by the astronomer William Herschel. Herschel had great proficiency with the telescope and had recently identified the first nebulae and postulated that most stars have planetary systems. He had already discovered Uranus, which he named after King George III, and he had made the first systematic attempt to determine the shape of the Milky Way galaxy. Herschel's latest discovery concerned three active volcanoes spurting lava on the moon. Just ten days previous, Herschel reported, he had observed these lunar volcanoes through his telescope. "Two of them are near the center of the Moon and resemble large faint nebulae with a bright undefined nucleus; these are thought to be either at the beginning or towards the end of their state. The third seems to be actually burning."

This report was followed by another, submitted by John Hunter, a physician who lived not far from Macie, on experiments he had recently conducted, which seemed to prove that the wolf, dog, and jackal, were of the same species. By breeding a wolf with a Pomeranian and a jackal with a spaniel, and observing the puppies to be dogs, Hunter determined that all three animals are of one species. Hunter left open the question of which of the beasts had been "the original in nature." But "as the dog is out of the question and the jackal is likewise a much tamer animal than the wolf, our

author is of the opinion that the latter must be the original stock animal."

The third and final paper of the evening covered a topic that should have peeled back the eyelids of anyone succumbing to the soporific effect of the recent repast. William Norris, a surgeon, rose to stand behind the crimson pillow and communicated the following story about "a remarkable Hydrocelle." A "gentleman aged 47 had been for 20 years troubled with a hydrocelle, or tumor, on the right side of his scrotum," Mr. Norris said. He became so incommoded by it that he was willing to undergo any operation, in hopes of a cure. The surgeon arrived and went to work, with the patient, in the fashion of the day, wide awake. "He made an incision the whole length of the morbid swelling," and prodigious quantities of "a curdled chocolate coloured fluid" poured out.

"The operator was obliged to use considerable force," Norris continued, but managed to remove the tumor, and another one next to it. On examination, the tumors were found to contain numerous "ossifications, the size of half a crown." Norris exhibited these ossifications to the room from his perch behind the crimson pillow. The report ended with the unfortunate news that "the patient died ten days after the operation, by no means from the effects of it, but from a fit of asthma, a disorder under which he had laboured many years."

The subjects covered at the Royal Society meetings during Macie's early years ran the gamut from the truly groundbreaking to the simply bizarre, grotesque, and ridiculous. The fellows had one foot in the past, in archaic ignorance, and one foot in the future, in which the sciences were going to explain electricity, the atom, and basic biology. The society's charter stated that it was founded for the improvement of natural knowledge, and the word *natural* was chosen very specifically, to differentiate scientific knowledge from the supernatural arts. Eighteenth-century scientists tried mightily

to distinguish themselves from the sorcerers and dabblers of the previous century. Royal Society scientists in the late eighteenth century were barely one hundred years away from an era when alchemy was acceptable science and chemistry still had metaphysical aspects. Devoted as he was to emerging standards of early modern science, even Macie had among his possessions a massive tome written in Latin and illustrated with the mysterious diagrams that identify it as some kind of alchemical textbook from the seventeenth century.

The Royal Society never gave an official inch to witchcraft or divination, but it was not yet averse to bizarre theories based on social prejudice or simply erroneous assumptions due to primitive tools. On any given Thursday night, analyses by Cavendish, Thomas Beddoes, and other serious chemists might share podium time with papers about rainstorms of blood in the remoter parts of America and the superhuman sexuality of Hottentot women.

The greatest chemical discoveries of the late eighteenth century were first steps in the direction of the modern world. At the time, people still accepted the Aristotelian four elements theory—earth, air, water, and fire. Scientists also believed in the existence of "imponderable fluids" to explain electricity, heat, light, and magnetism. But some scientists in England and in France—men whose ideas young Macie would come to know well—were breaking down those theories little by little and creating a foundation for modern chemistry and physics.

Electricity was the obsession of the age, although early experimenters with it had no idea that the force would someday make candles and fireplaces merely decorative and not requisite for existence. A debate was raging about whether electricity was in fact a fluid called "phlogiston." All over Europe, scientists of all ranks were conducting experiments, shocking themselves on purpose and using anything they had at hand to help generate it. Even candles

and umbrellas would sometimes do (as earlier, Ben Franklin had used a storm and a kite). Men whose names are now synonymous with electrical phenomena were beginning their major work. In 1786 the Italian Luigi Galvani discovered "animal electricity." Also on the Continent, Ampère and Oersted—men with whom Macie corresponded and sometimes socialized—would, during the next several decades, lay the groundwork for understanding electricity. In 1800 the Italian physicist Count Alessandro Giuseppe Antonio Anastasio Volta invented the first battery using disks of silver and zinc. The electric volt was named for him. In 1821, near the end of Macie's life, English scientist Michael Faraday built the first electric-powered motor.

The qualities and components of heat were also a matter of much investigation. British scientist Henry Cavendish was at the forefront of these experiments. When Macie joined the Royal Society, Cavendish was writing one of his most forceful papers to prove that the Newtonian theory of forces of attraction and repulsion was relevant to understanding heat, which contradicted the popular fluid theory upon which scientists were trying to base a "unified" theory of natural philosophy. The paper was never published during his lifetime.

WHEN HE WAS seventeen years old, James Lewis Macie entered Pembroke College, Oxford. The year was 1782. He enrolled under the Latin name Jacobus Ludovicus in the style of young scholars at the time, adding the abbreviation *"arm. fil,"* which stood for *"armiger filius,"* Latin for bearer of arms. Clearly the boy already had an idea of his real origins and wasn't shy about claiming the pedigree he believed was his birthright. There was a conspicuous discrepancy between his self-image and his real position. On the college's books, where the students' fathers were listed, the space for the name of Macie's father was left blank. A college mate of

Macie's, Davies Gilbert, noted in his diary that the Duke of Northumberland "was acknowledged on all hands to be his father," but nothing official confirmed that.

His parentage was common knowledge, but that did not translate into money or prestige. If the Duke of Northumberland financed Mrs. Macie or paid for his son James's education, as he had paid to expensively educate his illegitimate daughters in Paris, it was a very discreet arrangement. Pembroke College records indicate that James Macie paid his own fees. Mrs. Macie had an account in her own name at Hoare Bankers on Fleet Street. She initially funded it with £11,000 in bonds, and later supplemented it with smaller deposits, probably rent incomes. By 1785, young Macie had opened his own account at Hoare Bankers and kept one there throughout his life.

Pembroke was the college for smart boys with relatively smaller fortunes, known as gentleman commoners. This is not to say that Pembroke boys were poor. No poor boy went to Oxford, but the very rich and titled usually went to Christ Church or Trinity. Macie's father Hugh Smithson and Smithson's two legitimate sons were all Christ Church graduates. Macie was actually one of the richer students at Pembroke. He arrived with ample pocket money from his mother, enough to buy himself the necessities of student life at the time: wineglasses, teapots, tablecloth, shelves, maybe the repainting of his room. He would have had to buy his books. The required reading was heavily classic, and would have included Cicero's *Orations,* Tully, Sallust, Shakespeare, Echard's *Roman History,* Ainsworth's Latin *Dictionary,* and books on logic and mathematics, among others. Books were sold without covers at the time and young Macie would have had to decide whether to spend his funds on binding, gilding, and monogramming or otherwise personalizing his books as well. In later life, he never bothered with such niceties.

What Pembroke lacked in upper-crust cachet it made up for in

intellectual spirit. The most famous Pembroke alumnus at the time was Dr. Samuel Johnson. During Macie's time at Pembroke, there was a burgeoning of interest in the sciences. Some of Macie's contemporaries also went on to become well known in science. His friend Davies Giddy (who would, like Macie himself, change his name in midlife to a more socially respectable one, Gilbert) became a president of the Royal Society. Another peer, Thomas Beddoes, was a brilliant scientist who has been credited with helping discover nitrous oxide, or laughing gas—the first anesthetic.

Macie showed an aptitude for chemistry early on, and before long he was acknowledged as Pembroke's foremost student in the field. There was still no Oxford chair in chemistry, but the study of chemistry (and geology and mineralogy, then still subsets of chemistry) was flowering in the last quarter of the eighteenth century, formally dividing into the specialized fields we know today. Chemistry held the same appeal for smart young men then that the microchip or the genome has had for more recent generations. It represented uncharted territory on which the barest glimmers of a new kind of world could be imagined. Macie studied under a theologian named Dr. William Adams. Adams had spent forty-three years of his adult life holding various religious posts, all the while "considerably deep in chemistry." His zeal for the new science ignited the interests of not just young Macie, but Gilbert and Beddoes as well.

Most of the breakthroughs in chemistry were being made across the Channel in France. The French scientist Antoine Lavoisier had identified oxygen in 1778 and then discovered that water is made of hydrogen (called "flammable" or "phlogisticated" air) and oxygen or "vital" air. By identifying the components of water, Lavoisier had destroyed the Aristotelian theory, or at least removed one basic element by breaking it down. Then he and other chemists began adding a whole list of new elements. By 1790 Lavoisier published a

groundbreaking book containing all the recent chemical discoveries. The book was a major revision of chemical nomenclature and included new geometric symbols to identify metals, earths, and alkalis—the divisions within the known elements at the time. The book defined the start of chemistry as a science and is classed alongside Darwin's *On the Origin of Species* in terms of importance.

Macie was not a typical Oxford student. Boys at Oxford, like boys anytime, anywhere, at the age of eighteen, newly released from home, indulged in as many idle pastimes as they could afford. Oxford life was filled with trips to theater and musical events, hunting expeditions, cricket and cards, and, mostly, drinking. Descriptions of student life and memoirs of alumni from around the same time depict a campus as raucous as any in the United States today. The writer James Harris, later Lord Malmesbury (and coincidentally the purchaser from Mrs. Macie of Great Durnford Manor), attended Oxford the decade before James Macie arrived. He professed to be disappointed by the quality of his education. "The two years of my life I look back to as most unprofitably spent were those I passed at Merton [another Oxford college]. The discipline happened to be so lax, that a Gentleman Commoner was under no restraint, and never called upon to attend either lectures or chapel or hall. I never saw my tutor but during a fortnight when I took it into my head to learn some trigonometry."

Another alumnus, the writer Vicesemus Knox, claimed the Oxford examination system was a complete sham. "The greatest dunce usually gets his testimonium signed with as much ease and credit as the greatest genius. The examiners and candidate generally converse on the last drinking-bout, or on the horses, or read the newspaper, or a novel, or divert themselves as well as they can in any manner, till the clock strikes eleven, when the testimonium is signed by the masters."

College life was not without its rigors, by any means. The writer

and social reformer Jeremy Bentham, a student during the 1760s, wrote home to his parents complaining about having pulled out two of his own sore teeth, then being disbelieved by his Latin tutor when he showed up late with a swollen face.

At Pembroke, Macie stuck to his books and laboratory. Among the rough-and-ready collegiate boys, he was a small and perhaps shy figure who took himself, his mineral collection, and his pedigree quite seriously. He was a natural scholar, and capable of putting enormous focus into his experiments. The latter quality attracted the attention of other scientists at Oxford. Besides Adams, one of his earliest mentors was William Thomson; a few years older than Macie, he held the position of Reader in Anatomy at Christ Church from 1785 to 1790. Thomson and Macie were close friends during and after Macie's years at Pembroke. When Thomson didn't bother to present himself at the Royal Society after being elected, Macie in 1787 warned him that "it may prove troublesome," prompting Thomson to write to Sir Joseph Banks for a clarification about whether "that ceremony had been dispensed with, on my request, as communicated to you."

Thomson, who worked on cadavers, didn't have much time left in England though, and his Royal Society membership soon became moot when he was caught engaging in homosexual, or as reported at the time, 'unnatural' activity with a young boy. Thomson was summoned to appear before the Hebdomadal Board, the university's executive body, on October 20, 1790, to answer the charges made against him of a *"foedissimi et sodomitici criminis"* (a most "foul and sodomitic crime") committed with a William Parsons some four years previously. Parsons was, at the time of the alleged crime, a servant boy to a Mr. Fletcher, a local bookseller. Parsons was questioned by the board and confirmed that the crime had taken place.

Thomson failed to appear to refute the charges against him and

moved to Italy, where he lived for the rest of his life in Naples under the name Guglielmo Thomson. From his self-imposed exile, Thomson continued to work in science and made a name for himself in mineralogy. He also wrote a number of plaintive letters to mutual Italian friends, inquiring as to the whereabouts and doings of James Macie. If Macie didn't exactly drop his old friend, he made himself scarce, and no letters between the men have been collected. When he died, Thomson willed his mineral collection to Oxford, but it was refused, and it eventually went to the University of Edinburgh.

JAMES MACIE BECAME a chemist who chose mineralogy, the study of rocks, as his specialty. Such subspecialties in science were only beginning to exist. Most chemists or geologists or physicists or botanists called themselves simply "natural philosophers." Geology as an area of specialization only began to be recognized in the late eighteenth century, coinciding with a period when the study of the origins of the earth became an edgy, politically controversial, and theologically volatile topic. The Bible was still the primary source of knowledge about the age and origin of the earth. Many scientists, including Macie's mentors, were questioning this received wisdom, but cautiously. For the general public, the earth's age was a spiritual, not scientific matter. An Irish prelate, James Ussher, bishop of Armagh, had fixed the date exactly: God had started creating the earth exactly 5,773 years before 1769. The divines had put that relatively recent date on creation, but science was beginning to accept the idea that the earth was probably much, much older. The evidence was in fossils, but also in earthquakes, in volcanoes, and in the denuding abilities of seas and rivers, as well as the strata of the earth itself.

When Macie entered the field, there was still a great urgency

about classifying and organizing minerals. The study of rocks was key to the understanding of larger geological questions, chiefly the age and origins of the earth. A great breakthrough in geological thought happened when classification of minerals began to be based on where the minerals were found in the strata of the earth. The meticulous techniques of analysis in mineralogy that Macie was acquiring were especially useful in identifying strata in regions where the strata were not easy to identify by sight.

In the late eighteenth century the argument in geology was chiefly between so-called Neptunists, who believed a primeval universal ocean had formed the geological record, and the Plutonists, who gave credit for geological reality to the earth's interior heat, as evidenced by volcanoes. The Neptunists had the advantage—for their time—of being in accord with theological accounts of a great deluge. Mineralogy provided ammunition for these debaters. Rocks—their color, crystals, size, and shape, and where they were found—were the clues that might, if decoded, tip the balance in favor of one of these two groups. Yet many mineralogists, like Macie, didn't join the argument. Mineralogists were often men who couldn't or wouldn't see the forest for the trees. They didn't test theories of the earth that were opening so many avenues of political and theological controversy. Quiet, focused, and happy to be alone in the lab, Macie and his cohorts concerned themselves chiefly with collecting and identifying materials and breaking them down into their elements. Over time, Macie did give serious consideration to the earth's origins, and eventually confronted his generation's challenge to try and reconcile observable fact with faith-based notions of Creation.

The newness of geology and the excitement that went with that attracted Macie and others. These young men also had the appetite and energy for intrepid expeditions to remote places to gather specimens. Macie and his contemporaries—Beddoes, Edward Daniel

Clarke (who improved the blowpipe used by mineralogists like Macie to analyze rocks), Humphry Davy, and Sir James Hall—as well as mineralogists and geologists across the Channel, formed an ardent, affectionate network of men who shared letters and results, socialized, and conducted fieldwork together. Macie was eager to get into the field, a predilection he retained into middle age, when ill health forced him to spend more time at his desk. He was still in his teens when he traveled to a salt mine in the north of England to do his first fieldwork. In a journal, he wrote of descending the black, narrow shaft: "They let me down in a bucket, in which I only put one foot, and I had a miner with me. I think the first shaft was about thirty yards, at the bottom of which was a pool of water, but on one side there was a horizontal opening, from which sunk a second shaft, which went to the bottom of the pit and a man let us down in a bucket smaller than the first." Macie doesn't mention it in his journal, because it would have been presumed at the time, but a trip down a shaft was a dark and harrowing experience, especially for a nonminer. Workers operated by candlelight in the dark. It would be several decades before Macie's younger colleague, the brilliant chemist Humphry Davy, invented the first miners head-lamp.

Young earth scientists like Macie felt like adventurers. "I partake more largely of the spirit of the Knight of La Mancha than of his craven squire and prefer the enterprise and adventure of geological errantry to rich castles and luxurious entertainments," wrote the geologist William Conybeare. For Macie, there was probably more to it than sheer adventure. The isolation of the lab and the contemplation of natural truth, as opposed to social reality, gave him a focus and a home. As the science historian Roy Porter has written, "Dissatisfaction with polite society led many . . . to the pursuit of science."

By choosing mineralogy as his focus, Macie was entering a

rather odd field for a gentleman, but by no means one that did not interest other members of his class. Gentlemen amateurs, like his uncle George Keate, all over England were collecting fossils, shells, and rocks and playing at identifying them. As a profession, however, the field was empty, especially in England. In the universities, no professorships existed. Where mineralogy was taught, it was done so in conjunction with mining, an industrial application that, while it might have interested Macie, was beneath his position in life (or certainly his own sense of his status).

IN 1784, while in his third year at Pembroke, James Macie made his first serious field expedition, in a trip through Scotland aimed at studying the geological marvel of the Isle of Staffa. It was a rough journey, one that had deterred many of his elders, including the diplomat and vulcanologist William Hamilton and his nephew Lord Greville—the latter one of Macie's Royal Society mentors. The roads through Scotland were crude, and the sea voyage itself perilous. The journey promised hardships young gentlemen of Macie's set rarely experienced.

Staffa is an island off the coast of Scotland, part of the Inner Hebrides. Colossal vertical green-gray and black basalt columns— cooled lava from an ancient undersea volcano—form the island's base. From afar, the columns look like a giant harp rising out of the crashing sea. The most geologically significant part of the island is Fingal's Cave, an opening underneath the island created by a corridor of black basaltic columns. Inside this cave, it is possible to touch the rocks, inspect them closely, and scrape away samples. But the way to Staffa, and especially Fingal's Cave, is perilous even today. To get inside the cave, boats must head out into open sea west of the island, then circle back, skirting treacherous rocks that are only occasionally visible in the rough water.

Macie traveled with a group of accomplished older explorers, including the French geologist Barthélémy Faujas de Saint-Fond and the Italian adventurer and balloonist Count Andrioni. There was only one other young man around his own age, William Thornton, a British citizen born in the West Indies who was destined to design the U.S. Capitol a dozen years later. Macie was part of this august little group thanks to the warm accolades of his soon-to-be-disgraced Oxford mentor, William Thomson, who had written to Joseph Black, the Scottish chemist and discoverer of carbon dioxide, praising Macie's abilities in mineralogy. "His proficiency is not only already much beyond what I have been able to attain to—but must of course continue such."

The travelers left London in early September and headed north, through the Scottish border country owned for centuries by the Percy family, north into Scotland and through the cities of Edinburgh and Dumbarton before heading toward the sea. After some rough mountain riding, and nights passed sleeping close by the lochs and listening to ghost stories and local lore about the Celtic poet Ossian, they reached the gray-green castle of Inverary (seat of the Duke of Argyll, who feted the small party). At the little port city of Oban, the party finally surveyed the crashing water they would have to cross to reach Staffa, too far away to be visible from shore. The Frenchman, Faujas de Saint-Fond, was concerned. "As this cliff-girt island (Staffa) has neither harbour nor anchorage, and can only be reached in very small boats, settled weather and a calm sea are absolutely necessary. These conditions however are extremely rare upon this coast, strewn as it is with islands, washed by currents and exposed to tempestuous winds."

The Frenchman decided to wait for better seas, but Macie set off immediately. Dragging his servant with him, he was one of the first of the party to step into one of the small open rowboats and head out into the open surf. Four hours of rowing and bailing later,

Macie's boat reached the fabled isle. As he approached, he could see a thin, inhospitable crust of treeless green meadow layered over sheer black cliffs of basaltic columns, around which the sea swirled crazily. The rowboat tried to dock at the edge of Fingal's Cave, the black, water-filled chasm of basalt columns under the island, but it was too treacherous. Finally, the boat found safe harbor, and Macie and his servant carefully picked their way up the wet, steplike columns to the grassy island, gasping in fierce and unrelenting wind that ripped at their clothes. Once upon the island, the budding geologist unpacked his pickax and wouldn't be persuaded to leave that day, even when bad weather threatened to maroon him there.

Macie was marooned in a shepherd's barn for three days waiting for his rowers to feel confident enough to return. Only after another twenty-four hours did the weather turn calm enough to permit a return to the mainland. Macie's journal entries on the experience have survived.

"Sunday the 26th," he wrote. "The man of the island came at five or six-o'clock in the morning to tell us that the wind was dropped and that it was a good day. Set off in the small boat, which took water so fast my servant was obliged to bail constantly—the sail an old plaid, the ropes, garters."

Macie and his traveling companions (he doesn't mention names, but certainly Thornton and some others) returned to Oban and a hero's welcome. The members of their party who'd stayed behind had feared the worst, given that Macie and his friends vanished on the high seas for three days. Faujas de Saint-Fond, the timorous Frenchman who had remained at Oban out of fear of the rough seas, recorded the return of Macie and his companions in his journal. "They arrived at one o'clock on Sunday to their own and our great satisfaction. They were so emaciated with fatigue, vexation and misery, were so in want of food and rest, and so uneasy that they entreated us not to disturb them with any questions until they

were a little refreshed and particularly relieved from the multitude of lice that tormented them most cruelly. 'Fly! Fly from us!' said they. 'We have brought some good specimens of mineralogy but our collection of insects is numerous and horrible.'" The travelers immediately stripped and burned their clothes.

It took a few days to recover from this adventure, and the scientists passed the time at an Oban inn. Macie recorded that the innkeeper didn't much appreciate the significance of the mineralogical fieldwork going on inside his establishment. On September 29, he wrote, "This day packed up my fossils in a barrel and paid 2s, 6d. for their going by water to Edinburgh. Mr. Stevenson charged half a crown a night for my rooms, because I had brought 'stones and dirt' as he said, into it."

Macie got more than lice, fossils, and a rollicking sea adventure out of this trip. He also made a powerful connection. On the way from England to Staffa, the party had stopped off in Edinburgh. There, Macie met and won the respect of James Hutton, the great Scottish geologist who is sometimes called the father of geology. Hutton was one of the great men of science of the day. He was developing a theory of the earth which postulated limitless geological time (directly contradicting the theologians) and in which, for geologists, "the present is the key to the past." In other words, the same processes—earth's internal heat and water erosion, chiefly—that act to change the earth today have been changing it since the beginning of time.

Hutton was one in a series of important older men Macie was able to win over in his youth. Hutton thought so highly of the nineteen-year-old student that he entrusted him with money to buy and send him fossils from a quarry near Oxford. Macie apparently was unable to completely fulfill his mission, and in a letter to Hutton in April 1788, four years later, he asked if Hutton wanted him to buy fossils with the remainder of the two guineas Hutton

gave him, or send it back. In this letter also, Macie refers to the disgraced Dr. Thomson as "our common friend."

Word of the Staffa expedition and young Macie's intrepidity in the cause of science reached London by October. In a letter to Joseph Banks, Royal Society member Charles Blagden ridiculed Faujas de Saint-Fond for being unable to "muster resolution" to get in the boat once he saw the sea, and for "languishing on the main Land until their return." (This was not true; Faujas de Saint-Fond wrote in his journal that he made the trip, and Blagden notes that it is mere gossip that he did not, but clearly it was an irresistible opportunity to ridicule a Frenchman.) "Luckily, Thornton, whose drawings will furnish a record, found courage enough to venture over: the only person I am sure of having gone, however, is Mr. Massey [sic], whose letters are come to town with this account. Mr. Massey is said to be a natural son of the Duke of Northumberlands."

IN HIS EARLY YEARS as a Royal Society fellow, James Macie lived in modest rented quarters on John Street, Golden Square, just a short walk north through teeming Piccadilly from Northumberland House. Even if he did not visit Northumberland House, the massive dissonance between Macie's furnished apartment in Golden Square and the duke's palace was glaring. Golden Square was at the edge of Piccadilly and formerly called Gelding Square. According to a guidebook of London at the time, the access to it was dirty and "altogether it has no very high claims to distinction for its beauty or magnificence." It was built soon after the revolutions of 1688–89 in what were then called the Pest-House Fields, because, during the plague of 1665, the square was used as a pesthouse (temporary hospital). The Carnaby Market also occupied a considerable portion of "what previously was constituted a dirty waste."

By the time of his father's death in 1786, Macie was already well into his scientific career and he had a number of father figures in his life. Wealthy enough to devote himself fully to isolated pursuits that brought him no income, he was also talented enough to attract supporters. He had already attached himself to some powerful older men, including Hutton in Scotland, but he found his most important mentor in London. When the duke died, Macie was a member of the inner circle of one of Britain's top scientists, as an assistant inside the aristocrat-scientist Henry Cavendish's lavishly equipped lab.

Cavendish was a fantastically wealthy man—nicknamed "The Club Croesus" in the Royal Society—from a very aristocratic family, the Devonshires. He was also an eccentric scientific genius. His experiments on electricity (including shocking himself to measure degrees of voltage) and the properties of air and heat, as well as his calculations on the earth's mass, all helped advance science into the modern age. He was one of the few scientists of his generation to question the popularly held fluid notion of heat.

The patronage of this brilliant scientist-aristocrat flattered Macie, who regarded himself as a true, if unacknowledged member of the British aristocracy. Cavendish, though, didn't care for titles or anything social for that matter. He was a deeply introverted man whose noble bloodlines could have put him on the guest list for any of the Duke of Northumberland's fetes, but he was incapable of speaking to people about anything besides science. "He was shy and bashful to a degree bordering on disease," wrote a contemporary, the Scottish chemist Thomas Thomson. "He could not bear to have any person introduced to him, or to be pointed out in any way as a remarkable man."

Cavendish had built himself a museum-like house at 11 Bedford Square, just around the corner from the British Museum, where he displayed his vast mineral collection. The three-story brick house was decorated entirely in shades of green and is still standing, a

testament to the quality of the building, which was erected in the 1780s. The floors were of Norway oak, and sculptured marble chimneypieces dominated the drawing and dining rooms. There was nothing showy or extravagant about it. The house was like "a green, live-in scientific facility," according to Cavendish's biographers. It had a library with a librarian and housed specimens important to the Royal Society in addition to Cavendish's collection. Cavendish kept instruments at Bedford Square, but his lab was at his country house in Clapham Common, where he conducted his experiments. He also owned a third London house that he rented to other scientists, one of whom held a "Theatre of Anatomy" inside—replete with lectures and the exhibited bodies of dead criminals. In the garden, another tenant had constructed a vivarium of chained wild beasts.

Cavendish's odd personal habits were a Royal Society joke. Despite his massive wealth, he always attended society meetings with just enough money in his pocket to pay for his dinner and no more. "He always picked his teeth with a fork, hung his hat invariably on the same peg, always stuck his cane in his right boot." His pathological taciturnity was also much remarked. Cavendish "uttered fewer words in the course of his life than any man who ever lived to fourscore years, not at all excepting the monks of La Trappe," said one of his contemporaries, the jurist Lord Henry Brougham.

His fear and loathing of women were legendary. One evening, according to Royal Society lore, Cavendish observed a very pretty girl looking out from an upper window on the opposite side of the street, watching the philosophers at dinner. "She attracted notice, and one by one, they got up and mustered round the window to admire the fair one. Cavendish, who thought they were looking at the moon, bustled up to them in his odd way and when he saw the real object of their study, turned away in intense disgust and

grunted out 'Pshaw!': The amorous conduct of the brothers having horrified the woman-hating scientist."

Macie had to have been self-effacing and nonthreatening—to put it mildly—to be granted entrée by such a character. Given the older man's eccentricities, a less determined or less serious young man than Macie might have run back to the tavern bursting with amusing anecdotes from within the eccentric scientist's home. Instead, Macie was a trusted apprentice inside Cavendish's lab, where he met and was treated as a peer by some of Britain's greatest men of science.

Royal Society membership brought the young man into contact with the club's most influential president ever, Sir Joseph Banks. Banks was elected president in 1778 and served longer than any other—for forty-one years. Although he was an Englishman who spoke no other language, Banks became extremely influential in European science, serving as a kind of clearinghouse and networking hub for scientists across Europe. Even before his time, the Royal Society had begun overseeing government-financed expeditions that opened the world to modernity in the so-called Age of Discovery. As a young man, Banks had participated in several expeditions. The most daring was a three-year journey around the world aimed at viewing the transit of Venus over the South Seas in 1769 on the ship *Endeavour* with then-Lieutenant James Cook.

Banks later oversaw or otherwise involved himself in numerous expeditions, including Cook's other South Seas trip in 1772, a naval search for the North Pole in 1773, and Cook's last expedition to Hawaii in 1776, during which he died. Banks personified the mid-eighteenth-century ideal of a scientific patron and amateur practitioner. A prominent landowner himself, Banks was concerned chiefly with agricultural improvement and commerce. His house in Soho Square contained a vast library (presided over by curator Daniel Solander, a pupil of the great Swedish scientific organizer

Linnaeus) and herbarium. Banks had a profound influence on the government and commerce of England during his lifetime. He was a colonialist: For twenty years he advised the government on colonial affairs. He advised the East India Company on botany and initiated the idea of using Australia as a penal colony. He brought better wool-producing sheep—merinos—from Spain into England, altering the textile industry forever. He organized Captain Bligh's fated trip to the South Seas on the *Bounty,* which was outfitted as a botanical ship for the purpose of bringing breadfruit trees to plantation islands where slave labor needed to be fed. He was director of the king's gardens at Kew, where he planted varieties of exotic plants brought back from far-flung regions. More whimsically, he gifted the French with the first kangaroo ever seen in France, after another expedition to Australia.

By the time Macie met him, Banks was well settled in London as president of the Royal Society, supporting scientific expeditions around the globe and presiding over the stream of scientific visitors to his house and the society itself. He held breakfasts on Thursday mornings and "conversations" after Sunday dinner, and these were attended by multitudes of men of science over the years. The natural philosophers met in Banks's house and talked of many matters: the new flying machines called steerable balloons just invented in 1783, Benjamin Franklin's electrical experiments, better telescopes, recently arrived fossils, the composition of air.

Even in later years, when he was physically limited, Banks retained the spirit of discovery and adventure that had attended him on his voyage with Cook. He gamely volunteered to participate in an experiment on heat organized by Charles Blagden, a Royal Society fellow. Blagden heated a room to 260 degrees on the thermometer and Banks was the first person to enter it. In the official account of this experiment in the *Philosophical Transactions,* it is stated that Banks was the only person in the experiment "who

sweated profusely." For the last fourteen years of his life, Banks, like Macie's father, was completely incapacitated by gout and had to get around in a wheelchair.

For more than forty years Banks exerted enormous influence over scientists traveling the globe. His help was invaluable to many men—including James Macie eventually—during periods of war and civil strife when government intervention was needed to extricate scientists in foreign lands. His help came in the form of not only influence and money but also the most mundane matters. He once gave William Herschel an extremely large pair of shoes to wear when the astronomer was obliged to don seven layers of socks while stargazing on an extremely frosty night.

FROM HIS YOUTH, James Macie positioned himself as a serious scientist with his scrupulous laboratory methods and sometimes arcane choice of subjects, which included examinations of crystals and obscure minerals. Banks, Cavendish, and others noticed Macie's meticulousness and attention to emerging laboratory protocol, and they regarded him as a serious and promising member of the next generation of scientists. An infinite patience for studying tiny particles—without computers or even microscope technology as we know it—marked Macie's lab style for life. He combined the dainty hand and keen eye of an embroiderer with the exacting thoroughness of a modern-day scientist, while limited by the most primitive tools. His Pembroke peer and lifelong friend Davies Gilbert, who eventually became president of the Royal Society, said Macie, in his sensitivity to detail, rivaled the great chemist William Wollaston, a contemporary of Macie's who formulated a table of relative particle weights. Supposedly, Wollaston's "hearing was so fine he might have been thought to be blind, and his sight so piercing he might have been supposed to be deaf."

Wollaston once made a galvanic battery in a thimble and a platinum wire finer than a hair using just his hands and the rudimentary tools of the day.

Probably the most remarkable aspect of Macie's work by the standards of today's mineralogists and chemists was his ability to obtain fairly accurate results using such crude tools. He obsessively broke down minerals and sometimes organic material into their elemental essences using a blowpipe, acids, water, and tiny weights, repeated his tests hundreds of times, and then meticulously cataloged the result. This small work was laborious and taxing on the eyes, but it could also be dangerous. Chemists at the time, some of whom he knew, lost fingers, eyes, and sometimes their lives. One of his later experiments involved fluorine gas, a substance so caustic it can etch glass. Like all of his contemporaries, Macie would have collected it in a crude leather bag.

Much of his work was arcane or at least of interest only to other mineralogists, but he was not averse to addressing more practical questions. At the dawn of the Industrial Revolution, not everyone agreed that scientists should serve industry and, therefore, the common man. Some of Macie's contemporaries—James Watt, most notably, who had invented the steam engine, as well as Josiah Wedgwood—were much more concerned with practical uses for science than was deemed proper within the Royal Society at the time. These men represented a utilitarian trend that would break away completely from the ideal of the gentleman-scientist. Macie seems to have sought a middle ground. In a paper he published on improved lamp wicks, he wrote, "It is to be regretted that those who cultivate science, frequently withhold improvements in the apparatus and processes, from which they themselves derive advantage. When the sole view is to further a pursuit of whose importance to mankind a conviction exists, all that can be so should be imparted, however small may appear the merit which attaches to it."

When Macie's scientific interest was directed at the purely scientific he had a powerful focus. Attention to facts, particles, minutiae, the experiment redone hundreds of times, was a fundamental aspect of his personality, and one that he defended. "There may be persons, who, measuring the importance of the subject by the magnitude of the objects, will cast a supercilious look on this discussion," he wrote in a paper on blowpipe analysis of minerals. "But the particle and the planet are subject to the same laws, and what is learned upon the one will be known of the other."

All of his skills—persistence, attention to detail, and patience for repetitive testing—were on display in the first paper he presented to the Royal Society, which addressed the issue of whether inorganic materials could become organic and vice versa. The paper, titled "An Account of Some Chemical Experiments on Tabasheer," reported on experiments he made on a substance sometimes found inside bamboo plants. Tabasheer are rocklike nodules that form inside bamboo and rattle when shaken. They were used for medicinal purposes, but no one knew what they were made of or how the stony bits got inside the bamboo plant. Using the rudimentary lab tools available to him—a blowpipe made of a covered tobacco pipe, tiny coals for fire, small brass weights—and the tiny bits of tabasheer available to him, not exceeding half a cubic inch, Macie conducted 250 different experiments, including chewing the substance to find that it had "a disagreeable earthy taste." He repeated his tests because he was fully aware of the fallibility of his primitive equipment. He determined that the tabasheer nodules were composed of silica, the mineral of which sand is formed, and some organic material.

The experiment had a subtle significance because it addressed in a small way the greatest geological question of the time. Geologists were divided over whether rocks arrived where they were by force of water (the so-called Neptunian theory, which would back up the

biblical Noachian story) or whether rocks somehow came from below the earth's crust in a molten state and then cooled (the Plutonist theory). Macie's experiment showed that an inorganic substance, silica, could move within the bamboo tissue. If it could do that, then it could move through the earth's crust.

The tabasheer paper was the first of twenty-three Macie published during his lifetime. The subjects he chose to cover range from the abstract and highly specialized—"On a Native Compound of Sulphuret of Lead and Arsenic," for example—to the useful, including articles on improving balances, lamp wicks, and brewing better coffee, and finally to the whimsical, such as why flowers are red or purple and how to preserve paint in miniature portraits.

JAMES MACIE WAS extremely active in the Royal Society during his first two years as a member, and he barely missed a Thursday-night meeting. For him, being a fellow was not just another ego-gratifying honor or club membership with which to amuse oneself on an occasional Thursday night, as it probably had been for his father and was for many of the other fellows. The society gave Macie a social life and a professional standing that he might not have had otherwise, as a single and unattached young man in London without conventional prospects. The club also gave him an array of older men to attach himself to, a kind of extended family, beyond his mother, who was still living in London, and his younger brother.

Macie's life in his early twenties was already on a trajectory that differed greatly from the lives of his younger brother, Henry Dickinson, and his older, unacknowledged half brothers Hugh and Algernon Percy, or for that matter, most men of his class and age. Somewhere along the way, Macie stepped out of the stream of life,

and he stayed out of it. In his social reticence and single-minded devotion to science, he most closely resembled his two half sisters, Dorothy and Philadelphia Percy, the cloistered, Paris-educated spinsters. While Macie devoted himself to a solitary life and wrote of knowledge as though it were a spiritual calling, his brother, Henry, joined the British military and spent twenty years traveling the globe, fighting in wars, and taking a mistress by whom he had an illegitimate son. At the same age, Hugh Percy, the eldest half brother, had sowed his wild oats with Casanova, then later settled down as the second duke in comfortable splendor with a wife, children, and varied business interests.

At an age when his peers were preparing for professional posts, wives, and families, young Macie immersed himself in the pursuit of knowledge to the exclusion of family life. This is not to say he was friendless. Among his frequent companions were the scientist Christopher Pegge, who would become Reader in Anatomy after William Thomson's departure from Oxford; George Shaw, an Oxford doctor of physic; and the collector and writer William B. Coxe. He also brought with him foreign guests, indicating his early interaction with the international scientific community. One frequent guest of Macie's was the Finnish chemist and mineralogist Johan Gadolin, who in 1788 published a paper attempting to test Lavoisier's antiphlogiston theory and who would go on to discover the element yttrium—color television's red phosphors.

The Royal Society meetings provided James Macie with a social life and a setting where—unlike in some of the other London men's clubs—his pedigree mattered less than his mind. But on one Thursday night in late June 1787, barely two months after his own election to the society, James Macie walked into the Crown and Anchor and found himself face-to-face with the unfair hand fate had dealt him. He had brought two guests that night, Christopher Pegge and Adolphus Seymour, the future Duke of Somerset. Adolphus was

ten years younger than Macie, still a student at Eton, but destined to one day become a prominent member of the Royal Society himself. Macie was distantly related to the young man, through his mother, as a descendant of the Seymours.

Flanked by these two men, Macie had a human protection zone around his slight frame as the fellows toasted the presence of a very honored personage, His Grace Hugh Percy, second Duke of Northumberland. The duke's appearance at the Royal Society was his first since his father's death. Even though he was not as showy as his father, the duke's revered and robust body brushing past his slight, unacknowledged half brother must have stung the younger man to the quick, because Macie's true parentage was common knowledge and Macie clearly believed that he too was entitled to a coat of arms. The difference between their destinies would have been on full display that night. One man, the favored legitimate son, beneficiary of everything the English class system offered to firstborn males, including wife, family, political and financial power, lavish dwellings, and the respect of peers. The other, lonely and solitary by habit and by accident of birth, rootless, nobody's child, setting out on a peripatetic life lived in rented furnished apartments across Europe.

By this point, Hugh Percy was in the full power of middle age and revered both as a rich nobleman and as a war hero. More than a decade prior, in 1775, he had been honored for his conduct in leading British troops—without ammunition—in a retreat from Concord over thirty miles in ten hours, with American rebels shooting at them fully half the way. He did not wholeheartedly support the king's policy toward the Americans, although he served without reluctance and refused offers by his father to pull strings to have him extricated when the war was turning against the British. Percy was very popular with his own regiment partly due to his generosity. He sent home at his own expense the widows of men in his regiment killed at Bunker Hill.

One British analyst at the time believed Lord Percy "appreciated better than any other Englishman the temper and ability of the Americans." Percy's initial impressions of the Americans and their land were mixed. In letters to his father, he complained of the extremes of the climate. But he was also impressed. "I assure you it requires a far abler pen than mine to describe its different beauties," he wrote his father in August 1774, trying to describe the terrain around Boston. "It is . . . delightfully varied. In short, it has everywhere the appearance of a Park finely laid out. Mr. Browne [landscape architect Capability Brown, whose talents had been employed at Alnwick] he w[oul]d be useless."

He saved his most pointed private criticisms for the American people themselves, perhaps understandable from a man leading dwindling regiments through rebel fusillades in Massachusetts and New York. He wrote his father in the summer of 1774 that the Americans at Boston were "a set of sly, artful, hypocritical rascalls, cruel & cowards. . . . The people in this part of the country are in general made up of rashness & timidity. Quick and violent in their determinations, they are fearful in the execution of them (unless indeed they are quite certain of meeting little or no opposition & then like all other cowards they are cruel and tyrannical). To hear them talk you would imagine that they would attack and demolish us every night & yet when we appear they are frightened out of their wits." Percy made friends among the Americans, though, and his portrait still hangs at Boston Town Hall, alone among the British leaders to be so honored. He sustained a lifelong friendship with a leader of the Mohawk tribe, Joseph Brant, whose portrait still hangs at Alnwick.

Percy returned to England before the end of the war, remarried, and settled into a life similar to his father's, combining politics and business. He differed from his parents in one crucial way. Walpole described him as "totally devoid of ostentation, most simple and retiring in his habits." As a child, he supposedly had a weak

constitution, and later in life he suffered from severe gout, like his father. A painting of him in adolescence with his tutor bears a striking resemblance to a painting of James Macie at a similar age. As a young man, he was rather wild and entertained Casanova at Alnwick, allegedly sharing some of his women as well.

As duke, and living in the Northumberland estates in London and Alnwick, Percy was known for his generosity. He financially aided his favorite artists and actors, most famously giving £10,000 to the actor Roger Kemble after Covent Garden Theatre burned down. His tenant farmers in Northumberland erected a tower to him after he lowered their rents 25 percent during the Napoleonic Wars, but the tower became known as "the farmer's folly" when Percy, by now the second duke, refused to allow some farmers to renew their leases.

As an aristocrat, the second duke was sworn in as a Royal Society member with automatic entrée to the club. After that, he is never mentioned in the existing records of the society and he seems to have had little inclination for science. One of his sons, Algernon Percy, who became the fourth Duke of Northumberland, did develop a strong interest in the sciences. He eventually traveled with the astronomer William Herschel's son to view the southern constellations and became one of the first British explorers of Egyptian antiquities, undertaking an expedition in 1826, near the end of Macie's life.

The tradition of giving memberships to aristocratic amateurs, like the Dukes of Northumberland, would soon become a bone of contention at the Royal Society. As the sciences became more professional, some of the practicing scientists began to resent the presence of the dilettante nobility in their club. Eventually, by the 1820s, the dabbling aristocrats no longer formed a core of the Royal Society.

But in the 1780s pedigree alone still bought a fellowship at the

Royal Society. Macie sat on the benches, supported by his two seconds, as it were, while His Grace swept into the room and was greeted with the fawning respect typically given to nobility. The second duke then settled himself in to listen to the evening's presentation with as little ostentation as possible. That evening, Charles Blagden offered a proposal for recovering the legibility of decayed writings by a chemical investigation into the composition of ancient inks found in some Greek documents. Mr. John Hunter read a paper on the structure and economy of whales.

A year later, on January 17, 1788, Macie brought his younger brother, Henry Dickinson, to the Royal Society. The brothers heard a talk by Dr. Maxwell Garthshore, an expert in female reproductive organs, on some extrauterine pregnancies and ruptures of the ovarian tube. There was an account of a method to prepare a seed of the cedar of Lebanon for planting and a description of an apparatus to show the permeability of glass to the "electrical effluvia."

Dickinson was sixteen and about to sign up with the Horse Guards in Northumberland. He would spend the next twenty years of his life serving the British Crown in distant parts of the world, including India and Persia. The brothers would be separated for long periods, but they remained close enough that two decades later Dickinson made Macie his executor.

WHEN HENRY DICKINSON set off on his life of military adventures, his more intellectual older brother did not stay put in England but embarked on a ten-year scientific Grand Tour of the Continent. Although Macie returned to England periodically during his life, he never stayed as long as he had in the years leading up to his maturity. James Macie, an Englishman born in France, fluent in French and capable of reading and writing Italian and German too (some of his letters include several languages on the same

page), was cosmopolitan from birth. Culturally half-English and half-French and considered nobody's child in England, Macie found his true nationality in the European community of scientists.

The "Republic of Letters" was an eighteenth-century notion involving the network of scientists and scholars on the Continent and in England whose interests, studies, and abilities transcended national boundaries. It was Macie's true home, one without distinctions of birth, inheritance, name, or nationality. Men were citizens by virtue of pure thought, rational discussion, empirical experiments, and carefully annotated results. Parentage and pedigrees meant less than quality of mind. The Royal Society, while very English, was part of this international network, and during his long term as president, Joseph Banks was a major figure in it. He was solicited by scientific societies all over Europe, and by his death in 1820 he belonged to no fewer than fifty foreign academies. Extremely eminent foreign scientists were also voted into the Royal Society as members, putting Macie in the intellectual company of men like the French chemist Antoine Lavoisier. Membership in the Royal Society was the equivalent of holding citizenship papers in an international nation.

The men of this Republic of Letters considered themselves above politics and not bound by arbitrary national boundaries, but they were never immune to war or national crises. By 1788 rumblings of unrest were shaking France. That year, the French *parlements,* or law courts, were suspended by the government in an effort to end resistance to taxes needed to avert national bankruptcy. French nobles were incensed and retaliated by organizing popular revolts. The French scientific community continued to break new ground in chemistry, astronomy, mathematics, and zoology in spite of a growing movement that would forever alter France, toppling scientists and nobles alike.

In England, at the same time, a very different kind of political

trauma was under way. In October 1788 King George III's "flying gout"—as the doctors who treated him called it—reached his brain. He had been suffering from bouts of mysterious sickness for years, but this time the sickness settled in his head. The king was mad and had to be confined to his palace at Kew. The best of British doctors, including esteemed members of the Royal Society, could only speculate on the real cause of his condition, which moderns believe to have been a hereditary blood disorder called porphyria. Accounts of desperate treatment efforts reached the Royal Society, where the men of science were keen to hear the details. The king's health was a subject of much gossip at the Thursday-night meetings during that winter.

At Kew, the king endured great agonies. None of the medical treatments commonly prescribed at the time—emetics, purgatives, and bloodletting—had the slightest effect. After one particularly powerful emetic, tartar of antimony, was given to him without his prior knowledge, making him violently sick, the poor king knelt on his chair and "prayed that God would be pleased to either restore him to his senses or permit that he might die directly." The doctors finally tried opium pills and straitjackets, and these, combined with time, eventually did bring some relief.

Throughout the fall and winter of 1788 and 1789, the king's insanity roiled English politics, in the so-called Regency Crisis. To appoint the lazy Prince of Wales regent or not was the burning question in Parliament. The parties divided into two: those who supported the king, even mad, and those who wanted the prince in power.

The Regency bill was prepared and waiting for its final reading in February when William Pitt, the twenty-nine-year-old prime minister, halted the process. On February 26 a bulletin had arrived with news of an entire cessation of His Majesty's illness. King George III was restored to full health in March 1789, just in time to

be fully cognizant of the drastic events under way across the Channel. When he came to his senses, he learned what the rest of England had been aware of for more than a year by reading alarming missives from France, such as the one that follows, written in September 1788 by John Charles Villiers, the Earl of Clarendon. To the British aristocracy, it seemed the French people had gone mad:

> Every rank is dissatisfied, they despise their king, they detest their queen; the public walks are now filled in every corner with sets of politicians and every one seems eager to have some share of the business. In private companies the chief topic is now politics. . . . That fear which once tied their tongues, and that reverence which restrained their thoughts, is now no more. And where they are not afraid of spies, they can condemn their government, and abuse their King, with as much freedom and little ceremony as Englishmen, though with fifty times the reason.

Just four months after the English king had recovered from his illness, Parisians stormed the Bastille and the French Revolution commenced. For James Macie, the events across the Channel had an allure felt by many young Englishmen and -women, especially by those who felt disadvantaged in some way by the British system. Macie was still in his twenties, and his politics leaned toward the democratic; the new French ideology looked brave and hopeful. As William Wordsworth wrote in "The Prelude," a poem about the French Revolution, "Bliss was it in that dawn to be alive, / But to be young was very heaven!"

James Macie was young. And he was soon on his way to witness the great upheaval personally.

5

—

DISCOVERIES AND

REVOLUTIONS

O N NEW YEAR'S DAY, 1792, James Macie was back in
Paris. The young mineralogist was one of a dwindling
number of English travelers still in France. Six months earlier,
Louis XVI and Marie-Antoinette and their children had been
arrested trying to escape France, and the royal family were now
prisoners at the Tuileries. The Revolution was inching toward a
bloody showdown with the monarchy and all of Europe was ner-
vously watching. Sitting at his desk in a room at the Hôtel du Parc
Royal on the Left Bank, Macie had a front-row seat. He paused as
he wrote a long letter to Charles Fulke Greville, a dilettante collec-
tor and one of his Royal Society mentors back in London. Laying
aside his quill, Macie looked outside. It was an unusually warm
winter day. His windows were open and a fly had been walking on
the paper as he wrote, making tiny tracks in the still-wet ink.
Nearby were the mossy stone walls of the remains of the Abbey of
Saint-Germain-des-Prés. In the preceding few years, the great

medieval Benedictine abbey had been looted and burned, then claimed as government property. Even the ancient graves of the Merovingians on the grounds had been vandalized. All that remained intact was a bell tower and the old street names commemorating a different era. The rue Colombier, where Macie was lodged, was named after the dovecote the monks had kept on the edge of their property for centuries (*colombier* means pigeon house in French). The tame cooing birds were long gone, and any clerics who hadn't signed an oath of civil allegiance by 1792 were considered conspirators against the Revolution.

In the months before his arrival in Paris, Macie had been sickly. He had even lost his hearing for a while. His trip to the Continent was motivated by a desire not only to begin a scientific Grand Tour but also to reach the health-restoring warmth of the south of France, a region Macie aimed for throughout his life whenever he was feeling frail. On this trip, he was happily surprised to find that the Parisian climate, food, and revolutionary spirit were already reviving him. He wrote to Greville that the mild winter weather had so improved his health, and the whole city was at that moment so pleasant, that he had altered his plans to go south and decided to remain in the capital for the rest of the winter.

The young scientist was delighted to be in Paris, thrilled by the Revolution and not at all unhappy about the dismal fate of the royals or the religious orders, which at this point in his life he was referring to as "corrupt institutions." In 1792 Macie was still young enough to feel in his blood the wild, optimistic sentiment surging through the streets of revolutionary Paris. In the multitude of cafés, every minute another orator was mounting a chair to talk himself hoarse about liberty, brotherhood, and equality, or just to report the latest doings of the National Assembly. Whenever he stepped into the streets and boulevards, Macie passed men and women—all *citoyens et citoyennes* now—beaming with a new sense of power and freedom.

For the moment, Macie was enjoying the French Revolution. He was even hoping the French example might spread all over Europe. His rosy view of the French experiment would change as the Revolution turned into the Terror and finally devolved into Napoleon's wars of expansion, but in 1792 he was still thrilled at the demise of kings and Catholic priests alike. Two decades later, he insisted on recognition of his own noble bloodlines and eventually became a regular churchgoer—albeit Anglican, not Catholic.

Writing to Greville on New Year's Day, 1792, he called kings in general a "contemptible incumbrance [sic]." He compared the Revolution to the volcano he hoped to visit in southern Italy on the next leg of his tour. "I should like much to see the lava which is at present running from Vesuvius: however I console myself in some degree for the loss of that sight by the consideration that I am here on the brink of the crater of a great volcano, from whence lavas are daily issuing," he wrote. Vesuvius "is laying waste one of the finest countries in the world; is threatening with ruin the noblest efforts of human art; while this [the revolution], on the contrary, is consolidating the throne of justice and reason; pours its destruction only on erroneous or corrupt institutions; overthrowing not fine statues and ampitheatres but monks and convents."

He even anticipated that the French social cataclysm would spread across the Continent. "I do not see what can conquer and restore to ignorance 15 million people," he wrote. "This country will compel great changes in every part of the globe. . . . If only every other European nation should agree to cast away every arm but its shield; To diffuse light through every order of the people: If the millions of money, and the thousands of individuals which are at present sacrificed to war, should be applied to the promotion of science and arts, what may we not expect in our time!"

The Revolution had a personal significance for James Macie, nobody's child. As Tom Paine wrote in 1791 in *The Rights of Man:*

"Aristocracy never has more than one child. The rest are begotten to be devoured. . . . To restore, therefore, parents to their children—relations to each other, and man to society—and to exterminate the monster Aristocracy, root and branch—the French Constitution has destroyed the law of primogenitureship." That law in England, of course, had left Macie fatherless, nameless, and without any estate but what his mother could accumulate for herself.

THE REVOLUTION had not yet wreaked much visible destruction on the elegant city. On first approach, Paris in the years just after the fall of the Bastille in 1789, but before the massacres began in late 1792, looked just as it had when James Macie lived there as a boy. An infinite number of avenues still led into Paris from all directions, like the radii of a circle. From a distance, one could see Montmartre, a hill still covered with windmills. Within the newly finished city walls—meant to ensure royal taxation of all incoming goods and therefore deeply hated—coaches of all shapes rumbled along without springs and men, children, and ladies with rouged cheeks dove out of their way.

Commerce continued. Bread was baked and sold. Buildings remained standing and people crowded the cafés. On the quai de la Mégisserie, not far from Macie's rented rooms, the market for potted plants and flowers and nosegays was still open. Twice a week, early in the morning, the street was abundant with exotics like double-flowering pomegranate, Madagascar periwinkle, and tuberoses, and the fragrance of huge piles of sweet basil, much used in cooking, wafted far and wide.

One had to look closely to notice that the coats of arms that had once decorated the gates of hotels were gone, and even official and unofficial seals were engraved with cyphers only. Gone were the

"royal" tobacco or salt shops. The French people themselves were more altered than their city. The nobility had mostly left Paris and those who remained kept servants but didn't dare dress them in liveries. Extravagant French fashion—for years the butt of ridicule and yet a point of envy and comparison for the British—was cast off. Most Frenchmen had stopped wearing huge, ornate wigs that had become the national caricature and cut off their curls to sport powderless cropped locks like those of English farmers. Others wore little black scratch wigs, and both styles were called *têtes à la Romaine*. Soft red Phrygian caps, styled after headgear favored by freed Roman slaves, were in vogue. Women had exchanged the heavy, embroidered tapestries and yards of silk of the last decades and now favored loose white linen and muslin gowns without any stays. Tight lacing was a thing of the past, as were high and narrow-heeled shoes.

Of course, some French were still parading around exactly as the British caricatured them, wearing the national cockades, immense muffs, and copper buckles, but there was a new energy running through every person and in every street. The British political writer William Augustus Miles, living in Paris at the time, noted that fashion had become secondary to politics. "The inhabitants of Paris are so changed," he wrote. "That attention to dress which once characterized natives of this country and forbade a Frenchman to appear at dinner except in full dress, or with a sword, prevails no more. There is little doubt that the succeeding generation will be relieved from all that frivolity which marked their ancestors. The Palais-Royal, the Tuileries, the bridges and all the public places are inundated with news vendors and politicians, all ranks of men begin to reason on the principles of government."

JAMES MACIE and other Englishmen still in Paris in 1792 were not yet in danger, as they would be by the end of the year. They could still dine at La Taverne de Londres, which served up beef-steak, plum pudding, Cheshire cheese, porter, and punch just as at home. In the evenings, if the weather permitted, Macie could stroll out and see Parisian belles and beaux promenading around the Palais-Royal, walking their beloved guinea pig–sized Maltese "lion dogs" and inspecting the tiny white mice, canaries, and doves for sale in cages. In many ways, Paris offered the same scene that had so delighted the Duchess of Northumberland twenty years before. It was still possible to hear an orchestral performance or go to the theater. But on the stage, actors performed in new plays like *La Liberté Conquise*, a simple representation of the taking of the Bastille, and the orchestra would invariably play the revolutionary song *"Ça Ira,"* while the audience beat time clapping.

Even at this late date, just a year before Louis XVI was beheaded, the public could still watch Marie-Antoinette and her entourage going to mass or walking through the Tuileries gardens. The royals looked as fine as ever, in their quasi imprisonment, but with a subtle difference that the poet Samuel Rogers, watching them move through rooms at the Louvre, noticed. "The King came first with a good humour and unmeaning face, afterwards the Queen, bowing courteously to all about her, with the dauphin. She had a beautiful profile but her eyes are heavy." Another Englishman, visiting in the fall of 1791, noticed fewer "meetings and mobs" in Paris, but also fewer carriages and fine people about. "The fact is," one British visitor wrote, "all the nobility have left the country."

The beau monde social scene in Paris had been gone for some time. As early as 1790, William Wellesley Pole, the Earl of Morn-ington, visited Paris and noted that "the *aristocrates*" were "melancholy and miserable to the last" and leaving the city in droves.

"The number of deserted houses is immense, and if it were not for the deputies, the ambassadors and some refugees from Brussels, there would be scarcely a gentleman's coach to be seen in the streets."

Macie considered himself a member of the British aristocracy, even if the aristocracy didn't agree. Living in Paris in 1792, Macie belonged to a world lost as well as to a new one being born. The flavor of ancien régime France can be summed up in a charming little childhood anecdote recalled by a French noblewoman, Madame de Genlis. She and her sisters-in-law liked to disguise themselves as peasant girls and drive around the countryside collecting all the milk they could from the farms on their estate. They then carried it home on the backs of donkeys and dumped it into the château's four-person bathtub, where they whiled away afternoons lolling in milk and rose petals.

The writer Madame de Staël, daughter of the onetime French treasurer Jacques Necker, was born in 1766, making her an almost exact contemporary of James Macie's. Her life spanned pre- and postrevolutionary France, and she never lost her ancien régime customs. Voluptuous and large-boned, she shared a habit with many women of her generation of receiving morning callers in bed or while being dressed, with only a token tribute—a lace handkerchief pressed over an ample bosom—to modesty. A Swedish diplomat who called on her one morning was invited in to talk with her during her toilette. He found her in the process of having her hair powdered by one chambermaid, as her hands were manicured by another, and she raised one leg to be taken care of by a third; the only way she was able to acknowledge his presence was by an infinitesimal nod of the head. Madame de Staël kept to this custom through the rest of her life, receiving visitors half-dressed in bed and hiding little of what they might see, scandalizing the younger generation.

Madame de Staël, while not opposed to the ideals of the Revolution, lamented what was being swept away. In pre-Revolutionary France, she wrote, "words are not merely, as they say in other countries, a means to communicate ideas, feelings and needs, but an instrument one likes to play and which revives the spirit, just as does music in some nations, and strong liquors in others. It is a certain way in which people act upon one another, a quick give-and-take of pleasure."

This witty, whimsical world had its flip side, of course. The French monarchy had been in crisis for years and was technically bankrupt long before the fall of the Bastille. In the years just before the Revolution, Gouverneur Morris, an American politician, visited Paris and described the frivolity of the beau monde: "They know a Wit by his Snuff Box, a Man of Taste by his Bow and a Statesman by the Cut of his Coat." British visitors to France were routinely horrified at the way aristocratic folly could coexist alongside the extreme destitution of the poor and the brutal public punishment of minor criminals involving cages, thumbscrews, water pipes, and something called the crushing boot.

Macie did not regret the passing of some of the more frivolous or brutal aspects of ancien régime life. There is no indication that he enjoyed drawing room society—though he did indulge a middle-aged passion for gambling. Nor was he a great conversationalist, although he could hold his own and his youthful personality had a degree of energy that impressed his older scientific colleagues. Richard Kirwan, whom Macie met early on, never lost his high expectations for the young man. A decade after he sponsored Macie for Royal Society membership, the Irish geologist wrote to Joseph Banks, "From Mr. Macie I still expect much; how can a person of his Ardour be idle?"

As THE WEATHER warmed up, the king's position grew more tenuous. In April 1792 he was forced to agree to a declaration of war against Austria, an empire led by his wife's brother. A few weeks after this event, in early May, James Macie wrote another letter back to London. He was still in Paris and growing ever more enthusiastic about the French cause. Writing to his Oxford friend and fellow scientist Davies Gilbert in Cornwall, he could barely contain himself. "Well! Things are going on!" he wrote, after first chiding his friend for forgetting to procure some crystals he'd requested. " 'Ça Ira,' is growing as the song of England, of Europe, as well as of France. . . . Stupidity and guilt have had their long reign, and it begins, indeed, to be time for justice and common sense to have their turn."

By May the French were just a few short months away from the final overthrow of the monarchy, accomplished on August 10 with the massacre of the king's Swiss Guards. This was followed a few weeks later by the September prison massacres in Paris, an appalling episode of gore during which hundreds of helpless imprisoned religious people were butchered with knives, axes, and hatchets. Macie was probably out of Paris in August, but by May he was surely sensible to the rising animosity against the monks, nuns, and priests who had ruled over daily French life for so long. At this point in his life he had no sympathy for them. "You have understood, I hope, that the Church is now here quite unacknowledged by the state, and is indeed allowed to exist only till they have leisure to give it the final death-stroke," he wrote to Gilbert.

British travelers like Macie felt the profound shift in Parisian society whenever they set foot outside their hotels. Dr. John Moore, a British physician, visited Paris later in 1792 and was shocked at a typical encounter with what he described as a "genteel man" outside Paris. "They talk, said I, of dethroning the King. '*Tant*

pis pour lui,' said the man. *'Mais cela ne vous regarde pas.'* To hear a Frenchman talk with so much indifference of dethroning a king was what I did not expect. I remember the time when the most dreadful convulsion of nature would have been considered in France of less importance and would have occasioned less alarm."

The great leveling under way shocked, horrified, or cheered the English depending on their age, sex, class, and politics. Some English were enthusiastic while others were appalled and predicting doom. Edmund Burke, who did not visit revolutionary France, had by 1792 already written his attack on the French, *Reflections on the French Revolution.* Burke actually linked French radicalism with the new chemistry and scientific advances in general. Burke rightly thought of France as the leading scientific nation. In his *Reflections,* he linked the revolutionaries and the scientists, men he described as "these philosophers [who] consider man in their experiments no more than they do mice in an air pump, or in a recipient of mephitic gas."

There were certainly points where new science and very radical social thought coincided, and one of these was in the person of British chemist and Royal Society member Joseph Priestley, a man Macie would have encountered. Priestley was ecstatic in 1789 after the fall of the Bastille. "There is indeed a glorious prospect for mankind before us," he wrote. Priestley made explicit the link between science, progress, and the demise of the nobility in his writings. "The English hierarchy . . . has . . . reason to tremble even at an air pump or an electrical machine," he wrote once. Priestley's radicalism, while so popular in France that he was made a member of the National Assembly, provoked a conservative backlash in England, and his Manchester laboratory was destroyed by a monarchist mob. Eventually he emigrated to America.

———

JAMES MACIE HAD other reasons besides the Revolution to be happy in Paris that spring. As a scientist *and* an Englishman, Macie occupied a respected place in French society. The scientific community in Paris in the years preceding the Revolution had been the most intellectually vigorous in Europe. Macie arrived carrying letters of introduction from Joseph Banks and other British scientists, and he met and socialized with the most eminent French scientists. As in London, in Paris there was a community of men organized into an official group, the Académie des Sciences, or Institut des Sciences after the Revolution.

Even without possessing any drawing-room flair, Macie felt the respect of the French. The French had been wildly infatuated with anything scientific for years, from the rigorous to the ridiculous. With his growing mineral collection, traveling laboratory, and exacting but unobtrusive style, Macie enjoyed automatic status not only in the Paris scientific community but also in general society, something that was not always true in London.

Science had been in vogue in France ever since Ben Franklin came to Paris in 1776. The so-called Electrical Ambassador was mobbed wherever he went, and became better known by sight than the king himself. The Franklin mania was a political, social, and commercial phenomenon. As a representative of the American Revolution, he was hailed as a hero. French people snapped up objects with his likeness in engraved glass, painted porcelain, cottons, snuffboxes, and inkwells. There was even a Sevres chamber pot with his face on the bottom. The American was bemused, and in June 1779 he wrote to his daughter that he was "I-doll-ized" in France because of the number of dolls bearing his face.

Franklin died in America in 1790. In the years between his stay in France and the Revolution, the French science fad didn't diminish. The daily *Journal de Paris* was filled with reports of experiments from the provinces as well as the capital, and advertisements for

public lectures on topics from electricity to mesmerism to the latest chemical combustion. In December 1783 a writer lamented the way science had superseded art and literature in polite society. "In all of our gatherings, at all our suppers, at the toilettes of our lovely women, as in our academic lyceums, we talk of nothing but experiments, atmospheric air, inflammable gas, flying chariots, journeys in the air."

The greatest obsession of all had to do with the miraculous feat of man's conquest of gravity in the hot-air balloon. These flying machines were invented in France in 1783 and tested in various parts of Europe, often above the craned necks and slack jaws of hundreds of thousands of spectators. The greatest of the French balloonist-scientists was a young doctor, Pilatre de Rozier, one of many scientists or pseudoscientists who gained popularity and gave afternoon lectures on scientific topics in Paris in the 1780s. He even opened a *musée des sciences* in 1781, which displayed instruments, books, and experimental equipment. Seven hundred people subscribed immediately. His first lecture was on swimming and included a demonstration of a watertight robe in which he emerged dry from a six-foot bath. Other inventions on display included a hat with a built-in light for nocturnal rescues.

De Rozier spectacularly became a "martyr to science" at the young age of twenty-eight, when he attempted to cross the English Channel from Boulogne in June 1785. His balloon exploded near the shore, surrounded by "a violet flame" described by the crowd that had gathered to see him, and he and a companion fell fifteen hundred feet, perishing on the rocks. France reacted with a universal outpouring of grief and respect. One eulogist wrote, "It is said he loved glory too much. Ah! How could one be French and not love it?"

De Rozier's death didn't end the ballooning fad. Crowds still jostled one another in fields to watch balloons rise or land, and mobs

rioted when the machines—for reasons of weather or technical problems—failed to rise. French and British nobles were eager to personally test the skies. Women apparently were more courageous than men, and one French noblewoman rose eighty feet in the air, recording the details in a journal. The Duchess of Devonshire gave a "launch party" in 1784. A Frenchman did cross the Channel—four months before de Rozier's tragic end. He landed in a field where he had to undress for the English peasants and let them poke him before they would be convinced he wasn't an alien. People on the ground greeted one balloon landing with shouts of "Are you men or Gods?"

The French science mania had an irrational side as well. Newton's discoveries in gravity and Franklin's in electricity earlier in the century and all the ongoing work on gases (including the discovery of oxygen) demonstrated to people that they were surrounded by powerful invisible forces. Historian Robert Darnton has written that the very invisibility of these forces—more than the possibilities for changing human life inherent in their harnessing—provoked fear, irrationality, and more superstition. The craze for empirical science coincided in France with a popular belief in an invisible fluid named for a German, Mesmer, who began treating people's maladies with what he identified as the forces of animal magnetism, or mesmerism.

Young Macie scorned these more fanciful interpretations of the invisible forces. He agreed with the great French chemist Antoine Lavoisier, who said: "It is with things that one can neither see nor feel that it is important to guard against flights of imagination."

THESE MEN WERE revered, but once the Revolution was in full force, being a scientist was not by itself a badge of revolutionary loyalty. On the contrary, some of France's greatest scientific minds

were in danger. The premier French mineralogist of the time was Abbé René-Just Haüy. Haüy was twenty-two years older than James Macie and had established himself in the area of crystallography. The son of a poor weaver, Haüy got a theological education and became a priest; he was arrested during the Revolution along with other clerics for refusing to sign the civil oath. He was extricated thanks to the efforts of fellow scientists, including a former student, zoologist Étienne Geoffroy Saint-Hilaire, who would go on to make a name for himself as a scientist on Napoleon's Egyptian campaign (among other discoveries, he brought back from Africa the first giraffe ever seen in the West). Haüy laid the foundation of the mathematical theory of crystal structure and devoted himself entirely to its application to mineralogical classification. In this regard, he and Macie crossed paths.

Haüy was aware of and praising Macie's work analyzing rhomboid crystals as early as 1791. Macie was working on some of the same problems as Haüy, at least some of the time. Haüy corresponded with many mineralogists and did no fieldwork himself, but he had assembled a massive collection with the help of others. As a cleric, he also scrupulously avoided the theologically tricky issues of mineral genesis, focusing on the shapes of the minerals and ignoring all questions about the earth's origins.

While in Paris, Macie also met with the ill-fated Antoine Lavoisier, premier European chemist of the day. The elegant, silver-haired Lavoisier was a man of genius and rigorous discipline, who had, among other breakthroughs, identified the components of water and created a chemical table of elements that is the basis of the one in use today. Macie was thrilled to be in his presence. We know they socialized from copies of calling cards the men exchanged.

In 1789 Lavoisier published his *Traité élémentaire de chimie présente dans un ordre nouveau et d'après les découvertes modernes*

(Elementary treatise on chemistry presented in a new systematic order, containing all the modern discoveries). This book marked the start of chemistry as a science and is classed with Charles Darwin's *On the Origin of Species* in biology and Isaac Newton's *Principia Mathematica* in physics. In the book, Lavoisier explained why he rejected the phlogiston theory of electricity, described his oxygen theory of combustion, and for the first time presented a list of known "elements," which he defined as substances that cannot be further broken down into component parts.

Lavoisier's involvement in chemistry was only one facet of his work. A man of business as well as science, he made his greatest discoveries in his spare time. He habitually rose at six every morning, worked at science until eight, and returned to the lab again in the evening from seven to ten. During the days, he was a master of finance, a skill that ultimately led to his demise. He was a ranking member of the Farmers General, or "tax farmers," of the ancien régime. These men formed a syndicate that contracted with the king and agreed to advance the treasury money in return for the right to "farm" indirect taxes on salt, tobacco, and other minor commodities. The farmers were hated partly because they were brutally efficient. The gap between what people paid the farmers and what the treasury received was said to be very wide. The farmers were also the largest employer in France after the military, with thirty thousand workers, and of that number twenty-one thousand made up a paramilitary force that had the right to search and seize any suspicious property or household. The farmers were thought of as bloodsuckers even by moderates.

The tax farmers lived luxuriously and Lavoisier was no different. He couldn't have carried out his experiments without his expensive Paris laboratory with its beautiful instruments of brass, glass, and polished wood. He also owned a château outside the city and a house inside Paris.

Despite his lavish lifestyle, Lavoisier was an important and dedicated scientist. He spent a great deal of time studying "airs," or gases, and was especially interested in respiration, eventually postulating a combustion theory of respiration. In the process of this work, he discovered oxygen and synthesized water. For the respiration experiments he had to create or have made ingenious devices. For his experiments on animal respiration, he produced a machine of oiled silk to contain a man, with a mask for breathing joined by tubes to a system of glass vessels. Lavoisier's assistant Armand Séguin donned the silk suit to help determine the quantity of weight a human body loses by respiration.

As the Revolution gathered speed, changed face, and eventually turned on the great chemist, Lavoisier failed to recognize the danger. He daily stripped off his coat and went to work in his laboratory, apparently oblivious to the animosity toward the farmers and himself. He was working with Haüy on a universal standard of weight and mass as part of the great revolutionary French effort to create the metric system when he was arrested in 1793. Despite the efforts of fellow scientists to extricate him, after a period of imprisonment he was tried, convicted, and executed on the same day, along with all the other tax farmers, including his father-in-law. The next day, the French mathematician Joseph-Louis Lagrange said, "It took them only an instant to cut off that head, and a hundred years may not produce another like it."

JAMES MACIE WAS long gone from Paris on the day of Lavoisier's execution. Like other foreigners, Macie did not linger in the French capital as the Revolution bloodied the Paris streets. The French declaration of war on Austria sparked the conflict that would eventually—with the involvement of the French and British colonies—become worldwide and last for a decade as the

French Revolutionary and Napoleonic Wars. In August, Paris erupted in violence after a crowd stormed the Tuileries, killed the Swiss Guards, and threatened the king and queen. There were very few English left to witness the gore at this point. One of them, the British travel writer Richard Twiss, described the growing Terror. Twiss hid in his room during the massacre, then warily ventured out on the afternoon after the fighting had died down to find bridges piled with bodies of the dead, dying, and drunk.

It is unclear exactly when Macie left Paris, but he was most definitely gone by the king's execution on January 21, 1793. Few English remained in France after that and those who did were in hiding, facing prison or scrambling to get out. The regicide shocked London and provoked the British to expel the French ambassador. The two countries officially went to war. By the summer of 1793, the French Revolution had devolved into the Terror, with revolutionaries beheading suspected counterrevolutionaries by the hundreds and blood pouring off the guillotine. Beyond French borders, Europe was engulfed in war.

Instead of going home to sit out this chaos, Macie headed east on the Continent and south into Italy. He planned to spend the winter of 1793 in Naples, where another kind of eruption—one far more pertinent to Macie's work—was about to occur. The phenomenon of Mount Vesuvius had already drawn a group of notable British scientists, including Sir Joseph Banks and Sir Charles Blagden, to Naples. Vesuvius had last erupted in 1788 and it still smoked and rumbled. It would erupt again in 1794. Studying the volcano was the chief interest of the British diplomat William Hamilton—an uncle of Charles Greville's, with whom Macie was corresponding—who, with his sexy wife, Emma, had gathered in Naples a lively assortment of British scientific luminaries and social butterflies, all reveling in the southern Italian warmth. Georgiana,

Duchess of Devonshire, in exile after getting pregnant by her lover, joined them in the spring of 1793, adding sparkle to the scene. Together, these men and women dined nightly with the king and queen of Naples, threw dinner parties for fifty or more, and wandered through the orange and fig trees or took boat rides into the Naples bay. Many of them also climbed to the top of the volcano to gingerly watch smoke drifting out of the crater and collect lava samples.

Macie had requested from Greville a letter of introduction to Hamilton, and presumably he presented it. Macie was traveling in style and fit well into Hamilton's high society, at least on a material level. He was already worth £6,000—a comfortable living, thanks to his mother—and his possessions were those of a young gentleman capable of fitting into society. He had his own horse and carriage, a sixty-five-piece set of table silver, and ample clothes, including nineteen cravats.

Also living in Naples at the time was Macie's disgraced mentor, William—now Guglielmo—Thomson. Thomson was establishing himself among the Italians as a mineralogist, and his letters to the Florentine botanist Ottaviano Tozzetti indicate he kept in contact with Macie in Italy—and wished fervently to see more of the young man than he did. Throughout 1793 Thomson was waiting in Naples and writing to Tozzetti in Florence, inquiring after James Macie. In August he wrote, "Tell Mr. Macie that I am surprised he has not written me of his intentions."

In October Thomson was still looking for his young friend. "Forgive me if I inconvenience you one more time with a letter regarding Mr. Macie, because he writes me with much uncertainty about his residence in Florence. If by any chance he has left, where has he gone to and when does he think he will come here? I am surprised that neither he nor you has told me if he has met [mineralogist Giovanni] Fabbroni or not!" The next day, Thomson wrote

Tozzetti again, asking him to thank Macie for the protractor he sent him from Florence. Apparently Macie was not keeping current in his correspondence with his old friend, because Thomson complained again to Tozzetti: "Since one always waits a century for a reply from Mr. Macie, please tell me where he goes, to Rome or some other place."

Macie was passing the summer of 1793 in Florence, and he was already well on his way to being an esteemed visitor among a group of Italian scientists. Florentine science was flourishing under the sponsorship of the Duke of Tuscany, who gave financial support and made lab quarters available in the Pitti Palace. The Florentine scientists included Tozzetti, a professor of botany, who directed the duke's Ministry of Natural History. Macie also met Anton Vasalli-Eandi, inventor of an electrometer, and Fabbroni, a mineralogist with whom Macie became especially close. The Florentines introduced him by letter to other Italian mineralogists, including a Roman Catholic priest, Father Petrini, who eventually persuaded Macie to come to Rome. (For a man so avowedly opposed to the power of priests, Macie actually became quite close to several priest-mineralogists while in Italy.)

Fabbroni had more American connections than did Macie. He was a friend and correspondent of Thomas Jefferson, who had met Fabbroni when he visited Florence. The name of Jefferson's residence in Virginia, Monticello, is believed to be in honor of a town of the same name near Florence where Fabbroni discovered a new type of ore, eventually named Monticellite. Over the years, American researchers and Smithsonian operatives dispatched to Europe to learn more about their benefactor have tried in vain to locate evidence of any contact between Macie and Jefferson.

In Florence, Fabbroni and Macie exchanged information and specimens, and dined together frequently during that summer. Fabbroni kept records of his invitations from Macie and apparently

only refused one meeting because he had promised to go out with his wife instead.

Macie kept up with events and discoveries at home by reading English journals. He had a wry sense of humor about life in general. In one letter to Fabbroni, he shared this piece of news from a British journal: "I find in an English newspaper, which I read this morning, that about the middle of last month, there was a sale of some of Mr. Page's cattle; one bull, called Shakespeare, sold for 400 guineas, another, two years old, for 84 guineas, and one of 3 years sold for 70 guineas! You see whatever footing agriculture is upon at present in England, and you will not wonder that Kings have farms. Indeed at this rate, it will soon only be Kings that will be able to have them."

Macie stayed in Florence for some months, probably spent time in Naples, and then moved on to Rome, where he spent the Christmas season of 1793, only to return to Florence in 1794. From Rome, he wrote to Fabbroni—in Italian—that he was surprised to find himself liking the fabled city as well as he did. "I have derived here no small pleasure and advantage from the acquaintance of Father Petrini who is a pleasing and informed man and really possessed of a cabinet collection of specimens more extensive and complete than I should have expected in a town which, though so celebrated a capitol, is so far removed from the mineral, the commercial and I had almost said the scientific world."

THE 1790S SAW great scientific discoveries in many fields, but one landmark of the decade was the publication in 1795 by the Scottish geologist James Hutton—the same man who had so trusted young James Macie eleven years before—of a two-volume tome called *Theory of the Earth, with Proofs and Illustrations*. This book, sometimes described as the founding tome of modern

geology, laid out the principle of "uniformitarianism," the theory that the earth is gradually changing and will continue to do so infinitely. Hutton theorized that the earth was formed over a very long period by a series of catastrophic events involving water and fire—seas and volcanoes and earthquakes. The theory that both aqueous and subterranean processes had created the earth—and were still creating it—suggested an eternal creation cycle, with no evidence of a beginning or an end, and therefore no evidence of a creator's hand. Eventually this view was to prevail against the so-called Neptunists.

It would be many years before this theory of the earth's origin was generally accepted (in fact, some would still argue against it today). Macie was keenly aware of the general state of ignorance in which he operated, and as a young man he lamented it even as the unlimited possibilities for discovery energized his fieldwork and analysis. "Chemistry is yet so new a science, what we know of it bears so small a proportion to what we are ignorant of," he wrote shortly after university. "Our knowledge in every department of it is so incomplete, consisting so entirely of isolated points, thinly scattered, like lurid specks on a vast field of darkness, that no researches can be undertaken without producing some facts leading to consequences which extend beyond the boundaries of their immediate object."

After Paris and Italy, Macie spent the late 1790s on the move. Although young, he was plagued by weak health. In one letter home he asked for information about a blowpipe constructed with a bladder "as it is quite impossible to stand the fatigue of blowing with one's lungs when one has a number of specimens to [illegible] at the same time." He compiled a vast list of "receipts," or recipes, for cures for everything from coughs and bruises to venereal diseases. As a traveling man, he needed to be self-sufficient when it came to his own well-being. Even with his frailties, he remained

vigorous enough to conduct fieldwork in Italy, Germany, and alpine Switzerland throughout the next ten years. From his forays into the woods and hills, Macie not only enlarged his own collection but also gathered and sent specimens to Joseph Banks and later to the great French paleontologist Georges Cuvier.

On his tour, Macie certainly became aware—if he wasn't before—that the most important work in mineralogy was being done on the Continent by Swedish, German, and French men. The field was also crowded with gentleman collectors and amateur mineralogists. The mania for natural philosophy was especially prevalent among the upper classes. Macie's correspondent Charles Greville—not a mineralogist but a gentleman amateur— had such an extensive collection of rocks from all over the world that Macie frequently appealed to Greville to borrow samples. Even Georgiana, Duchess of Devonshire, had her own mineral cabinet.

Mineralogy was so new, and discoveries were being made at such a rapid rate, that anyone with leisure time, a pickax, and a collecting bag might reasonably expect to add to the body of knowledge about the earth's origins. Even the work of men like William Hamilton, a gentleman scientist of the old school, in studying Vesuvius added incrementally to the arguments being advanced by one side or the other. Hamilton's studies convinced him that the volcanoes themselves might have been active for at least twenty thousand years and that contrary to being freakish unnatural events, they were part of nature's regular, albeit destructive, construction process.

Macie examined volcanic material, but his analyses covered many different minerals from far-flung parts of Europe and he doesn't seem to have been working in the direction of any specific geological theory, other than breaking materials down into their smallest elements. The particle was the key to the planet, and for

him no amount of exacting analysis was too laborious. His experiments on bits of rock were not changing the field of geology, but he was well known among the chief Continental mineralogists and highly respected for his scrupulous lab methods. As early as 1791, Abbé Haüy, the great French mineralogist, mentioned Macie's work in an early study of the geometric form of some calcite. Haüy mentioned Macie again in 1793, in a letter to the paleontologist Georges Cuvier, who had begun to dabble in mineralogy and was trying to re-create some results of Macie's on the geometry of crystals. Haüy went on to quote Macie several times in his *Traité de minéralogie*, the first major book on the subject, which he published in 1801.

After several seasons in Italy, Macie packed his servant and household and moved on to Germany, where he set up a lab in rented quarters in Kassel, a city in Hesse in western Germany, near to various mountainous areas of geological interest. For the next five years, Macie conducted fieldwork from this base. Germany was home to some of the most advanced mineralogists in Europe at the time, and the greatest of them, Martin Klaproth, lived in Berlin. Macie corresponded and traded specimens with Klaproth and shared his experiments and results with him. Klaproth was preeminent in the field because of his careful laboratory methods, especially in the matter of weighing tiny amounts of material. Macie, also a skilled practitioner of blowpipe analysis, eventually developed his own set of tiny weights made of springs that could be easily transported. The men remained collegial long after Macie moved on. In 1809 Klaproth sent to Macie, who was in Paris at the time, six volumes of a book called *The Annals of Chemistry*.

The city of Kassel was experiencing a great building boom during the late eighteenth century, and new parks were being constructed within its walls to beautify the views. (The city was leveled

in a World War II bombing and no longer resembles the city in which Macie lived.) In 1779 the Museum Fridericianum had been founded, modeled on the British Museum in London, based on the large natural history collection of the Earl of Hessen-Kassel. When Macie lived in Kassel, the museum was a center for the study of mineralogy and was developing an impressive mineral collection. Macie shared his work with Karl Cäsar von Leonhard, a government official in Hesse who became the professor of mineralogy and geography at the University of Heidelberg. Von Leonhard was a prominent scholar in geology in Germany and Europe, and in 1807 started the *Taschenbuch für die gesammte Mineralogie,* one of the first journals on earth sciences in Europe.

Macie spent a great deal of time in Germany during the next ten years, doing much fieldwork in the wilderness, but he didn't have much fondness for the people. At one point, he was back in Italy and expressing a definite disdain for the German intellect. An Italian female acquaintance wrote in one letter of seeing him: "Our friend the philosopher Macie is here, on his way to Germany (he might well just be back from Germany), and he says that within 26 Million human beings he found only one who had common sense."

Macie's forays into the German wilderness were fruitful, if lonely, and he eventually analyzed numerous bits of rock picked up during this period. In May 1799 he wrote a letter to Joseph Banks from the Hotel de Pologne in Dresden, and sent it along with a vivid blue flowering plant to London with Lord Carmarthen, a fellow Continental traveler returning to England. Macie was now in his midthirties, and the letter is imbued with the young man's fervent hope of impressing the Royal Society eminence. "I sincerely wish that [the plants] may prove something new or at least something rare," he wrote. "Should they be quite unimportant I hope my total ignorance of botany will plead my excuse for troubling you

with them and that you will see in the action only the ardent desire to be of use to you, and if it has not more shown itself during my travels has been occasioned by the fear of being more troublesome than useful."

Macie concluded his letter with a brief allusion to new discoveries in his own field. "I have met during my journeys with a good many new substances which had escaped the notice of mineralogists, but will not fatigue you at present with any account of them as it is not, I know, the part of natural history to which you are partial." He signed the letter, "Yr most obdt. Servant James L. Macie."

THAT LETTER WAS one of the last he would sign as "Macie." In May 1800 Elizabeth Hungerford Keate Macie died in England, leaving the bulk of her property to her first son, James Macie. It is unclear whether Macie was in England at the time of her death, but as her executor he had to have been there for the proving of the will. He found himself now in possession of her London town house, £10,000 in cash, and properties in Wilts County, which he apparently sold and converted to stocks over the years. He was also entrusted with an annuity for his younger brother, Henry Dickinson. With the £3,000 from Dorothy Percy and now his mother's estate, Macie was a wealthy man with acknowledged ties to the aristocracy. But he was still not an accepted member of the nobility, certainly not entitled to the coat of arms he'd coveted since university.

Mrs. Macie's death profoundly changed her eldest son's life. The mother and son were close, as she chose him and not his younger brother to execute her will and inherit the bulk of her estate. She also left James with something more personally altering. Besides bequeathing her firstborn son most of her estate, Mrs. Macie left

him with a request—whether in writing or in person, we do not know—that he change his name in order to publicly claim his true parentage. Macie gave her request as his official reason for taking the name of Smithson.

The first acknowledgment in the public record that James Macie was actually the duke's son had occurred six years prior, in his half sister Dorothy Percy's will, where she called Macie "my half-brother." This transpired while Macie was traveling on the Continent. But his real parentage seems to have been common knowledge for many years before that. Macie knew who his father was at least since his Pembroke days—his use of the abbreviation *"arm. fil.,"* indicated he believed he was entitled to a coat of arms. The scientist Charles Blagden had also acknowledged it in 1786, when, writing about the Staffa expedition, he noted that Massey was believed to be a son of the Duke of Northumberland.

Common knowledge of her son's status as a Smithson was not enough for Mrs. Macie. Since the duke had never publicly acknowledged his illegitimate male offspring, Mrs. Macie and her son decided to do it for him, posthumously. In February 1801, less than a year after his mother's death, James Macie died in name too. The Royal Warrant book states: "Whereas James Macie . . . hath by his petition humbly represented unto us, that his mother Elizabeth Macie . . . widow deceased, having during her lifetime, expressed her earnest desire that the petitioner and his issue should take and use the surname of Smithson, instead of that of Macie. The Petitioner is desirous of complying therewith."

On February 16, 1801, James Smithson, né Macie, "came out" at the age of thirty-five as the son of Hugh Smithson, the Yorkshire baronet, who had himself changed his own name to Percy and died the Duke of Northumberland. The world was informed of the change immediately in a notice in the *London Gazette.* Smithson

had already started using his new name as early as December 1800, when he signed himself and a guest into a Royal Society meeting as "James Smithson." Possibly, he had started using his father's name as soon as Mrs. Macie died.

The new name coincided with new status. Smithson, as he now called himself, spent the year after his mother's death in London, and perhaps the new name or his long Continental sojourn gave him a new confidence. He hadn't signed himself and a guest into a Royal Society meeting for eight years, indicating, probably, that he was away on the Continent for most of the 1790s. But on December 1, 1800, he appeared at a meeting and was elected a Royal Society Council member. The six council members were elected by secret ballot at the last meeting of each year. Smithson was elected along with his mentor Charles Greville, the diplomat-vulcanologist William Hamilton, and others. While this post was an honorable one, putting him into close contact with Joseph Banks and other British science luminaries, Smithson hardly participated. He attended only one council meeting in mid-January 1801 and never reappeared during the year. Instead of dining on beef and porter twice a month in the manly conviviality of the Crown and Anchor Tavern, James Smithson had been lured back to the adventure of Continental travel, fieldwork, and the companionship and professional discourse of his peers in mineralogy across the Channel. He made his way back to Germany, and in April 1806 he submitted one small paper to the fellows from his residence in Kassel, on a discovery in some lead mines in Westphalia of minium, a red lead used in paints and dyes. He submitted it by post, to be read in his absence at the Royal Society.

EUROPEAN SCIENTISTS and explorers at the turn of the nineteenth century carried out their experiments and expeditions

amid the chaos of a mass war on land and sea. Napoleon and his troops were engaging British and other soldiers from the edges of France to deep within what is now Italy and north into Scandinavia. Roads were often clogged with crowds of uniformed troops, horses, and carts hauling artillery. On the waterways, civilian ships were always subject to search and capture. These conditions severed or severely hampered communications and travel for people, letters, and instruments. Scientists on both sides of the Channel kept up their professional contacts and continued to share their work only with difficulty.

The problems were often logistical. Ships were diverted or captured and specimens, books, and instruments on board were lost, sometimes forever. Captain Matthew Flinders, a British explorer and a member of the Royal Society, was held captive by the French on the Indian Ocean island of Mauritius for years, after being stopped on his way back from an expedition to Australia. All the rare flora and animals on the ship were lost—a disaster that Joseph Banks had tried to prevent by writing repeated letters to individuals within the French government. Even the more simple business of disseminating new ideas, so crucial to these early experimenters, was hampered. Richard Kirwan, one of Smithson's early mentors, complained to Banks as early as 1797 that a ship carrying fourteen hundred copies of the second volume of his book on mineralogy to London had been captured by a French privateer. Undeterred, Kirwan simply ordered it reprinted in London.

Scientists crossing borders during wartime faced numerous hurdles. They had to obtain complicated bureaucratic passage documents and letters of introduction, and most of all have some contacts in high places. Being isolated in the wrong country at the wrong time, a British scientist would quickly learn that he was British first and a scientist second. Smithson himself was soon to find his Englishness a problem on the wrong side of a national border.

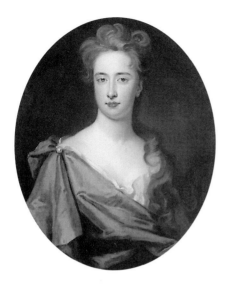

Mrs. Langdale Smithson. Hugh Smithson's mother, the former Philadelphia Revely, was a great beauty. Her son inherited her looks but shed the family's Catholicism. *Reprinted by permission of the Duke of Northumberland*

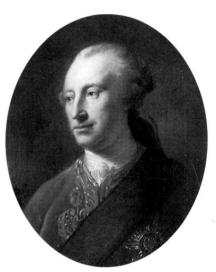

Hugh Smithson. This portrait was painted in 1764, when the duke was in his middle years and life was sweet indeed. *Reprinted by permission of the Duke of Northumberland*

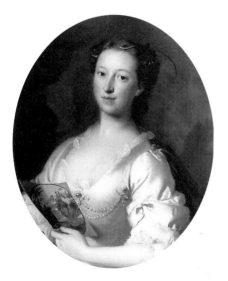

Lady Betty Smithson, as she was known in her younger days, was equal parts insufferable snob and jovial adventuress. Never a great beauty, she made up for her average looks with high personal flaunting of her pedigree. *Reprinted by permission of the Duke of Northumberland*

James Smithson and his contemporaries relied on primitive tools, made of wood, glass, leather, and brass, to get surprisingly accurate results in chemistry labs like the one pictured here. Chemists at the time lost fingers, eyes, and sometimes their lives in the lab.
Reprinted by permission of the University of Pennsylvania

Young Hugh Percy with his instructor. Hugh Percy, Smithson's elder half brother, sowed his wild oats with Casanova as a young man and endured an embarrassing public divorce before becoming a British war hero during America's Revolutionary War.
Reprinted by permission of the Duke of Northumberland

James Smithson in middle age. Smithson cut an elegant figure in the gambling dens of Paris in the early nineteenth century.
Reprinted by permission of the Smithsonian Institution

Sir Joseph Banks presided over the Royal Society during James Smithson's membership. He eventually helped free Smithson from imprisonment by Napoleon's forces.
Copyright by the Royal Society

Henry Cavendish. The patronage of the brilliant scientist-aristocrat Henry Cavendish flattered young Smithson, who regarded himself as a true, if unacknowledged, member of the British aristocracy.
Copyright by the Royal Society

H. Cavendish

THE HONOURABLE HENRY CAVENDISH.

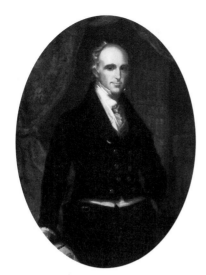

Richard Rush was one of six surviving sons of Philadelphia doctor Benjamin Rush, a framer of the Constitution. When Rush was sent to secure Smithson's money, he was considered one of the most accomplished diplomats of his generation.
Reprinted by permission of the Department of the Treasury

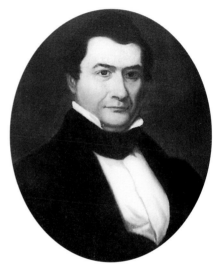

"Don" Ambrose Sevier, as Arkansas's first senator was known in his home state, was godfather of a powerful political family. John Quincy Adams believed Sevier had stolen Smithson's money.
Reprinted by permission of the Arkansas History Commission

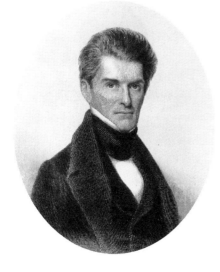

John Calhoun, the senator from South Carolina, was a slave owner adamantly opposed to any expansion of federal power, including the creation of an institution to diffuse knowledge. He argued that to accept money from an anonymous Englishman was "beneath the dignity" of the United States.
Library of Congress, Prints and Photographs Division

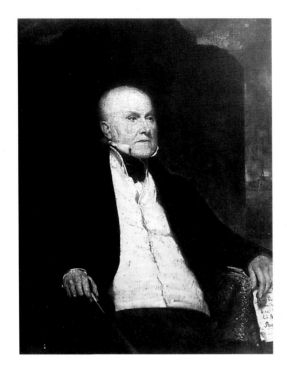

John Quincy Adams
was deeply moved by
Smithson's request that
the money be used to
increase and diffuse
knowledge among
mankind.
*Library of Congress, Prints
and Photographs Division*

The Smithsonian Castle was just ten years old when it caught fire in 1865.
The flames were visible from the Capitol.
Reprinted by permission of the Smithsonian Institution

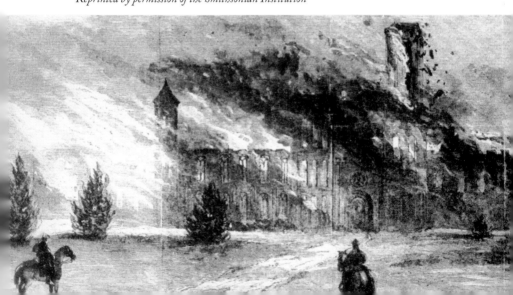

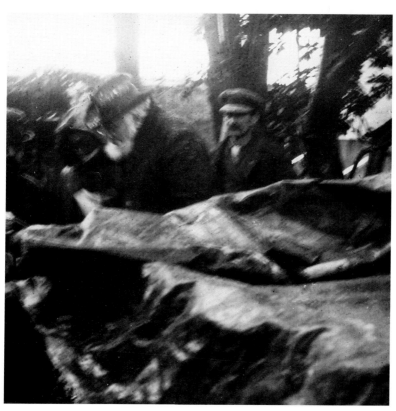

Alexander Graham Bell
inspecting Smithson's
remains.
*Library of Congress, Prints
and Photographs Division*

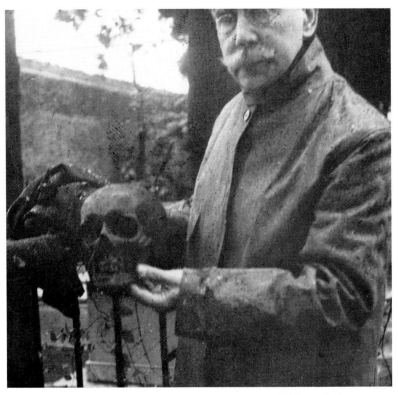

After the grave was opened, the American consul, William Bishop, held up Smithson's skull and examined it in the wintry air.
Library of Congress, Prints and Photographs Division

These difficulties did not deter the launching of expeditions, nor did they destroy the international network of scientists. Even as the governments of France and England sent ships and men to attack each other, the scientists within the two countries considered themselves a United Republic of Letters. Wars were inconveniences, not necessarily causes to be espoused, and national hostilities did not deter relationships between thinkers. "The sciences are never at war," wrote the British scientist Edward Jenner, who had perfected the smallpox vaccine, in a letter to the Institut National de France in 1803. "Peace must always preside in those bosoms whose object is the augmentation of human happiness."

The truth on the ground was a bit different. Scientists during the Napoleonic Wars sometimes enjoyed a modicum of personal immunity from their opposing governments, but usually the immunity was hard-won and involved the vigorous intervention of men like Joseph Banks, with contacts in very high places. From his house in London, Banks wrote literally hundreds of letters to men on both sides of the Channel during wartime to ensure the continued work of his friends, involving himself directly in the safety of dozens of French and British scientists, including eventually James Smithson. Napoleon himself—a scientist manqué—sometimes recognized scientific immunity. When Humphry Davy, the leading British chemist of the day, wanted to see some extinct volcanoes at Auvergne in 1813, Napoleon personally granted him full passage, even though the British were battling their way through the Pyrenees at the time.

Smithson believed heartily in this Republic of Letters. "The man of science is of no country; the world is his country, all mankind his countrymen," he once wrote. He lived in that spirit. He spent fifteen years roaming the Continent, communicating in at least three languages. He tried to solidify his citizenship in the Republic of Letters by corresponding with eminent men. In April

1806 he wrote a letter from Germany in French to the Paris-based paleontologist Georges Cuvier, extolling the need for scientific cooperation during wartime and enclosing some small fossil specimens he'd stumbled on in his German fieldwork. The letter, written in a reverential tone, was similar to his earlier letters to Banks. Smithson was not a young man anymore but an established scientist, and he signed himself James Smithson, *"Seigneur Anglais"*— English Lord.

"It seems to me, Sir," he wrote to Cuvier, "that the man of genius who through important discoveries expands the scope of the human mind is entitled to something beyond a mere and fruitless admiration. That he is entitled to expect that all contribute as much as they can to facilitate research so that, if fame is achieved, they can share in the benefits. And it would indeed be unjust if national differences as well as resentment and war should have any bearing in this matter. The works of scientists being for all nations, they themselves should be looked upon as citizens of mankind."

Unfortunately, troops in uniform were not trained in the concept of the universal citizenship of the scientist. Smithson was one of the unlucky Englishmen to be taken prisoner. In 1807 he was finishing research in Denmark and—typically—finding the gloomy Scandinavian climate unkind to his fragile health. He noted in a letter that "my physicians"—more than one apparently—"were all of opinion that my life depended on my immediately quitting the Danish territory." Longing to get to the south of France, he began the journey only to be seized before he got out of Denmark. The French controlled Denmark, which had just broken with England, and Smithson was seized and imprisoned simply for being an Englishman in enemy territory. He managed to get free briefly but was reimprisoned in the port city of Hamburg, where he spent a year before being allowed to make contact with anyone who could assist him. From house arrest in Hamburg in

1808, where he'd been moved after a harrowing period in a wet and freezing prison in Tonningen, Smithson finally got a letter off to Joseph Banks, begging for help. In Tonningen, where he was first taken, he wrote that he had feared for his life as fellow Englishmen were killed around him.

"The dampness and unwholesomeness of that place, which is situated in the middle of the fens, and the vigorous manner in which the English were treated and which occasioned the death of several, threw me into a state of dangerous illness and brought on a spitting of blood." Things weren't much better in Hamburg. "Two *Gendarmes* were put into the room with me day & night, who behaved in a very riotous manner & in all respects I suffered a treatment very little suited to a very sick man. In this state I continued, without going out, from the 30th of June to the 6th of August. They kept talking of dragging me as a prisoner to Verdun, a journey to which I was little suited . . . for all this time I kept frequently spitting blood."

When he wrote to Banks, Smithson had already spent more than a year in confinement all the while "vibrating between existence & the tomb," he wrote. His own death was much on his mind but so was the passing of time that could have been spent on his work. He lamented the lost days, promising to send Banks a paper he had been working on before incarceration "the moment I can hunt for it" and reporting that his collection of papers and notes was now vast. "I wish much to get to England to arrange & finish them, as I should be sorry that they were all lost by my death after all the pains & time they have cost me."

He also wrote that he had no desire ever to return to France— although he would in fact spend the last years of his life there— and concluded with a curious non sequitur about his supposed aristocratic ancestry. "Since equality is abolished in France, I should have expected to have met with something more regard

here than I have done, owing to the situation I hold in life from the rank of my mother and father. She was the heiress of the Hunger-fords of Studley, & great niece to Charles the proud Duke of Som-erset, and since her death I make little mistery [*sic*] of my being brother to the present Duke of Northumberland and L. Beverley [Algernon]."

If Banks was alarmed by this sudden claim to noble blood from the normally reticent mineralogist, he didn't record it. Rather, he went to work immediately to spring his younger colleague. He wrote a letter to Jean-Baptiste Delambre, the French mathemati-cian who had carried out the survey upon which the metric system was based. Delambre, also an astronomer and a historian of astron-omy, was no stranger himself to the effects of war on scientific work, having had to interrupt his own metric survey during the French Revolution and sit out the Terror in exile.

After summarizing Smithson's case, Banks left the matter in Delambre's hands. "What my friends in France will do on this occasion . . . I must leave entirely to their own feelings. What they are permitted to do by their own government I am ignorant of. I cannot however resist cherishing a pleasant hope that my friend will in some way or other find an amelioration of his destinies through the intercession of those who as friends of science must also be friends to him."

Banks's letter was read at the meeting of the Institut National de France on March 20, 1809, and the French scientists voted to write a letter to the minister of war on Smithson's behalf. Wheels turned invisibly and Napoleon's approval of Smithson's release was reported three months later, at a meeting of the *institut* on June 19, 1809. By that time Smithson was already back in England and being treated as something of a hero at the Royal Society.

Half a year after he was freed from Hamburg, Smithson's Royal Society colleagues voted him into the council again on November

30, 1809. His fellow council members included Charles Blagden and the younger but now extremely renowned chemist Humphry Davy. Smithson retained that office for two terms, into 1811, and was a much more involved member than he had been during his first election. Council minutes indicate he attended three council meetings in 1810 and two in 1811.

The long incarceration permanently damaged Smithson's health, and it marked a turning point in his life. Once freed, he didn't forget his vow to Banks to organize his own work into some form that might survive his death. He returned to the Continent but spent much more time writing and much less time in the field. He turned his attention to all the notes and scribbled papers accumulated during the two decades of work before his imprisonment. Of the twenty-nine papers he published in his lifetime, all but four were published after his imprisonment.

Back in London, he also reunited with his brother, Henry Dickinson. Now a colonel, Dickinson had recently retired from the military after twenty years and was suffering from the effects of various afflictions contracted on the Indian subcontinent. The two brothers had not crossed paths in England since before their mother's death. Now, both middle-aged and ailing, they had many adventures to share. Dickinson's own experiences included not just military campaigns in India but tours of Italy and France; in the latter country, he watched Bonaparte review his troops. In 1802 Dickinson had a personal audience with the pope, and he recorded his caustic impressions in a journal. "We found him alone and standing in the middle of his apartment," he wrote. "His manners were affable but it appeared to me that he did not observe sufficient state. He brought [rosaries] himself from an adjoining room and apologized for their want of intrinsic value. His appearance was much against him and totally deficient in dignity." Dickinson also told Macie of climbing to the top of Mount Vesuvius and visiting catacombs in

Naples, where, he recalled, "the bodies of nuns which had been interred for a time and dug up again and dressed in the habit they wore when alive presented a most disgusting spectacle."

In July 1810 Smithson brought Dickinson to another Royal Society dinner and meeting. Sitting together on the hard-backed benches in Somerset House, the two ailing brothers listened to accounts of Humphry Davy's experiments on muriatic acid and Dr. George Pearson's recent investigation into "The Properties of Pus."

THE GIFT

D ECEMBER 1821: Frascati's, the most luxurious gaming club in all of Paris, was lavishly decorated and glowing. The winding staircase was brilliantly lit and draped with evergreen and laurel. In the casino room, chandeliers above the baize-covered tables were encircled with wreaths, emanating fragrance and flickering candlelight. An orchestra played an overture, and female dancers draped in Grecian-style gowns worked the throng of gamblers, their long hair loose, their white bosoms half exposed and gleaming.

A slight, unobtrusive figure stood in deep concentration among the dozens of perfumed and elegant denizens crowded around the green oval *Rouge et Noir* table. James Smithson was fifty-six years old but already well into his physical decline. He was now far short of a full set of teeth, and his petite and fragile chest was almost concave. He coughed frequently and often didn't have the energy to venture outside his rented apartment. He stood a full head shorter than most of the other men around the table, and many of the buxom ladies in their feathers, heels, and flowing dresses dwarfed

him. Still, the English *seigneur* as he styled himself in France, was elegantly turned out, with a gleaming cravat and stiff collar that buried the lower part of his face, and lace cuffs from another era.

Smithson was a familiar sight to the Parisian card dealers and other gamblers. For years, whenever he wasn't traveling or working inside his Paris apartment, he had visited this gaming palace on the rue de Richelieu or one of the others in the Palais-Royal. In these clubs, he could indulge in a pastime he preferred to everything else in his life except his work. *Rouge et Noir,* called Thirty-one in English, was a game of chance similar to blackjack. Played on thirty-foot-long tables, it involved six decks of cards and a dealer. An unlimited number of players placed their bets on *Le noir* or *Le rouge* and pushed their money into one of two spots on the green table marked accordingly. The dealer carefully unsealed six fresh packs of cards before the players, then carefully counted and shuffled to assure the assembled that no cheating was under way. After this ceremony, the players pushed their money forward, and the game commenced. The dealer picked and laid the cards on the table in two rows, the first row being the *noir* and the second, the *rouge,* stopping at or above thirty-one points. The row whose value was closest to thirty-one won, at which point the dealer announced the winning color and began another deal.

By 1821 Smithson only played the game until he had reached a predetermined limit of loss, then walked away. It was a habit of self-control rather recently acquired. He retired to the dining room, where a late supper was always served. On the dance floor, the young women and their male admirers performed quadrilles to the music, nuzzling and flirting. The graying scientist hunched over his supper, now and again leaning back to observe the scene. Occasionally, the voice of the dealer, barking *"rouge gagne"* or *"noir gagne,"* drifted in above the laughter and music.

Devoted to science as he was, Smithson was never entirely

sustained by lectures in the pews at Somerset House, followed by lonely hours with his own vast mineral collection and lab tools. His private life is perhaps the most mysterious thing about him, but gaming filled a great deal of it. The record of his social existence is a scanty series of calling cards and notes exchanged over the course of his life with other scientists in London, Paris, and Italy, men with whom he dined, breakfasted, or traded books and specimens. Smithson never married and it is not clear whether he had any intimate relationships with women at all. He corresponded superficially with one or two women (the below-mentioned Mrs. Eccles and the woman in Italy who told of his disdain for German intelligence), but their identities have been lost. A few more women are listed as recipients of small amounts of money in his bank statements over the years—probably domestics or hotel keepers. The evidence of his relationships is slight and not revealing. There is a surviving letter to one woman, Mrs. Eccles, in which he complains of his ill health. There are allusions in the archival material to a miniature portrait of Smithson kept by an unnamed woman in France who died some time after he did. The woman was never identified and the portrait never acquired by the Americans. There is a mysterious lock of hair in a gold clasp left among his possessions at death and two portraits, apparently of himself. But there are no love letters, diaries, keepsakes, or cards—no relics that would attest to a fulfilling personal life.

Smithson was a rich man, with an income sometimes as high as £18,000 a year. His bank records throughout adult life indicate regular sums coming in from annuities, stocks, and bonds, probably from investments of his mother's estate, as well as a regular relatively small payment from a glass company, Apsley Pellatt, which had a great interest in glass chemistry. He also received regular large sums during the first decade of the 1800s from "Hugh Smith," in amounts between £200 and £4,000. Hugh Smithson had been

dead for fifteen years, and it is unclear whether these payments were posthumously paid by the duke, or whether the money was from someone else similarly named.

James Smithson was rich, but as a bastard son without a title or an estate, he could not offer much to a woman of his own (or what he believed to be his own) class. He lived in an era when aristocratic marriages were entered into mainly to benefit families. He might not have been inclined to a vigorous domestic life with a wife and children anyway. He was slight and sickly, something of a hypochondriac. He often reported in letters that he was unwell, near death even.

The addiction to gambling was common to late-eighteenth-century aristocrats. Men and women played at home, at parties, and at private clubs until morning, winning and losing enormous sums of money. The heedlessness with which people like the Duchess of Devonshire, who bankrupted herself repeatedly, and the politician Charles James Fox lost fortunes reflected the dissipated lifestyle of the upper classes. It was also a symptom of a deep sense among them of standing on the edge of drastic and frightening change, represented in the worst sense by the Terror of the French Revolution, and in another sense by the Industrial Revolution and scientific discovery. Living for the moment was, for many, the best way to cope.

Gambling was not limited to the nobility, but since they had more money to lose, the play was more spectacular and the stories more outrageous. Smithson's own father, the Duke of Northumberland, was himself a gambler, although not one of the more notorious of his generation. Legend has it he was caught cheating at whist during a night at Brooks' and the incident was memorialized in an anonymous poem, "The Rolliad," which describes "Northumbria's Duke" as "furbelow'd and fine/With full-made sleeves and pendant lace." The poet claims the money box was loose on the

table, and the duke simply slid it under his arm and wouldn't give it back. When he was accused of cheating, he decided to split the take with the waiter rather than with his fellow players.

An entirely different account of the duke's gaming style is given in the duchess's diary, where she relates how her husband was cheated at a game of whist at Newmarket in 1767. "My Lord engaged in a party at Whist, and among the sitters was Major Brereton [a noted gambler] who after some Time said he could not be sitting by & seeing My Lord lose all his money and be so egregiously play'd & impos'd on as he was by the party with whom he play's . . . and he charg'd them with being in a Confedracy to cheat my Lord, making signs to each other of the number of trumps he held in his hand. . . . My Lord remained neuter in the Affair."

Smithson's gambling habit was known to his friends and colleagues in France and provoked some concern. He told scientific colleagues that he experienced more amusement from his play than from any other use of his money. For years they had watched the little Englishman, who now signed his letters "James Smithson, *Seigneur Anglais*," don his cravat and cuffs and indulge himself at the tables, losing more often than winning.

One of these friends was the French astronomer Dominique-François-Jean Arago. Arago was twenty-one years younger than Smithson. Inducted into the French Academy of Sciences at the age of twenty-three, he was a brilliant chemist and co-editor of a monthly science journal with Joseph-Louis Gay-Lussac, another chemist and Paris friend of Smithson's. Arago watched Smithson's habits with dismay. "It was a source of great regret to me that this learned experimentalist should devote half of so valuable a life to a course so little in harmony with an intellect whose wonderful powers called forth the admiration of the world around him."

As Arago told the story later to fellow scientist Louis Agassiz, once, after Smithson lost a great sum in a Paris salon, Arago

contacted him and offered a wager of his own. If Smithson could tell him what game he played and how much he usually wagered, Arago could predict how much money he would lose the next month. Smithson complied and a month later discovered he had lost nearly the amount predicted. The knowledge prompted him to put a limit on his bets, although he never gave up the habit altogether. Smithson told Arago that he was getting more amusement from gambling than from any other use of his money, and so he would not give it up but simply keep wagers within safe limits relative to his income.

Years after Smithson's death, Arago often joked that the Smithsonian Institution might not have been founded except for him.

WHEN HE LEFT Frascati's late in the evening, Smithson returned to one of a series of rented and furnished apartments he kept in Paris. He lived alone, although he had a devoted English servant, John Fitall, as well as a French servant named H. H. Sailly, who attended him when he was in Paris. His households were always well furnished, and he was never without the accoutrements of a gentleman for entertaining his friends. He was not robust enough to have engaged in the English and French nobility's hunting pastime, but he did own a gun.

A little of the inner life of Smithson can be divined from the books he read and from his own writings. When he died, Smithson had among his possessions a small library consisting of dozens of books on a wide variety of subjects. Most of them were up-to-date scientific tomes, many written by the men he knew and corresponded with in France, Germany, and England. There were numerous travelogues, one containing up-to-date descriptions of North America in general and Washington, D.C., in particular. About a third of his books were in French and dealt with French politics or prominent French figures. He also had a copy of a memoir by Louis Dutens, tutor to his half brother Lord Percy. Dutens

had decidedly unflattering opinions of the character of the Duke of Northumberland, which he'd published after the duke's death.

Most of Smithson's books were not bound in leather but left in the printer's original form, in what was considered provisional or temporary binding. Wealthy book collectors commonly sent their books to binders to have them bound in leather and sometimes engraved or embossed with a monogram or family crest. Presumably, Smithson did not collect his books as treasures to cherish and display but simply to read.

Smithson's domestic life was quite orderly, and since he traveled always with a servant, it was a life of some ease, but he also took a personal interest in the management of his own household. He had two cookbooks in his collection, one of which, *The Art of Cookery*, was published in 1770 and might have belonged to his mother. Both books are thick and exhaustive, explaining how to make every dish known to the English eighteenth-century table, from wines, meats, "ragoos," and anchovies, to rice, chestnut, and bread puddings, to eggs fried "round as balls," and syllabubs, cheesecakes, biscuits, and jellies. On a blank page, in his own hand, there is a short list of what were perhaps his favorite dishes, and the page numbers on which they could be found: Scotch collops, beef collops, pulled fowl, pulled mackerel, and a beef and veal stew.

He lived quite well at home, if his kitchen and dining accoutrements are any indication of lifestyle. He owned a plated wire flower basket, plated coffeepots, pairs of wine coolers, glass vinegar cruets, silver and silver-plated candlesticks, vegetable dishes, plate warmers, mahogany cabinets, full china tea service. But he clearly valued his mineral collection—some ten thousand specimens, including bits of most of the meteorites that had fallen in Europe during several centuries—and his books more highly than his household comforts.

Among his books, and not surprising for a man of science who was often sickly himself, was a massive notebook of medicinal

"receipts" written in his own hand. These several hundred recipes cover the gamut of what were considered cures in his time, such things as Whitworth's Drops, Gowland's Lotion, Ginger Beer, Pommade Divine (for swelling bruises), Daffy's Elixir, Dutch Drops, and Eau de Cologne, as well as gold varnish and harness blacking. Smithson's frequent references to his poor health in his surviving letters suggest that he used some of these cures on himself. He certainly suffered from recurring respiratory ailments and must have tried the various cures for cough on himself. He had no fewer than four pages of recipes for curing gonorrhea. Whether the latter had a personal provocation, or whether he merely dispensed these recipes to the afflicted, we will never know. If he had women lovers, none of them came forward after his death to lay any claim to his estate or otherwise make themselves known. On the other hand, there are no Royal Society stories that put him in the same class as his mentor Henry Cavendish when it came to actually loathing women. Given the prevalence of sexually transmitted diseases among men of his generation and class, the various cures were probably a part of every scientific gentleman's library. Most men living in European cities at the time had at some point in their lives contracted gonorrhea. The source was prostitution, another vice as common among the genteel as gambling. In fact, before the advent of street prostitution in London in the 1790s, when it started afflicting the poor as well as the rich, gonorrhea was known as "the gentleman's disease."

JAMES SMITHSON PUBLISHED twenty-nine articles on various scientific experiments and discoveries he made during his lifetime. Smithson really did carry out the vow he'd made to Joseph Banks during his incarceration to organize his papers for posterity. Most of the papers dealt with analyses of substances collected in earlier years in southern Italy and in Germany.

Smithson was acknowledged by his contemporaries, especially those on the Continent, as a serious, highly disciplined mineralogist, albeit one who worked in a narrow range. His work with calamines led a French chemist to propose in 1832 that zinc oxide— a mineral in the calamine family best known to laypeople as the white stuff lifeguards slather on their noses to ward off sunburn— be named smithsonite after him, which it was. (The calamine lotion we use to treat poison ivy also has its base in the same substance.) Smithson had published a paper on the mineral in 1802, and referred to diggings he'd made in Somerset and Derbyshire— perhaps even from the quarries on his mother's lands. "We hope that the name 'smithsonite' will not meet with any opposition as it recalls the name of a scientist to whom we owe several important accomplishments in a time when the science of chemistry had made but few advances," wrote F. S. Beudant in *Traité élémentaire de minéralogie.*

In the end, he was a serious but not terribly original or brilliant scientist. His travels and interests connected him at least peripherally with some of the greatest scientists of his time, like a late-eighteenth-century Zelig. His determination to break substances down into their essences is probably the hallmark of his reputation as a serious scientist. In focusing on the essential elements, he preceded by some years the first modern atomic theory, and provoked at least one contemporary critic to put Smithson's name along with that of John Dalton, who actually gets credit for formulating the atomic theory. Later papers dealt with extremely esoteric analyses of minerals and organic material he had collected on his travels, such as a saline from Mount Vesuvius; ulmin, a substance from the elm tree; a red lead called minium; zeolite; compound sulfurets of lead and arsenic; capillary metallic tin; copper; potassium chloride; and hydrous aluminate of lead.

Besides the twenty-nine published papers, Smithson left many unpublished writings, amounting to two hundred manuscripts and

scraps that one American observer described as "cyclopedic notes." Unfortunately, all this material was destroyed in the 1865 Smithsonian fire, and we have only the account of one American, Walter R. Johnson, a scientist with the National Institute, a precursor to the Smithsonian, who examined the papers and published a memoir on Smithson's scientific researches in 1844. This memoir was republished as part of the first Smithsonian biography of Smithson in the late nineteenth century. Johnson's goal was to study Smithson's published scientific writings and so his description of the unpublished papers was scanty. They covered a broad array of general subjects—history, arts, language, rural pursuits, gardening, and especially the design and the construction of buildings. A "copious mass of notes," according to Johnson, dealt with "habitations," including detailed notes about architecture as well as interior decoration. Johnson did not record what if anything he found that pertained to Smithson's politics or personal life.

Smithson's lab inquiries wandered far afield of rocks, which might have been slightly detrimental to his standing as a serious scientist. He experimented and then published papers on why violets are blue and poppies red, on how to brew the perfect cup of coffee, on how to render a crayon portrait smudge-proof, and on coloring materials used in ancient Egyptian relics. By the standards of the day he was not notably prolific, although he published more than his mentor, the notorious perfectionist Henry Cavendish, who published just a few articles and only after he was convinced his results were infallible.

In rapidly industrializing England, clanking with new steam machinery and darkening daily with factory soot, a gentleman scientist like Smithson seemed a bit whimsical and irrelevant. His meticulous work with blowpipes on bits of rock was interesting, but he belonged to another day. He still liked to tinker with coffee and crayon portraits, while his younger peers were moving on to the

myriad possible uses of electricity and the mass sanitizing proper-
ties of chlorine. He had even analyzed for his own amusement that
quintessentially eighteenth-century substance, a lady's tears. The
tear analysis was never published, but it was read posthumously to
the Royal Society by his Oxford friend Davies Gilbert.

"Mr. Smithson frequently repeated an occurrence with much
pleasure and exultation, as exceeding anything that could be
brought into competition with it," Gilbert told the Royal Society
while eulogizing Smithson. "This must apologize for my introduc-
ing what might otherwise be deemed an anecdote too light and tri-
fling on such an occasion as the present. Mr. Smithson declared
that, happening to observe a tear gliding down a lady's cheek, he
endeavored to catch it on a crystal vessel; that one-half of the drop
escaped, but having preserved the other half, he submitted it to
reagents, and detected what was then called microcosmic salt, with
muriate of soda and I think, three or four more saline substances
held in solution."

Smithson had always straddled the divide between curious gen-
tleman and scientific professional. In his later years, that divide was
growing and he was sidelined. The sons of woodcutters and book-
binders' apprentices like Humphry Davy and Michael Faraday were
establishing themselves as major scientists. Smithson clearly sup-
ported the ideal of diffusing scientific knowledge as a way to order
and improve society. He probably didn't approve, at this point in his
life anyway, with the complete restructuring of the old order that
was under way, which was to make his sometimes old-fashioned,
gentlemanly style of broad scientific pursuit obsolete. With his lace
cuffs, gambling habit, and old blowpipes, and his growing obses-
sion with his aristocratic bloodlines, he did not quite fit into the
new world.

Sometime in the 1810s, Smithson is said to have had a falling-out
with younger members of the Royal Society. The aristocratic science

dabbler was fast becoming a relic at the Royal Society and the professional scientist was ascendant. The last paper published by Smithson in the Royal Society's official journal, *Philosophical Transactions*, was in 1817. When the Smithsonian regents went hunting for information about their benefactor in the mid–nineteenth century, they picked up the story that Smithson had intended to leave his estate to the society but changed his mind when they refused to publish some of his papers. This was never confirmed, but after 1817 all his work went to a rival journal.

By the early 1820s Smithson was spending a great deal of time in Paris. He had evidently overcome his anger with the French following his incarceration more than a decade previously, and again found Paris a better home than London. His set now included most of the greatest French scientists of the day, many of whom were younger men. Among his correspondents was Étienne Lenoir, an instrument maker who improved on the navigational instrument called the repeating circle (Smithson had one of these in his possession when he died); Louis Cordier, a geologist and the official French mine inspector who was one of the first men to use chemistry and mechanical methods to study fine-grained rock; Antoine-César Becquerel, a physicist who contributed a number of discoveries to the progress of the understanding of electricity; and Pierre Dulong, a chemist who lost an eye and two fingers discovering nitrogen chloride. Dulong's experiments in 1819 on heat paved the way for the simple determination of many atomic masses. Later in life, Dulong and François Arago were assigned by the French government to arrange scientific data to help write the laws on steam engines. Smithson's other Paris friends included the chemist Claude-Louis Berthollet, who set up in the early 1800s La Société d'Arcueil, at his estate in Arcueil, which became a gathering of some of the greatest scientists of the time, including Jean-Baptiste Biot, Alexander von Humboldt, Arago, and Joseph-Louis Gay-Lussac.

At this point, Smithson was a respected mineralogist in France,

but he led a lonely existence. His younger brother, Henry Dickinson, had died in Paris in 1820, leaving Smithson now without any family. His friends were professional colleagues much more vitally involved in life. Most had wives and children and professional posts that demanded a great deal of energy. Smithson's disengagement from a personal life sets him apart from his scientific peers.

A poignant remnant of the social emptiness of Smithson's later years survives in a small set of invitation cards and responses. The cards were all written just before Christmas, 1821. They are replies to Smithson's invitations to various members of the Parisian science set to join him for a holiday gathering. Each of the men declined, citing prior engagements. "I most sincerely thank Mr. Smithson for his kind remembrance and courteous invitation which he was so good as to address to me for Wednesday next," wrote the great chemist Jean-Baptiste Biot. "Unfortunately I am not able to accept it, having a standing engagement to dine with some friends of mine every Wednesday." And from the French geologist Louis Cordier: "I much regret my inability to accept the invitation of Mr. Smithson for Wednesday next. There will be on that day a business session of the Professors of the Museum."

HIS DEVOTION TO Knowledge with a capital *K* was genuine, but Smithson's career was marginal, maybe even irrelevant as far as the great questions of his day. He did not—for reasons that have died with him—choose to engage vigorously in any controversy. His feeble health, his dubious social status, and his own personality—solitary and reticent—were limitations. There was something else too, a reluctance to enter the fray, that held him back so that his choices about what to study and analyze were usually of only minor import. He never tried to form a cohesive theory out of his work. Only at the end of his life did he venture into anything close to a controversial subject by challenging biblical geology.

Around 1800 workmen in the Yorkshire countryside scraped away some weeds and gravel and discovered a cave with an opening so small that men had to crouch to enter. The Kirkdale Cave, as it was named, contained a surprise. The floor was heaped with the bones of animals common to Africa but never known to have existed in England. There were hyenas, a rhinoceros, a tiger, hippopotami, and an Asian elephant alongside the remains of local water rats. Rumors about this unusual bone collection attracted eminent geologists, including William Buckland, vice president of the Geological Society of London and Oxford's first professor of geology.

Buckland was the first man to identify and name a dinosaur, but during his lifetime his claims to fame were his deep personal eccentricity and his attempts to reconcile geology with biblical creation. In the 1820s he wrote that geological evidence proved a great flood had indeed once covered the earth. His habits were the stuff of legend for generations of Oxford boys, who wrote fond epistles to his weirdness. His classroom and house were packed to the rafters with bones, fossils, and live and dead animals. His dinner table groaned with odd meats, including crocodile, batter-baked mice, and horsemeat. He claimed to have eaten his way through the whole of the animal kingdom, declaring at first that moles were nastiest. On his wedding tour of the Continent, Buckland visited a shrine in Sicily. When shown the supposed bones of Saint Rosalia, for whom the shrine was constructed, he cried out, "They are the bones of a goat, not a woman!" The priests slammed the sanctuary doors on him.

Buckland, the bone expert, personally crawled into Kirkdale Cave and, after poking around underneath the floor of the cave, confirmed that inside was a whole collection of bones different from those belonging to animals known to roam England in recorded history. He positively identified hyenas and elephants and other exotics and theorized that the area had once been a vast lake and the climate of England much warmer, or that a collection of

foreign animals had arrived in England on a tidal wave. To explain how the animals got in through the small cave opening, he suggested that hyenas had perhaps dragged their dead prey piecemeal into the cave.

Buckland's paper on the cave was published in *Philosophical Transactions* and read at the Geological Society on February 21, 1822. The controversy was only beginning. The cave and its mysterious bones also attracted the attention of a Christian fundamentalist, the writer Granville Penn, who was weaving together a much more elaborate theory. Penn was a grandson of William Penn, proprietor of the American colony of Pennsylvania, and heir to a vast fortune. Even though the Pennsylvanians had declared their independence, Penn was still rich in British property. He was scholarly, with an understanding of Latin, Greek, and Hebrew, and he had translated Greek classics. He was best known for defending literal interpretations of the Bible. Penn took the cave as proof of the Genesis account of creation and the deluge. He had already written a book comparing his view that Noah's flood was the basis for earthly geology with what he called "mineral geology," which examined the world based on minerals and their locations in the earth's crust. Scientists didn't pay any attention to his theory, although churchmen received it with enthusiasm.

Penn seized on the Kirkdale Cave as proof positive that the biblical deluge had occurred and deposited exotic animals in England. According to his theory, the flood had also deposited a thick layer of mud, which dried into limestone. The putrefying drowned animals had become embedded in the mud and produced a gas that had created the cave itself. Penn published this theory in a supplement to his previous book on the biblical theory of geology. The *Journal of the Royal Institution*—of which Smithson was a founding member—published a review of the supplement in January 1824 and summarized Penn's view.

Smithson published his response to Penn in *Thomson's Annals of Philosophy* in June 1824. It is unclear why Smithson decided at this point in his career to get involved in the theology-versus-geology argument, a battle that had raged throughout his life. By this time, most serious geologists had already moved beyond the question of whether the Bible explained the earth's phenomena, and Penn's theory, while probably popular with laypeople, was essentially meaningless within the field. The fact that Smithson decided to address the question is somewhat significant because he was taking Penn seriously. It is also possible that, derailed from fieldwork by ill health, he simply had more time on his hands.

"I have yielded," he wrote in explanation, "to a conviction that it is in his knowledge that man has found his greatness and his happiness, the high superiority which he holds over the other animals who inhabit the earth . . . and consequently that no ignorance is probably without loss to him, no error without evil, and that it is therefore preferable to urge unwarranted doubts, which can only occasion additional light to become elicited, than to risk by silence letting a question settle to rest, while any unsupported assumptions are involved in it."

Smithson's article is most notable for the gentle tone in which he laid out the scientific evidence disproving Penn's theory. There isn't a trace of derision or superciliousness. His respect for religious faith was clear, although he wasn't afraid to contradict the Bible. "In a book held by a large portion of mankind to have been written from divine inspiration, an universal deluge is recorded," he began. "It was natural for the believers in this deluge to refer to its action all, or many, of the phenomena in question; and the more so as they seemed to find in them a corroboration of the event. . . . The success however was not such as to obtain the general assent of the learned; and the attempt fell into neglect and oblivion."

He then took apart each of Penn's assertions, point by point.

Scientific evidence, Smithson wrote, could not support the notion that the earth was once covered with a deep layer of limestone mud. Chemical experiments prove that gases from putrefying animal bodies could not create a cave out of a layer of drying limestone. He seconded Buckland's idea that hyenas or some other carcass feeders had dragged the various bones into the small cave mouth. Finally, Smithson challenged the idea that the cave held any proof of the biblical flood. If the deluge had happened during humanity's existence, "Human bodies by the million must have then covered the waters" and their bones must be part of the fossil record. They are not.

Smithson expressed wistful sorrow at the difficulty mankind has in reconciling scientific evidence with the Bible. "How greatly must we regret that . . . we must relinquish the delightful hope of some-day finding in the body of a calcareous mountain the city of Enoch built by Cain!" Smithson never ultimately challenged the Bible. He suggested only that no one who studies the natural world can ever reconcile biblical stories with the earthly evidence. The only solution, he wrote, was to divide scientific observation from matters of faith. The flood will never be proved by man, maybe because "the Creator repined at the severity of his justice" and obliterated the record of the deluge himself.

Clearly, Smithson was a man of faith as well as science. He probably would have agreed with Einstein, who wrote more than a century later: "Science without religion is lame, religion without science is blind."

IN 1826 James Smithson was sixty-one years old and in declining health. Besides his feeble lungs, he had suffered massive periodontal disease during the course of his life and he was now missing seventeen teeth, including eight of the ten on the left side of his

mouth. He also had numerous painful abscesses in his jaws. In October he wrote a will, and signed and dated it October 26, at Bentinck Street, Cavendish Square, London, where he was again living in rented furnished quarters. It is interesting to note that on October 23, sixty years prior, Hugh Smithson had become Duke of Northumberland and in the act signed away his right to acknowledge children by women other than his wife. James Smithson wrote the will himself, with the help of a pamphlet on do-it-yourself will writing: "Plain advice to the public, to facilitate the making of their own wills, simple and elaborate, containing almost every description of bequest, especially the various modes of settling property for the sole use and benefit of married women for their lives, with power of appointment to them by will ordered, . . . and a chapter of useful hints to persons about to make their own wills."

In his will, he left the whole of his estate—minus small annuities for servants—to his nephew, the illegitimate son of his brother Henry Louis Dickinson, a young man who was at the time calling himself Henry Hungerford. If young Hungerford died intestate, Smithson wrote, "I bequeath the whole of my property . . . to the United States of America, to found at Washington, under the name of the Smithsonian Institution, an Establishment for the increase & diffusion of Knowledge among men."

Over the years, scholars and Smithsonian officials have tried to divine the founder's politics, sometimes making assumptions on scant evidence. Smithson cannot really be claimed by either the democratic or the royalist camps, because his views shifted throughout his life. His early letters indicate that he was attracted as a youth to the antimonarchist, anticlerical ideas of radical progressives. As he matured and traveled, witnessing and personally experiencing some of the brutal excesses of French republicanism, he developed more conservative politics. By the end of his life, he still shared with the French philosophes the notion that society

could be improved by spreading knowledge into the lower classes. But he was also firmly convinced of the significance of his own noble bloodlines, and he was certainly no atheist.

The most revealing clue to Smithson's politics and to the thinking behind his mysterious bequest can be found in his position as a charter member in the Royal Institution, organized by British elites to bring scientific knowledge to the masses. In 1800 fifty English gentlemen contributed fifty guineas each to create a new "Institution for Diffusing the Knowledge, and facilitating the General Introduction, of Useful Mechanical Inventions and Improvements; and for Teaching, by Courses of Philosophical Lectures and Experiments, the Application of Science to the Common Purposes of Life." The Royal Institution was underwritten by the English elite, but its stated aim was to bring knowledge to the masses. It counted among its early members the poet William Blake, the abolitionist William Wilberforce, and several members of Parliament as well as Royal Society scientists Cavendish, Banks, and Smithson, among others.

The institution's goal was to clear minds of superstitious notions and replace those notions with useful facts. It also had a nationalistic character. It was believed that bringing scientific knowledge to a lay audience could make people more efficient. A more efficient British people meant a stronger British commercial power vis-à-vis France. The gentlemen founders hoped more efficient workers would speed the industrialization of England and improve agricultural yields.

In the decades following its founding, the institution was home to some of England's preeminent scientists, men whose greatest discoveries were made inside the institution's basement labs. Some of these discoveries had profound effects on daily life, especially those relating to electricity.

To attract public support, in the early years the Royal Institution

also presented public demonstrations of scientific experiments, the more spectacular, entertaining, and dangerous the better. The young chemist Humphry Davy was employed for this purpose. Davy, the son of a woodcutter, had made his name in experiments with nitrous oxide (laughing gas). He had tried the gas out on various poets and philosophers, including William Wordsworth and Samuel Taylor Coleridge. Early publicity about the institution caricatured Davy administering the gas in public to members. He also invented the miners safety lamp and advanced understanding of electrochemical action following Volta's invention of the battery. Davy isolated numerous chemicals in the course of his work, including barium, sodium, potassium, magnesium, calcium, and strontium. He was knighted in 1812.

Davy's successor, Michael Faraday, was another self-educated British chemist who learned his science while apprenticed as a bookbinder. Faraday continued experimenting in the basement labs of the Royal Institution. He discovered benzene and the laws of electrolysis, and discovered and named electrochemical phenomena that we use today, including cathode, anode, and electron. Eventually Faraday oversaw the first introduction of electrical light at a lighthouse in the 1850s.

The founders of the Royal Institution were not the only men in England concerned with "diffusion of knowledge" at the turn of the nineteenth century. The phrase could be commercial, politically progressive, or radical depending upon who was speaking and the time and place. In its most radical interpretation, it reflected a belief that knowledge would free common men from the oppression of the upper classes. So, during the most optimistic days of the French Revolution, radical British preacher Richard Price delivered an address in November 1789 to commemorate the British Revolution. "Tremble all ye oppressors of the world!" he thundered. "What an eventful period this is! . . . I have lived to see a *diffusion*

of knowledge, which has undermined superstition and error. I have
lived to see the rights of men better understood than ever."

The Royal Institution's use of the phrase was not nearly as revo-
lutionary. The organization's founding and development in the
early nineteenth century coincided with enormous social changes
in Britain brought on by new knowledge. The people who bene-
fited most from the diffusion of knowledge in the early nineteenth
century were not the poor but the new professionals, and it was
they—and not the lower classes—who flocked to the Royal Institu-
tion's lectures. Science had helped make the machines that now
enslaved the lower classes inside factory walls. The advent of the
Industrial Revolution meant factory work was replacing the old
way of life for the poor. At the turn of the nineteenth century, the
bleakness of the lives of the industrial laborers was many years away
from being relieved. Charles Dickens would not begin to write
about orphans and child labor until the 1840s. But a backlash was
already under way, with machine-breaking and rioting in the cities.
The world was dividing into factory mob and professional class,
with the old nobility increasingly irrelevant.

In this world, the rules of aristocratic politesse familiar to—or at
least aspired to by—James Smithson were fast disappearing. It was
probably that fact, more than the plight of the new class of industrial
laborers, that most disturbed James Smithson, a man with one foot
firmly planted back in the eighteenth century. On the face of it,
Smithson's bequest has a leveling ring to it. He wanted his money to
promote the "diffusion of Knowledge" among men and from a pre-
cisely selected point on the planet—the capital of the great new
democracy. Did he think diffused knowledge would make "oppres-
sors tremble" as did Richard Price? Or did he hope that the lower
orders would become more efficient and productive members of
society? He probably intended it in the same way as the Royal Insti-
tution founders. That is, he shared with them a belief that more

knowledge available to more people would improve the lives of everyone—without abolishing kings and the landed gentry in the process.

"It is difficult not to believe that Smithson did not have the Royal Institution in mind when he drafted his will," says the historian Frank James, the Royal Institution's official reader in the history of science.

THERE IS perhaps another more personal and narcissistic explanation. Perhaps Smithson wanted to make his *name* more potent. Smithson was the name his father had discarded for the more socially impressive Percy, and in doing so, Hugh Smithson had agreed in principle and in law to disinherit his bastard son. Perhaps James Smithson could more easily imagine achieving immortality with his name on a building in the infant republic of the United States than in the more sophisticated capitals of Europe. We know that Smithson—*Seigneur Anglais*—had grown more and more obsessed not just with his name but with his social standing in later life. The practice of signing himself in letters as an English lord hints at how at odds his self-image had become vis-à-vis his real status.

At some point in his life, Smithson supposedly vowed to make his own name more famous than that of the Percy family that had refused to acknowledge him. One of the phrases that survived from Smithson's copious unpublished notes was this: "My name shall live in the memory of man when the titles of the Northumberlands and Percys are extinct and forgotten." American news articles published around the time of the retrieval of his bones from Genoa frequently reprinted the sentence, which was recorded by the American Walter R. Johnson when he surveyed Smithson's notes for his memoir on Smithson's scientific work. But verification that Smithson actually

wrote those words—and proof that the phrase is not simply a piece of the American legend—is now impossible.

The practice of wealthy people donating money to put their names on buildings, museum halls, or professorial chairs was not as common in the early nineteenth century as it is today (Smithsonian officials now can't fend them off vigorously enough). But there was already a tradition in English science of the names of great collectors or practitioners being attached to their collections or to chairs in their honor. A number of professorships at both Oxford and Cambridge were named after prominent figures in the respective fields. Joseph Banks did not leave a major bequest to the Royal Society, but he did leave his library and herbarium to the British Museum. The herbarium formed the basis of the "Banksian Department," which came to be known as the General Herbarium.

Smithson could have decided to leave his money to one of the British institutions with which he was associated—but whether that would have guaranteed his name a place in the pantheon is uncertain. His half a million dollars was not exactly a huge fortune by European standards. It was by American lights. Still, the Royal Society would have been appreciative. The Royal Society was private and relied mainly on subscriptions and payments from its membership. Its most important scientific award, given annually since 1736, is the Copley Medal, named after Sir Godfrey Copley, who gave £100 to the society in 1709 to be used for carrying out experiments. Gifts and presents of books were always made to the Royal Society and were incorporated into its library. Society meetings always commenced with a mention of gifts, usually books, and a word of thanks to the donor.

Public bodies like the British Museum, which drew on government funding, would have been other willing recipients. Government funding to the British Museum was not generous in the early years, and the museum's major collections were founded on gifts

and purchases from the generations leading up to, and including, that of Banks. The donors' names included Sloane, Cotton, Harley, Banks, Hamilton, Cratcherode, Townley, Payne, Knight, and the kings George I, II, and III.

Some names were passed on to collections and posts as a result of the significant role played by influential figures in the historical development of the disciplines involved. These include the Ashmolean Museum at Oxford, named after the great scientific collector Elias Ashmole, who donated his collection to start the museum, and the Leverian Museum, named after Sir Ashton Lever, a collector who created a private museum during his lifetime that was one of the precursors to the great natural history museums of England. Both existed in England during Smithson's time.

For Americans, the most tempting theory behind the bequest is that Smithson made a calculated choice to leave his money to the United States based on his strong positive feelings about the new republic. During his later years, Smithson had converted all the land inherited from his mother into more easily transferred paper, and that fact has been cited as proof that Smithson planned his bequest to the Americans years before his death. He was, though, certainly aware that British law required lands owned by illegitimate children to revert to the Crown after death, and he probably wanted to avoid that outcome. Perhaps Smithson simply wanted to ensure that the funds never went to the British government. He must have known also that if he did not specify a contingent use for his money, and his nephew died, the estate would revert to the government of England. In other words, it would benefit the very class of people that had included his father's pedigreed wife and her legitimate children, his privileged half brothers. That hardly seemed an appropriate destination for a fortune amassed by a woman socially suspect for bearing a nobleman's son out of wedlock.

AFTER DEPOSITING the will with his lawyers, Smithson packed his household and left London for good. For the last time, he traveled across the Channel and south through France to Genoa. The Italian city, then still under French control, was colorful and warm, if diminished from its medieval glory, which added to the charm. English gentry and nobles seeking a sunny retreat had purchased or built houses among the old palazzi scattered in the steep hills overlooking the bay. More than a hundred years before, Oliver Cromwell had had a country house built for himself in the hills of Genoa.

The city lay between a bleak wall of mountains to the north and the sea to the south, and from a distance the cascading white buildings rose like an island between the peaks and the water. The palazzi were still quite magnificent centuries after the city's power had declined and the doges lost their influence. Vast gardens stretched away from them on all sides, and down to the water, planted with roses and oranges. The high walls surrounding them were painted with landscapes and figures, which some English found gaudy but still charming. Inside the city, the principal street, the Strada Nuova, was lined with buildings whose exterior stolidity belied the insanely lavish decor on the inside.

Countess Margaret Blessington, a British traveler, visited Genoa several times in the 1820s and 1830s to be near her idol, the poet Byron as he was preparing his ill-fated expedition to Greece. She complained that the fantastic profusion of columns, friezes, fountains, arcades, and palazzi crammed with the art of Renaissance masters, including Rubens and Van Dyck, prevented any single beautiful thing in Genoa from being viewed on its merits alone. Inside, the buildings were always more spectacular than their outer walls, with gilt ceilings and walls, lofty and spacious rooms, statuary,

luxurious furniture, and views beyond vast casement windows of two different shades of blue, sea and sky. "How mean and insignificant our houses in England appear in comparison with those I have seen here!" Lady Blessington gushed in her diary. Behind the palaces the medieval character of the city was plain in the narrow, shadowy alleys winding between tall gray buildings that let no sun onto the cobbled ground.

Genoa was deeply Catholic, with a religious history that included being one of the launching points for the Crusades. No fewer than thirty-eight churches stood within its walls, richly decorated with marble friezes, statuary, and paintings. So many priests strolled about that the streets were checkered "like a backgammon board," Lady Blessington wrote, owing to their black and white robes. "One cannot proceed twenty paces without meeting two or three monks," she wrote, adding that people seemed to waste a great portion of their time making holy festivals. There were saints' fetes two or three times a week, during which pious workers simply left their jobs. "Superstition and idolatry are but too visible," she complained.

The local religious culture had already clashed with the enlightened rationalists from Paris. The church of San Lorenzo had for centuries contained among its holy relics a plate said to be composed of a single giant emerald and on which Christ was served the Last Supper. Legend had it that the crusaders brought it back from Palestine in the twelfth century. Any Genoese who touched it faced a fine of a thousand gold ducats. In the eighteenth century, the French entered Genoa and took the plate back to Paris, where they had it inspected to find out what it might be worth at auction. "Alas! It passed not unblemished the ordeal of a laboratory: on scientific examination it was proved to be a piece of glass, instead of a pure and matchless emerald," wrote Blessington.

In Genoa, James Smithson, the aging scientist who had advocated

the separation of reason and faith but not the demolition of God, became a regular churchgoer himself, as a member of the Anglican Church of the Holy Ghost. From the windows of his rented quarters he could watch the frequent elaborate Catholic religious processions passing in the alleys below. Church dignitaries in rich embroidered dresses led the way, followed by monks in white and brown robes, priests in black wearing shepherd's hats, and young men all robed in white carrying immense wax lights. There followed sometimes litters laden with colorful flowers and bearing statues of Christ and the Virgin Mary, the Virgin always decked in a profusion of gold, pearl beads, and trinkets. On other days, the processions were deeply morbid, with death's-heads carried aloft beside grotesque images of dying saints and martyrs, and monks wearing cowls with holes cut for eyes and crossbones painted on their breasts to symbolize their mortality.

These displays were matched in colorful dress by the Genoese themselves. Women strolled the streets in lacy black head coverings called *mazeros*, and sometimes with a bouquet of flowers on the front of their heads. They draped themselves in layers of gold and silver filigree jewelry, a Genoese specialty, at neck and ears. Peasant women wore vibrant scarves painted with birds and flowers. The Genoese men habitually wore scarlet Venetian caps and casually slung their coats over their shoulders. Food carts were rolled through the streets at mealtimes, piled with trays of polenta, *polpetti*, and ravioli, trailing delicious aromas along the ancient lanes so that the artisan customers for whom this service was intended crowded the doorways eager to buy.

All in all, Genoa was a fine place for a man of weakening health and perhaps embittered temper to while away his days. "There is a peculiar lightness and elasticity in the air of this place, which begets a buoyancy of spirits even in us children of a colder clime," wrote Lady Blessington. "It is positive enjoyment to look out on the blue

unclouded skies, and the not less blue waters. . . . Climate, aided by the light yet nutritious food in general use in Italy, is productive of a disposition to be pleased, that robs the asperities of life of half their bitterness; although it may indispose people to studious pursuits, or unfit them for laborious ones."

Smithson might have continued to work with his blowpipe and mineral collection in Genoa after 1826, but he published no more. If his eyes were still keen enough, he passed most of the time reading. Among the books found at his death was Isaac Weld's two-volume travelog about North America, which gave a detailed description of a swath of America from upstate New York down to Georgia. The book was fair to the inhabitants and crammed with observations on all the New World flora and fauna that seemed marvelous to European eyes. Weld reported on the monstrous bullfrogs that lowed like cows in the night, the strange flying insects that lit up in the summer woods, the plagues of "musquitoes" that could cause men to scratch off their skin, and, of course, the rough citizens and their cities.

Weld visited the new city of Washington in 1796. He found the president's house by far "the handsomest building in the country," but he had a hard time envisioning a real city, since "the whole place is covered with trees." He also described plans to construct a large park or mall in front of the Capitol. "[It] is to run in an easterly direction from the river to the capitol. The buildings on either side of this mall are all to be elegant in their kind; amongst the number is proposed to have houses built at the public expence for the accommodation of the foreign ministers &c." Reading about this mall, the old man in Genoa could not possibly have dreamed that two hundred years in the future most buildings on it would be associated with his name.

Smithson lived among his instruments and books in Genoa for three more years, until he died at two o'clock in the morning on

June 26, 1829. He was just sixty-four years old. His parents had both lived about ten years longer. A manservant—the Frenchman Sailly who had been with him for years—was nearby when he took his last breath. He died surrounded by his books, papers, telescope, and, of course, the cabinets filled with ten thousand mineral samples, fruits of a lifetime of barter and fieldwork. A portrait of his father was also among his possessions.

The British consul was notified of the death the next day and quickly arrived and conducted an inventory of the dead man's things. The consul also set about trying to find next of kin. Smithson hadn't had any serious relationships with women, unlike his younger brother, who acknowledged a mistress and an illegitimate son in his will. If Smithson ever acknowledged any illegitimate children, or if their mothers might even have suspected his paternity, the advertised promise of a vast fortune when the British government went searching for heirs would surely have lured someone forth.

The valuables were boxed in trunks and sealed. They included silver plate with the coat of arms of the Northumberland family; various chemical apparatuses; test cups; a thermometer; a snuffbox; the portrait of Hugh Smithson; a set of scales; an umbrella case; a riding whip; a sword, belt, and plume; silver spoons and butter knife; ornamented spools for winding gold wire; a copper plate with the Smithson name engraved on it; a mineral collection; silver candlesticks; and his elegant silver service. He also had a marble head of Saint Cecilia, which had been presented to him at Copenhagen by Dr. Brandis, physician to the king of Denmark; a rustic painting of cows sleeping on a field by Berghem; many specimens of petrified wood; several specimens of marble; a glass model of the great Russia diamond (the original was then valued at £600,000 sterling); a miniature chemical laboratory for traveling; and a walking cane.

There was also a good bit of jewelry, his own, or perhaps his mother's, all of which went to his first heir, his nephew, and was never noted again. This collection, according to the consul, included a pin with sixteen small diamonds, a cameo ring with the head of a Moor, rings of agate and amber, some tortoise boxes, and two rings with diamonds. Most intriguing, he owned a clasp of gold with a lock of hair inside. The color of that hair, and any clue as to whom it once belonged, are lost to history.

105 SACKS OF GOLD

T HE TALL, BALD AMERICAN with his black suit and
chiseled features cut a lean and elegant figure as he walked
along London's St. Catherine's Docks in the mid-July heat, toward
the sailing ship *Mediator*. He was a deeply tactful man, a diplomat
by title and inclination, and no one who saw or spoke with him
on that morning in 1838 noticed he was filled with dread at the
prospect of leaving firm ground for yet another monthlong sea voy-
age back to the United States. The westbound journeys, he knew
from experience, always took longer, thanks to the Gulf Stream
winds, averaging thirty-six days from port to port. Even though it
was summer, he dreaded the Atlantic squalls he knew only too well
from past journeys. His fears were going to be confirmed too, as
this particular summer season would be remembered for unusually
rough weather on the high seas.

He felt the queasy effect of the brackish swell soon after he
planted both feet on the gangway rising toward the elegant sailing
ship that was to be his home for the next weeks. This, even
though the ship was still far from open water. Once one had been

a victim of seasickness, the mere expectation of nausea was its own provocation. For the moment, the diplomat was able to distract himself from the sound, smell, and feel of water slapping on wood. He occupied himself with inspecting, for the last time, the strong room where the 11 boxes containing 105 sacks of gold sovereigns, double-sealed and addressed to the United States government, were stowed. Satisfied that the treasure hoard under his care was safe, he retired to his room to resign himself to whatever lay ahead.

American and British packet ships like the *Mediator* were small but splendid vessels that plied the Atlantic Ocean during the first half of the nineteenth century, before the advent of the big steamships. The packets were famous for reliability. They always left on schedule, undeterred by weather in winter or summer. They were used chiefly for hauling cargo—books, iron, French wines, and textiles leaving London, cotton and other raw goods coming back from the New World. Humans on board might have wished themselves to be inanimate cargo for the duration of the journey. A packet ship traveler in the 1830s wrote of the experience: "At *best*, a sea voyage is a confinement at once irksome and odious, in which the unfortunate prisoner is compelled for weeks or months to breathe the tainted atmosphere of a close and crowded cabin and to sleep at night in a sort of box, about the size of a coffin. . . . At *worst* it involves a complication of the most nauseous evils that can afflict humanity,—an utter prostration of power, both bodily and mental, a revulsion of the whole corporeal machinery, accompanied by a host of detestable diagnostics, which at once convert a well-dressed and well-favoured gentleman into an object of contempt to himself, and disgust to those around him."

Passenger steamships were already available in the late 1830s, but sailing was still preferable to many travelers. For a man prone to seasickness like the American diplomat Richard Rush, steamship

travel was hellish. Steamships busted through the water, creating severe pitching, whereas the sailing ships skimmed the surface. Rush wasn't alone in choosing sail over steam. A few years later, Charles Dickens boarded an American packet at New York for his return to London in 1842, after taking a steamer on the westbound journey to America.

The largest single article shipped in both directions on the packet ships in the 1830s was money, referred to as "specie"—huge sums of it too. Specie was shipped back and forth across the Atlantic, and it was not unusual for the packets to carry hundreds of thousands of dollars in coin, packed in boxes or casks and locked in the strong room. The *Mediator*'s captain in 1838 was a Connecticut Yankee named Henry Champlin, who'd been sailing between London and New York since the early 1820s. The fact that there was a hoard of gold bullion worth half a million American dollars aboard his ship when Richard Rush strode aboard hardly impressed Champlin. In fact, it was a considerably smaller sum than the record $1,250,000 in coins the *Mediator* had safely brought from London to New York just a few months earlier, in April.

When Richard Rush boarded the *Mediator* in the summer of 1838, the ship was still relatively new, built two years before by the New York shipper Westerveldt and Roberts. The polished wood planks and brass fittings still gleamed. It weighed 660 tons, was 138 feet long, but only 32 feet wide, and at full rig it had three majestic white masts. Rush, being an honored first-class passenger, had a tiny private cabin off the dining room, a small stateroom where captain, crew, and passengers dined together. The crew tried to make him as comfortable as possible. The packet ships were known for how well they fed the crew and cabin, or first-class, passengers. There was always fresh meat (live animals were stowed on board for the purpose) and produce and several stewards to serve at table. Fine wines from Bordeaux were poured, and champagne was

always in stock, not only for celebrations but because it was believed to alleviate seasickness.

Having a stock of this supposed remedy on board was small comfort to Rush, who was more aware than most of the limitations of nineteenth-century medicine when it came to the vicissitudes of the human body. His father, Benjamin Rush of Philadelphia, had been the preeminent American doctor of his day. Benjamin Rush had studied under the chemist Joseph Black in Edinburgh—one of James Smithson's early mentors—and returned to the United States to become an important figure in the Revolutionary generation. As a delegate from Pennsylvania, he was a signer of the Declaration of Independence.

Richard Rush, born in 1780, was one of six surviving sons of Benjamin Rush. He had studied law, then became a statesman and diplomat who fathered eleven children. When he was sent to secure Smithson's money, Rush was in the prime of his life and known as one of the most accomplished diplomats of his generation. He had served as America's ambassador to the Court of St. James's. He understood the English better than most Americans in Washington, which was why he'd been selected for the mission he had just completed when he boarded the *Mediator*.

In Washington and in London, Richard Rush was known to be a man of grave and tempered character, but he also possessed a friendly and sometimes witty demeanor. A natural diplomat, he was an American who could work efficiently with the English, unlike his predecessor, the dour John Quincy Adams, son of the second American president. Adams's powerful American bias and unrelenting Puritanism—always on fierce display among the blasé British wits—had provoked the Swiss-born American minister at Paris, Albert Gallatin, to remark that American politicians compared with European diplomats were like "rough colts who want breaking in."

Rush's first diplomatic stint began in 1817 and lasted eight years.

As minister, his life in London included hobnobbing with aristo-crats and familiarizing himself with the British cultural organiza-tions, including the Royal Institution. He attended some of the public science lectures and became friendly with the chemist Humphry Davy, who in 1818 was advising the British Admiralty on a projected North Pole expedition. Rush also met the abolitionist William Wilberforce, another founding member of the Royal Institution. There might have been opportunities for Rush, while at the Royal Institution, to brush shoulders with the little mineralo-gist named James Smithson, who would play such a posthumously prominent role in Rush's life. But if he saw Smithson, Rush took no note. When he was dispatched back to England in 1836 to secure the Smithson fund, Rush was as mystified as every other American by the personality, life, and motives of the stranger who'd left his fortune to America.

EIGHT YEARS BEFORE the bequest was known to the Ameri-cans—a year before James Smithson had even scratched out the famous final clause on his will—Richard Rush left London for America to become President John Quincy Adams's secretary of the treasury. The America to which he returned in 1825 was a provincial, agrarian nation and the constant butt of European cul-tural condescension. The new nation had so far failed to live up to early expectations—from both sides of the Atlantic—that political liberty would promote a flowering of artistic and scientific achieve-ment on a par with ancient Greece. No framework yet existed for such a flowering and there was not even any agreement among American politicians that the American government ought to be engaged in encouraging what we today would call culture. On the contrary, there was deep and strong opposition to expanding the government's role in any way.

Rush and Adams, two sons of the Revolutionary generation,

keenly felt the failure of America to live up to these early dreams of cultural greatness. When Rush returned to Washington after eight years in London, the contrast between the two capitals couldn't have been more stark. Rush had palatial court interiors fresh in his mind when he went to meet with Adams in the White House. The president's house at the time was a simple southern plantation house, with outdoor plumbing. It was situated just two blocks from open countryside. A usually muddy road led to the front door. The "garden" was a utilitarian grazing area where sheep, pigs, and cows ambled, waiting to be milked or butchered for the presidential household. There was no running water and no lighting. If the meanness of the president's quarters wasn't enough to jolt Rush back into the New World reality, the president's Puritan habits snapped him to attention. Instead of operas and lavish dinners that ended at midnight, Rush was now on Adams's schedule, in which the White House day began at four A.M. in summer, five A.M. in winter, and the work only ended at midnight.

Simple as it was, the White House was still the grandest building in town after the Capitol. Washington's streets were unlit, muddy, and half-finished, lined with brick and wooden hotels and rooming houses that served as temporary quarters for the members of the House and Senate. From his second-floor office, the American president could look out on what we now know as the green expanse of the Capitol Mall and see a soggy and unkempt field separated from the city by shallow, rank trickles of the Potomac. It was covered with brush and generally served as a haven for drunks and criminals. Down on the docks of the Potomac River, not far from the presidential quarters, slave auctions were held on a weekly basis, advertised in the daily papers. Duels and brawls—sometimes involving elected officials—made the newspapers with some regularity.

Rush and Adams both saw this mean, rough city as a great

beginning. The two men had deeply different personalities, but they shared certain notions about America's future. They had a common belief in what was called nation building, the notion that the American government could and should be structured to actively further both the commercial and the cultural advancement of the country. The nation-building philosophy was part of a grander scheme to advance the ultimate supremacy of the young republic over the Old World colonialists and imperialists. All this was going to be done democratically, not despotically. In modern terms, Adams and his men liked Big Government. Not everyone agreed with this policy then, just as it remains controversial today.

From the presidential bully pulpit, Adams wasted no time preaching the doctrine of a more paternalistic and involved government to a Congress that was deeply unreceptive. His first State of the Union speech in 1825 was especially ambitious and provocative. For the first time, Adams laid out the novel notion that the federal government was responsible for the nation's culture and science. "Among the first, perhaps the very first instrument for the improvement of the condition of men is knowledge," he thundered. He called on the nation's leaders to promote knowledge with a national university, and claimed Congress had a duty to advance science, including conducting geographical exploration and building astronomical observatories. He bemoaned the fact that in Europe there were 130 of these "lighthouses of the skies," as he called them, while in the whole of America there wasn't one. The audience was dumbfounded, as though he had proposed visiting the moon, and the "lighthouses" phraseology provided his enemies with a lifelong mocking slogan.

Adams delivered this speech to an audience of scoffing politicians and newspaper editors who immediately went on the attack. Congress was not just unreceptive to Adams's ideas but openly hostile. There were a number of reasons for this, but the issue of

slavery was the silent engine motivating much of the fierce reaction. The unspoken question on all minds was how long the South could continue a way of life that many agreed was anathema to the Constitution. Forty years before the Civil War, the country was already dividing sectionally, with the agrarian South opposed to the nationalist programs of the manufacturing North. The Southern politicians were very wary of federal expansion and began to view Adams's schemes and the nation-building system itself as a plan to improve only one section of the country—the North.

Adams, who sympathized with the abolitionists in his home state of Massachusetts, eventually became a more and more outspoken opponent of slavery. But during his presidency he rarely spoke of it. His more diplomatic friend and cabinet member, Richard Rush, was also opposed to slavery, but Rush always approached the problem in a typically nonconfrontational manner. He was a leading member of the American Colonization Society, a nonpartisan organization devoted to settling freed slaves in an African republic. The society accomplished very little during its years of activity, but it further provoked the antagonism of Southerners against Rush himself.

Rush's treasury post was key in the nation-building plan, as almost every proposed project for advancing the nation—and there were many on Adams's mind—came down to money. From his treasury post, Rush joined Adams enthusiastically. His goal, he wrote, was "a great scheme of national advancement. . . . To organize the whole labor of a country . . . so that every particle of ability, every shade of genius, may come into requisition. . . . [I]n other words to lift up the condition of a country, to increase its fiscal energy, to multiply the means and sources of its opulence."

While Adams was under constant and open attack, Rush was usually able to operate safe from open controversy. In 1828, though, he drew fire from the most eccentric member of Congress at the

time, John Randolph of Roanoke, Virginia. Randolph was a slave-holder and possibly a medical eunuch, who habitually wore riding clothes and brought his hunting dogs with him to the floor of the House. An unidentified childhood disease had left him thin and ghostly pale, nearly hairless, and with a strange high-pitched voice. He was also very tall and he deliberately accentuated his strange-ness by affecting the dated eighteenth-century dress and speech of an English country gentleman.

Randolph actively opposed expansion of federal power for years. He was also an implacable foe of Adams and his men, and had already literally dueled with Adams's secretary of state, Henry Clay (they dueled over Randolph's public assertion that Clay had made a "corrupt bargain" with Adams in accepting the cabinet post, and neither man was injured). Randolph started baiting Rush, at the time Adams's ill-fated vice presidential candidate, in the summer of 1828. He attacked him from the House floor, first comparing his appointment as treasury secretary to Caligula's appointment of his horse as consul. He then read into the record a poem he had sup-posedly found: "And as for R——, his early locks of snow, betray the frozen region that's below./Though Jove upon the race bestow'd some fire,/The gift was all exhausted by the sire./A sage consumed what thousands might well share, and ASHES! Only fell upon the heir!"

Randolph's challenge marked the only time in his life that the circumspect Rush was truly provoked. He responded with an uncharacteristically personal and nasty attack in a letter to the *National Journal* under the name Julius: "John Randolph/Abroad and at Home/The fiend is Long and lean and lank/And moves upon a spindle shank." He ridiculed the effeminate, child-voiced Randolph's bizarre appearance and speech. "His grotesque aspect, the object of popular stare and scientific speculation, his profound obeisance to rank . . . a sort of wandering whimsiculo." No one,

Rush concluded, "has committed more offenses against those good feelings and good manners that are the cement of the social and moral world; whose career has been more broadly marked by affectation, mummery and malevolence."

James Smithson, living out his last years across the Atlantic Ocean in London and Genoa, puttering with his blowpipes and rocks, might have read about the controversy over whether the fledgling American government should be involved in promoting national culture and science. The London magazines had a keen interest in American affairs, but mostly only as they affected British interests. It is probably mere coincidence that only a year after Adams provoked his enemies by saying government should promote public knowledge, Smithson was writing a last line into his will instructing the American government to use his money to diffuse knowledge among men.

In 1828 Adams lost the White House to the populist frontier Democrat and war hero Andrew Jackson in a bitterly fought campaign. The new president represented a profound change in Washington. Jackson was the first president who was not connected to the original American founding group. His election represented a kind of triumph of frontiersmen over the educated elite. The campaign had been dirty, with charges of corruption and sexual scandal sullying both men's reputations. The Puritanical Adams was outrageously accused of putting up a billiard table in the White House; Adams's camp infuriated Jackson by questioning the premarital virtue of his wife, Rachel. Adams refused to attend the new president's inauguration and Rush was the only cabinet member who stayed away with him. But while Adams's bitterness was permanent, Rush made amends with the new powers. He became a Democrat and eventually took some diplomatic assignments from Jackson. One of these was the politically sensitive trip to England to secure James Smithson's half a million dollars.

ON JUNE 29, 1829, the British consul at Genoa had written a letter to the advocate general of Genoa asking that government seals be taken off the residence of "the late Sir Jacques Smithson English Gentleman who died the 26/24 of [June] at two o'clock in the morning." The consul advised the Genoese official that prior to the seals being affixed, he had already sent an aide to the deceased's house. The British vice-consul had already been inside the residence and conducted an inventory of the dead man's effects, carried out in the presence of Mr. S. L. Gibbs, "English Merchant in this city, Banker of the deceased." Smithson's papers had been put in boxes and trunks, and his clothes were being washed. The consul noted too that he had written "to the deceased's relatives to get their instructions."

These relatives were Henry Dickinson's former mistress, a woman once named Mary Ann Coates but now married to a Frenchman named Theodore La Batut, and her son by Henry Dickinson, named Henry Hungerford. When Smithson's younger brother, Dickinson, died in 1820, he left his estate to his elder brother, James, with the proviso that some of the money be held in trust for his illegitimate son and some be put into an annuity for his former mistress. Smithson had done that—and more. In his own will, he bequeathed all of his own and his brother's money to Henry Hungerford. After his mother's marriage—in the now well-established name-trading tradition among the Smithson-Macie-Dickinson men—young Henry had renamed himself Baron Eunice La Batut. The young baron was Smithson's nephew, sole blood relative, and now the heir to his substantial fortune.

Nobody knows whether Smithson had any reason to suspect his nephew wouldn't live a full lifetime and produce heirs of his own. The young baron was supposedly a high-living Continental dandy,

and there is even the mild suggestion that he was gay. The baron was not so dissolute that he didn't try to show appreciation to his uncle. He had Smithson buried in the most lavish sarcophagus in the British cemetery at Genoa, and paid for a marble cenotaph with a respectful epitaph. Unfortunately for future biographers, the young baron was misinformed, or didn't bother to check and just guessed at his benevolent uncle's true age. He instructed the stonecutters to carve "Age 75 years" on the tomb. In fact, although his missing teeth and poor health might have added years to his appearance, Smithson was eleven years younger than that when he died.

The baron then went on his way, in possession of Smithson's personal belongings and the income from stocks valued at around £100,000, a handsome if not princely living for a young single man. He had five years during which to enjoy his inheritance, which he apparently did heartily. The young baron traveled around Europe "living for his pleasures which did not, however, include women" until 1835, when at the age of twenty-eight or twenty-nine he died in a hotel at Pisa.

James Smithson's money—minus whatever the baron had managed to spend—was back in the care of his executors in England, the bankers Drummond. It was their duty to notify the American president of a peculiar sentence at the very bottom of Smithson's will, a sentence that would profoundly affect American cultural life for centuries. The news was not wholly welcome.

IN THE SUMMER of 1835, when Baron Eunice La Batut died at Pisa, the populist American president nicknamed Old Hickory was in his second term and, in his single-minded focus on retiring the federal debt, he had abandoned the Big Government plans of Adams. No one in politics was still seriously talking about federal support for the arts and sciences when Jackson received word late

in 1835 that a dead foreigner had left an enormous fortune—half a million dollars—to the United States "for the diffusion of Knowledge among men." Jackson saw not a gift but potential political trouble. American politics was not a sport played by intellectuals. The notion of applying a massive sum of money to an institution for diffusing knowledge and then putting a stranger's name on it sounded deeply ridiculous, if not outright offensive, especially as it was redolent of Adams and his lofty plans.

The other problem was that the donor was English. American politicians agreed on few things, but one bit of common ground was that the British couldn't be trusted. England-bashing was still a guaranteed crowd pleaser two decades after the War of 1812. Captain Basil Hall, a member of the Royal Navy who visited Washington around this time, sat in the congressional galleries and was astonished at the gratuitous anti-English sentiment that was a routine part of debate. "There was not one speech uttered in the House," he wrote, "wherein the orator did not contrive, adroitly or clumsily, to drag in some abuse of England. It might almost have been thought, from the uniformity of this sneering habit, that there was some express form of the House by which members were bound, at least once in every speech, and as much oftener as they pleased, to take a passing fling at the poor Old Country."

A very large national gift from an unknown Englishman was certain to provoke controversy, and Jackson had other problems to contend with, including a war with the Seminole Indians in Florida. Jackson threw the issue over to the Capitol in December 1835 when he formally notified Congress about the bequest, explaining that the executive did not have the authority to deal with it. Congress was not immediately receptive. Most, like Jackson, were preoccupied with other matters. Some Southerners immediately saw the money as a symbol of government expansion and argued against accepting it by appealing to national honor and

dignity. It was "dishonorable" to take any money from an Englishman, and it was "beneath the dignity" of the United States to confer immortality on a man merely for sending over a treasure hoard of cash.

John Quincy Adams, the former president now serving in the House, stepped into the breach. He was one of the few American politicians acquainted even tangentially with Smithson's milieu. Adams had communicated with the British Royal Institution and studied the model of the British national observatory, and he was still dreaming of creating a European-class American scientific community. Adams saw the money as a sign from God that his notion of American government involvement in science was providentially approved. Appointed to head a committee on the bequest, he persuaded Congress to vote to send an emissary to London to secure the funds.

Jackson, after being instructed by Congress to select an emissary, picked Rush, whose lengthy British experience and current status as a private citizen made him a convenient choice, to go across the Atlantic and accept the money. Rush was offered a salary of three thousand dollars a year, an expense fund of two thousand dollars, and a ten-thousand-dollar letter of credit to cover all legal expenses, every penny of which was appropriated reluctantly by Congress. Rush was required to post a personal bond of one hundred thousand dollars (in case he lost or stole the sum apparently), which he borrowed from a wealthy brother-in-law, and leave for England at once.

It was August 1836 when Rush sailed from New York to Liverpool with his son Ben on the first packet he could get, as usual suffering from seasickness almost from the first day out. A fellow passenger on this journey was Peggy O'Neale Eaton. Mrs. Eaton was the scandalous new wife—reputedly a former prostitute—of Jackson's former secretary of war and minister to Spain. Her dubious

origins and her elevated place in Washington society had provoked a larger breach between the president and his vice president, John Calhoun, and eventually precipitated the resignation of Jackson's cabinet.

A month later, the seasick diplomat sighted land. Rush was always struck with uncharacteristic emotion at his first sight of England, and this trip was no different. His initial impression on first sighting the city in 1817 had been one of shock at the scale and activity of London—the biggest metropolis the American native had ever seen, and he wrote about it at length in his diary. "I did not get back until candle-light," he wrote after his first day in London. "The whole scene began to be illuminated. Altogether what a scene it was! The shops in the Strand and elsewhere, where every conceivable article lay before you; and all made in England, which struck me the more, coming from a country where few things are made, however foreign commerce may send them to us; then the open squares and gardens; the parks with spacious walks, the palisades of iron, or enclosures of solid wall, the people, the countless equipages, and fine horses. . . . What industry, what luxury, what infinite particulars, what an aggregate!"

Disembarking at London in autumn 1836, Rush was no longer the wide-eyed provincial. He could navigate the bustling maze of streets, but more important, he knew his way around the halls of government and commerce. Straightaway he looked for a firm of British solicitors to represent the American cause and selected Clarke, Fynmore & Fladgate, after making some preliminary inquiries to assure himself that they "had a standing suited to the nature of the case and to the dignity" of the United States.

Rush initially hoped that he might secure the fund without having to actually file a suit in the notoriously slow Chancery Court, but the solicitors quickly disabused him of that notion. First, they told him, in order to make the claim valid with the British, there

would have to be a suit or legal proceeding. And second, there were some rival claimants, the French La Batut family. At this point, Rush had no concerns at all about the latter, writing to Secretary of State John Forsyth that "the mother of Mr. Hungerford not having been married to his father, it is scarcely necessary at this time to detail the circumstances of it [her claim]." He would soon be revising that report.

By November, the days were shortening, the weather was turning damp and dark, and Rush's optimism was on the wane. His hope of being able to secure the fund quickly and without a lawsuit was dimming. "The solicitors had said it could not [be done], but on a preliminary point so important I did not think that it would be proper to rest on them alone, but take the opinion of eminent counsel." He sought out and conferred with a Thomas Pemberton, "pretty squarely agreed" to be the most qualified member of the Chancery bar. Pemberton confirmed what the solicitors had already said. Not only would a suit have to be filed, but, Pemberton suggested, it would be a good idea to put both the president's name and the attorney general's name on the application in court. Making Jackson personally a party might help ensure that the case would be given high priority in a docket backed up with eight hundred cases ahead of the Americans. Rush was also told that "a Chancery suit is a thing that might begin with a man's life and its termination be his epitaph," a phrase that chilled the diplomat and which he kept in the front of his mind throughout his London assignment.

Pemberton also informed Rush of another possible fly in the ointment, in the form of a peculiarity in British estate law that especially affected James Smithson, bastard son. If the Smithson bequest contained any lands, the Crown was entitled to claim them, under an awkwardly named provision in the law called "the limitation after a limitation to illegitimate children." James Smithson—as an illegitimate son—was not legally entitled to bequeath

land rights to anyone. Although the Crown rarely exercised this right, it existed, and there was no telling whether the diplomatic situation might suddenly worsen and provoke the English to invoke Smithson's illegitimate status as a bar to the bequest. In a memo to Rush in November 1836, Pemberton wrote: "It is understood that the testator Smithson was illegitimate, we think that it will be advisable to make the attorney general a party to the suit in order that he might represent before the court any claim which the Crown may have by reason of the question of the validity of the limitation to the United States after a limitation to illegitimate children, or by reason of any part of the property consisting of interests in land."

Rush did not know then that Smithson, clearly anticipating this limitation, had converted his mother's entire estate into stocks and money long before he wrote his will.

BY CHRISTMASTIME, 1836, three months into his London stay, Rush had lost any illusions that he could finish his business quickly, and he began to make that clear in letters to Forsyth, warning the secretary of state to be prepared for "long intervals of inaction" in London. "I dare not undertake to say at present when I can get through," he wrote at the end of November. "*If* the court should not order an inquiry into the facts of Hungerford having died without children legitimate or illegitimate and *if* the attorney general should not make, or not press, for the Crown the point which our counsel have thrown out, then indeed I shall hope on good grounds for an early termination of the suit. But these are important *Ifs.*"

A full year then passed with no action, as the Master of Chancery studied the case. At first, matters looked promising for the Americans. The Crown and the executors put up no fight. The illegitimacy issue was moot because the property had been

converted to paper. The lawyers continued to try to find out more about the enigmatic benefactor, and to uncover any heirs who might have valid claims to the pile. They put advertisements in papers across Europe looking for children, legitimate or not. None came forward.

There was still, however, a claim to at least some of the money from the French La Batut family. Mary Ann La Batut, the former lover of Henry Dickinson and mother of the late young baron, was not a blood relative of Smithson's nor even a sister-in-law. But Henry Dickinson had expressly provided for her in his own will, by instructing that she be paid an annuity. She had been receiving that annuity from her son after Smithson's death, which had abruptly ceased when her son died.

Mrs. La Batut's husband, Theodore, traveled from southern France to London and demanded and won several face-to-face meetings with Rush and the lawyers. Rush was inclined not to cooperate. In his diary Rush described the Frenchman as a "troublesome person with unreasonable expectations. . . . It is understood that as long as [Dickinson] lived, he made her an ample allowance; but his death put an end to it and as far as the will of Smithson is concerned . . . she can claim nothing. This I understand to be agreed by counsel on all hands here." After the first meetings Rush refused to see La Batut personally again.

The La Batut claim had some validity, though—and the English Chancery Court saw it—since Dickinson had instructed his heirs to pay the mother of his son an annuity during her lifetime and she was still alive. After more quibbling and court inaction, Rush agreed—for the sake of expediency more than a sense of charity or what he believed to be the rightness of the claim—to set aside £5,000 out of which Madame La Batut would be paid an annuity for life. In a letter to Forsyth in May 1838, Rush said he decided to let the annuity stand simply in order to close the case and block off

any future fortune hunters from coming forward. The longer the suit lasted, the greater were the risks to which it was exposed, he wrote. "A large sum of money . . . was to go out of the country unless an heir could be found to a wandering young Englishman. . . . Here was basis enough for the artful and dishonest to fabricate stories of kinship on allegations of this young Englishman having been married. Fabrications to this effect might have been made to bear the semblance of truth by offers in the market of perjury in Italy, France and England, incidents like these being familiar to history." Such claims might have been ultimately defeated, but "it is easy to perceive that time and expense would have been required." The La Batuts apparently felt they deserved more of the fortune than the mere annuity itself. Ensuing generations of the family sent angry letters to the American government, implying that a fortune had been stolen from the rightful hands of a bereaved mother.

Legal costs had soared, and Rush was anxious to close off that spigot as well. The list of expenses filed by Rush's London solicitors was extensive, including every conceivable fee, from coach hires to parchment, clerk's fees, and firewood. A trained lawyer himself, Rush still professed astonishment at the way the piddling costs piled up. He had obviously been away from private practice too long. "It seems that something is to be paid for every step taken, every line written, and almost every word spoken by counsel, senior and junior, solicitors, clerks, and everybody connected with the courts and officers attached to them," he complained in one letter home. He wrote that he goaded them on by constant "teasing" in order to expedite the process.

When not dealing with his lawyers and the "troublesome" Frenchman, Rush had whiled away the long intervals of court inaction by calling on posh friends from his diplomatic days, visiting their country houses, talking politics, and picking up whispers and

gossip. King William had died and Queen Victoria was ascendant, ushering in a new period in English history. The Regency era and the Georgian days of Smithson's scandalous parents' heyday were receding into cultural dust. Circulating among the British swells, Rush made personal attempts to learn more about James Smithson. The fullest description he gave of Smithson was in a letter written on May 12, 1838—at the very end of his stay in London. Rush hadn't learned much about the benefactor, but he had decided—he doesn't say why—that the bulk of Smithson's fortune came from his father, the Duke of Northumberland.

"I have made inquiries from time to time in the hope of finding out something of the man, personally a stranger to our people, who has sought to benefit distant ages by founding in the capital of the American nation an Institution," Rush wrote near the end of his mission. "I have not heard a great deal. What I have heard and may confide amounts to this: that he was in fact the natural son of Hugh, Duke of Northumberland, that his mother was a Mrs. Macie of an ancient family in Wiltshire of the name of Hungerford, that he was educated at Oxford . . . that he went under the name of Macie until a few years after he had left the university, when he took the name of Smithson, ever after signing only James Smithson, as in his will; that he does not appear to have had any fixed home, living in lodgings when in London, and occasionally staying a year or two at a time in cities on the Continent, as Paris, Berlin, Florence, Genoa, at which last he died; and that the ample provision made for him by the Duke of Northumberland, with retired and simple habits, enabled him to accumulate the fortune which was passed to the United States. . . . Finally, that he was a gentleman of feeble health but always of courteous though reserved manners and conversation."

As to the benefactor's politics, Rush learned that Smithson was by no means deeply enamored of democratic American principles.

"[H]is opinions as far as known or inferred were thought to favor monarchical rather than popular institutions, but . . . he interested himself little in questions of government, being devoted to science."

Besides the curious assumption that Smithson's money came from the duke—proof of which Rush never provided—Rush seems to have learned nothing more about Smithson than the basic facts of his life. Given Rush's scruples, if there was any strange or scurrilous drawing room gossip circulating about Smithson, it was not something the diplomat would insert into the public record of the founding of what he hoped would be a great American institution.

Rush was too tactful to engage in speculations like those of the American chargé d'affaires in London, Aaron Vail, whose initial letter home on the bequest had cast some doubts on Smithson's mental health. Vail was the first American to see Smithson's will. His first impression was that the testator was not mentally sound, based on the grandiosity of the opening words about the noble blood in his veins. "The caption of the Will is in language which might induce a belief that the Testator was under some degree of mental aberration at the time it was made," Vail wrote to Forsyth.

Hints of mental illness or legal troubles emerge here and there in the scanty historical record, but with no anecdotal evidence or convincing sources. An entry in a German science biography claims Smithson ultimately left England as a result of "a blow to his reputation or a legal matter." No citation for this is given. In years to come, John Quincy Adams would write in his own diary—probably based on the Vail letter—that Smithson was "supposed to be insane."

ON MAY 12, 1838, almost two years after leaving for London to get the money, Rush wrote to the secretary of state to inform the

president that the Chancery Court had finally made a judgment in favor of the United States. Minus the La Batut annuity amount, the fund amounted to just over £100,000, most of it invested in 3 percent annuities. Rush now had to figure out how to turn the large amount of stock into cash without depressing the market and losing money at the same time. Selling on the open market was going to be a delicate task. He was especially worried that domestic events and foreign affairs—including a rebellion against British rule in Canada—might depress the stocks. He spent a month conferring with the American consul in London, Colonel Thomas Aspinwall, about the best method and time to sell the stocks. The two agreed to proceed cautiously until June 1838, a very merry month in England, with young Queen Victoria's coronation festivities in full swing. Rush suddenly had a sense that there would be no better time than the sunny present moment to finish the business. After all, he wrote, the jolly new queen might eat or party herself into ill health before the festivities ended.

On June 16, 1838, he wrote to Aspinwall: "The more I reflect upon the stock sales, the more disposed I am not to delay them. The little Queen I have always understood is a great eater, and every newspaper tells us she is a great frolicker. Now, if the little thing should chance to be taken sick in these junketing times of the coronation, only think how the stocks would come down. . . . As we are now at the close of the week, I think we had better get to work again on Monday and Tuesday in earnest . . . the stocks are really high now."

The Americans sold the rest of the stocks at the top of the market, a fact to which Rush proudly alluded in his final report to Forsyth: "[T]he sales were effected . . . with favorable results not to be surpassed . . . as the public records of the London stock market will attest." He then transferred the cash into gold bullion and employed no fewer than thirty-two private underwriters to insure

its travel. On July 14, 1838, Rush wrote his last letter to the secretary of state just days before boarding the packet ship *Mediator* with the sacks of gold.

"I have had much anxiety and no slight trouble in bringing to a close all these many matters," he wrote. Along with the gold, he oversaw the loading of fourteen boxes of Smithson's personal effects, which he had personally inspected and found in sad condition. "When first opened, it was evident that time, mould and careless packing in the first instance, had nearly destroyed many of the articles," he wrote to Forsyth in his final report. On July 16 the American consul Aspinwall paid two pounds, twelve shillings to the bullion porters, as well as a few more pence for packing and marking, to load 105 sacks of gold sovereigns into boxes. The following day these boxes, double-sealed, were loaded onto the *Mediator*.

Rush the diplomat was now charged with the menial but tense chore of personally guarding this treasure. His letters home indicate an eagle-eyed attentiveness to its every movement. Rush's next letter to Forsyth was just a scrawled few sentences, dated August 28, written from the harbor of New York. Within sight of the church spires of New York, Rush's seasick body must have longed to disembark after more than a month at sea and stand on the land before him, but he didn't mention his own condition. "Sir," he wrote, "I have the honor to report to you my arrival here in the ship Mediator with the amount of gold of the Smithsonian bequest received for the United States." He promised to hold it in his personal custody, as ordered by the act of Congress of 1836. There were several days of customs business to be completed before the ship could actually dock. Rush was still on the boat, bobbing at sea, on August 29, waiting to dock.

By September 4, Rush had stumbled ashore and taken a coach to Philadelphia with the gold beside him. After seeing the fund— worth 104,960 pounds—deposited at the U.S. Mint, he took to his

bed in his family home just outside the city. Seven days later, on September 11, 1838, he had regained the strength to write to Treasury Secretary Levi Woodbury, apologizing for not informing him earlier that the fund was already deposited at the Mint. This, though, Woodbury already knew.

Rush's biographer wrote that his involvement in the Smithson bequest—which did not end here but continued until the founding of the institution—was one of the proudest achievements of Rush's life. His correspondence makes clear he felt he'd done a good job, whether Congress agreed or not. Half a year after he'd been back in America, he wrote to the American consul Colonel Aspinwall in London, congratulating him and patting them both on the back for a job well accomplished. The colonel had lost a daughter to a childhood illness in the interim, and Rush, who had buried two of his own children years earlier in London, assured him that "there are none who would offer you more heartfelt condolences than Mrs. Rush and myself." He then informed Aspinwall that as far as "the little Smithson affair, I assure you we both came well out of it.

"I have reason to know there were those in Congress eagle-eyed to find fault but they could not. All that I did, with your good aid, was so fair and square—so above all cavil even—that they had to give up the task as hopeless. . . . But what a little uproar would have been raised if we had not left the main fund as undiminished as possible! Even our old friend Mr. Adams would not have spared us you may be sure."

Being a cautious man, Rush made no predictions about what might now be done with the treasure hoard he'd safely delivered to his country. He must have known, though, writing in May 1839, that half a year previous, Congress had invested the fund in state stocks without any determination as to how the money would begin to increase and diffuse knowledge. He did know, but did not discuss in this letter to the grieving Aspinwall, that during his two

years in London, the American nation had not fared at all well economically. It had, in fact, descended into an official depression beginning with a financial panic in 1837. Unemployed people were rioting in New York, the sale of public lands had fallen drastically from twenty million acres in 1836 to three and a half million in 1838, and the banks were teetering. The nation was, for all intents and purposes, broke. It would run a deficit for four of the next five years.

And in the late summer of 1838, thanks to the dedicated efforts of Richard Rush, half a million dollars was—ever so briefly—loose change inside the United States Treasury.

"A RATTLESNAKE'S FANG"

W HEN SMITHSON'S BEQUEST landed on American shores, America was not known for its scientists, its intellectual life, or its diffusion of knowledge. The new country was the subject of derision and withering anecdotes about provincial manners in almost every British journal in the early nineteenth century. European travelers (with notable exceptions like Tocqueville) often sent back scathing tracts about the backwardness of the people and their savage habitat. European superciliousness had even infected scientific minds like that of the Count de Buffon, the great French naturalist, and a contemporary of Smithson's. Buffon dissected and compared the animals of America and Europe and theorized that American animals (and humans) had migrated to the New World from the Old World and thereafter degenerated in size and vigor thanks to the inferior climate and diet. Jefferson himself while in Paris personally worked to refute the theory.

Within America and to some extent England, there were—or had been, anyway—high hopes that America after the Revolution would become a new Athens. Horace Walpole certainly thought so.

"The next Augustan Age will dawn on the other side of the Atlantic," he wrote in the mid–eighteenth century. "There will, perhaps, be a Thucydides at Boston, a Xenophon at New York, and, in time, a Virgil at Mexico." Political and economic freedom were expected to unleash creativity, which in turn would form the basis for a thriving culture of arts and sciences. "It is impossible for the arts and sciences to arise, at first, among any people unless that people enjoy the blessing of free government," the Scottish philosopher David Hume had written in the mid–eighteenth century.

In America in the 1830s, though, reality had been slow to catch up with the dream. For years, there were almost no institutions of higher learning in the United States in which American scientists and their work could be nurtured. There was certainly nothing like the Royal Society, the Royal Institution, or the Institut National de France. John Quincy Adams, who had staked his doomed presidency on the deeply unpopular notion of expanding the federal government into the realms of science and education, was one of a group of men who keenly felt American intellectual inferiority. But that sense wasn't widely shared. It wasn't that Americans were unappreciative of science or ignorant of its potential. On the contrary, the country was a nation of extremely pragmatic men and women who had a great interest in the ways scientific knowledge could be put to practical use. By the 1830s popular magazines were already devoted to informing readers about new uses for electricity and improved agricultural methods and were advertising new gadgets to make life easier.

The premier American man of science had been Ben Franklin, whose international status as a practical polymath—writer, scientist, revolutionary—continued to be the quintessential positive American image abroad well into the nineteenth century. Franklin personified the nation's utilitarian attitude toward culture. Science had to have some practical *use*, or it was wasteful. Knowledge for its

own sake, a notion unquestioned at the Royal Society in Smithson's time, was not enough. "All things have their season and with young countries as with young men, you must curb their fancy to strengthen their judgement," Franklin wrote. "To America, one schoolmaster is worth a dozen poets, and the invention of a machine or the improvement of an implement is of more importance than a masterpiece of Raphael."

Franklin's ingenuity applied to his broad interests—everything from politics to electricity to a cure for the common cold—was an eighteenth-century approach that Smithson and his peers in the Royal Society understood. Franklin's international stature had helped raise hopes outside America for the future of American science, but he was not matched by any other American. Within the United States, his admirers included Benjamin Rush, Richard Rush's father, who attended Franklin at his deathbed in Philadelphia. Richard Rush was just a small boy of ten when the great Franklin expired in 1790, but his father made sure his son was fully aware of the genius of Benjamin Franklin. Benjamin Rush wrote of Franklin's last days, "The evening of his life was marked by the same activity of his moral and intellectual powers which distinguished its meridian."

Thomas Jefferson was another member of the founding generation whose interests exemplify the utilitarian American attitude toward science. Jefferson had no use for theories unless they could be put into practice. Geology, he once said, was "too idle to be worth an hour of any man's life." Botany was relevant only insofar as it increased farm yields or served to beautify the landscape, and chemistry only when it led to better beer, soap, vinegar, and other products.

By the early nineteenth century, there was no question in America about the validity of the idea that diffusing scientific knowledge could improve the lives of men. But unlike their European counter-

parts, American scientists had neither the leisure for experimental work nor the formal framework for communication that existed in the Europe. Nor was there official support for theoretical science, which was regarded with the same kind of distrust that many early Americans had for the fine arts.

Meanwhile, the American continent remained a subject of deep fascination to European scientists, and any serious American scientist studying the land and its people had to contend with competition from better-funded and better-educated men eagerly traveling from across the Atlantic. As Alexander von Humboldt, the German explorer of South America, wrote, the ecstatic feelings of a European naturalist upon first sighting American shores were indescribable. European scientists—and their American counterparts—knew that the lush scrim of trees and coastal mountains first visible from the Atlantic were just the outer boundaries of a new universe of scientific discovery. There were new species of plants and animals to classify, strange new geology to probe, aborigines to study, antiquities to collect, and a vast mapping to be done.

In colonial times, American scientists in the early part of the eighteenth century were often little more than assistants or specimen collectors for the Europeans. Even early in the nineteenth century, Joseph Banks was still overseeing the botanical exploration of America, with the junior cooperation of Americans. One of these American botanists, Jacob Greene, lamented the fact that all the glory of discovery was going to the Europeans, who "have immortalized themselves" in the process. Even the plants collected on the Lewis and Clark expedition were classified by a visiting German.

With the exception of Ben Franklin and his kite, most of the breakthroughs in chemistry and electricity of the late eighteenth and early nineteenth centuries were European. Conditions in the United States were simply not advanced enough to support the kind of work done by Lavoisier in France and, later, Davy and Faraday

in London. After the Revolution, American scientists began to come into their own, but they faced huge constraints in terms of time, communications, tools, and money. European scientists came abroad to study and classify American botany, geography, geology, animals, and humans. There were no American Smithsons traveling the nation's muddy lanes and picking their way up mountainsides in lace cuffs, with servants hauling their miniature chemical kits and collections for them, their pursuits limited only by their curiosity. The wealth and leisure of the European men of science simply did not exist in America.

The nation's first chemists, geologists, and botanists were usually practicing physicians, and any experiments they made were strictly on the side, after the daily round of purgings and bloodlettings. The American Mineralogical Society in New York was originally organized by the editors of a medical journal. Benjamin Rush complained that American doctors were "chained down by the drudgery of their professions, so as to be precluded from exploring our woods and mountains." Early American astronomers practiced their sky watching as an avocation, while they worked days as surveyors or held public office to support themselves.

Even when early Americans had time for science, they had a hard time finding any tools or books or venues in which to share their work. "We have no cabinets of natural history in America," lamented one early American scientist, the clergyman, botanist, and congressman Manasseh Cutler, writing to a European friend in 1799. "We have many public libraries, consisting of large collections, excepting on the different branches of natural history, in which there are few . . . and our booksellers import no books on this subject."

There was no counterpart in America for the Royal Society. American organizations had begun to be formed with the purpose of creating a community of science, but they had no connection to

the federal government or the capital. The American Philosophical Society in Philadelphia was the first, founded by Ben Franklin. Franklin suggested the society in 1743, in *A Proposal for Promoting Useful Knowledge Among the British Plantations in America*. The society, Franklin wrote, would be centered at Philadelphia, because of its location at the center of the Colonies, and would employ a physician, botanist, mathematician, chemist, geographer, and natural philosopher. The topics to be investigated were broad and included "[a]ll new-discovered plants, herbs, trees, roots &c., methods of propagating them. . . . Improvements of vegetable juices, as ciders, wines &c. New methods of curing or preventing disease. All new-discovered fossils. . . . New discoveries in chemistry, such as improvements in distillation, brewing, assaying of ores &c. New mechanical inventions for saving labour." On and on went the list, heavily weighted toward the practical, not theoretical, applications of science.

The preface to the first volume of the society's *Transactions* distilled the essence of the American attitude toward science at the time. "Knowledge is of little use when confined to mere speculation," the editors wrote. "But when speculative truths are reduced to practice . . . and when by these agriculture is improved, trade enlarged, the arts of living made more easy and comfortable, and of course the increase and happiness of mankind promoted; knowledge then becomes really useful."

Eventually, two more American scientific foundations joined the American Philosophical Society—the American Academy of Arts and Sciences at Boston and the Franklin Institute, also at Philadelphia. The scientific societies provided the kernel of a network and by the 1830s were starting to publish work that was more theoretical as opposed to purely practical. Even with new associations and journals, and with public interest growing, American science was slow to evolve. Philadelphia chemist Robert Hare urged another

American chemist, Benjamin Silliman, in 1817 to send his articles to British journals instead of publishing in America. "It really seems bad policy to publish anything in this country upon science in the first instance," Hare wrote. "It is rarely attended to in England and we are so low in capacity at home that few appreciate any thing which is done here unless it is sanctioned abroad."

When Smithson's money arrived, the impetus behind American scientific experimentation remained practical. How could science aid the work of carving a new nation out of the wilderness? As roads, canals, mines, and railroads were built, as geological surveys were established, America had a greater need for men of science. By the late 1830s most of the great American scientists were, for the first time, actually born on American soil. What they still lacked was a central repository and the frame of an institution.

Smithson's money and his instruction as to what to do with it were received in America within a specific context that included a very utilitarian approach to science and a distrust among some of what we would today call high culture. The politicians assigned to define an institution for the diffusion of knowledge were not immediately able to fulfill the task because of competing ideas about what America's culture was going to be. Some thought a working farm attached to an agricultural college in the capital best diffused the kind of knowledge Americans needed; others imagined building the greatest library in human history; still others wanted the money to go toward educating the common people, in the form of a normal school. In the beginning anyway, those who wanted the money to go into an institution specifically aimed at the sciences were in the minority. The fact that they prevailed is itself one of the earliest indications of an American intellectual community being born.

———

IN THE 1830S New York, Philadelphia, or Boston was the logical place in which to establish a national scientific institution. If Smithson had not specifically named Washington in his will, it is unlikely any American alive then would even have considered putting a Smithsonian in the national capital. The fact that Smithson selected Washington probably created as many problems for the Americans as did the phrase "diffusion of Knowledge."

Washington City in the early nineteenth century was more like a frontier town than the seat of a national government. Vast areas of the city were forest or scrub, interrupted by muddy construction sites. Some of the buildings we recognize today—the Capitol, the White House—had just been built and gleamed an incongruous white above acres of wild marshland. Workmen lured from the bigger American cities and Europe were just piling up the great stone blocks of the Treasury building. Pennsylvania Avenue already linked Congress and the president's "Palace," but it was a dirt road flanked by swamp grass, tree stumps, and bushes, not the broad avenue lined with government buildings we recognize today. The capital city climate was unforgiving for people living in an era before cars and air-conditioning. In winter fog and icy mud made travel treacherous if not impossible. Steaming summers brought mosquitoes and malaria. Cholera epidemics raged annually, killing people from all ranks of life, starting with the freed blacks who huddled together in provisional huts, moving through the Irish shopkeepers and boardinghouse owners and their servants, and finally into the homes of the families who considered themselves "quality"—the new government officials.

Besides the threat of disease and the city's awkward, muddy newness, Washington had a seedy, dangerous edge. High culture— fine arts, theater, music—was nearly nonexistent within the city, and many of the elected officials who bunked there during legislative sessions held a view shared by many Americans that such

things were wasteful, maybe even harmful to the vigor of the new nation. Side arms, chewing tobacco, and hip flasks were Capitol Hill accoutrements for most officeholders. Hunting dogs shared floor space with congressmen in the House. Fistfights sometimes broke out at presidential parties inside the White House. The Americans called these events "levees," drawing out the accent on the last syllable to the great hilarity of visiting Europeans trained in proper French pronunciation. Duels were still an acceptable, if illegal, method of settling disputes involving honor, and even high-ranking national officials indulged in "rencontres," as they were delicately described in the press. Alongside the muddy streets, unkempt bands of workmen assembling the great stone buildings amused themselves by taking breaks and drinking during the day. When the Smithson bequest arrived, Washington newspapers were running front-page ads desperately seeking women to come to Washington to be wives to the stoneworkers on the Treasury building.

The American writer Anne Royall was moved by the architecture and interior design of the Capitol but horrified by the iniquity inside its halls. "It is not in the power of language to express anything equal to the interior of those domes, for richness and beauty, flowers and wreaths, in profusion, decorate their inside as white as alabaster," she gushed after an 1826 trip to Washington. She was less charmed by the city's inhabitants. "[I]gnorance, impudence and pride, are decided traits in the bulk of the citizens of Washington," she wrote in the same account. "One is astonished upon going into the shops and stores, which are spacious buildings, to meet with the most unpolished, uncouth looking people." For publishing that slander on the good people of the capital in her travelogue, Anne Royall was legally due a ducking, but a judge let her off with a fine.

The prim, gray-headed belletrist in her bonnet and stays saved

her deepest outrage for the denizens of the Capitol building. "[O]f all sights that ever disgraced . . . a house of Legislation, and one which most astonishes a stranger, is the number of abandoned females, which swarm in every room and nook in the capital, even in daylight. I have seen these females with brazen fronts, seated in the galleries listening to the debates. They used to mix promiscuously with the respectable class of females until Mr. Clay assigned them a place by themselves. Mr. Clay certainly does deserve much credit for this public homage to virtue."

Easy women pitching their "brazen fronts" above the national debates were only exceeded in impropriety by the "temple" dedicated to drink at the very door of the House of Representatives. In a fantastic little anteroom lighted with skylights, one of the abandoned women presided over a table spread with liquor for sale. An attempt to shut down the little establishment was beaten back on constitutional grounds, a fact to which Royall alluded with a stream of horrified exclamations. "In short the bold strides of licentiousness seem to threaten a total overthrow of virtue!" Eventually Capitol liquor sales were abolished, but one could still get a nip of gin or whiskey under the name of sherry or brandy at the oyster shop in the basement.

There was another, more grotesque aspect to Washington City at this time, one that never failed to appall visitors from foreign lands. In spite of the best efforts of abolitionists and some congressmen to stop it, slaves were still bought and sold on the banks of the Potomac. Within sight of the steps of the Capitol, shackled slaves sometimes shuffled by, in pitiful condition. One writer described the sickening scene from the Capitol doors in 1815: "A procession of men, women and children, resembling that of a funeral . . . bound together in pairs, some with ropes, some with iron chains." The city jail was sometimes described as a storehouse for slave merchants. Even freed blacks—of whom there was a

growing population in Washington—were in danger of being kidnapped and sent back to the South.

Socially, Washington was still working out its rules of protocol. Needless to say, there was nothing even approaching the witty, elegant, and rigidly hierarchical court circle that Richard Rush encountered at the Court of St. James's in London. During the 1820s John Quincy Adams as secretary of state was charged with working out some rules of official etiquette, and he often complained in his diary about the nasty quarrels and general rudeness that prevailed at the presidential levees. Even with some rules of conduct, because this was a republic, no one was ever barred from the presidential "Drawing Rooms" which were held weekly from December to March. At these parties, according to one contemporary observer, "conversation, tea, ice, music, chewing tobacco and excessive spitting afford employment for the evening." Culturally, the city didn't offer much. Adams and his wife introduced musical nights at their White House salons, but the city was unimpressed.

In 1836 the diffusion of knowledge among mankind was not at the top of the agenda in Congress. The dreadful state of the budget, tariffs, the fall of the Alamo, the expansion of slavery, and an Indian war in Florida all held far greater interest. In Washington the political reaction to news of Smithson's bequest was not joy but befuddlement, followed quickly in some quarters by indignation at the idea of wasting good money on something as esoteric as diffusing knowledge. As one historian has written, "Congressmen of the 1820s and 1830s would as soon have been caught in adultery as in writing a book."

One House member—the former president John Quincy Adams, now in his fourth year of what would be a seventeen-year career in the House—was deeply moved by James Smithson's

posthumous words. After his bruising 1828 presidential loss to Andrew Jackson, Adams had bitterly vowed to retire from politics. But in 1830 his home district in Plymouth, Massachusetts, elected him to the House of Representatives, and he returned to Washington where for the remainder of his life he served as a powerful, influential leader.

Adams was one of a handful of American presidents who can be described as truly intellectual. He was an oxymoron, a scholar-politician, and a Continentally educated Puritan. Surrounded as he was with rough men and ugly customs, he was also habitually disappointed. Adams battled his despair by clinging to a spiritual faith in the power of knowledge to save men from sin. Adams's Continental education and travels, undertaken while his father was an emissary for the Revolutionary Americans in Europe, had been heavy on classics and language, giving him a solid base of learning and lifelong scholarly habits. At the age of seventy, he taught himself Hebrew. His rigorous Puritan self-discipline, his serious cast of mind, his wide and deep reading, and his passionate interest in mathematics, science, and especially astronomy made him a highly unusual figure in American politics in his time. Unfortunately, Adams's intellectual powers were not matched by an equal portion of what modern psychologists call emotional intelligence. Adams was not a charming, easy man, and his grim personality put him at a great disadvantage in politics.

Anne Royall met Adams when he was secretary of state, just before he ran for and became president. Her observations paint a reverential picture of a humorless, serious man, in many ways out of his time and place. "Mr. A. received me with that ease of manner, which bespeaks him what he really is, the profound scholar," she wrote. "I had heard much of Mr. Adams. . . . While beholding this truly great man, I was at a loss how to reconcile such rare endowments with the meek condescension of the being before me. He

neither smiled nor frowned but regarding me with a calmness peculiar to him, awaited my business. . . . His complexion is fair, his face round and full, but what most distinguishes his features is his eye, which is black; it is not a sparkling eye, nor yet dull, but one of such keenness that it pierces the beholder. . . . He has the steadiest look I ever witnessed, he never smiled while I was in his company, it is a question with me whether he ever laughed in his life, and of all the men I ever saw, he has the least of what is called pride, both in his manners and dress." Anne Royall's question about his ability to laugh was no isolated observation. The former president was so habitually dour that Ralph Waldo Emerson suggested he took sulfuric acid with his tea.

When news of James Smithson's bequest reached Congress, Adams was at a particularly low point in his personal life. He was recovering from a lengthy period of disappointment and grief. His son John, who had served as his secretary in Washington, had died the year before of some unnamed malady probably related to dissipated living. Six years earlier, his son George Washington Adams had fallen off a river steamer and drowned—a possible suicide resulting from a chronic alcohol addiction. Both sons—but especially George—had a fondness for drink, a weakness that the rigorous Adams could hardly bear to contemplate.

When Adams first heard of the bequest and its purpose, he was enormously cheered. It seemed to his Puritan imagination that his long-cherished dream of a federal science institution—maybe even that much-jeered lighthouse of the skies—now had God's personal approval. He recorded his feelings in his diary in January 1836: "A stranger to this country, knowing it only by its history, bearing in his person the blood of the Percys and Seymours, brother to a nobleman of the highest rank of British heraldry who fought against the revolution of our independence at Bunker's Hill—that he should be the man to found, at the city of Washington, for the United States

of America, an establishment for the increase and diffusion of knowledge among men, is an event in which I see the finger of Providence, compassing great results by incomprehensible means."

As head of the House committee on the bequest, Adams was immediately curious to know as much as possible about the man behind the money. He had wanted to include some personal information "complimentary" to the donor in the report he was directed to give to the full House on the Smithson bequest, but facts were scarce. Nasty charges were already rushing into the vacuum. "[S]o little are the feelings of others in unison with mine on this occasion, and so strange is this donation of half a million dollars for the noblest of purposes, that no one thinks of attributing it to a benevolent motive," he wrote in his diary. "Vail [the American chargé d'affaires in England] intimates in his letter that the man was supposed to have been insane. Colonel Aspinwall conjectures that Mr. Smithson was an antenuptial son of the Duke and Dss of Northumberland, and thus an elder brother of the late Duke."

Adams delivered his first major speech on the bequest in January 1836, just a month after Jackson had notified Congress. Adams argued that accepting the gift was "an imperious and indispensable obligation." He was well aware of the objections being raised to accepting money from an Englishman and he tried to address them. America had "been freely visited, and often in no friendly spirit by travelers from the native land of Mr. Smithson," Adams said. These travelers reported back on the manners and opinions of Americans with "no complacent or flattering pictures." He argued that the fact that Smithson, an Englishman exposed to these unflattering reports, had chosen America as his beneficiary was "a signal manifestation of the moral effect of our political institutions upon the opinions, and upon the consequent action, of the wise and good of other nations."

Adams briefly charted Smithson's illustrious pedigree for his

colleagues—without noting his illegitimacy—and then proceeded to wax eloquent on the subject of diffusing knowledge. "The attainment of knowledge is the high and exclusive attribute of man, among the numberless myriad of animated beings, inhabitants of the terrestrial globe," Adams told his House colleagues. "To furnish the means of acquiring knowledge is, therefore, the greatest benefit that can be conferred upon mankind."

Adams took the job of shepherding the bequest with, as he put it, "no small degree of anxiety." Adams was well aware of the weaknesses of his fellow politicians, and he suspected ulterior motives in even those who genuinely shared his interest in seeing the money well spent. Before Richard Rush had even left for London, Adams was privately worried about the fate of the money. "Whether this bequest will ever come to anything is much doubted by almost everyone," he wrote in his diary in 1836. From the start, Adams pessimistically believed the money would only become a source for the "diffusion of Knowledge" with great vigilance on his part. "I proceed with a heavy heart from a presentiment that this noble and most munificent donation will be filtered to nothing and wasted upon hungry and worthless political jackals." His fears were probably being realized as he wrote the words.

HALF A MILLION DOLLARS in 1836 was the equivalent in buying power of $50 million today. It was an enormous sum in a land where the per capita income was $96 or $109, depending on whether slaves were considered consumers. It was nearly equal to the entire endowment—$600,000—of Harvard at the time. The bequest could have purchased four hundred thousand acres of federal land at the 1840 price of $1.25 an acre. The total sum invested in manufacturing in the state of Virginia was only just over $11,000. In short, no single benefactor had ever left so much money to any

American institution for the sole purpose of increasing and diffusing knowledge.

It was big money, but when Jackson's message about the Smithson bequest reached the Capitol in December 1835, most congressmen were indifferent. It took them six months to pass the legislation just to pay for Richard Rush's trip to London. A few saw the bequest as a tool with which to argue for or against other political or economic issues. A smaller few immediately sniffed out a chance for personal gain. It was this last group—and not the states'-rights Southerners—that Adams most feared.

On August 6, 1838, while Richard Rush and his hoard of gold coins were still bobbing somewhere on the Atlantic, Treasury Secretary Levi Woodbury took out an ad in the *Washington Globe* announcing that the U.S. government would soon have Smithson's half a million dollars to invest in state stocks. A month earlier, just after Rush had notified American officials that he had secured the fund, Congress, in a last-minute "tack" attached a nongermane amendment to a bill authorizing appropriations for West Point. That amendment authorized the treasury secretary to invest all of Smithson's money in state stocks. Nowhere were the states directed to see that the money would diffuse knowledge among men.

Woodbury publicly invited proposals from people with stocks to sell. In the midst of a national economic slowdown, with a bank panic just months away, the August advertisement of half a million dollars seeking a home was red meat before a pack of starved carnivores. Bankers and brokers from all over the union surged forward with proposals, but they might not have bothered. The winning proposal came from the inner circle.

Washington City was rough, but it had already attracted a class of smooth men expert in turning an amiable government official into a handsome profit. To place his half a million, Woodbury chose a familiar face, the eminently well connected Washington

broker William W. Corcoran, founder of the D.C. banking firm Corcoran & Riggs, an institution that survives in modern Washington. Corcoran and Woodbury had a close working relationship throughout the secretary's term. Corcoran's firm profited even in its first year, because the treasury secretary kept Corcoran apprised of competitors' bids on U.S. treasury notes. At the time, such cooperation between a cabinet member and a businessman was considered neither unethical nor illegal.

Rush didn't know it, but when he wrote to Woodbury in September 1838 assuring him the sacks of British coins were safely at the U.S. Mint in Philadelphia, the money was already spent. Woodbury had paid Corcoran $499,500 within three days of the conversion of British gold to U.S. dollars. Corcoran purchased five hundred Arkansas state bonds with most of the funds. Over the next ten months Corcoran invested the rest of the Smithson fund money in eight state bonds of Michigan and twenty-three more from the state of Arkansas. Corcoran himself was enriched by these transactions, receiving a healthy commission on half a million dollars. The U.S. Treasury was not so lucky. The bonds were supposed to pay 6 percent per annum. Given the teetering national economy and dicey conditions within the frontier states, the bonds, not surprisingly, turned bad rather quickly. Worse, they contained a requirement that the principal remain untouched until 1860.

The national press covered the early debates about Smithson's money, but the sudden and undebated investment of it in state bonds went unreported. Adams was the sole voice of protest in the Congress when the West Point appropriations bill—during the final hours of the 1836 session—was slammed through with its nongermane amendment putting Smithson's money in state stocks. "This is one of the worst abuses of legislative power," he said later, speaking of the time-honored congressional maneuver—practiced to this day—of a last-minute "tack" onto a crucial appropriations bill. Affixing a dubious and nongermane measure onto a necessary

bill like the West Point appropriation, Adams told his constituents, was like holding a cup of wholesome liquid to the lips of a thirsty man that contained "a portion of poison."

By January 1839 Adams was worried, and he said so on the House floor. "Not so easy will it be to secure, as from a rattlesnake's fang, the fund and its income forever from being wasted and dilapidated in securities to feed the hunger or fatten the leaden idleness of mountebank projectors and shallow and worthless pretenders to science," he warned.

Two years later, his worst fears were realized when the Arkansas bonds stopped paying interest. Adams was now spurred by a sense of outrage. In April 1841 he wrote, "The chief obstacle will now be to extricate the funds from the State of Arkansas." To effect that, he persuaded his House committee to draft legislation demanding that the Treasury give an accounting of the vanished Smithson fund, and pledge the U.S. government to step in and make the payments.

The treasury secretary's evasive response gave no clear idea of how the funds were doing. "There are no means here for ascertaining the market value of the State stocks at any particular time with accuracy," Woodbury wrote. "Sales of such stocks are rarely entered in the reports of stock operations at the boards of the brokers in the principal cities and extensive and tedious correspondence would alone enable me to give a near approximation to their worth at the periods of these numerous purchases."

Woodbury had good reason not to want to look too closely into the bonds. He had apparently cut a gentleman's deal with Corcoran that required no "tedious correspondence." The Treasury report on the state bonds does include a series of letters between the secretary and various bond brokers and state officials during 1836. After Woodbury's advertisement soliciting offers for the half million, the Treasury was flooded with offers from a dozen states and brokers all over the union. A one-line letter to Woodbury from the Washington broker Corcoran effectively outbid all other offers.

A number of men eventually profited from the Arkansas default. William Corcoran certainly got his share, and legally. The rest of the winners are men whose names and fates are as murky as the muddy river that winds through Little Rock. Once the bulk of Smithson's money was in the Arkansas Real Estate Bank, its fate became tied up in the wild, frontier politics of a state where official financial malfeasance was as common as splitting rails and clearing timber. Even construction of the Arkansas statehouse had to be halted after the funds to build it were embezzled.

The leading political figure in the Arkansas territory was Ambrose Hundley Sevier. Sevier was a fireplug frontiersman with a ragged bowl-shaped haircut and a mean temper. "Don Ambrose," as he was called, was godfather of a powerful Arkansas political "family." He first served as territorial representative in the House, then took a seat in the U.S. Senate beginning in 1836, the year Arkansas was admitted as the twenty-fifth state, and coincidentally, the year Smithson's bequest became known in Washington. Sevier's manner was as rough as the southwestern frontier from which he hailed. A New York newspaper in 1843 described him as "a political partisan of the most ultra-radical type . . . one of those rough and tumble geniuses which no country can produce but ours; and in ours only in the extreme western portion."

On the Senate floor, Sevier favored the "barbarian" style typical of politicians from frontier and western states. Exaggerated swaggering, tobacco-spitting, and profanity differentiated the real western men from the pompous dignity and scholarly style of some of the easterners—Adams among them. Sevier's roughness was not a put-on. He owed his leadership in Arkansas to the fact that the preceding territorial delegate had been killed in a duel. His own uncle had been killed in a duel during Sevier's first run for the U.S. House as territorial delegate, and Sevier himself had accepted a challenge and narrowly escaped with his life. Ironically, Sevier's

chief work in the Arkansas legislature had been attempting to outlaw duels.

Sevier was a backwoods ruffian, but he was also a canny politician and a powerful advocate for his state in Washington, convincing federal officials to pay a salary to the territory's legislators and grant the state public land on which to build a capitol. He also oversaw numerous appropriations for road and river navigation improvements.

Adams certainly detected a political motive in the purchase of the Arkansas bonds, but he never named Sevier, either in his diary or in public. Publicly, Adams called the purchase of the Arkansas bonds a "bribe," traded by the administration for a crucial House vote. "I might press these objections further by calling to your minds the weight and importance of the State of Arkansas and of her single representative in the House at Washington, upon the contingency of a Presidential election but I forebear," he said in Boston in 1839. Sevier had been the sole Arkansas representative in the House before 1836.

In the fall of 1839 Adams gave two major public speeches on the subject of the Smithson bequest, trying to rally public interest. He spoke of the scientist's lofty dream, and his own interpretation of how to fill it. He spent most of his time detailing how politicians had already failed to carry out their responsibility. He wrote the two speeches to be delivered as lectures on his home turf in Boston and Quincy, in November, as a personal barnstorming effort.

"If I can possibly rouse the public mind to take some interest in this foundation, it may save the fund from being utterly wasted and lost," he wrote in his diary in November 1839. "And the more frequently I go before the public upon it, the more chances will there be for connecting public sympathies with it."

Adams read the first speech in Boston personally in November. The second speech he was forced to have read for him a few weeks

later, because of yet another family tragedy. At the hour when he was supposed to be reading the lecture in Quincy, he was sitting at the bedside of his dying granddaughter Georgiana, daughter of his dead son John, who took her last breaths as Adams's speech was being delivered by another man.

Even as he wrote about the "gauntlet of rapacious and piratical adventure" through which the Smithson fund had already passed, he was privately in despair about its fate. "It is hard to toil through life for a great purpose with a conviction that it will be in vain," he wrote. "If I cannot prevent the disgrace of the country by the failure of the testator's intention, by making it the subject of a lecture I can leave a record for future time of what I have done, and what I would have done, to accomplish the great design, if executed well."

Adams was extremely downcast about the prospects of ever retrieving the money from the "rattlesnake's fang." He wrote in his diary around this time that the Smithson bequest "weighs deeply on my mind. The private interests and sordid passions into which that fund has already fallen fill me with anxiety and apprehensions that it will be squandered upon cormorants or wasted in electioneering bribery." The combined forces of greed and Southern dissension were all "so utterly discouraging that I despair of effecting anything for the honor of the country, or even to accomplish the purpose of the bequest—the increase and diffusion of knowledge among men."

Finally, in late 1841, thanks entirely to Adams's persistence, Congress voted to repeal the bill authorizing investment of Smithson's money in the state funds. No one was held personally accountable for the loss, but the U.S. Treasury was ordered to replenish the fund. The closest Adams came to actually naming Sevier as a scoundrel was when he recorded in his diary that he'd complained to the treasury secretary in 1843. (The secretary, John Spencer, "turned up his eyes at the swindling speculation of the Senator

from Arkansas, and shrugged up his shoulders at the prospect of ever recovering the money from that State," he wrote.) Sevier and his cronies very likely personally profited from the Smithson money. The Arkansas General Assembly censured Sevier in 1842 for financial malfeasance regarding bonds associated with a failed Arkansas Real Estate Bank, and he was investigated by Congress in 1844 for the same scandal. His political career suffered after state officials forced him to report that he had mixed revenue from the sale of state bank bonds with his personal expenses, but he remained in power.

Interestingly, in Senate debate about what to do with Smithson's money, Sevier was on the side of applying the money as Adams wished—to a noneducational institution. During Senate debate on repealing the state investments, Sevier interjected only once. When the bill to repeal the state investments was read, the Senate record states, "Mr. A.H. Sevier made some observations in relation to the amendment not being distinctly heard in the gallery." It is tempting to interpret this cryptic aside in the official record as reference to Sevier's friends and cohorts perhaps loudly denouncing the move from above.

For the rest of his life, Adams remained furious over the fact that someone had absconded with the original half a million dollars, but at least the U.S. government was committed to restoring the scientist's money. The U.S. Treasury was pledged to pay 6 percent a year on the (now lost) capital fund of half a million. Political efforts to raid the bequest ceased after that.

There was still no agreement on what to do with it.

FOR THE INCREASE AND
DIFFUSION OF KNOWLEDGE

I N T H E W I N T E R O F 1842 John Quincy Adams was seventy-four years old. He had become gnomelike with age, his bald head and pale round face tinged the unhealthy pink of a man who would soon begin to suffer debilitating strokes. Only the black eyes with their steady, piercing look remained of the younger man's visage. From the study in his house on F Street in Washington or his rooms at the Adams farm in Quincy, the ex-president still habitually worked late into the night. Once the sun had set, the darkness outside was always complete, except for the light of the moon. In that premotorized era, night silence was disturbed only by the clip-clop of a passing horse and buggy or the isolated call of a bird. On clear nights, Adams could step outside and look at the stars in the black vacuum of space. In the waning years of his life, disappointed by politics and the moral weaknesses of his fellow officeholders, Adams looked skyward with an ever more wistful prayer. He still desperately wanted to see America enter what he called the "sublimest" science—astronomy.

Adams tried to record in his diary why he felt so passionately about the mechanical workings of the universe. Late in his life, the perceived movement of stars, moon, and sun had a spiritual relevance for him. "I saw the sun rise and set, clear, from Charles' house on the hill," he wrote in his diary. "The pleasure that I take in witnessing these magnificent phenomena of physical nature never tires; it is a part of my own nature, unintelligible to others. . . . The sensations which affect me at the rising and setting sun are first, adoration to the power and goodness of the Creator . . . mingled in the morning with thanksgiving . . . and in the evening with sadness . . . and with humble supplication for forgiveness of my own errors and infirmities."

He had hoped that with Smithson's money, he would "witness . . . the means of increasing and diffusing favorable knowledge among men, by a systematic and scientific series of observations on the phenomena of the numberless worlds suspended over our heads—the sublimest of the physical sciences." It was not to be.

Adams's obsession with a national observatory possibly did more damage to his political image than any other single thing, by giving his enemies a silly slogan to attach to his name (like "Governor Moonbeam"). Still, in the early 1840s Adams was more fixated than ever on building an American observatory, outfitted with great telescopes and staffed by learned men. He had almost single-handedly wrested Smithson's money away from the "mountebanks." With the money again available, Adams knew exactly what he wanted to do with it, and he was willing to brave persistent ridicule about his "lighthouses in the sky" to see it through.

Adams gave speech after speech on the subject. On the House floor in March 1840, he reminded his colleagues that astronomy was the primary pursuit in man's quest for knowledge, citing biblical origins. "In the first chapter of the Sacred Volume we are told that, in the process of Creation, 'God said, let there be lights in the firmament of the heavens, to divide the day from the night; and let

them be for signs, and for seasons, and for days and years.' By the special appointment then, of the Creator, they were made for . . . signs. Signs of what?"

In pleading with his congressional colleagues for an observatory, Adams even tried national pride as a goad. He asserted that the absence of an observatory on American soil was a stain on America's honor. Even Russia, "that land of serfs," had one, and no less scientific a group of men than the French were publishing the Russians' observations in French journals. "The journalist of a free country [France] applauding the exertions of a land of serfs to promote the progress of science avows that he should blush for his own country," Adams noted. "The Committee of the House . . . casting their eyes around over the breadth and length of their native land must blush to acknowledge" that there are no observatories to be found in America.

In 1842 Adams did finally witness the establishment of the Naval Observatory in Washington, but it was an enterprise unrelated to the Smithson fund and much smaller than he had wished. Adams also lived to see something else approaching his dream. In 1843 he made a perilous winter journey over the icy Great Lakes to see the opening of a larger observatory in Cincinnati. He returned from that trip gravely ill, with a "grave yard cough" and, worse, for the first time in his life, memory problems. Afterward, he wrote, "my strength is prostrated beyond anything that I ever experienced before."

PERHAPS ADAMS'S PREFERENCE for looking at the skies was motivated by his hopelessness at what he witnessed on the earth. By the time the Smithson bequest arrived on American shores, Adams had become a lightning rod in the growing national debate over slavery. Unlike many of his Massachusetts constituents,

Adams was not an active abolitionist. He was even willing to concede—privately and with a heavy heart—that slavery would be a fact of American life for a long time. But he wouldn't allow slaveholders to trample the people's hard-won constitutional right to be heard by their government. And that was exactly what the slave owners' representatives had engineered with an odious measure known as the gag rule.

In the 1830s American politics was already rippling with sectional interests that, even thirty years before the Civil War, had their roots in slavery. Slavery dominated the thoughts of men in power long before any bullets were fired. The fates of runaway slaves in free states were often debated in court, even though the national law still upheld the rights of slave owners to their human property. On the high seas, the 1841 capture of the Spanish slaver *Amistad,* which had been hijacked by mutinous slaves, forced the American government to decide the fate of foreign slaves (the Supreme Court sent them back to Africa, at Adams's urging and over the wishes of slave-owning interests). Congress was often occupied arguing whether to expand slavery into newly admitted states in the West. Most of all, slaveholders and their political leaders were feeling the moral precariousness of their "peculiar institution" and the growing resentment and antagonism of people and politicians living in the nonslave states.

In May 1836 the House passed the gag rule. The rule was a response by Southern congressmen to a flood of antislavery petitions coming into Congress daily from the ever more active abolitionists. The petitions—some of which Adams himself read in the House for his constituents—were especially concerned with the slave trade in and around the nation's capital. The gag rule automatically tabled all petitions or bills addressing the issue of slavery, without discussion or referral to a committee.

Attitudes about the eccentric scientist's bequest often reflected

attitudes about federal power in general and slavery in particular. The debaters fell into roughly two camps. Southerners—with some notable exceptions, including the South Carolinian Joel Roberts Poinsett—opposed accepting the money and then, after it was accepted, were opposed to creating a new federal institution. Northerners and westerners were in favor of spending the money on a national institution—although the form of that institution was a subject of much disagreement even among those who supported it.

A scan of the capital city journals shows just how intertwined slavery and Smithson's money were—temporally if not explicitly. Runaway slave and auction notices shared page space with reports on debates about whether to send someone to England to accept the Smithson legacy. Opposition to accepting the bequest always had as its subtext Southern slaveholders' concerns about growing federal power, but those concerns were not always explicit. Usually, they were buried in terms like "honor" or American "dignity" or couched in snide remarks about England or the national capital itself. So, for example, in the 1840s Andrew Johnson of Tennessee, the future president, objected to setting up an educational institution inside Washington—the seat, he said, of all "extravagance, folly, aristocracy and corruption." Jefferson Davis, the future president of the Confederacy, asked him whether he favored returning the money to England. Johnson said that he did. One South Carolinian, William C. Preston, spoke for many of his Southern colleagues when he announced that the money was "a cheap way of conferring immortality" on an unknown British scientist, which put Congress in the position of "pandering to the paltry vanity of an individual."

The handsome, black-haired Senator John C. Calhoun of South Carolina eventually led the fight against accepting the money and—once it was accepted—articulated the case against creating a

new federal institution. Calhoun was a South Carolina lawyer whose family was one of the biggest slaveholders in his home state. He had served as Jackson's vice president before resigning to enter the U.S. Senate from South Carolina in 1832, where he was sitting when Smithson's bequest became known.

Calhoun opposed Smithson's institution for increasing and diffusing knowledge, but he was by no means a backwoods boor. The South Carolina senator was a refined, well-educated man with strong convictions about restricting federal power. Calhoun eventually earned the moniker "the great nullifier" as one of the architects of the legislative method of resisting federal authority practiced first in South Carolina, a precursor to secession and the Civil War. During his twenty years in Congress, Calhoun defended slavery as an essential economic tool for the South. He was therefore at constant loggerheads with Adams and the antislavery faction. He died in 1850, before the outbreak of the Civil War, and he did not support armed insurrection during his lifetime. But his power and his contributions to various pro-slavery theories, including pushing for universal recognition of the *inequality* of mankind, helped the next generation of Southern politicians—the secessionists—craft and solidify their positions.

Calhoun always argued that accepting Smithson's money was both unconstitutional and "beneath the dignity" of the United States. His real concern was the expansion of federal power into an area—education—reserved for the states alone. Any expansion of federal power represented a threat to the Southern states' perceived right to do as they pleased when it came to commerce in human flesh. In the Senate in February 1839 Calhoun laid out his position vis-à-vis Smithson's money and the creation of a new institution at length.

"We accept a fund from a foreigner and do what we are not authorized to do by the Constitution," he said. "We would enlarge

our grant of power derived from the States of this Union. Sir, can you show me a word that goes to invest us with such a power? I not only regard the measure proposed as unconstitutional, but to me it appears to involve a species of meanness which I cannot describe, a want of dignity wholly unworthy of this government. . . . We would accept a donation from a foreigner to do with it what we have no right to do and just as if we were not rich enough ourselves to do what is proposed, or too mean to do it if it were in our power. Sir, we are rich enough and if we are not, this bequest cannot give us the power." Calhoun also reiterated the states' rights position. The federal government was merely "a trust" established by the states "with the profoundest jealousy, for it was apprehended that [federal powers] would be so great as to utterly absorb the state governments."

Calhoun might have been a slaver, but he was principled. He left no doubt about what should be done with the half a million dollars. "But it is asked, what are we to do with the money? There is no difficulty in that: it must be returned to the heirs. Sir, this is a question of vast magnitude and no one knows the consequences which may grow out of it."

Adams, who regarded the South Carolina senator with loathing as a member of the "slave-breeder" class, eventually branded Calhoun's speeches on Smithson's bequest "the very delirium of malignity." Animosity between the men and their camps was mutual. By the time Calhoun gave his first speech on the Smithsonian, Adams had become a conduit in Congress for the views of the growing number of abolitionists in the North.

Adams, Calhoun, and their fellow congressmen never had to look far from their Capitol desks to observe the fact of human bondage in American life. While Congress was debating and passing the gag rule and discussing the Smithson legacy, the slave trade in the American capital had reached tremendous levels. On a single

day in March 1836, the *National Intelligencer* reported that twelve hundred slaves were being offered for sale by three traders near the Potomac. Even the slave owner John Randolph of Roanoke had expressed alarm at the situation. "In no part of the earth, not even excepting the rivers on the Coast of Africa, is there so great, so infamous a slave market, as in the metropolis, the seat of government of this nation, which prides itself on freedom."

Besides advertising these massive auctions, capital city newspapers printed daily runaway slave notices, mostly from Virginia planters whose land abutted the district. The little runaway notices told volumes in terms of the desperation and individual suffering of the slaves, the callous attitudes of the slaveholders, and the relative inhumanity of American society in general just outside the Capitol dome. A typical runaway slave notice was placed in the *National Intelligencer* by Jacob Weaver of Warrenton, Virginia, on May 4, 1836, a few days after one of the major congressional debates about the Smithson fund: "100 Dollars Reward," announced large, bold-faced type on page one. "Ran away from the Lodge farm of the subscriber, Fauquier County, Virginia, on Cedar run, on Monday the 17th instant, a negro named Mark, about 27 or 28 years of age, six feet high, of thin visage and rather a bright complexion. . . . This fellow was lately apprehended in Belair, Maryland, with free papers in his possession and brought home; and it is very probable that he has obtained other free papers, and in his second trip is making his way to Pennsylvania or Ohio. A reward of fifty dollars will be given to anyone who will secure said negro in any jail in Virginia or Maryland, and one hundred dollars if secured in any free state, so the subscriber can get him again." Mr. Weaver's runaway slave notice appeared next to another large ad offering two hundred dollars for the capture of another slave escaped from another Virginia farm.

These ugly facts of daily life in Washington stung men like

Adams all the more because congressmen were now forbidden to discuss the subject of slavery at all. Fighting the gag rule became Adams's personal crusade. One biographer has written that the gag rule finally gave the deeply religious Adams a public channel for his innate zealous energy. That might have been, but the fight was also secular, in that it involved one of the primary elements of the Bill of Rights, freedom of speech. The gag rule removed one of the basic rights of Americans, the right of the people to petition. That right was "so essential . . . that it took on a religious sanctity" for Adams, wrote the biographer Paul Nagel. "This cause transformed him into a debater so impassioned, so stubborn, and so radical that his foes and even some friends wondered at times if he had lost his sanity."

Adams's long fight against the gag rule was so all-consuming that his family worried for his health. His son Charles wrote, "My own opinion is and has been for many years that his whole system of life is very wrong—that he sleeps by far too little, that he eats and drinks too irregularly, and that he has habituated his mind to a state of activity which makes life in its common forms very tedious." His wife, Louisa, supported his fight, but she also felt he was wasting his intellect on an impossible dream. He was pouring "all the energies of his fine mind upon a people who do not either understand or appreciate his talents," she wrote.

Adams was undeterred by his family's pleas. Even threats of death and physical harm had no effect on his enthusiasm. During the years when he was jealously guarding Smithson's money, Adams was under constant attack from people he called "the slave mongers." Death threats became common. In February 1842 he read on the House floor from a letter he'd received the previous month from Jackson, North Carolina. The writer was "threatening me with assassination and [he included] the engraved portrait of me with the mark of a rifle ball on the forehead. With the

motto, to stop the music of John Quincy Adams . . . 'Who, in the space of one revolving moon/Is Statesman, poet, babbler and buffoon.' "

In late May 1842 he wrote in his journal that "[n]ot a day passes but I receive letters from the North and sometimes the West, asking for an autograph and scrap of poetry or of prose, and from the South, almost daily, letters of insult, profane obscenity and filth." Adams professed not to be afraid or even alarmed. "These are indices . . . to the moral sensibilities of free and slavery-tainted communities," he wrote. "Threats of lynching and assassination are the natural offspring of the slave traders and slave breeders; profanity and obscenity are their natural associates. Such dross the fire must purge."

Adams was used to being abused in Washington. He'd weathered the notoriously dirty 1828 presidential campaign, vowed never to return to Washington, and then returned to serve in the House anyway. The anonymous death threats were more frightening than published slander and whispered lies. What his enemies did not know, and would have rejoiced at if they did, was that all his life Adams was subject to fits of debilitating melancholy, what might be called depression today. He was a deeply pessimistic man, perpetually at war against his own despair. The Southerners who loathed him heard his fiery opposition to slavery, but they had no inkling of his profound private resignation on the subject. The truth was, Adams simply didn't think slavery could be eradicated in his time. One night in January 1842, after fielding another assassination threat, he entertained some friends, including Augustus Young, a House member from Vermont, in Washington. "Mr. Young feels deeply the degradation of the free and especially the eastern portion of the Union, by subserviency to the insolent domination of the Southern slave-traders and slave-breeders," he wrote. "But he sees and I see no prospect of breaking the yoke in my lifetime."

ON DECEMBER 10, 1838, President Martin Van Buren officially notified Congress that Smithson's money had arrived and been invested in state stocks "agreeably to an act of the last session." He urged Congress to formulate a plan for how to manifest the stranger's wishes in a timely fashion, but arguments over what to do with the Smithson money would continue for eight years. Before the question was settled, there would be 401 discussions in the Senate and 57 in the House. As head of the House committee for most but not all the years of the debate, Adams was the point man for the bequest, but he was not alone in trying to make the stranger's wishes manifest. Had he been acting alone, his abrasive personal style could well have blocked the Smithsonian from ever being created. During his seven years as head of the committee, Congress never considered a fully outlined plan.

Other men in Congress believed as strongly as the former president in a federal role in diffusing knowledge, and their support was crucial to the crafting of a final bill. Chief among them was the Southerner Joel Poinsett, a congressman from South Carolina who had served as war secretary and minister to Mexico. Born into wealth and the Southern landed aristocracy, Poinsett was a progressive cosmopolitan and a gentleman scientist. Opposed to slavery and nullification, he was the antithesis of Calhoun, a fellow South Carolinian. In the latter years of his life he tried to persuade Southerners against slavery, unsuccessfully. He died before the Civil War but was one of the organizers of a Unionist militia in South Carolina in the years before the war began.

Poinsett was, for his time, one of the American capital's most cosmopolitan inhabitants. Born in Charleston, Poinsett studied medicine at Edinburgh and spoke many languages. As a young man, he had traveled extensively in Europe where he met and

socialized with Madame de Staël and Napoleon in France and Czar Alexander I in Russia. He served as a diplomat in South America before going to Washington. Unlike his fellow Southerners, he was strongly in favor of a federal role in promoting a national culture. "A flourishing state of the arts at the seat of government would be felt in the remotest parts of our country," he believed. He was a devoted natural philosopher in the broad, eighteenth-century sense, a great collector of curiosities. Specimens he brought back from his diplomatic stint in Mexico, mainly minerals and shells, went on display in a museum in Charleston. He was honored by botanists for bringing back to the United States a red Christmas flower from Mexico, which was named *Poinsettia pulcherrima* after him.

Poinsett was widely read in the eighteenth-century philosophers and knowledgeably referred to the French anthropologist Count Buffon—a precursor of Darwin—and Georges Cuvier, the founder of paleobiology, among other scientific luminaries, in his speeches. He wanted to diversify the southern agrarian economy, which by the 1830s was responsible for supplying the cotton that accounted for half of the nation's exports, and which depended wholly on slave labor. Poinsett's travels in Italy and France had interested him in grape growing, and he believed grapes could be grown in the Southern states, along with silk, olives, cork, camphor, and flax. His studies of agricultural methods had led him to decide that slavery was not only immoral but an unprofitable method of farming. He tried to introduce other progressive agricultural methods, including crop rotation, to his fellow Carolinians.

Poinsett's interest in natural history and science kept him from accepting numerous political posts. In midlife, he served as a Banksian figure of sorts in American science, supporting young scientists and authorizing American expeditions to the South Seas, the Pacific Coast, and the unexplored regions of America between the

Mississippi and Missouri Rivers. His interest in science involved him in the Smithson bequest. In response to it—anticipating that the money might go to an existing organization—Poinsett formed the National Institute for the Promotion of Sciences at Washington in 1840. His vision for it would have combined elements of the botanical Jardin des Plantes at Paris, the national observatory that Adams wanted, and included laboratories, libraries, and publications for both scientists and laypeople. Poinsett led the institute valiantly but he was unable to persuade Congress to put Smithson's money at its disposal. Even his calling of a national convention of scholars at the capital in 1844 did not save his institute. His fellow politicians wanted a Smithsonian created fresh with its own name and legislation. The Smithsonian as eventually created resembled his national institute, though, and Poinsett is considered one of its founders.

The Smithsonian would not have come into existence without the work of yet another progressive, a much younger congressman who eventually replaced Adams at the helm of the bequest committee. Robert Dale Owen, a representative from Indiana, was the son of Robert Owen, a Welsh-born industrialist and socialist reformer who had created an experimental utopian community in Indiana. The younger Owen was one of the most intriguing characters to appear in mid-nineteenth-century American politics. An advanced thinker, far more populist than Adams, he was at different times a politician, a barnstorming reformer, an agnostic intellectual, and finally a Christian spiritualist. Born in Glasgow in 1801, raised around his father's experimental factory community, and educated at a progressive school in Switzerland, Owen had followed in his father's footsteps in taking an interest in social reform, and particularly in believing that education was the key to overcoming class, gender, and economic limits. In 1825, he came to America, where soon after arriving, he made his mark in New York with a rabble-rousing speech attacking the capitalist notion of buy-

ing low and selling high. He moved westward and taught at New Harmony, Indiana, the utopian community founded by his father. He also participated in another experimental community in Nashoba, Tennessee, a refuge for freed or purchased slaves founded on the notion that blacks and whites could learn to live together. Owen also wrote the first American birth control tract in 1830 and had a lifelong interest in women's rights.

Owen's fondest hope was that the Smithsonian money would be used to build a school. He felt anything more was elitist—especially a library. On the other hand, he was enough of a pragmatist to be willing to compromise—something Adams could not do—and he eventually agreed to drop the school idea for the sake of seeing a bill passed.

IDEAS ABOUT what to do with Smithson's money reflected the finest aspirations of men in a newborn country as well as the low schemes of the self-interested. Like Owen, many men thought the best way to implement the increase and diffusion of knowledge would be to create a national school. Educators from all over the country sent in proposals for schools or universities to be founded with the money. Samuel Martin of Campbell's Station, Tennessee, suggested that the fund be applied to the instruction of females. Another professor suggested creating a postgraduate liberal arts institution in Washington for students to spend a year "carrying forward their classical and philosophical educations" before continuing into their chosen fields. Dr. Thomas Cooper suggested giving the money to the city of Georgetown (to get around objections to the creation of a federal university) and opening a science college dedicated to chemistry, botany, mechanical knowledge, and calculus. "No Latin or Greek," Cooper wrote. "No literature. Things, not words."

The notion of a national university was not new, but it had never gathered much political support. Benjamin Rush, in 1787, was one of the first Americans to propose a federally funded institution in which "every thing connected with government, such as history . . . the civil law—the municipal laws of our country—and the principles of commerce—would be taught by competent professors." Rush's proposal went nowhere after the delegates at the 1787 Constitutional Convention—many of whom believed the power to establish a national university should be exercised only by the states—rejected it. (Calhoun based his charge that a school was unconstitutional on this vote.)

George Washington was very attached to the idea of a national university and even tried to advance it in his will, by leaving a chunk of stock with which to establish a "NATIONAL UNIVERSITY" (capital letters his). But the company went bankrupt and the shares became worthless before anything was done. When Washington became president there were just twenty colleges in the thirteen states. Harvard was the largest with 150 students. Jefferson and Madison also tried and failed. Jefferson wanted a national university that would keep American youth at home, instead of sending them to Europe where their morals would be corrupted. Others believed the university could be used to promote national union and patriotism.

John Quincy Adams was the last president to promote a national university. In his ill-fated 1825 address on nation building, he urged that in addition to roads and canals, a national university be erected. His cabinet members, with whom he had shared the speech in advance, begged him not to mention a school, knowing the response it would provoke among states' righters, who were dominant in Congress. Adams went ahead anyway. As predicted, he was denounced for trying to steal the sovereignty of states. He later admitted that the mere suggestion had been "a perilous experiment."

Adams supported a national university in theory, but he was always adamantly opposed to using Smithson's money to create one. To him, the British scientist's own words precluded any institution meant to educate the young. He argued this repeatedly, because there was no shortage of proposals that the money be used for exactly that. Adams shot down each one, even if it reflected the most benevolent motives. One suggestion would have applied Smithson's money to a school for black children in the capital. Adams immediately smelled trouble from the slavers, as he told his constituents back in Massachusetts. "It will easily be perceived that the mere proposal of such a project as the education of the coloured population under the superintendence of Congress would awaken all the State's rights jealousies, and excite the prejudices of a portion of the South against the whole purpose of the Testator itself."

After a college or school, the most persistent proposal for the money was the creation of a capital-city agricultural college, including a farm where improvements to crops and livestock could be displayed. For many years, politicians seriously considered this idea. At least two extensive plans for a large farming college can be found in congressional records. The most detailed proposition would have set aside 640 acres of land within the District of Columbia for vineyards, a hop garden, pasturage, an orchard, 500 acres of woodland to supply the farm with fuel, a sugar beet refinery, working cattle, stables, "piggeries," and cow and poultry houses. The Smithson farm proposal in modified versions remained viable for many years. Needless to say, the city of Washington today would have looked—and smelled—much different with a working farm on the Mall.

At the other end of the cultural spectrum, there were the elitists, exemplified by Rufus Choate, a Massachusetts jurist and senator. Choate was another deeply learned politician steeped in the classics, especially the writings of Cicero and Aristotle, whose phrases he often quoted in the Senate. He was a staunch Federalist and a

believer in an involved government. He also shared with Edmund Burke the notion that radicalism and democracy didn't belong together, and advocated a conservative approach to political freedom. Choate, who had an eight-thousand-book library of his own, had no use for a school or a farm. He was adamant that the money be used to found a great national library to rival Europe's finest. He gave a long, erudite speech in the Senate opposing a Smithsonian school or lecture hall as too utilitarian and making the case for using Smithson's money to buy hundreds of thousands of books. "Does not the whole history of civilization concur to declare that a various and ample library is one of the surest, most constant, most permanent and most economical instrumentalities to increase and diffuse knowledge?" he thundered. Choate, whose speaking style was uncharitably compared by one contemporary to that of "a monkey in convulsions," went on to suggest that the entire bequest be used for his dream. "Five hundred thousand dollars discreetly expended not by a bibliomaniac, but by a man of sense and reading . . . would go far, very far, toward the purchase of nearly as good a library as Europe can boast." Choate's determination on this matter was such that even after the Smithsonian was created, he remained involved as a regent and argued with other regents to expand its library.

Richard Rush, who had personally secured the money at such cost in time and effort, never lost interest in its fate. He wrote up his own suggestion for an institution and submitted it in 1838. Rush wanted an institution that could nourish American intellectual resources and banish the image of America as a backward nation inhabited by ill-educated provincials. "The continent that Columbus found was a desert, or overspread with barbarous people and institutions," Rush wrote. "The continent that steam has found teems with civilization, fresh, advancing, and unavoidably innovating upon the old world. It is at such a point in the destinies of

America that the Smithsonian Institution comes into being. By their physical resources and power, the United States are well known. Their resources of intellectual and moral strength have been more in the background but may not an auspicious development of these be aided by an institution like this?"

Rush's plan was very close to the institution as it was created. He proposed that a building be erected in Washington, with rooms for lecturers and curiosity cabinets, and that the institution be empowered to publish a journal. In a nod to the agriculturists, he also proposed that the building have sufficient grounds to plant seeds and plants ("with a view to diffusing through the country such as might be found to deserve it"). He suggested the institution work with American diplomats and military men posted around the world, who would send back seeds, plants, and other indigenous life-forms to be cataloged and collected in Washington, much like the wide-ranging natural history cabinets that had so occupied Joseph Banks and his contemporaries.

Rush submitted this plan shortly after he returned from England with the money, but it was eight years before something like it was taken seriously by the full Congress. The final proposal resembled Rush's but was grafted together with other plans for a new kind of institution with similar science-oriented parameters and focus. Those years were filled with backroom maneuvers broken up by long periods of inactivity. The more than four hundred pages of the *Congressional Record* on Smithson's bequest is just the truncated version published for the public years after the founding of the institution.

IN 1839 Adams wrote in his diary that James Smithson's money was a matter about which "I felt an interest more intense than in anything else before that body." That intensity sustained him

through the years of political inertia. Adams's diaries give the reader a better idea of the obstacles—mundane and mighty—he faced throughout the long period when the money was lost or in limbo. Because the bequest was rarely a burning issue to any but a handful of congressmen, it was not unusual for Adams's House committee to meet and have only two members show up. Without a quorum, no business was done and the committee nattered away on other subjects like graft and bribery. On March 2, 1842, Adams recorded that only three members were present and discussed "the manner of canvassing votes at an election in Kentucky—treating, barbecues, small loans of one or two dollars, to be forgotten, tavern bills paid half and half by the candidates." A week later, Adams himself arrived for a meeting two hours late. "Of my tardiness I failed not to be reminded," he wrote acidly. Thus began a morning of acrimony in which "every provision of every section [of his latest proposal] was contested and the only sound principle settled was that the principal use of the bequest should be preserved unimpaired as a perpetual fund."

The general lack of urgency about creating an institution was compounded by Calhoun and his camp, who remained actively opposed to taking the money and devised ways to hinder any progress toward a final plan. Someone proposed to send it back to England during every debate. The Southern response slowed the process considerably, to Adams's eternal annoyance. In one of his diary entries, Adams described his frustration at a Georgia congressman on his committee, who as late as 1843 still opposed taking the money. "His argument was the danger and difficulty of carrying it through Congress; and he said that only yesterday one of the members from the South urged, in conversation with him, that Congress had no constitutional power to accept the bequest, and that the money ought to be sent back to England. I saw the finger of John C. Calhoun and of nullification . . . and said that Mr. Cal-

houn and his coadjutors had urged it from the beginning and it had been time after time settled against them; that any application of the fund to the purposes of the testator would be resisted by them."

Adams was also forever on the lookout for corrupt politicians who might have dishonest designs on the bequest. His distrust combined with his rigidity slowed the process by which the institution was created. Adams's suspicions became "an ineradicable phobia," wrote one historian, and hurt his cause. The ex-president battled against a variety of suitors who he believed cared more about securing lifetime salaries than diffusing knowledge among mankind. Adams was not always being paranoid—there was no shortage of self-interested proposals. He was outraged by the efforts of Asher Robbins, a lame-duck senator from Rhode Island, to use the fund for a university that he—Robbins—would run. Robbins, "being laid politically on the shelf by his constituents, had taken a fancy to this fund for the comfort and support of his old age, and projected a University, of which he was to be Rector Magnificus," Adams wrote. The effort ultimately failed, although the Senate (led by Calhoun who, seeing a chance to poison the well, was suddenly in favor) passed it. As chairman of the bequest committee, Adams refused to let the bill be considered in the full House. But he also opposed Owen's eventual bill and did not work with Poinsett either.

In 1846 the twenty-ninth Congress forged a compromise. By this point, Adams was no longer chairman of the House committee, having been replaced by Robert Dale Owen. Owen's final bill was an amalgam of what had been proposed over the years. It contained a farm, lecture halls, a school, inexpensive publications aimed at informing the masses, and a library. The bill that finally passed out of Congress lost the farm and school but retained Rush's ideas about collecting seeds and plants from far-flung places and included lecturers, journals, and a library. The legislation created "a

Smithsonian Establishment," specified a governing board of regents and a secretary, and directed them to find a site, erect a building, and make accommodations for a museum, library, art gallery, chemical laboratory, and lecture rooms.

There was no observatory, but Adams had already abandoned all hope of getting any Smithson money for his dream. In debate on the final bill, he said, "I no longer wish any portion of his fund to be applied to an astronomical observatory."

The bill narrowly passed the House in April 1846, by a nine-vote margin of 85 to 76, and in the Senate three months later, by a vote of 26 to 13. The voting was sectional: of forty-two congressmen from the Deep South who voted, all but six were nays. On August 10, 1846—eleven years after word of Smithson's bequest first reached America and seventeen years after James Smithson's death in Genoa—President James K. Polk signed the bill that created the Smithsonian Institution.

By now, Adams had slowed down considerably. Before the end of the year, he would suffer the first of two strokes, the second of which would kill him. He still faithfully attended the Smithson committee hearings. Even in declining health, Adams harbored much anger about the initial misuse of the money. He forced the committee to consider producing a final report that accused the states of Arkansas, Illinois, and Michigan of embezzlement. "I had moved to have this statement made and provided for in the bill," he noted in his diary. "But excepting Mr. Marsh [the intellectually inclined Vermont representative George Perkins Marsh], no other member of the committee would consent to it. They were unwilling to uncover the nakedness of the States. They consented however, to . . . an expression of the opinion of the committee that there would be no ultimate loss to the United States of the funds thus invested." Adams was outraged and moved to strike that line, since it was "an expression of confidence I could not honestly avow." The committee acquiesced.

At the end of 1846, before his first collapse from stroke on the House floor, Adams could savor the fact that he had saved the fund and seen the strange benefactor's dream made manifest. Adams didn't have the great observatory of his dreams, but he had ensured that the money was not dissipated or used to build a school. Winning on two out of three issues within the compromise machine that is the congressional process is even today considered a success.

Adams's generous formula was used in calculating how much money would have been in the Smithson fund on the day Congress enacted the institution—if the States had not lost it. It provided that $515,169—the amount of the bequest before Congress deducted Rush's costs from it—be put aside in the Treasury, plus 6 percent interest, which amounted to $242,129. This grand total, $757,298, was now mythically "on deposit" at the Treasury. In reality, the Treasury was bound to pay 6 percent interest on that sum in perpetuity.

No one was ever held accountable for Smithson's missing money. Ambrose Sevier was hand-slapped but kept his office. Levi Woodbury became a U.S. senator and president of the ill-fated National Institute for the Promotion of Sciences, after Poinsett. The former treasury secretary worked hard to get the Smithson money applied to the establishment under his care, but he failed. The institute (nicknamed "America's attic," as the Smithsonian itself would become) had an ignominious end. Even the collection of fossils that had piled up in one room of the building was treated as garbage and sent off to a bone mill in Georgetown, where it was ground up for fertilizer.

WHEN THE SMITHSONIAN BILL was finally signed into law there was enormous jubilation in the city of Washington, which had been anticipating this infusion of half a million dollars for eight years and periodically petitioning Congress to act more

speedily. The project meant jobs for day laborers and skilled workers, business for contractors and merchants, improvements to what would become the Mall. When the bill passed, the mayor declared that "since the rebuilding of the Capitol [in 1814] nothing has occurred calculated to exert such an influence on the fortunes of the city, even unto the distant future." Unlike New York or Philadelphia, Washington desperately needed the Smithsonian. It was a city without a real cultural center. Between the scrub brush and swamp grass and rising white edifices, there was nothing but government business. Theaters never lasted for more than a few weeks before going belly-up, and even the rowdy White House levees had been abandoned. The Smithsonian would not entirely change the tone of the city, but it went a long way toward giving the city a cultural foundation.

The newly appointed Smithsonian Board of Regents wasted no time. On November 30, 1846, the regents hired the young architect James Renwick Jr. of New York to design what was supposed to be "a suitable building . . . without unnecessary ornament." The regents had studied thirteen plans and could not have selected an architect less likely to produce an unornamented building. At twenty-seven, Renwick had already shown his penchant for gargoyles and towers with several Gothic and Romanesque churches in Manhattan, including Grace Church. He later built St. Patrick's Cathedral in what is now midtown Manhattan. The Smithsonian building he designed, standing on the Mall today, is a Norman-inspired castle of red sandstone. It still clashes with the classical style and white stone of the rest of federal Washington. It has nine turrets, each of which "is so painstakingly different, [they] show to what extremes the desire for romantic picturesqueness could lead," wrote one twentieth-century critic.

In a land without nobles or palaces, the American public rather liked the incongruous red castle as it slowly rose to decorate the low

skyline of Washington in the 1850s. It is not inconceivable to think that James Smithson, with his manservant and traveling silver service, would have smiled at it too. A man who in life had been barred at the moat, figuratively if not literally, now had his very own castle, with the name he'd taken for himself carved in stone above the door.

THE SMITHSON MYSTERY

J ANUARY 24, 1865, was a bitter cold day in Washington. The sky was clear, a brisk wind whistled, and old snow glazed the surface of the ground. William J. Rhees, chief clerk of the Smithsonian Institution, was sitting in his office in the Castle, talking with an associate. Frost etched the windowpanes and if the men moved just a little away from the fireplace, their breath turned white. Rhees would eventually be ordered to write the first definitive book about James Smithson and the founding of the institution. Unfortunately, on that icy day in January, Rhees had not yet gotten around to reading the thousands of memos and pages of notes that were part of James Smithson's personal effects stored in a wing of the castle not far from his office.

It was a delay he would live to regret.

Just after lunchtime, the men heard a faint but persistent crackling sound. They assumed the noise was just ice breaking off the eaves or falling from the Castle's turrets, and continued their conversation. One floor up and a few rooms away from where Rhees and his friend sat, a group of workmen also listened to the crackling

noise. They had been toiling all morning in the freezing cold, making some interior improvements, and had decided to increase their comfort by bringing in a small wood-burning stove and venting it into a hole in the wall between two windows. The workers assumed the hole led into the building's main chimney.

Having lit their fire, the workmen warmed their hands and then returned to their saws and hammers. For some time, they were oblivious to the fact that the heat, sparks, and smoke from their little stove was not venting up a flue at all but was flowing directly into the open loft and wooden beams under the roof, next to the true chimney and not inside it. In years to come, the purpose of that mysterious fluelike hole in the wall would be the subject of much discussion, without answer. In any case, by the time the workmen realized something was wrong, the rafters above the ceiling were ablaze.

After "a considerable time," as they would describe it later, the crackling sound grew more insistent in the chief clerk's office, and Rhees and his visitor began to detect the alarming odor of burning wood. Realizing too late that a disaster was under way, they ran into a nearby lecture room and found fire had already penetrated through the twenty-five-foot-high ceiling and was rapidly spreading to all sides of the room.

WHEN THE SMITHSONIAN CASTLE caught fire, the institution had been under the charge of one man, its first secretary, Joseph Henry, since its creation. Henry was a scientist, born in Albany, the son of a Scottish day laborer. As a young man, he had served as a tutor at Albany Academy, where, by odd coincidence, another accidental fire had played a role in his life. Henry was teaching his young charges to fly hot-air balloons when one of the fire-powered devices ignited a neighboring barn. One of Henry's

students, Henry James Sr.—father of the novelist—was thirteen years old and was severely burned trying to stamp out the blaze. He spent two years in bed following amputation of his leg above the knee. Because of this accident, the great novelist's father spent his life with a cork leg.

In his career before the Smithsonian, in addition to tutoring boys, Henry was first a road surveyor, then a math professor, and then a professor of natural philosophy at what became Princeton University. He was most interested in physics and experimented with electricity. He can take some credit for the electromagnetic telegraph (full credit for which goes to another American, Samuel Morse). But it is as the first secretary of the Smithsonian that he really made his mark on American and scientific history. Ultimately, he is remembered for having turned Smithson's mystifying phrase into a concrete program.

Even before his official appointment, Henry was ready with a plan, one that leaned toward the scientific and away from the popular. While still being considered for the post, he wrote a "Programme" for realizing Smithson's words, and circulated it in preliminary draft to various learned societies and individuals around the country. Very simply, under his plan the Smithsonian would increase knowledge by stimulating and rewarding "men of talent to make original researches," and diffuse knowledge by publishing the memoirs of these men's work and disseminating them around the world.

Once appointed, Henry commenced projects immediately to advance his program. He designed the nation's first meteorological survey, a network of weather stations across the nation that eventually became the U.S. Weather Service. He put together the beginnings of a vast publication program. The first volume of the Smithsonian's *Contributions to Knowledge* was published in 1848 and focused on America's indigenous people (the Smithsonian col-

lected an enormous amount of information on American Indians during the nineteenth century), titled *Ancient Monuments of the Mississippi Valley*. The next volume included some of the earliest groundbreaking astronomical work by an American on the orbit of the newly discovered planet Neptune. Henry also oversaw the publication of vast numbers of other treatises, on such varied topics as "Instructions in Reference to Collecting Nests and Eggs of North American Birds" and "Psychometrical Table for Determining the Force of Aqueous Vapor and Relative Humidity of the Atmosphere from Indications of the Wet and the Dry Bulb Thermometer, Fahrenheit." He initiated the Smithsonian International Exchange Service, which disseminated the institution's papers outside the United States and gave American scientific contributions world-class status for the first time. Henry persuaded steamship operators to carry his papers free of charge, hired agents abroad, and between 1846 and 1877 alone sent about eleven thousand boxes of his publications to museums and learned societies and libraries all over the world.

From the start, Henry put science ahead of other more popular interests, such as museum collections, a library, and the public lectures that vied for Smithsonian focus in the original legislation. He waged an ongoing battle with various congressmen, including Rufus Choate and Robert Dale Owen, who were now regents and who still wanted to see a great library, a museum, and an art gallery put in place. Owen, who envisioned the institution to be a multifunctional cultural repository, had won an early round, by the very creation of the turreted, complicated Castle building itself, which included popular lecture halls and was not exactly the ideal design for chemistry labs.

The Castle was erected around the same time as the Washington Monument and formed a part of a project for beautifying the Mall. When the Castle was constructed, the canal along the north of the

Mall still carried waste from the Patent and Post Offices. The Ellipse was filled with sewage. Not everyone was delighted by the Castle, including Henry himself, who thought it impractical for his purposes. The sculptor Horatio Greenough, arriving in Washington in 1851 and strolling along the Potomac at night, was another critic, but for symbolic reasons. "Suddenly as I walked the dark form of the Smithsonian palace rose between me and the white Capitol, and I stopped. Tower and battlement, and all that medieval confusion, stamped itself on the halls of Congress, as ink on paper! Dark on that whiteness—complication on that simplicity!"

Besides having to accept construction of a castle he didn't much like, Henry fought—and lost—on the question of whether the Smithsonian was to become a museum. As the National Institute folded, its collections started cluttering up space in the U.S. Patent Office, and the government decided to foist what remained of them on the Smithsonian. Henry tried to reject them. One scan of the catalog shows why a serious scientist might be leery of making space in his institution for such a motley collection. Among the objects transferred to Henry's care: pieces of rock upon which the navigator Captain Cook was killed in Hawaii; a Liberian lemon; a "hair brush neatly made by a blind boy in the Illinois Institute for the Education of the Blind"; Ben Franklin's cane; a double-headed snake from Maryland; a massive marble Syrian sarcophagus; and gifts to the United States from the imam of Muscat, including cashmere shawls and a case of attar of roses.

Henry was eventually forced to accept these and many other objects and oversee the expansion of the museum. The Smithsonian's future as "America's attic" was sealed. He lamented this fate in his next-to-last report in 1876. In that year the museum had become the recipient of such sundry items as twenty-three cards illustrating the different kinds of hooks made by the American Needle & Fish-Hook Co., a series of domestic turkey feather dusters in

five sizes, and some grasshoppers from Indiana—none of which, separately or taken together, fulfilled Henry's vision of increasing and diffusing knowledge (nor Smithson's in all likelihood). "I may further be allowed to remark that the experience of the last year has strengthened my opinion as to the propriety of a separation of the Institution from the National Museum," Henry wrote. "The functions of the Museum and the Institution are entirely different. . . . Every civilized government of the world has its museum . . . while there is but one Smithsonian Institution. It has been supposed that the Institution has derived much benefit from its connection with the Museum in the way of adding to its popularity, but it should be recollected that the Institution is not a popular establishment and that it does not depend for its support upon public patronage."

Henry had inadvertently helped along the process of "museumizing" his institution by having the Smithsonian outfit and train people for at least twenty expeditions before 1858. These expeditions, part of the effort to increase knowledge, were to Greenland, South America, Mexico, the western states, and Alaska. The expeditioners sent back crates full of specimens and curiosities that so impressed Congress that lawmakers increased appropriations for the Smithsonian museum's collections in 1860.

Henry didn't like them, but the Smithsonian's lectures and museum attracted growing popular support. The museum was more easily understood by recalcitrant congressmen than were the scientific papers. Even a decade and a half after the founding, there was still not agreement in Congress that the Smithsonian had a right to exist. Senator John P. Hale of New Hampshire expressed this view when he said, "I have devoted some time every year, more or less, to finding out what on earth that Smithsonian Institution was for. . . . So far as I am concerned it has never distributed knowledge enough to me to let me know what the thing is for, or what it does." The same senator quoted the writer Horace Greeley,

who had written that the Smithsonian "was a sort of lying-in hospital for literary valetudinarians." The *Atlantic Monthly* also ridiculed the Smithsonian in 1861 as part of a larger scathing indictment of Washington, D.C., writing that the capital had "a Scientific Institute which does nothing but report the rise and fall of the thermometer."

Henry's greatest contribution to the development of the institution was to find a way to manifest the benefactor's words. Under his guidance, the Smithsonian fostered an increase in knowledge by supporting expeditions and rewarding the work of individual scientists and diffused it around the world with publications and exchange services. Henry was quite proud of the way he had managed to set in motion the diffusion of American knowledge. "Should the government of the United States be dissolved," he wrote in one of his annual reports, "the Smithsonian Contributions to Knowledge will still be found in the principal libraries of the world, a perpetual monument to the wisdom and liberality of the Institution."

AS THE FIRST SECRETARY of the Smithsonian Institution, Joseph Henry faced a tremendous task. He needed—and fortunately he had—a clear vision of exactly how the increase and diffusion of knowledge could be manifested in Washington. He had to conjure up, out of thin air as it were, a viable, respected scientific clearinghouse and publishing concern for America's botanists, geologists, explorers, chemists, and natural historians. And he had to persuade the regents and Congress—the latter with its still-bickering members and conflicting aims—to support him.

In this context, the benefactor's moldy clothes, lab instruments, silver service, and unpublished personal papers—all of which the Americans had inherited along with his money—were not the first

matters on the secretary's mind. This is not to say that Henry was unconcerned with the founder's life story and personal effects. On the contrary, he kept close track of them, as bits of notation in his desk diary indicate. In March 1847 Henry set about trying to find out if articles of Smithson's clothing that had been donated to an orphanage could be recovered and "preserved by means of arsenic or otherwise." "RAIN RAIN," he began on April 8, 1852. "Called at the Patent office to see Mr. Ewbank and to ascertain the condition of the Smithsonian effects [that is, Smithson's effects]. These should be moved to the Institution as soon as a room is prepared for them. Found the putty in the keyholes undesturbed [sic]. The cases have probably not been desturbed [sic]."

Henry commenced efforts to find out more about Smithson—whom he referred to as "our Saint"—before the ink was dry on his contract as secretary. Unfortunately, those efforts did not include an immediate and detailed review of the thousands of notes and scraps of paper written in Smithson's own hand and packed in trunks with his silver service and instruments. Henry might have personally inspected the papers, but his notes don't indicate any specific observations. Rather, Henry focused on collecting new information. He begged the American botanist Asa Gray, who was traveling in Europe, to seek out the widow of Smithson's servant in London and "take whatever falls from her lips in writing." Gray never made the visit. Two years later Henry wrote a letter to Alexander Dallas Bache, a friend and fellow regent. "I have set one of my young men at work to explore all the scientific Journals accessible at Princeton for notices of Smithson and his labours and I have in this way procured an obituary notice of our Saint by Davies Gilbert who speaks of him in terms of affection and respect. They were college mates at Oxford and were drawn to each other by a kindred love of science." (The Gilbert family eventually provided some of the most lively anecdotes available in the otherwise scanty record.) Henry also

wrote in 1852 to Royal Society member and Smithson contemporary Charles Babbage, asking whether Smithson in fact had intended to bequeath his property to the Royal Institution, and noting that "from his manuscripts, now in my possession he was a person of rather eccentric habits and opinions." Babbage's reply, if he made one, does not survive.

Henry and others involved with him in creating the Smithsonian Institution tried to find out more about James Smithson, the stranger they knew by name only. If they received any information about Smithson, the Americans would have entered it into the institutional record. That is, of course, unless it was contrary to the image of a patron saint. American politics and the vested interests of the early shapers of the Smithsonian needed a certain legend to support their endeavors. The narrative required Smithson to be a serious scientist of sound mind and purpose.

The romance of a lonely, poor, and outcast British bastard, robbed by the bar sinister of a full and happy life in feudal England, bequeathing money to the land of the free, gave the early institution a neat patriotic story. Anything that supported that notion was polished up and presented to the world.

Smithson's credentials as a scientist also needed to shine in order to support the aim of Joseph Henry that the Smithsonian should be an institution of science and not just a museum or a library. It was critical that the mysterious little mineralogist be portrayed as a man who worked with theories and experimented according to some professional standards, instead of being a mere dilettante and collector. To that end, his scientific papers were published together, along with a few essays by contemporary scientists who had written about his significance. Furthermore, at least one prominent scientist in Europe, Louis Agassiz, was asked to weigh in on whether Smithson would have wanted his money to go to a library, for example. The answer to that was, not surprisingly, no.

Finally, as a patron saint, his personal character had to be sterling. For that reason alone, his first biographer, William J. Rhees, a Smithsonian employee, chose to delete the words questioning Smithson's sanity in the first letter sent to the United States from Aaron Vail, the chargé d'affaires in London. The sentence that read "The caption of the Will is in language which might induce a belief that the Testator was under some degree of mental aberration at the time it was made" was replaced with asterisks in the first full publication of documents relating to the founding in 1881.

In the late 1870s the board of regents made a fresh effort in Europe to find out more about Smithson. They launched a sweeping search in England and across Europe for anything relevant to Smithson's life and career, in order to produce a book. Joseph Henry commenced this new attempt with a letter to the office of the London solicitors who had served as executors of the Smithson bequest almost forty years before. "Gentlemen," Henry wrote, "As you were his solicitors, I have thought it not impossible that you may have some scraps of information in regards to him that may be interesting, and I therefore take the liberty of writing to request, on behalf of the Institution, that you will furnish me with a copy of anything of the kind. Any anecdotes that may serve to illustrate his character, dates, such as those of his birth, death, etc.—in short, any information however apparently insignificant, will be acceptable."

The lawyers unearthed nothing new.

In 1880 the Smithsonian hired a London bookseller named William Wesley to undertake some detective work in England. Wesley spent a year contacting scores of individuals, placing advertisements in scientific journals around Europe, and distributing circulars or flyers in venues Smithson was known to frequent. The circulars, distributed in May 1880, requested information about not only Smithson but also his relatives, his heirs, and the relatives and heirs of the servant mentioned in his will. Wesley also made personal appeals to previous investigators and surviving family members.

His first step was to contact Henry Stevens, who had been authorized by the Smithsonian in 1852 to collect material on the life of Smithson. No reply was ever received. Wesley was able to contact the family of John Fitall, Smithson's servant, already deceased. Except for a portrait of Smithson, which had been supplied to the institution years previously, there was nothing left of interest in the Fitall family. Furthermore, the widow herself "was too old and imbecile to have been able to give any information."

Wesley did most of his work in London. The oldest living members of the Royal Society, ninety-two in number, were each contacted for anecdotes about their late colleague, dead now fifty years. Two dozen of the oldest members of the Linnean Society were also contacted. Not one man provided a shred of a memory. Wesley had been specifically instructed to find some evidence of Smithson's rumored falling-out with the Royal Society. No evidence of that turned up either. Journal ads sought any correspondence between Smithson and the leading scientists of his time, any communications between Smithson and the Royal Society or to *Thomson's Annals of Philosophy*, beyond what was already published. No responses came. Despite sending queries to twenty-three neighbors on Bentinck Street, Smithson's last-known London address, Wesley was unable to find out even precisely what building Smithson occupied when he wrote his will.

Letters to the Parisian bureaucracy were also fruitless. As is the response today to anyone inquiring after Smithson's birth or passport records at the Archives Nationales in Paris, the French information officials said that any records of the little scientist's birth or residence in Paris had been destroyed or lost. There is no evidence that Wesley contacted any genealogists or made much of an effort to discover the facts about Mrs. Macie's marriages and pedigree.

In his final report to the second Smithsonian secretary, Spencer Baird, in late 1880, Wesley detailed his efforts, including the failure

of the circulars and advertisements to reap any new leads. He, at least, forgave himself. "After all," he concluded in his letter, "it is not so very surprising that little can be ascertained respecting an English gentleman of retired habits who lived abroad many years and died in 1829, more than half a century ago."

It is possible that just three decades after his death, absolutely no one in England remembered the shy, reclusive Smithson, but records of the searches in the Smithsonian archives make clear that the investigators didn't turn over every stone. There are no letters, for example, from investigators to members of the Hungerford or Macie families nor, it seems, any personal visits to the still-angry La Batuts in southern France. Many reasons existed for this failure. The most plausible one is the sheer volume of other pressing business faced by the Smithsonian's early officials—money, politics, and bureaucracy—involved in creating a major national institution. There was also the messy business of the benefactor's birth and his mother's lifestyle. In Victorian England and Puritan America, a closer inspection of the loose morals of late-eighteenth-century British aristocrats might have been too much to ask. If anyone had spent much time in Bath or Wiltshire, for example, at that early date they would have turned up more evidence of Elizabeth Macie's life, habits, and family.

THE SMITHSON MYSTERY generated its own world of legend and myth. For a century and a half now Smithsonian officials and staff have made repeated further attempts to understand more about the man whose profile is stamped on books, papers, and buildings all around them. These efforts have turned up small numbers of new letters, mainly dealing with his scientific friendships, but nothing terribly illuminating. The most alluring avenue of research for many Smithsonian officials has been to try to find a

link between Smithson and any eminent American of his time. It made sense, for example, to speculate that Smithson, who spent so much of his time in Paris, might have encountered Ben Franklin, so revered in France during Smithson's youth. In the 1950s, Smithsonian secretary Dillon Ripley wrote to the curator of the Ben Franklin papers in Philadelphia, who replied, unequivocally, "Alas, *rien.*" There was, however, just a single degree of separation between the two men. Faujas de Saint-Fond, the timorous Frenchman who journeyed to the Isle of Staffa with young Macie in 1784, was a great friend and admirer of Franklin's. He corresponded with the American frequently and kept him abreast of most of his discoveries. During 1783 alone, the year before the Staffa expedition, Faujas de Saint-Fond sent Franklin samples of some new rustproof metal for shipbuilding, some odd stones from a building in Sicily, a memoir on sulfur caves in Italy, and an account of the ascent of Montgolfier, which Franklin sent on to Joseph Banks. During that same year, Faujas de Saint-Fond also invited William Temple Franklin, a grandson of Franklin's who was just a few years older than Macie, to accompany him to an exhibit in Paris of a new "robot."

It is plausible that Faujas de Saint-Fond could have sent a young British protégé Franklin's way as well. Franklin himself was at Passy during 1784, housebound due to ill health. Although there is no record of Macie's being in France during that year, it is always possible that he did visit and that Faujas de Saint-Fond introduced them then or at some other time when Franklin was still in France.

There are a few other coincidental links between Smithson and the Americans of his own generation. William Temple Franklin lived on Bentinck Street in London during the 1790s, around the time that Macie also had an address there. Ben Franklin by then was already dead. Recently, a theory was advanced that Smithson's interest in Washington and its institutions might have been a result

of his acquaintance with the only other man on the Staffa expedition who was around the same age. William Thornton, the future designer of the American Capitol, was in his mid-twenties when he and James Macie and the others adventured across Scotland and made the wild water crossing to Staffa. Throughout his life, one of Smithson's side interests was in buildings and architecture. Given his youthful friendship with Thornton, it seems possible that he kept abreast of architectural developments in Washington. But no letters between the two men have turned up.

Unfortunately for those who would like to know more about James Smithson's mind and motives, most of the clues to his personal life and thoughts as regards the Americans—and the rest of his life—were obliterated on an icy day in January 1865. The Smithsonian Castle was just ten years old when it caught fire, a very new structure merely made to look old, and it had all the advantages of the best fire-protection system available in the mid–nineteenth century. That is, night guards and buckets of water were placed at strategic points throughout the building, smoking and the carrying of open lights inside were prohibited, and an alarm system that consisted of a loud bell in a box was in place to alert the city's fire brigades. Unfortunately, the wintry weather worked against the best efforts of the system. Water in buckets was iced over. The alarm itself was frozen shut and precious minutes were wasted getting it operational. By the time the horse-drawn fire engines pulled up with their water tanks, the steady January wind had fanned the flames and pushed the fire westward over the roof of the main building.

The fire was soon visible from the Capitol, where one observer said the flames leaped from the towers "like volcanoes." A crowd, hearing the sound of the alarm and then seeing the fire engines speeding across the city, gathered to watch. As the flames darted out of the turrets, the Castle fire became a fantastic spectacle. Fire

poured out of the windows and flocks of pigeons, disturbed from their roosts, fluttered among the balls of ash that broke off and sailed through the wind. At about four o'clock in the afternoon, one of the roofs caved in with a mighty crash and spitting of flames.

The Civil War was still raging hundreds of miles to the south, and people who saw the flames from a distance might have been justified in initially imagining that the fighting had moved into the nation's capital. But by January 1865 the war had turned in favor of the Union army, and the brunt of the violence was taking place in South Carolina. In a week, on January 31, Congress was going to pass the Thirteenth Amendment to the U.S. Constitution, abolishing slavery and accomplishing that which John Quincy Adams had been certain—and rightly so—would never happen during his lifetime. "Neither slavery nor involuntary servitude, except as a punishment for crime whereof the party shall have been duly convicted, shall exist within the United States, or any place subject to their jurisdiction," read the amendment.

On that day in January, though, the issue of slavery was still far from settled. In the winter of 1865 sections of the nation were still a waste of violence. Nearly three hundred thousand Union soldiers remained locked in a savage fight with the dwindling Confederate army, and the South was losing. General Sherman was marching through South Carolina toward the sea, leaving ruins and pillage in his wake. Atlanta was already in ashes, as were other Southern cities. A month prior, a few days before Christmas, Sherman had reached Savannah, Georgia, leaving behind a path of destruction three hundred miles long and sixty miles wide all the way from Atlanta. Sherman telegraphed Lincoln, offering the president Savannah "as a Christmas present." In Washington bedraggled and starving slave refugees had been pouring in by the thousands. No one could guess what violence still lay ahead. In spring Union soldiers would burn Richmond, and by April the Confederacy would

be surrendering at Appomattox Court House. Then the president would be assassinated.

In such grim times, an *accidentally* burning Castle had some entertainment value. The civilian crowd watching flames devour the Smithsonian swelled and stamped on the icy Mall and grew jolly, and some, no doubt warmed with leftover holiday spirits, decided to storm the open Castle doors and poke around in the ashes. "Very many were eager to risk any personal exposure with the hope of saving something from the flames," reported the *Chicago Tribune*. The city police were called out, followed quickly by a detachment of cavalry, who drove the crowd back with such brutality that the newspaper thought fit to report it. "In some instances, the cavalrymen were more precipitate than duty or necessity required, periling the limbs if not the lives of those whom they were driving back quite as much as would have been risked by a closer proximity to the burning building."

The soldiers' violence was provoked first by the fact that it was wartime. They were charged with protecting a storehouse of unknown national treasure. For all they knew, a Confederate raiding party was already inside the burning Castle, looting not just petrified wood and preserved skeletons but whatever gold, silver, and rubies might also be housed within. In 1865, with the institution not even two decades old, neither the public nor the fire brigades could be expected to appreciate the true value of the thousands of scientific specimens and manuscripts inside the Castle walls. In fact, sheer ignorance contributed to the demise of some of the specimens. One story current in the Smithsonian today is that Washington City firemen stopped amidst their business on that cold day to warm themselves by swigging the alcohol from the broken specimen flasks.

By the time it was extinguished, the fire had ravaged an entire section of the Castle. It stopped only when it reached the central

part of the museum, which had been fireproofed, leaving intact the main exhibit of stuffed animals, reptiles, and birds' nests and eggs from all parts of the globe. Whole rooms were destroyed in a matter of minutes. Among the lost material was a vast and irreplaceable collection of American Indian portraits, Joseph Priestley's lab apparatus, thousands of pages of records relating to the institution's work, and countless jars of specimens. And, in one room that was burned early on, nearly every scrap of the personal effects of James Smithson, the institution's benefactor, was incinerated.

The 1865 Report of the Secretary to the Smithsonian Institution detailed what was lost in terms of Smithson's belongings. "The effects of Smithson had but little intrinsic value," wrote Smithsonian secretary Joseph Henry. "And were chiefly prized as mementos of the founder of the Institution. They consisted of a number of articles of chemical and physical apparatus, such as were used by him in his perambulatory excursions, two small cabinets of minute specimens of minerals, a silver-plated dinner service, and a trunk filled with manuscripts. . . . The manuscripts consisted principally of notes on scraps of paper, intended apparently for alphabetical arrangement in a common-place book, after the manner of philosophical dictionary." All that remained on earth of James Smithson now, besides his bones at Genoa, were two portraits, a bronze medallion likeness, 150 volumes from his personal library, and a small landscape painting.

Joseph Henry was upset by the incineration of Smithson's papers in the fire, but as he noted, the personal effects had little intrinsic value. He deemed their loss *inferior* to the twenty years of institutional business and history that had perished in the flames. "The most irreparable loss was that of the records, consisting of the official, scientific and miscellaneous correspondence," he wrote. These included thirty-five thousand pages of copied letters, fifty thousand pages of letters received by the institution, receipts of publications

and specimens, records of experiments, and miscellaneous diaries, memorandums, and account books.

Henry's relative indifference to the loss of everything that remained of the benefactor speaks volumes about the way the past is dissolved by the demands of the present. Henry and the other early shapers of the institution had managed to accomplish a great deal using Smithson's money, without knowing very much at all about the man. From a blank slate, they created an institution that gave the U.S. scientific community a global reputation, at a time when the nation was still seen as a backward, agrarian wilderness. The institution then expanded in ways Henry never imagined, to include sixteen museums and galleries and the National Zoo, some of the most-visited public places in the world. The tens of millions of people who come to the American capital every year and stroll the Mall cannot avoid assuming that Mr. Smithson, whose name is on every sign and building, played some vital role in American history. The classical white bulks of the national museums and the odd red turreted facade of the Castle face each other across the Mall, symbols of permanence bearing a stranger's name. In their solidity, they give no hint of the fact that the benefactor's attachment to this country was but a mysterious and seemingly random act, less accessible to us than his bones.

Notes

I

THE BODY SNATCHERS

Details about the Bells' experiences in Genoa come from Mabel Bell's journals and Alexander Graham Bell's Home notes for the year 1904 (vol. 4), all of which are preserved and available at the Alexander Graham Bell National Historic Site of Canada in Nova Scotia. Additional information, specifically about Bell's doctor's advice to him to travel, is from letters Bell wrote to the Smithsonian secretary, preserved in Smithsonian Institution Archives Record Unit 7000 (henceforth SIA 7000). Details of the inside of the hotel, Bell's illness, the foul Genoa weather, and the difficulties the couple faced in getting permits are all described in Mabel Bell's letter to her daughter Daisy, at Alexander Graham Bell National Historic Site.

Bell's notes for his speech written on board the *Dolphin* are contained in the Home notes, 1904.

Bell's nearly missing the Smithson welcoming ceremony is recounted in Robert V. Bruce, *Bell: Alexander Graham Bell and the Conquest of Solitude,* page 371. The column on Smithson's being "entitled to the respect of silence" is in a folder of newspaper clippings regarding Bell's trip to Genoa, SIA 7000.

The forensic report on Smithson's bones is part of the record in SIA 7000, as are news articles describing the small fire the workmen started and their method for extinguishing it.

The overview of Smithson's politics is derived from reading James Smithson's letters to Charles Fulke Greville, Davies Gilbert, Joseph Banks, and Georges Cuvier, all in SIA 7000, and the letters of Richard Rush from London to Secretary of State John Forsyth, at the Library of Congress Manuscript Reading Room, Papers of Richard Rush, series II, item 24.

2
THE DUKE AND THE WIDOW

Bath Chronicle news reports from 1761 are available on microfilm at the Bath Library, Bath, England. The Northumberlands' traveling style is detailed by Horace Walpole in his *Memoirs and Portraits,* page 153. For general Bath descriptions I visited the city and read Tobias Smollett, *The Expedition of Humphry Clinker;* Iris Origo, "The Pleasures of Bath in the Eighteenth Century"; *The New Bath Guide or Useful Pocket-Companion;* Penelope Corfield's article on Bath as a setting for Sheridan's play *The Rivals,* "Georgian Bath: Matrix and Meeting Place"; and R. S. Neale, *Bath, 1680–1850: A Social History, or, a Valley of Pleasure, Yet a Sink of Iniquity.*

For general eighteenth-century habits, speech, hygiene, manners: T. H. White, *The Age of Scandal: An Excursion Through a Minor Period;* Liza Picard, *Dr. Johnson's London: Everyday Life in London in the Mid-18th Century,* page 225; Joan Wildeblood and Peter Brinson, *The Polite World: A Guide to English Manners and Deportment from the Thirteenth to the Nineteenth Century.*

The Millers' *bout-rime* parties are described in Origo, "Pleasures of Bath," and Lady Betty's *bout-rime* is printed in George Tate, *The History of the Borough, Castle, and Barony of Alnwick,* vol. 1. Hugh Smithson's tastes are discussed in many books about the nobility and also about late-eighteenth-century English design and architecture, including Christopher Simon Sykes's *Private Palaces: Life in the Great London Houses* and E. Beresford Chancellor's *The Private Palaces of London Past and Present.*

Details of Elizabeth Macie's inheritance from her husband, John Macie, in a lawsuit are available at the Public Record Office, Kew (PRO Location Number C12/1028/19, 1770). John Macie's will, dated 12 June 1755, left his mortgages, securities, household goods, linen, plate, and china to Elizabeth Macie, for her lifetime (and beyond). John Macie's obituary is in the *Bath Chronicle,* on microfilm at the Bath Library.

The family history of Elizabeth Seymour, Duchess of Northumberland, and the story of her inheritance are laid out in Brian Masters's *The Dukes* and Tate's *History of Alnwick.* Modern-day Northumberland wealth is explained in Kevin Cahill, *Who Owns Britain.*

Hugh Smithson's improvements to his estates and properties and critical reactions to them are found in Thomas Pennant, *A Tour in Scotland,* page 32, and George E. Cokayne, *The Complete Peerage of England, Scotland, Ireland, Great Britain and the United Kingdom, Extant, Extinct and Dormant,* page 744. For Northumberland's income increases and superior business practices, see Tate's *History of Alnwick.* Descriptions of Northumberland House and parties and the amounts of food consumed are detailed in Sykes's *Private Palaces,* pages 152, 157. See also the Victoria and Albert Museum's 18th Century Collection. The menu for dinner and lavish lighting is from Mrs. Delany, *The Autobiography and Correspondence of Mary Granville, Mrs. Delany,* vol. 4. The description and history of Syon House is based on the author's visit to Syon House and an interview with Syon House curators in May 2002.

Selwyn's quote and Dutens's on Northumberland are from Sir Leslie Stephen and Sir Sidney Lee, eds., *The Dictionary of National Biography*, "Hugh Smithson" entry, page 864. Johnson on Northumberland is from James Boswell, *The Life of Samuel Johnson*. Walpole on Northumberland is from his *Memoirs*, page 153. Hugh Percy's embarrassing divorce is detailed in Masters's *The Dukes*, pages 250–55.

For Hugh Smithson's pomposity, his dirty politics, and the mob reaction to him, see Masters's *The Dukes* and Sykes's *Private Palaces*.

Lady Betty's dangerous Channel crossing is recounted in *Diaries of a Duchess*, page 100. Her penchant for vulgar show is discussed in Masters's *The Dukes*. Walpole's opinion of the Duchess affirms his *Memoirs*. American Cherokees are described in *Diaries of a Duchess*, page 47. The difference between the duchess's and the duke's tastes in art is explained in L. Dutens, *Memoirs of a Traveller Now in Retirement*, page 101. The duchess's love letters to her husband found and crumbled into dust is from William Weaver Tomlinson, *Comprehensive Guide to Northumberland*, page 372.

Information about Mrs. Macie's pedigree relied on Hungerford family history as recorded in *Hungerford Cartulary*, pages xiii–xv, and Sir Richard Colt Hoare, *Hungerfordiana: or Memoirs of the Family of Hungerford*. A copy of Penelope Fleming Keate's will is in SIA 7000. Elizabeth Macie's litigiousness is amply evident in her nine lawsuits preserved at the PRO at Kew: *Macie v. Hungerford*, 1766; *Macie v. Blake*, 1767; *Macie v. Dickinson*, 1769; *Macie v. Cowdry*, 1771, 1772; *Macie v. Cocks*, 1772; *Leir v. Macie*, 1773, 1796; *Macie v. Walker*, 1782–84; *Macie v. Baldwin*, 1792; *Leir v. Macie*, 1795.

For the sexual habits of women in Mrs. Macie's class and age, I relied on Amanda Foreman, *Georgiana, Duchess of Devonshire;* Brian Dolan, *Ladies of the Grand Tour: British Women in Pursuit of Enlightenment and Adventure in Eighteenth-Century Europe;* and Randolph Trumbach, *Sex and the Gender Revolution*, vol. 1, *Heterosexuality and the Third Gender in Enlightenment London*. For sexual habits of the eighteenth-century aristocracy in general, see *Road to Divorce: England, 1530–1987* and *The Family, Sex and Marriage in England, 1500–1800*, pages 521, 588, both by Lawrence Stone.

For the discussion about Mrs. Macie and the duke leaving no paper trail, I interviewed Colin Shrimpton, the archivist at Alnwick. The original "Tête-à Tête" column about the duke and "Mrs. White" is in *Town and Country Magazine*, July 1769, at the British Library, London.

3
NOBODY'S CHILD

An excellent source for background and anecdotes about eighteenth-century British upper-class women and travel, and the differences between France and England for British women, is Brian Dolan's *Ladies of the Grand Tour: British Women in Pursuit of Enlightenment and Adventure in Eighteenth-Century Europe.* Mr. Dolan generously answered my questions on the subject in a series of e-mails. I also gained much understanding about eighteenth-century British women and

illegitimacy from *In the Family Way: Childbearing in the British Aristocracy, 1760–1860*, by Judith Schneid Lewis; *Georgiana, Duchess of Devonshire*, by Amanda Foreman; and *Women in the Eighteenth Century: Constructions of Femininity*, edited by Vivien Jones.

The specifics of an eighteenth-century coach trip come from Andre Parreaux, *Smollett's London: A Course of Lectures Delivered at the University of Paris (1963–1964)*, page 70. For descriptions of Channel crossings, see Dolan, *Ladies of the Grand Tour;* Tobias Smollett, *Travels Through France and Italy;* Duchess of Northumberland, *Diaries of a Duchess.* Descriptions of Paris in the 1760s come from *Diaries of a Duchess*, pages 105–107; Evelyn Farr, *Before the Deluge: Parisian Society in the Reign of Louis XVI*, pages 21, 23; Smollett's travelogue; and Dolan. Lady Coke's experience is recounted by Dolan, page 84. Brooke is also from Dolan, page 93.

Mrs. Macie's pregnancy and childbirth in eighteenth-century England and Paris are reconstructed from a reading of Lewis, *In the Family Way;* Jacques Gélis, *History of Childbirth: Fertility, Pregnancy, and Birth in Early Modern Europe;* and *Eighteenth-Century Women: An Anthology*, edited by Bridget Hill. The chilly eighteenth-century attitudes toward children, including the Edward Gibbon anecdote, the unfashionableness of domesticity among the upper classes, and the limited relationship with children rely on Bogna W. Lorence, "Parents and Children in Eighteenth-Century Europe," pages 1–2, 6–7, and Rosamond Bayne-Powell, *The English Child in the Eighteenth Century.* The change in tone in the later eighteenth century is discussed by Stone in *The Family, Sex and Marriage in England.* The prevailing eighteenth-century child-care methods, details of common childhood diseases and their cures, nursery dangers, and lack of pediatric care are all described by Guy Williams in *The Age of Agony: The Art of Healing, 1700–1800*, pages 50, 65.

Details about Elizabeth Macie's inheritance come from John Bateman, *The Great Landowners of Great Britain and Ireland; The Victoria History of Wiltshire*, edited by R. B. Pugh and Elizabeth Crittall, page 80; John Aubrey, *Wiltshire: The Topographical Collections of John Aubrey, F.R.S., A.D. 1659–70;* and James Pope-Hennessy, *Lord Crewe, 1858–1945: The Likeness of a Liberal.* Elizabeth Macie's purchase of the Bath house on Queen Square is on the Bath tax rolls, Bath archives. Details of Elizabeth Macie's travels during her son's early years can be pieced together from the "jactitation" lawsuit she filed, *Macie v. Dickinson*, at the Public Record Office (PRO), Kew. John Marshe Dickinson's personal information is in *The Dictionary of National Biography* entry for his father, Marshe Dickinson. Details of the Macie-Dickinson marriage—their fights, disputes over money, and his death—are all from her lawsuit, *Macie v. Dickinson*, at PRO. Elizabeth's letters are at the London Metropolitan Archives. Violent moods believed to be the cause of miscarriage is from Lewis, *In the Family Way.*

The Henry Louis Dickinson birth story is pieced together from Leonard Carmichael and J. C. Long, *James Smithson and the Smithsonian Story;* documents in SIA 7000; and the military discharge records for Henry Dickinson at the PRO in Kew; also see R. C. Arrowsmith, *Charterhouse Register, 1769–1872.*

Elizabeth Macie's control of the Macie lands and her style of ownership are

based on a reading of the nine lawsuits preserved at PRO that show her scrapping with relatives and stewards over rents and mineral and timber rights as well as her right to improve houses and lands.

Descriptions of London in the 1770s rely on W. A. Speck, *A Concise History of Modern Britain, 1707–1975;* Smollett, *Humphry Clinker;* and Parreaux, *Smollett's London.* Description of dress in London comes from Ann Buck, *Dress in 18th Century England,* page 27. Anecdotes about the mob are from Parreaux and T. H. White, *Age of Scandal.* Observations about men's clubs in London and British intellectual life are from A. S. Turberville, *English Men and Manners in the Eighteenth Century,* page 115. Young Macie/Smithson's lifelong "foreignness" is alleged in Davies Giddy (Davies Gilbert) notes in SIA 7000. Brutality of eighteenth-century English methods for educating children is described in Lorence, "Parents and Children in Eighteenth-Century Europe," page 17.

For George Keate's life, work, and friendships, see Kathryn Gilbert Dapp, *George Keate, Esq.: Eighteenth Century English Gentleman,* and *The Dictionary of National Biography.*

Macie's naturalization petition is reproduced in Carmichael and Long, *James Smithson;* the authors are among the Americans who proposed that the limits in it were probably inserted by the Northumberland/Percy family. The actual law is described and explained in Danby Pickering, *The Statutes at Large from the Eighth Year of King William III to the Second Year of Queen Anne,* vols. X, XIII.

For Hugh Smithson's dukedom and the ways it was encumbered, see Brian Masters, *The Dukes,* page 261.

The social punishment of women in Mrs. Macie's situation is discussed by Lewis, *In the Family Way;* Foreman, *Georgiana, Duchess of Devonshire;* and Hill, ed., *Eighteenth-Century Women.*

Rumor of a link between Mrs. Macie's and Northumberland's houses appears in a letter to Secretary Ripley from 10th Duke of Northumberland, SIA 7000. But this rumor has her living on Hertford Street, not Upper Charlotte.

See David Saul, *Prince of Pleasure: The Prince of Wales and the Making of the Regency,* page 129, for a discussion of the commonness of bastards among the upper classes and examples thereof. The different styles of treatment of bastards by the upper classes of Northumberland's generation are described in Lawrence Stone, *The Family, Sex and Marriage in England,* pages 533–34. The description of the Duke of Northumberland's treatment of his two illegitimate daughters and their life stories are from obituaries in *Gentleman's Magazine,* 1794.

Examples of rich men supporting their bastards, including Devonshire, Buckingham, and Pembroke, are detailed in Stone and Miriam Allen De Ford, *Love-Children: A Book of Illustrious Illegitimates.*

British attitudes toward American revolutionaries are from various books, including Speck, *A Concise History of Modern Britain,* page 37; Douglas Hay, *Eighteenth-Century English Society: Shuttles and Swords;* Charles Knowles Bolton, ed., *The Letters of Hugh Earl Percy, from Boston and New York, 1774–76;* William Willcox and Walter Arnstein, *The Age of Aristocracy, 1688 to 1830;* and *Town and Country Magazine,* 1770–1786, British Library.

The duke's death, obit, and list of causes of death in London in 1786: *Town and Country Magazine* and *Gentleman's Magazine*, 1786, British Library.

Dutens's refusal to become a companion to the duke: Dutens, *Memoirs of a Traveller*, vol. 4, page 103.

Abigail Adams's description of the duke's lying in state: letter, July 20, 1786, copy in SIA 7000.

The list of Northumberland items in Smithson's possession at the time of his death comes from the catalog of Smithson's final possessions in SIA 7000 and published in William J. Rhees, *James Smithson and His Bequest.*

4
CHOOSING SCIENCE

Description of the Royal Society Thursday-night dinner meeting at the Crown and Anchor and Somerset House: Faujas de Saint-Fond, *Travels in England, Scotland, and the Hebrides*, pages 46–53; Thomas Sprat, *History of the Royal Society;* and John Timbs, *Clubs and Club Life in London*, pages 56–60. Specific details of Macie's induction are from the Royal Society citation record for Macie. Papers discussed at Macie's first meeting as a member and members present are recorded in *Royal Society Journals*, April 26, 1787.

Richard Kirwan's quote is from Roy Porter, *The Making of Geology*, page 158. The alchemical textbook in Macie's possession at his death is part of Smithson's personal library preserved at the Smithsonian. For great discoveries occurring in science during the 1780s, from phlogiston to the electric motor, see *Chronology of Science* and Roy Porter, *The Creation of the Modern World: The Untold Story of the British Enlightenment.* Cavendish's work on heat is detailed in Russell McCormmach, "Henry Cavendish on the Theory of Heat."

Macie's youthful description of himself as *"arm. fil"* is in the Oxford matriculation record, copy in SIA 7000. Davies Gilbert's diary entry regarding Macie is also in SIA 7000.

Mrs. Macie's and James Macie's bank account information: archives of the Royal Bank of Scotland.

For Pembroke anecdotes, names of other students, and comparisons with Trinity and Christ Church, see Carmichael and Long, *James Smithson*, and Jan Morris, ed., *The Oxford Book of Oxford.* The list of books Macie would have had to buy is from Douglas Macleane, *A History of Pembroke College, Oxford, Anciently Broadgates Hall, in Which Are Incorporated Short Historical Notices of the More Eminent Members of This House.* Biographical information on Dr. William Adams is in *The Dictionary of National Biography* and Macleane.

Breakthroughs in science in France and Lavoisier's work: Charles Coulston Gillispie, ed., *Dictionary of Scientific Biography*, and entries on DuLong, Cuvier, Geoffroy Saint-Hilaire, Gay-Lussac, Berzelius, and others; Porter, *Creation of the Modern World;* and Michael R. Lynn, "The Consumption of Natural Philosophy in Enlightenment France."

Pembroke and Oxford life, general anecdotes and memoirs: Morris, ed., *The Oxford Book of Oxford*, pages 151, 165. The story of the William Thomson sodomy case comes from Alice Blackford, Assistant Keeper of the Archives, Oxford University Archives, Bodleian Library. William Thomson's friendship with Macie is referred to in Thomson's letters in the Tozzetti Letters, Biblioteca Nationale Centrale, Florence. Thomson's letter to Banks inquiring about his Royal Society membership is in Banks Letters, British Library, Add. MS, 33978, 128.

Thomson's failed attempt to donate his collection to Oxford: Ellis Yochelson and Gordon Craig, "Do the Roots of the Smithsonian Institution Extend to Edinburgh?"

Theological estimated age of the earth: Simon Winchester, *The Map That Changed the World*. Plutonists versus Neptunists: Roy Porter, *The Making of Geology: Earth Science in Britain, 1660–1815*, pages 141, 171; and Charles Coulston Gillispie, *Genesis and Geology: A Study of the Relations of Scientific Thought, Natural Theology, and Social Opinion in Great Britain, 1790–1850*. Young geologists' attitudes toward their studies, Conybeare's quote, and mineralogy as a subfield of geology are from Porter, *The Making of Geology*. Macie's trip down the salt mine in a bucket is from Macie's journal quoted in William J. Rhees, *James Smithson and His Bequest*, page 140.

Macie's expedition to Staffa: Faujas de Saint-Fond, *Travels in England, Scotland, and the Hebrides;* Macie's own journal notes, published in Rhees; and author's visit to Staffa and Fingal's Cave.

William Thomson's letter to Joseph Black praising Macie: Edinburgh University Library, gen 873/11/184–5. Macie's letter to James Hutton: Fitzwilliam Museum, Cambridge, Percival Collection, J8, from Yochelson and Craig, "Do the Roots of the Smithsonian Institution Extend to Edinburgh?" Charles Blagden to Joseph Banks on Macie's Staffa trip and Macie's relationship to the Duke of Northumberland: British Museum of Natural History; Neil Chambers editing Banks papers, in prepublication for *The Scientist's Letters*.

Descriptions of John Street, Golden Square, and Piccadilly: Samuel Leigh, *Leigh's New Picture of London*.

Descriptions of Henry Cavendish: Timbs, *Clubs and Club Life of London*, page 67; Christa Jungnickel and Russell McCormmach, *Cavendish: The Experimental Life*, pages 304, 315, 317; and George Wilson, *The Life of the Hon. Henry Cavendish, Including Abstracts of His More Important Scientific Papers, and a Critical Inquiry into the Claims of All the Alleged Discoverers of the Composition of Water*.

Descriptions of Joseph Banks, his life, and his leadership style: Edward Smith, *The Life of Sir Joseph Banks, President of the Royal Society, with Some Notices of His Friends and Contemporaries;* Patrick O'Brian, *Joseph Banks, a Life*, page 210; and John Gascoigne, *Science in the Service of Empire: Joseph Banks, the British State and the Uses of Science in the Age of Revolution*. Quotes from Macie's letter to Joseph Banks accompanied by plant: Macie to Banks, Smithson correspondence, copy in SIA 7000.

Kirwan's letter about Macie's "Ardour" and, across the Channel, René-Just Haüy's mentions of Macie in his work on crystallography, both fully cited in

chapter 5, give a sense of how his elders viewed him at this time. Macie's patience for lab work is evident in the arcane materials he chose to study, the huge number of repetitions he put them through, and the words of his companions, especially Davies Gilbert's comparison of Macie to William Wollaston, quoted in Rhees, *James Smithson and His Bequest,* page 6. Smithson's views on disseminating scientific information for the common good: James Smithson, "On Some Improvements in Lamps, Particularly Referring to the Form of the Wicks," in *The Scientific Writings of James Smithson,* edited by William J. Rhees. Smithson on the relationship between particle and planet: "On a Method of Fixing Particles upon the Sappare," in Smithson, *Scientific Writings.* Macie's tabasheer experiments: Smithson, *Scientific Writings.* Geological significance of the tabasheer experiment: Yochelson and Craig, "Do the Roots of the Smithsonian Institution Extend to Edinburgh?"

Lists of Macie's Royal Society guests are contained in *Royal Society Journals,* 1787–1810.

Visit of the second Duke of Northumberland to the Royal Society and his induction as a member: *Royal Society Journals,* June 1787. Hugh Percy's Revolutionary War service and life, his generosity, his habits, and his connection to Casanova are found in Sir Leslie Stephen and Sir Sidney Lee, eds., *The Dictionary of National Biography,* and Masters, *The Dukes.* Percy's letter to the duke from Boston: *Letters of Hugh Earl Percy, from Boston and New York, 1774–1776,* edited by Charles Knowles Bolton.

The scene of Macie at the Royal Society with Dickinson is from *Royal Society Journals,* January 1788. Macie more foreign than English: Davies Gilbert's diary, copy in SIA 7000. Macie's linguistic fluency is evidenced in his letters, in the Macie/Smithson correspondence, SIA 7000, and is also discussed in the Carmichael and Long and Rhees biographies. The "Republic of Letters" is explained in Sir Gavin De Beer, *The Sciences Were Never at War.* Banks's memberships in foreign academies: Gascoigne, *Science in the Service of Empire,* page 150.

Beginnings of the French Revolution: Simon Schma, *Citizens: A Chronicle of the French Revolution.* King George III's illness and confinement: Ida Macalpine and Richard Hunter, *George III and the Mad Business,* pages 76, 86; and Charles Chenevix Trench, *The Royal Malady.*

The Earl of Clarendon's comment on the French revolutionaries comes from a collection of writings by a wide variety of British visitors to France during the Revolution: *English Witnesses of the French Revolution,* edited by J. M. Thompson.

5

DISCOVERIES AND REVOLUTIONS

The description of Macie at the Hôtel du Parc Royal, his feelings on French politics, "corrupt institutions," his health, and his future plans are all from his letter to Charles Fulke Greville, written on January 1, 1792, SIA 7000. Other descriptions of Paris during January 1792 rely on Simon Schama, *Citizens: A Chronicle of the French Revolution;* J. M. Thompson, *English Witnesses of the French Revolution;* and Arthur Young, *Travels During the Years 1787, 1788 and 1789.*

Macie becoming a regular churchgoer as an old man in Genoa comes from Leonard Carmichael and J. C. Long, *James Smithson and the Smithsonian Story.*

The view of the royal family at the Tuileries, the absence of nobles in Paris, and the William Wellesley Pole quote are all from Thompson, *English Witnesses of the French Revolution.*

Madame de Genlis milk-bath anecdote: Simon Schama, *Citizens,* page 138. Madame de Staël's public dressing style and quotes: J. Christopher Herold, *Mistress to an Age: A Life of Madame de Staël,* pages 69–70. Gouverneur Morris on prerevolutionary French frivolity: Evelyn Farr, *Before the Deluge: Parisian Society in the Reign of Louis XVI,* page 70.

Richard Kirwan on Macie's "Ardour": letter to Banks, Natural History Museum, B.L. D.T.C. X (1) 119–121.

Macie to Davies Gilbert, on the growing French revolutionary spirit and the church's demise: letter, April 1792, SIA 7000.

Dr. John Moore quote: Thompson, *English Witnesses of the French Revolution.* Edmund Burke's reaction to the Revolution and his linking scientists to radical thought is evident in Burke's own writing on the French Revolution, and is also discussed in Maurice Crosland, "The Image of Science as a Threat: Burke versus Priestley and the 'Philosophic Revolution,'" page 142. Priestley quotes from his *Experiments and Observations on Air* are from Crosland.

The reverence for scientists in French society is discussed by Schama in *Citizens,* page 43, and Robert Darnton, *Mesmerism and the End of the Enlightenment in France,* page 24. Details of French affection for Ben Franklin: Schama. Pilatre de Rozier story and balloon mania: Schama, page 127. Quote from *Journal de Paris:* Robert Darnton, *Mesmerism.* Invisible forces in science and the public reaction to them, including Lavoisier quote: Darnton, *Mesmerism,* page 16.

Abbé René-Just Haüy's life story is from Charles Coulston Gillispie, ed., *Dictionary of Scientific Biography.* Haüy on Macie's relevance: A. Lacroix, *Georges Cuvier et la minéralogie,* available at Muséum National d'Histoire Naturelle.

Antoine Lavoisier's personality and lifestyle, and explanation of the tax farmers: Schama, *Citizens,* and Gillispie, ed., *Dictionary of Scientific Biography.* Details on Lavoisier's lab and work habits also come from the Musée des Arts et Métiers, Paris. Macie-Lavoisier social connection is shown in an invitation in James Smithson's correspondence, copies in SIA 7000. Lagrange quote on Lavoisier's execution is from Schama. Richard Twiss's anecdote comes from his *A Trip to Paris in July and August, 1792.*

Description of William and Emma Hamilton's Naples salon: Flora Fraser, *Emma, Lady Hamilton,* and David Constantine, *Fields of Fire: A Life of Sir William Hamilton.* Macie's financial worth at this point: Carmichael and Long, *James Smithson.* William Thomson's letters to Ottaviano Tozzetti in August 1793 seeking Macie's whereabouts: Tozzetti letters, Biblioteca Nazionale Centrale, Florence. Macie in Florence and his friendships there with various mineralogists are described in Long and Carmichael. Macie's letter to Fabbroni quoting the English journal and Macie's letter to Fabbroni regarding his friends in Rome are translated and reproduced in Carmichael and Long, *James Smithson,* pages 90–91.

Macie's quote on the incompleteness of scientific knowledge: Rhees, *James Smithson and His Bequest*, page 7.

Macie's complaint about the difficulty of using the blowpipe with his weak lungs: Macie to Greville, Greville Papers, Letter 166, 42071, British Library.

Mania for natural philosophy and mineralogy: Roy Porter, *The Creation of the Modern World: The Untold Story of the British Enlightenment*. James Hutton's place in geology: Mott T. Greene, *Geology in the Nineteenth Century: Changing Views of a Changing World*, and Rachel Laudan, *From Mineralogie to Geology: The Foundations of a Science, 1650–1830*. Haüy quotes Macie and praises his work in a letter reprinted in Lacroix, *Georges Cuvier*, Muséum National d'Histoire Naturelle.

The outline of Macie's stay at Kassel and his dealings with Martin Klaproth are contained in Macie's letters, 1799–1806, SIA 7000. Specific Kassel descriptions and anecdotes about the geologists' community there were shared by German science historians Peter Schimkut and Professor Martin Guntau in e-mail and letter exchanges with the author. Macie's comment to an anonymous woman regarding the relative intelligence of German people is quoted in Carmichael and Long, *James Smithson*. Macie's letter to Joseph Banks from Dresden, May 1799, is in SIA 7000.

Elizabeth Macie's will is in PRO, Kew, England. Dorothy Percy's will is in SIA 7000.

Macie's name change and the reason for it is documented in PRO, Kew, HO Warrant Book 1801–1802, vol. 48. The first use of the name Smithson at the Royal Society is found in *Royal Society Journals*, December 1800. Smithson's election to the Royal Society Council is also documented in *Royal Society Journals*, December 1800. His scant appearances at council meetings thereafter are evidenced by the council records and lists of those present during 1801. Smithson's paper on minium, read after Matthew Flinders spoke, is recorded in *Royal Society Journals*, April 1806.

French Revolutionary and Napoleonic Wars and their effects on European travel are discussed in Gregor Dallas, *1815: The Roads to Waterloo;* T. C. W. Blanning, *The French Revolutionary Wars, 1787–1802;* and Gavin De Beer, *The Sciences Were Never at War*. The Kirwan lost-books anecdote comes from Warren Dawson, *The Banks Letters*, page 494. Banks's efforts for scientists and expeditions during wartime, including the Humphry Davy anecdote, are all detailed in letters published in De Beer.

Smithson's quote "The man of science is of no country; the world is his country, all mankind his countrymen": *The Scientific Writings of James Smithson*, ed. William J. Rhees.

Smithson's letter to Cuvier, April 1806, is in SIA 7000.

The saga of Smithson's experiences as a prisoner, including his letter to Banks, is contained in a pamphlet called "James Smithson in Durance" (The White Knight Chapbooks, Banksiana Series). Banks's reply and his letter to Delambre are printed in De Beer, *The Sciences Were Never at War*, page 184, and Delambre's response is outlined in *DeLambre & Smithson: A Translation and Explanation by Professor David Eugene Smith of a Letter in the Library of Columbia University*.

Smithson's reelection to the Royal Society Council in 1809 and his subsequent appearances at council meetings are documented in *Royal Society Journals* of November 30, 1809, and in council minutes during the years 1810 and 1811.

The Henry Dickinson wartime and travel narrative is contained in SIA, Rhees Collection, box 37, no. 2. Smithson and Dickinson's appearance together at the Royal Society is documented in *Royal Society Journals*, July 1810.

6

THE GIFT

The descriptions of Frascati's in the 1820s can be found in *Frascati's; or, Scenes in Paris,* an anonymously written book about an Englishman's dissolute life in Paris. The descriptions of the game *Rouge et Noir* are from that book as well as a curious tome called *Rouge et Noir: The Academicians of 1823, or the Greeks of the Palais Royal and the Clubs of St. James,* by Charles Persius, pseudonym of Charles Dunne.

My description of James Macie's physical state in his later years is based on the forensic report completed by the Smithsonian, as well as letters he wrote throughout his life complaining of ill health and especially, while imprisoned, coughing up of blood.

The letter to Mrs. Eccles is part of the original correspondence of Smithson in SIA 7000.

Details about Smithson's gambling addiction, his friendship with Arago, and the story Arago liked to tell about how his calculations persuaded Smithson to put a limit on his wagers were provided to the Smithsonian by the scientist Louis Agassiz, who knew Arago. Agassiz's letter is in SIA 7000 (Memorandum of the Secretary, Nov. 14, 1894).

All information about Smithson's bank accounts comes from the Royal Bank of Scotland Archives.

The general discussion of gambling among aristocrats in the late eighteenth century and later is based on reading Amanda Foreman's descriptions of the gambling habits of Georgiana, Duchess of Devonshire, and her set, and Andrew Steinmetz, *The Gaming Table: Its Votaries and Victims, in All Times and Countries, Especially in England and in France.* The Duke of Northumberland's alleged cheating at cards is described in "The Rolliad," an anonymously published 1799 poem, and his being cheated is described by his wife in *Diaries of a Duchess,* page 78.

The names of Smithson's male servants are contained in his will. The fact that he had a full china service is part of the catalog made of his estate when he died. Smithson's books—those that survived the trip to the United States and the Smithsonian fire—are preserved at the Smithsonian under the care of Leslie K. Overstreet, Curator of Natural-History Rare Books, Smithsonian Institution Libraries. I am indebted to her for letting me thumb through them and helping me with her own descriptions of some of these books, as well as giving me the anecdote about the binding of books and Smithson's apparent preference to leave his books unbound.

The full story of the prevalence of gonorrhea among the British upper classes in Smithson's time is related in Randolph Trumbach, *Sex and the Gender Revolution*, vol. 1, page 198.

All of Smithson's published scientific writings were collected and published by the Smithsonian in *The Scientific Writings of James Smithson*, edited by William J. Rhees. The work also includes some short reviews and quotes about his relevance by other scientists collected by the Americans. These latter articles are slightly more reverential than factual in tone but are still helpful for laypeople who want to understand where Smithson's work fit into the bigger picture of mineralogy and science in his day. The Beudant quote on naming smithsonite is cited in Leonard Carmichael and J. C. Long, *James Smithson and the Smithsonian Story*, as F. S. Beudant, 1832, in *Traité élémentaire de minéralogie*, page 104.

The description of what was in the "cyclopedic notes" surveyed by Walter R. Johnson before the fire is included in William J. Rhees, *James Smithson and His Bequest*.

The anecdote about the analysis of the lady's tear comes from Davies Gilbert's eulogy of Smithson, a copy of which is in the Smithsonian archives, SIA 7000; it is also reprinted in Rhees and in Carmichael and Long.

The suggestion that Smithson had a falling-out with his younger Royal Society colleagues is contained in Carmichael and Long, and is based on letters to the institution from English investigators who were picking up rumors in the late nineteenth century.

Smithson's acquaintance with various members of the Paris scientific set, including Dulong, Cordier, Becquerel, and others, is documented by a series of calling cards and invitations he either sent or received from these men, copies of which are stored with the Smithson correspondence in SIA 7000. The fact that these men were more involved in life, with families and professional posts, is evident in their entries in Charles Coulston Gillispie, ed., *Dictionary of Scientific Biography*. Quotes from the responses to Smithson's invitations are all from the copied documents in SIA 7000.

The Kirkdale Cave story, with biographical information about Granville Penn, comes from Carmichael and Long, *James Smithson*, and from Smithson's own article about the cave. Anecdotes about William Buckland's eccentricity and career are from Jan Morris, ed., *The Oxford Book of Oxford*, page 192. Quotes from Smithson's article are all from the Rhees edition of Smithson's scientific writings.

Smithson's will is preserved in SIA 7000. The pamphlet on will making is part of his personal library.

The Royal Institution's history was shared with the author by Dr. Frank James, official reader in the history of science at the Royal Institution, during an interview and various e-mail exchanges in 2002. I also relied on pamphlets and books about the Royal Institution and its founding members. Among the written sources are Frank James, *Guides to History of the Royal Institution;* "Michael Faraday and American Science," a lecture by Frank James published as a pamphlet; Morris Berman, *Social Change and Scientific Organization: The Royal Institution, 1799–1844;* and Sanborn C. Brown, *Benjamin Thompson, Count Rumford.* Richard Price's quote is from Roy Porter, *The Creation of the Modern World: The Untold Story of the British Enlightenment.*

For suggesting that I look into the tradition of individuals "naming" things after themselves posthumously as a possible explanation of Smithson's motivation, I am indebted to Marc Rothenberg, editor of the Joseph Henry papers at the Smithsonian.

The descriptions of Genoa come from the author's visit to Genoa and to the university library there, where librarian Alexis Quey provided on-the-spot translations from Italian into English of numerous passages about Genoa in the 1820s. My description of Genoa here also relies on the journals of Lady Margaret Blessington, whose time in Genoa coincided with Smithson's, published as *The Idler in Italy*, especially pages 297, 315, 320.

Carmichael and Long, in *James Smithson*, say Smithson was a regular member of the Anglican Church in Genoa, without citing a source, page 141.

The description and quotes from Isaac Weld, *Travels Through the States of North America, and the Provinces of Upper and Lower Canada, During the Years 1765, 1796, and 1797*, come from my reading of the book itself.

The full list of Smithson's possessions at his death is published in Rhees, *James Smithson and His Bequest.*

7

105 SACKS OF GOLD

Details about packet ships, including the *Mediator*, come from Robert Greenhalgh Albion, *Square-Riggers on Schedule: The New York Sailing Packets to England, France, and the Cotton Ports*, and Basil Lubbock, *The Western Ocean Packets*. I also relied on an interview with Norman Brouwer, a marine historian at the South Street Seaport Museum in New York City. Albion's book contains the names of the *Mediator*'s captains and details about the amounts of money it transported, page 39. The quote about the horrors of being a packet ship passenger comes from Thomas Hamilton, *Men and Manners in America*, pages 9–10.

Richard Rush's life story, including details of his early years in London and the meetings at the Royal Institution, is told in J. H. Powell, *Richard Rush: Republican Diplomat, 1780–1859*, the only biography of Rush. Rush's own description of seeing London for the first time and many other thoughts on the British are contained in his published journal, *Memoranda of a Residence at the Court of London*. His terrible seasickness is described in his own letters on microfilm at the Library of Congress and in his biography.

The descriptions of the White House and Washington in the 1820s generally rely on Constance McLaughlin Green, *Washington: A History of the Capitol, 1800–1950*. For Adams's rigorous hours: Powell, *Richard Rush*, page 180. Rush's speech about the relevance of his treasury post and his hopes for "a great scheme of national advancement" are from Powell, page 185.

For details about Adams's nation-building efforts and his speeches on the subject, I relied on Paul C. Nagel, *John Quincy Adams: A Public Life, a Private Life*, and Adams's diaries, published in thirteen volumes and available at the Library of Congress Manuscript Reading Room as *Memoirs*. Powell's *Richard Rush* also provided background for the political tensions of the time, as well as the details and

quotes from the Randolph-Rush dispute, pages 189, 218. Information about the strange life of John Randolph of Roanoke is entertainingly related in Robert Dawidoff, *The Education of John Randolph.*

Details about Smithson's death and the British consulate's response to it are from a letter from the British consul, at the Public Record Office, Kew (FO 762/5, 2 July 1829, FO 762/5, Major J. Stirling, H.M. Consul Genoa to Marquis Stagliano, 29 June 1829, copy).

The details of Henry Dickinson's will and his relationship to Mary Ann Coates, and his instructions to leave money in trust for her, are contained in SIA 7000, and detailed also in William J. Rhees, *John Smithson and His Bequest,* and Leonard Carmichael and J. C. Long, *James Smithson and the Smithsonian Story.*

The suggestion that the baron was gay comes from Carmichael and Long, who wrote, "The nephew was a wastrel, living for his pleasures, which did not however, include women," unfortunately without further explanation or citation, page 139.

American Anglophobia is discussed in Powell, *Richard Rush,* and the quote about congressional England-bashing is from Captain Basil Hall, *Travels in North America in the Years 1827 and 1828,* page 60. The anecdote about Peggy Eaton's sharing a boat with Rush is from Powell. The quote from Rush on first sighting London is from his own journal, published as *A Residence in London.*

All of the quotes from Rush's letters to John Forsyth between September 1836 and July 1838 are from the Rush letters at the Library of Congress Manuscript Reading Room, Papers of Richard Rush, series II, item 24. The quote from Aaron Vail regarding Smithson's supposed "mental aberration" is from a letter of Vail to Forsyth, quoted in Geoffrey Hellman, *The Smithsonian: Octopus on the Mall,* page 35. The quote about a blow to Smithson's "reputation" is from Johann C. Poggendorff, *Biographisch-Literarisches Handwörterbuch der exakten Naturwissenschaften.* Adams's comment about Smithson's supposed insanity is in his diaries, published as *Memoirs.*

Rush's description of his decisions regarding the stock sales are in his letters to Forsyth. His letters to Levi Woodbury and to Colonel Thomas Aspinwall are in the Library of Congress Manuscript Reading Room, Papers of Richard Rush, series II, item 24.

8

"A RATTLESNAKE'S FANG"

European condescension and theories about American inferiority are described in John C. Greene, *American Science in the Age of Jefferson,* page 30; Richard Gooch, *America and the Americans in 1833–4;* and Tyrone Power, *Impressions of America During the Years 1833, 1834 and 1835.* Walpole's quote about American potential comes from Joseph Ellis, *After the Revolution: Profiles of Early American Culture,* page 8. David Hume's quote is from Ellis, footnoted to T. H. Green and T. H. Grose, eds., *Essays: Moral, Political and Literary by David Hume* (2 vols.,

London, 1898). The Franklin quote about schoolmasters and poets is from Ellis, footnoted to Constance Rourke, *The Roots of American Culture* (New York, 1942).

General information about American culture leading up to the 1830s came from a variety of sources. Interesting and helpful were Jean V. Matthews, *Toward a New Society: American Thought and Culture, 1800–1830;* George E. Probst, ed., *The Happy Republic: A Reader in Tocqueville's America;* and Thomas K. Murphy, *A Land Without Castles: The Changing Image of America in Europe, 1780–1830.*

Richard Rush's description of Franklin's last days is from H. W. Brands, *The First American: The Life and Times of Benjamin Franklin,* page 710. Jefferson's ideas about theory and science, the quote from Jacob Greene, Benjamin Rush's complaint about a doctor's time-consuming drudgery, and Manasseh Cutler's quote are all from Greene, *Science in the Age of Jefferson,* pages 11, 12, 21, 33. Franklin's proposal for the Philosophical Society comes from H. W. Brand, page 168. The quote from the first *Transactions* is from Greene, as is Silliman's comment about the preferability of publishing in Europe, pages 6, 8.

Descriptions of Washington City in the 1830s come from a variety of sources, including Constance McLaughlin Green, *Washington: A History of the Capitol, 1800–1950;* Anne Royall, *Sketches of History, Life and Manners in the United States;* Frances Trollope, *Domestic Matters of the Americans,* pages 134, 157; and Captain Frederick Marryat, *Diary in America,* page 191.

Description and quote about the slave processions in the capital are from Green, *Washington,* as are descriptions of the raucous behavior at presidential levees, pages 81, 96.

The observation about 1830s congressmen, books, and adultery is from the preface of L. H. Butterfield, *The Great Design,* page 10.

The John Quincy Adams overview, including his sons' dissipation, relies on Paul C. Nagel, *John Quincy Adams: A Public Life, a Private Life;* a reading of his diaries; and discussions with the historian Michael Conlin (the sulfuric acid quote). Adams's quote about Smithson and the Percys is from his diaries, *Memoirs,* vol. IX, page 270. Adams's comment about Vail's letter is also from *Memoirs,* vol. IX, page 269. Quotes from Adams's speech to the House on Smithson's bequest is from William J. Rhees, *The Smithsonian Institution: Documents Relative to Its Origin and History. 1835–1899.* Adams's doubts about his ability to steer the bequest through the "jackals": *Memoirs,* vol. IX, page 273.

An explanation of the relative value of Smithson's bequest is from a memo to the secretary prepared by the Smithsonian, dated Nov. 1, 1999, SIA 7000.

William Corcoran's life story and affiliations with the treasury secretary are in *The Dictionary of American Biography,* page 504. The entire state bonds deal is described and annotated in Rhees, *The Smithsonian Institution.* The nongermaneness of the legislation was discussed by Adams in his Massachusetts speeches on Smithson's money, published in Butterfield, *The Great Design,* page 56. Woodbury's evasive letter is reprinted in Rhees, *The Smithsonian Institution,* vol. 1.

Sevier's life story and the "barbarian" style are covered well in an article by Brian G. Walton in the *Arkansas Historical Quarterly,* "Ambrose Hundley Sevier in

the United States Senate, 1836–1848." Also see Lonnie White, "The Fall of Governor John Pope."

Adams's thoughts on taking his case to the public are quoted by Wilcomb Washburn in his foreword to Butterfield, *The Great Design*. Adams's thoughts on "the great design" electioneering bribery and the "swindling speculation of the Senator from Arkansas" are in his diaries, all from his *Memoirs*, vol. X, page 336.

"Mr. A. H. Sevier made some observations in relation to the amendment not being distinctly heard in the gallery" is from the Congressional record published in Rhees, *The Smithsonian Institution*, vol. I, page 222.

<div align="center">

9

FOR THE INCREASE AND DIFFUSION OF KNOWLEDGE

</div>

John Quincy Adams's continuing hopes for an observatory and his thoughts on his attachment to astronomy referred to in the opening part of this chapter come from his later diaries, in *Memoirs*, vol. XII, page 200. The 1840 speech on the House floor is from William J. Rhees, *The Smithsonian Institution: Documents Relative to Its Origin and History. 1835–1899*, vol. 1, page 196. Adams's trip over the Great Lakes to see the Cincinnati Observatory and his return with a graveyard cough are from Paul C. Nagel, *John Quincy Adams: A Public Life, a Private Life*, page 398; Sally Kohlstedt, "A Step Toward Scientific Self-Identity in the United States: The Failure of the National Institute, 1844"; Marlana Portolano, "John Quincy Adams's Rhetorical Crusade for Astronomy"; and Steven J. Dick, "John Quincy Adams, the Smithsonian Bequest, and the Origins of the US Naval Observatory."

William C. Preston's quote is from Rhees, *The Smithsonian Institution*, vol. I. Biographical information about Calhoun is from the *Dictionary of American Biography* and Charles Maurice Wiltse, *John C. Calhoun: Nullifier, 1829–1839*. Quotes from his speeches on Smithson are from the *National Intelligencer*, April 8, 1830, and from Wiltse. Adams on "the delirium of malignity" is in his diaries, *Memoirs*, vol. X, page 113.

The anecdote about twelve hundred slaves auctioned in one day and John Randolph's quote are from Therese O'Malley, "A Public Museum of Trees: Mid-19th Century Plans for the Mall," page 6. The runaway slave notice is from the *National Intelligencer*, May 4, 1836.

Adams's devotion to the gag-rule fight and his family's worried response are from Nagel, *John Quincy Adams*, pages 356–57. Adams's opinion of the threats directed at him is in his diaries, *Memoirs*, vol. X, pages 82, 159. His fits of melancholy are described in Nagel. His resignation to seeing slavery continue throughout his lifetime is in his diaries, *Memoirs*, vol. XI, page 65.

Joel R. Poinsett biographical information is from the *Dictionary of American Biography* and from J. Fred Rippy's biography, *Joel R. Poinsett, Versatile American*. Rippy provides the Poinsett quote about needing a flourishing of the arts near the seat of government, page 199.

Robert Dale Owen biographical information is from the *Dictionary of American Biography* and Richard William Leopold, *Robert Dale Owen: A Biography*.

The list of ideas for how to spend the money, and quotes from Dr. Cooper and others, come from Rhees, *The Smithsonian Institution*, vol. I. History of the idea of a national university, including anecdotes about Washington and Jefferson, is related in Albert Castel, "The Founding Fathers and the Vision of a National University," page 280. Adams's quote about his "perilous experiment" is from his diaries, *Memoirs*, vol. XIII, page 64. Mention of the suggestion for using the money to found a school for blacks comes from an Adams speech delivered in Massachusetts and reprinted in L. H. Butterfield, *The Great Design*, page 73.

The Smithsonian farm proposal is outlined in great detail in Rhees, *The Smithsonian Institution*, vol. I. Rufus Choate's library suggestion and his speech on the subject is in the same book, as is Richard Rush's proposal.

Adams on the committee's diversions and his tardiness is in his diaries, *Memoirs*, vol. XI, page 102. Adams on seeing "the finger of John C. Calhoun" behind the obstructions to the Smithsonian is also in his diaries, *Memoirs*, vol. XI, page 113. Wilcomb Washburn in his foreword to Butterfield, *The Great Design*, talks about Adams's endless suspicions regarding the motives of his colleagues, page 30.

Details on the final proposal and vote are from Rhees, *The Smithsonian Institution*, vol. I. Adams on his colleagues being "unwilling to uncover the nakedness of the States" is in his diaries, *Memoirs*, vol. XII.

The National Institute's fossils going to a Georgetown bone mill is from Geoffrey T. Hellman, *The Smithsonian: Octopus on the Mall*, page 53. Washington mayor's quote welcoming the new institution is from Constance McLaughlin Green, *Washington: A History of the Capitol, 1800–1950*. The remark about extremes of "romantic picturesqueness" is from Talbot Faulkner Hamlin, writing in *The Dictionary of American Biography*, in "James Renwick" entry.

10
The Smithson Mystery

The description of the fire and details of Rhees's and the workmen's responses come from the Report of the Secretary in the *Smithsonian Annual Report for 1865* and two newspaper articles covering the fire: *Washington Star*, February 11, 1865, and *Chicago Tribune*, February 2, 1865, copies of which are stored at the Smithsonian archives.

Joseph Henry's biographical information (the Henry James Sr. fire anecdote) comes from Geoffrey T. Hellman, *The Smithsonian: Octopus on the Mall*; Paul Oehser, *The Smithsonian Institution*; and *The Dictionary of American Biography*. Descriptions of his "Programme" and the early manifestation of it are from Oehser.

The Horatio Greenough quote is from Kenneth Hafertepe, *America's Castle: The Evolution of the Smithsonian Building and Its Institution, 1840–1878*, page xxi. Henry's losing the museum fight is described in Hellman and Oehser. The list of odds and ends he was forced to accept comes from Hellman, page 86, as does the quote from his plea in his next-to-last report. The Horace Greeley quote is from Hellman, page 75, as is the *Atlantic Monthly* criticism.

Quotes from Henry's own papers and letters to Asa Gray, Alexander Dallas Bache, Charles Babbage, and Smithson's London solicitors: Joseph Henry Papers Project, pages 56, 68, 294, 295, 302.

The asterisks that replaced Vail's comments about Smithson's mental state are in William J. Rhees, *The Smithsonian Institution,* vol. I.

The record of William Wesley's efforts in England and his letters back to the Smithsonian are in SIA 7000, box 4.

The letters between Dillon Ripley and Claude-Ann Lopez discussing a Franklin connection are in SIA 7000. Ellis Yochelson has written about the possible connections between William Thornton and Smithson in an unpublished manuscript he shared with me.

The flames looking "like volcanoes" is from a letter written by a citizen witness to the fire, Richard Sherman, to his son, a copy of which is preserved at the Smithsonian archives. The anecdote about firemen swigging alcohol from the specimen jars was shared with me by Bill Cox, a Smithsonian archives research specialist. Henry's comments about the relative value of the Smithson materials is in his 1865 Report of the Secretary.

Bibliography

PRIMARY SOURCES

James Smithson's personal papers and papers related to the founding of the Smithsonian Institution, James Smithson Collection, 1796–1751, Record Unit 7000, Smithsonian Institution Archives, Washington, D.C.

James Smithson's books, Natural History and Rare Books Room, Smithsonian Institution Libraries

Chancery, military, and birth and marriage records, Public Record Office, Kew, England

Royal Bank of Scotland, PLC Archive section, London

Real estate records, Trowbridge and Wiltshire Record Office, Trowbridge, England

London ratebooks, 1780–1820, City of Westminster Archives Centre

Fores eighteenth-century London travel guides, Guildhall Library Collection, London

Birth and passport records, Archives Nationales, Paris

Records relating to the Dutch consulate in Paris in the 1760s, Archief Nationaal, Amsterdam, Holland

Syon House, Kew, England

Percy, Greville, and Banks Letters, British Library, London

The Diaries of a Duchess: Extracts from the Diaries of the First Duchess of Northumberland (1716–1776). Edited by James Greig. New York: George H. Devon Company, 1926.

Records relating to James Macie and William Thompson, Pembroke College Archives, Oxford

Records relating to William Thompson, Christ Church College Archives, Oxford

Bath Historical Society Archives, Bath, England

Bath Chronicle, 1760s, Microfilm Collection, Bath Library, Bath, England

Royal Society Journals and *Council Minutes* 1787–1825, Royal Society Archives, London

Georges Cuvier Collection, Muséum National d'Histoire Naturelle, Paris

Cordier Collection, Institut de France, Paris

18th Century and Lavoisier Collections, Musée des Arts et Métiers, Paris

18th Century Collection, Victoria and Albert Museum, London

Papers of Ottaviano Targioni Tozzetti, Biblioteca Nazionale Centrale, Florence, Italy

Memoirs of John Quincy Adams, Comprising Portions of His Diary from 1795 to 1848. Edited by Charles Francis Adams, 12 volumes. Philadelphia: J. B. Lippincott and Company, 1874.

Richard Rush Papers, Manuscript Division, Library of Congress, Washington, D.C.

National Intelligencer, Washington, D.C. Daily newspaper from the 1830s and 1840s, Microfilm Collection, Library of Congress, Washington, D.C.

Alexander Graham Bell Papers, Parks Canada, Alexander Graham Bell National Historic Site of Canada, Nova Scotia, Canada

Messrs. C. Hoare & Co., London

Chancery records, London Metropolitan Archives

Joseph Henry Papers Project, Institutional History Division, Smithsonian Institution Archives, Washington, D.C.

Gentleman's Magazine, British Library, London

Town and Country Magazine, British Library, London

The following experts were consulted and have in some cases provided copies of primary-source documents:

Norman Brouwer, marine historian, South Street Seaport Museum, New York, New York

Neil Chambers, curator of the Joseph Banks Archive Project, Natural History Museum, London

Michael Conlin, American historian and author of thesis "Science Under Siege: Joseph Henry's Smithsonian, 1846–1865," on the founding of the Smithsonian Institution and the antislavery movement, Eastern Washington University, Cheney, Washington

Bill Cox, research specialist, Smithsonian Institution, Washington, D.C.

Edwin S. Grosvenor, author of *Alexander Graham Bell: The Life and Times of the Man Who Invented the Telephone*

Frank James, reader in history, Royal Institution, London

Stefano Marabini, Italian science historian

Marc Rothenberg, director of the Joseph Henry Papers Project, Smithsonian Institution, Washington, D.C.

Peter Schimkut, German science historian

Colin Shrimpton, archivist, Alnwick Castle, Alnwick, England

Ellis Yochelson, Museum of Natural History, Smithsonian Institution, Washington, D.C.

BOOKS AND ARTICLES

Albion, Robert Greenhalgh. *Square-Riggers on Schedule: The New York Sailing Packets to England, France, and the Cotton Ports.* Princeton, N.J.: Princeton University Press, 1938.

Alexander, William, M.D. *The History of Women, from the Earliest Antiquity to the Present Time.* London: W. Strahan and T. Cadell, 1779.

Arrowsmith, R. C. *Charterhouse Register, 1769–1872.* London: Philmore & Co., 1974.

Aubrey, John. *Wiltshire: The Topographical Collections of John Aubrey, F.R.S., A.D. 1659–70.* Corrected and enlarged by John Edward Jackson. Devizes, England: Wiltshire Archaeological and Natural History Society, 1862.

Bannet, Eve Tavor. "The Marriage Act of 1753: A Most Cruel Law for the Fair Sex." *Eighteenth Century Studies* 30, no. 3 (1997): 233–54.

Bateman, John. *The Great Landowners of Great Britain and Ireland.* 4th ed. London: Harrison and Sons, 1883.

Bayne-Powell, Rosamond. *The English Child in the Eighteenth Century.* London: J. Murray, 1939.

Bemis, Samuel Flagg. *John Quincy Adams and the Union.* New York: Knopf, 1956.

Beretta, Marco. "Chemists in the Storm: Lavoisier, Priestley and the French Revolution." *NUNCIUS* 8, no. 1 (1993): 75–104.

Berman, Morris. *Social Change and Scientific Organization: The Royal Institution, 1799–1844.* Ithaca, N.Y.: Cornell University Press, 1978.

Blanning, T. C. W. *The French Revolutionary Wars, 1787–1802.* New York: St. Martin's Press, 1996.

Blessington, Marguerite, Countess of. *The Idler in Italy.* Vol. 1. Philadelphia: E. L. Carey and A. Hart, 1839.

Bode, Carl, ed. *American Life in the 1840's.* Garden City, N.Y.: Anchor Books, 1967.

Brands, H. W. *The First American: The Life and Times of Benjamin Franklin.* New York: Anchor Books, 2000.

Brown, Sanborn C. *Benjamin Thompson, Count Rumford.* Cambridge, Mass.: MIT Press, 1979.

Bruce, Robert V. *Bell: Alexander Graham Bell and the Conquest of Solitude.* Boston: Little, Brown, 1973.

Buck, Anne. *Dress in Eighteenth-Century England.* London: B.T. Batsford, 1979.

Burstein, Andrew. *America's Jubilee.* New York: Knopf, 2001.

Cahill, Kevin. *Who Owns Britain.* Edinburgh: Canongate, 2001.

Carmichael, Leonard, and J. C. Long. *James Smithson and the Smithsonian Story.* New York: Putnam, 1965.

Castel, Albert. "The Founding Fathers and the Vision of a National University." *History of Education Quarterly* 4 (1964): 280–302.

Chaldecott, J. A. "Scientific Activities in Paris in 1791: Evidence from the Diaries of Sir James Hall for 1791, and Other Contemporary Records." *Annals of Science* 24 (1968): 21–52.

Chancellor, E. Beresford. *The Private Palaces of London Past and Present.* London: K. Paul, Trench, Trubner & Co. Ltd., 1908.

Cokayne, George E. *The Complete Peerage of England, Scotland, Ireland, Great Britain and the United Kingdom, Extant, Extinct and Dormant.* Rev. ed. Stroud, England: Sutton, 2000.

Coleman, William R. *Georges Cuvier, Zoologist: A Study in the History of Evolution Theory.* Cambridge, Mass.: Harvard University Press, 1964.

Conlin, Michael F. "The Smithsonian Abolition Lecture Controversy: The Clash of Antislavery Politics with American Science in Wartime Washington." *Civil War History* 46 (September 2000): 301–23.

Constantine, David. *Fields of Fire: A Life of Sir William Hamilton.* London: Weidenfeld & Nicolson, 2001.

Corfield, Penelope. "Georgian Bath: Matrix and Meeting Place." *Connecticut Review* 12, no. 1 (1990): 69–79.

Crosland, Maurice. "The Image of Science as a Threat: Burke versus Priestley and the 'Philosophic Revolution.'" *British Journal for the History of Science* 20 (1987): 277–307.

Dallas, Gregor. *1815: The Roads to Waterloo.* London: Richard Cohen Books, 1996.

Dapp, Kathryn Gilbert. *George Keate, Esq.: Eighteenth-Century English Gentleman.* Philadelphia: University of Philadelphia Press, 1939.

Darnton, Robert. *The Great Cat Massacre and Other Episodes in French Cultural History.* New York: Basic Books, 1984.

———. *Mesmerism and the End of the Enlightenment in France.* Cambridge, Mass.: Harvard University Press, 1968.

Dawidoff, Robert. *The Education of John Randolph.* New York: W. W. Norton, 1979.

Dawson, Warren R., ed. *The Banks Letters: A Calendar of the Manuscript Correspondence of Sir Joseph Banks, Preserved in the British Museum, the British Museum (Natural History) and Other Collections in Great Britain.* London: Trustees of the British Museum, 1958.

De Beer, Sir Gavin. *The Sciences Were Never at War.* London: Nelson, 1960.

De Ford, Miriam Allen. *Love-Children: A Book of Illustrious Illegitimates*. New York: Dial Press, 1931.

Delany, Mrs. [Mary]. *The Autobiography and Correspondence of Mary Granville, Mrs. Delany; with Interesting Reminiscences of King George the Third and Queen Charlotte*. Edited by the Right Honourable Lady Llanover. London: R. Bentley, 1861.

Dick, Steven J. "John Quincy Adams, the Smithsonian Bequest, and the Origins of the US Naval Observatory." *Journal for the History of Astronomy* 22, no. 1 (1991): 31–44.

Dolan, Brian. *Ladies of the Grand Tour: British Women in Pursuit of Enlightenment and Adventure in Eighteenth-Century Europe*. New York: HarperCollins, 2001.

Dutens, L[ouis]. *Memoirs of a Traveller, Now in Retirement*. Translated from the French. London: R. Phillips, 1806.

Ellis, Joseph. *After the Revolution: Profiles of Early American Culture*. New York: W. W. Norton, 1981.

Emden, Paul H. *Regency Pageant*. London: Hodder & Stoughton, 1936.

Farr, Evelyn. *Before the Deluge: Parisian Society in the Reign of Louis XVI*. London: P. Owen, 1994.

Faujas de Saint-Fond, Barthélémy. *Travels in England, Scotland, and the Hebrides; Undertaken for the Purpose of Examining the State of the Arts, the Sciences, Natural History and Manners, in Great Britain*. London: J. Ridgway, 1799.

Foreman, Amanda. *Georgiana, Duchess of Devonshire*. New York: Random House, 1998.

Fores, S. W. *Fores's New Guide for Foreigners: Containing the Description of London*. London: Fores, 1789.

Frascati's; or, Scenes in Paris. 2 vols. Philadelphia: E. L. Carey & A. Hart, 1836.

Fraser, Flora. *Emma, Lady Hamilton*. New York: Knopf, 1987.

Gascoigne, John. *Science in the Service of Empire: Joseph Banks, the British State and the Uses of Science in the Age of Revolution*. Cambridge, England: Cambridge University Press, 1998.

Gélis, Jacques. *History of Childbirth: Fertility, Pregnancy, and Birth in Early Modern Europe*. Translated by Rosemary Morris. Cambridge, England: Polity Press, 1991.

Gillispie, Charles Coulston. *Genesis and Geology: A Study of the Relations of Scientific Thought, Natural Theology, and Social Opinion in Great Britain, 1790–1850*. Cambridge, Mass.: Harvard University Press, 1951.

———, ed. *Dictionary of Scientific Biography*. New York: Scribner, 1970–1990.

Golinski, Jan. *Science as Public Culture: Chemistry and Enlightenment in Britain, 1760–1820*. Cambridge, England: Cambridge University Press, 1992.

Gooch, Richard. *America and the Americans in 1833–4*. New York: Fordham University Press, 1994.

Green, Constance McLaughlin. *Washington: A History of the Capitol, 1800–1950*. Princeton, N.J.: Princeton University Press, 1976.

Greene, John C. *American Science in the Age of Jefferson*. Ames: Iowa State University Press, 1984.

Greene, Mott T. *Geology in the Nineteenth Century: Changing Views of a Changing World*. Ithaca, N.Y.: Cornell University Press, 1982.

Grosvenor, Edwin S., and Morgan Wesson. *Alexander Graham Bell: The Life and Times of the Man Who Invented the Telephone*. Foreword by Robert V. Bruce. New York: Harry Abrams, 1997.

Hafertepe, Kenneth. *America's Castle: The Evolution of the Smithsonian Building and Its Institution, 1840–1878*. Washington, D.C.: Smithsonian Institution Press, 1984.

Hall, Basil. *Travels in North America in the Years 1827 and 1828*. 3 vols. Edinburgh: Cadell, 1829.

Hamilton, Thomas. *Men and Manners in America*. Philadelphia: Carey, Lea & Blanchard, 1833.

Hay, Douglas. *Eighteenth-Century English Society: Shuttles and Swords*. New York: Oxford University Press, 1997.

Hellman, Geoffrey T. *The Smithsonian: Octopus on the Mall*. Philadelphia: Lippincott, 1967.

Herold, J. Christopher. *Mistress to an Age: A Life of Madame de Staël*. London: H. Hamilton, 1958.

Hill, Bridget, ed. *Eighteenth-Century Women: An Anthology*. London: Allen & Unwin, 1984.

Hoare, Sir Richard Colt. *Hungerfordiana: or Memoirs of the Family of Hungerford*. Bristol, England: R. N. Hungerford, 1981.

Jardine, Nicholas, James A. Secord, and Emma C. Spary, eds. *Cultures of Natural History*. Cambridge, England: Cambridge University Press, 1996.

Jones, Vivien, ed. *Women in the Eighteenth Century: Constructions of Femininity*. London: Routledge, 1990.

Jungnickel, Christa, and Russell McCormmach. *Cavendish: The Experimental Life*. Rev. ed. Lewisburg, Pa.: Bucknell, 1999.

Kirby, J. L., ed. *The Hungerford Cartulary: A Calendar of the Earl of Radnor's Cartulary of the Hungerford Family*. Trowbridge, England: Wiltshire Record Society, 1994.

Knight, David. *Humphry Davy: Science & Power*. Oxford, England: Blackwell, 1992.

Kohlstedt, Sally. "A Step Toward Scientific Self-Identity in the United States: The Failure of the National Institute, 1844." *Isis* 62, no. 3 (1971): 339–62.

Laudan, Rachel. *From Mineralogie to Geology: The Foundations of a Science, 1650–1830*. Chicago: University of Chicago Press, 1987.

Leigh, Samuel. *Leigh's New Picture of London: or, A View of the Political, Religious, Medical, Literary, Municipal, Commercial, and Moral State of the British Metropolis*. 4th ed. London: Printed for Samuel Leigh by W. Clowes, 1820.

Leopold, Richard William. *Robert Dale Owen: A Biography*. Cambridge, Mass.: Harvard University Press, 1940.

Lewis, Judith Schneid. *In the Family Way: Childbearing in the British Aristocracy, 1760–1860.* New Brunswick, N.J.: Rutgers University Press, 1986.

Lorence, Bogna W. "Parents and Children in Eighteenth-Century Europe." *History of Childhood Quarterly* 2, no. 1 (1974): 1–30.

Lubbock, Basil. *The Western Ocean Packets.* Glasgow: J. Brown & Son, Ltd., 1925.

Lyte, H. C. Maxwell. *Dunster and Its Lords, 1066–1881.* Exeter, England: Privately printed, 1882.

Macalpine, Ida, and Richard Hunter. *George III and the Mad Business.* London: Pimlico, 1991.

Macleane, Douglas. *A History of Pembroke College, Oxford, Anciently Broadgates Hall, in Which Are Incorporated Short Historical Notices of the More Eminent Members of This House.* Oxford, England: Oxford Historical Society, 1897.

Marryat, Captain Frederick. *Diary in America.* Edited by Jules Zanger. Bloomington: Indiana University Press, 1960.

Masters, Brian. *The Dukes.* Rev. ed. London: Pimlico, 2001.

Matthews, Jean V. *Toward a New Society: American Thought and Culture, 1800–1830.* Boston: Twayne Publishers, 1991.

McCormmach, Russell. "Henry Cavendish on the Theory of Heat." *Isis* 79, no. 296 (1988): 37–67.

Morris, Jan, ed. *The Oxford Book of Oxford.* New York: Oxford University Press, 1978.

Murphy, Thomas K. *A Land Without Castles: The Changing Image of America in Europe, 1780–1830.* Lanham, Md.: Lexington Books, 2001.

Nagel, Paul C. *John Quincy Adams: A Public Life, a Private Life.* New York: Knopf, 1998.

Neale, R. S. *Bath, 1680–1850: A Social History, or, a Valley of Pleasure, Yet a Sink of Iniquity.* London: Routledge, 1981.

The New Bath Guide or Useful Pocket-Companion. 4th ed. Bath, England: C. Pope, 1766.

O'Brian, Patrick. *Joseph Banks: A Life.* London: C. Harvill, 1987.

Oehser, Paul H. *The Smithsonian Institution.* Boulder, Colo.: Westview Press, 1983.

O'Malley, Therese. "A Public Museum of Trees: Mid-19th Century Plans for the Mall." *Studies in the History of Art* 30 (1991): 60–76.

Origo, Iris. "The Pleasures of Bath in the Eighteenth Century." *Horizon* 7, no. 1 (1965): 4–15.

Parreaux, Andre. *Smollett's London: A Course of Lectures Delivered at the University of Paris (1963–1964).* Paris: Nizet, 1965.

Paston, George. *Social Caricature in the Eighteenth Century.* London: Methuen, 1905.

Pennant, Thomas. *A Tour in Scotland.* 3rd ed. Warrington, England: W. Eyres, 1774.

Persius, Charles. *Rouge et Noir: The Academicians of 1823, or the Greeks of the Palais Royal and the Clubs of St. James.* London: Privately printed, 1823.

Picard, Liza. *Dr. Johnson's London: Everyday Life in London in the Mid-18th Century.* London: Weidenfeld & Nicolson, 2000.

Poggendorff, Johann Christian. *Biographisch-literarisches Handwörterbuch der exakten Naturwissenschaften.* Leipzig: Barth, 1863.

Pope-Hennessy, James. *Lord Crewe, 1858–1945: The Likeness of a Liberal.* London: Constable, 1955.

———. *Monckton Milnes: The Flight of Youth, 1851–1885.* London: Constable, 1951.

———. *Monckton Milnes: The Years of Promise, 1809–1851.* London: Constable, 1940.

Porter, Roy. *The Creation of the Modern World: The Untold Story of the British Enlightenment.* New York: W. W. Norton, 2000.

———. *The Making of Geology: Earth Science in Britain, 1660–1815.* Cambridge, England: Cambridge University Press, 1977.

Portolano, Marlana. "John Quincy Adams's Rhetorical Crusade for Astronomy." *Isis* 91, no. 3 (2000): 480–503.

Powell, John Harvey. *Richard Rush: Republican Diplomat, 1780–1859.* Philadelphia: University of Pennsylvania Press, 1942.

Power, Tyrone. *Impressions of America During the Years 1833, 1834 and 1835.* Vol. 1. London: Richard Bentley, 1836.

Probst, George E., ed. *The Happy Republic: A Reader in Tocqueville's America.* Gloucester, Mass.: Peter Smith, 1968.

Pugh, R. B., and Elizabeth Crittall. *The Victoria History of Wiltshire.* London: Oxford University Press, 1953.

Reingold, Nathan, ed. *The Papers of Joseph Henry.* Washington, D.C.: Smithsonian Institution Press, 1972–1996.

Rhees, William J. *James Smithson and His Bequest.* Washington, D.C.: Smithsonian Institution, 1880.

———. *The Smithsonian Institution: Documents Relative to Its Origin and History. 1835–1899.* 2 vols. Washington, D.C.: Government Printing Office, 1901.

Richardson, Joseph. *The Rolliad, in Two Parts: Probationary Odes for the Laureateship and Political Eclogues: With Criticisms and Illustrations.* 21st ed. London: J. Ridgway, 1799.

Rippy, J. Fred. *Joel R. Poinsett, Versatile American.* Durham, N.C.: Duke University Press, 1935.

Royall, Anne Newport. *Sketches of History, Life and Manners in the United States.* New Haven, Conn.: Privately printed, 1826.

Rush, Richard. *Memoranda of a Residence at the Court of London.* 2nd ed. Philadelphia: Key and Biddle, 1833.

Saul, David. *Prince of Pleasure: The Prince of Wales and the Making of the Regency.* New York: Atlantic Monthly Press, 1998.

Schama, Simon. *Citizens: A Chronicle of the French Revolution*. New York: Knopf, 1989.

Sedgwick, Romney. *The House of Commons, 1715–1754*. London: Her Majesty's Stationery Office, 1971.

Simond, Louis. *Journal of a Tour and Residence in Great Britain, During the Years 1810 and 1811*. 2nd ed. Edinburgh: A. Constable and Co., 1817.

Smith, David Eugene. *DeLambre & Smithson: A Translation and Explanation by Professor David Eugene Smith of a Letter in the Library of Columbia University*. Fulton, N.Y.: Morrill Press, 1934.

Smith, Edward. *The Life of Sir Joseph Banks, President of the Royal Society, with Some Notices of His Friends and Contemporaries*. London: John Lane, 1911.

Smithson, James. *Letter from James Smithson to Sir Joseph Banks, from Hamburg, September 18, 1808, As a Prisoner of War*. Palo Alto, Calif.: White Knight Press, 1943.

———. *The Scientific Writings of James Smithson*. Edited by William J. Rhees. Washington, D.C.: Smithsonian Institution, 1879.

Smollett, Tobias George. *The Expedition of Humphry Clinker*. London: J. Walker and Co., 1815.

———. *Travels Through France and Italy*. London: R. Baldwin, 1766.

Speck, W. A. *A Concise History of Modern Britain, 1707–1975*. New York: Cambridge University Press, 1993.

Sprat, Thomas. *History of the Royal Society*. Edited by Jackson I. Cope and Harold Whitmore Jones. London: Routledge, 1959.

Stearns, Elinor, and David N. Yerkes. *William Thornton: A Renaissance Man in the Federal City*. Washington, D.C.: American Institute of Architects Foundation, 1976.

Steinmetz, Andrew. *The Gaming Table: Its Votaries and Victims, in All Times and Countries, Especially in England and in France*. London: Tinsley Brothers, 1870.

Stephen, Sir Leslie, and Sir Sidney Lee, eds. *The Dictionary of National Biography*. London: Oxford University Press, 1921–27.

Stone, Lawrence. *The Family, Sex and Marriage in England, 1500–1800*. London: Weidenfeld & Nicolson, 1977.

———. *Road to Divorce: England, 1530–1987*. New York: Oxford University Press, 1990.

Sykes, Christopher Simon. *Private Palaces: Life in the Great London Houses*. London: Chatto & Windus, 1985.

Tate, George. *The History of the Borough, Castle, and Barony of Alnwick*. 2 vols. Alnwick, England: H. H. Blair, 1866–69.

Thomas, Joseph. *Universal Pronouncing Dictionary of Biography and Mythology*. Rev. ed. Philadelphia: J. B. Lippincott, 1885.

Thompson, J. M. *English Witnesses of the French Revolution*. Oxford, England: Blackwell, 1938.

Thomson, Thomas. *History of the Royal Society, from Its Institution to the End of the Eighteenth Century*. London: R. Baldwin, 1812.

Timbs, John. *Clubs and Club Life in London.* Rev. ed. London: Chatto & Windus, 1899.

Tomlinson, William Weaver. *Comprehensive Guide to Northumberland.* 11th ed. Reprint. New York: A. M. Kelley, 1969.

Trench, Charles Chenevix. *The Royal Malady.* New York: Harcourt, Brace & World, 1965.

Trollope, Frances. *Domestic Matters of the Americans.* Edited by Donald Smalley. New York: Knopf, 1949.

Trumbach, Randolph. *Sex and the Gender Revolution.* Vol. 1, *Heterosexuality and the Third Gender in Enlightenment London.* Chicago: University of Chicago Press, 1998.

Turberville, A. S. *English Men and Manners in the Eighteenth Century.* Oxford, England: Clarendon Press, 1926.

Twiss, Richard. *A Trip to Paris in July and August, 1792.* London: Privately printed, 1793.

Walpole, Horace. *Memoirs and Portraits.* Rev. ed. Edited by Matthew Hodgart. New York: Macmillan, 1963.

Walton, Brian G. "Ambrose Hundley Sevier in the United States Senate, 1836–1848." *Arkansas Historical Quarterly* 32, no. 1 (1973): 25–60.

Weld, Isaac, Jr. *Travels Through the States of North America, and the Provinces of Upper and Lower Canada, During the Years 1795, 1796, and 1797.* 2nd ed. London: John Stockdale, 1799.

White, Lonnie. "The Fall of Governor John Pope." *Arkansas Historical Quarterly* 23, no. 1 (1964): 74–84.

White, T. H. [Terence Hanbury]. *The Age of Scandal: An Excursion Through a Minor Period.* New York: Putnam, 1950.

The Whole Art and Mystery of Modern Gaming. London: n.p., 1726.

Wildeblood, Joan, and Peter Brinson. *The Polite World: A Guide to English Manners and Deportment from the Thirteenth to the Nineteenth Century.* London: Oxford University Press, 1965.

Willcox, William, and Walter Arnstein. *The Age of Aristocracy, 1688 to 1830.* Lexington, Mass.: D. C. Heath and Co., 1996.

Williams, Guy R. *The Age of Agony: The Art of Healing, 1700–1800.* London: Constable, 1975.

Wilson, George. *The Life of the Hon. Henry Cavendish, Including Abstracts of His More Important Scientific Papers, and a Critical Inquiry into the Claims of All the Alleged Discoverers of the Composition of Water.* London: Cavendish Society, 1851.

Wiltse, Charles Maurice. *John C. Calhoun: Nullifier, 1829–1839.* Indianapolis: Bobbs-Merrill, 1949.

Yochelson, Ellis L., and Gordon Craig. "Do the Roots of the Smithsonian Institution Extend to Edinburgh?" *Edinburgh Geologist* 32 (1999): 20–29.

Young, Arthur. *Travels During the Years 1787, 1788 and 1789.* Dublin: Privately printed, 1793.